Raqqa Revisited

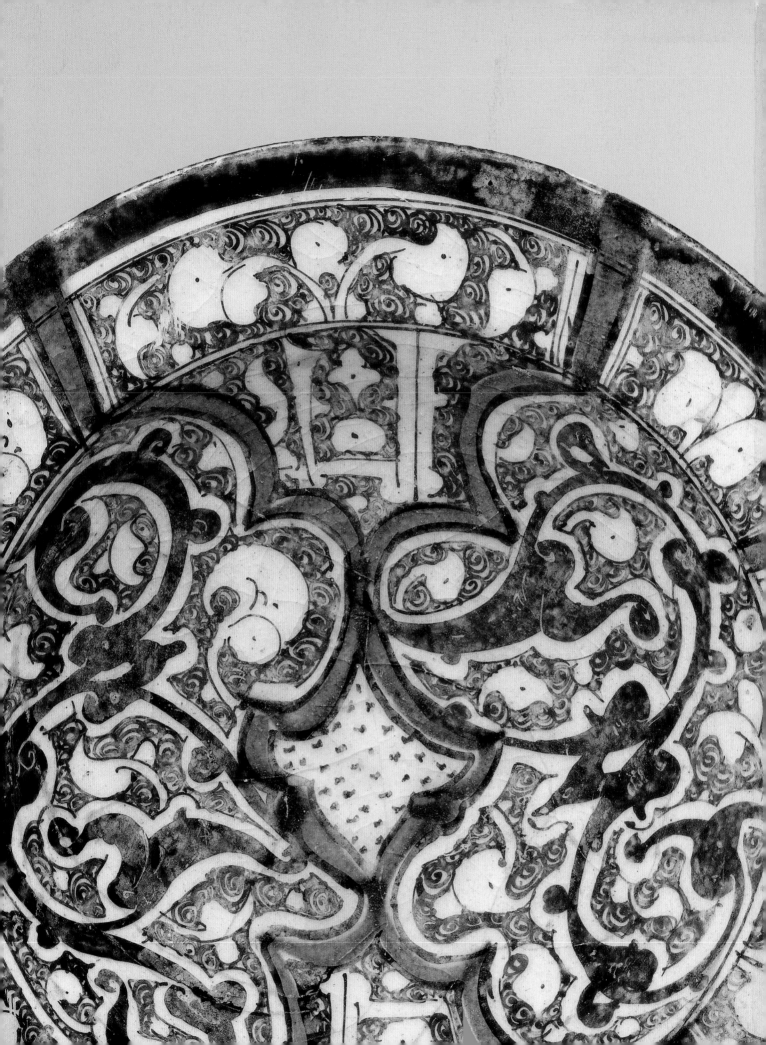

Raqqa Revisited
Ceramics of Ayyubid Syria

Marilyn Jenkins-Madina

The Metropolitan Museum of Art, New York

Yale University Press, New Haven and London

This publication is made possible by The Adelaide Milton de Groot Fund, in memory of the de Groot and Hawley families.

Published by The Metropolitan Museum of Art, New York

John P. O'Neill, Editor in Chief
Emily March Walter with Margaret Donovan, Editors
Bruce Campbell, Designer
Douglas Malicki, Production
Robert Weisberg, Assistant Managing Editor
Jean Wagner, Bibliographic Editor

Photographs of objects in The Metropolitan Museum of Art, New York, by Peter Zeray, The Photograph Studio, The Metropolitan Museum of Art; of objects in Turkey, by Tuğrul Çakar; of objects in Syria, by Anwar Abdel-Ghafour; of the *bacini* in the Bove Pulpit, Ravello, by Mario Milo.

Drawings by William Schenck and Annick Des Roches.
Map designed by Anandaroop Roy.

Typeset in Bell MT
Color separations by Professional Graphics, Inc., Rockford, Illinois
Printed on Burgo R-400
Printed and bound by Mondadori Printing S.p.a., Verona, Italy

Cover: Inverted pear-shaped jar, 1200–1230, composite-body, underglaze-painted. The Metropolitan Museum of Art, H. O. Havemeyer Collection, Bequest of Horace Havemeyer, 1956 (56.185.20); see chapter 4, MMA40
Frontispiece: Tazza, 1200–1230, composite body, underglaze and luster-painted. The Metropolitan Museum of Art, H. O. Havemeyer Collection, Gift of Horace Havemeyer, 1948 (48.113.11); see chapter 4 MMA16

Library of Congress Cataloging-in-Publication Data

Metropolitan Museum of Art (New York, N.Y.)
 Raqqa revisited : ceramics of Ayyubid Syria / Marilyn Jenkins-Madina.
 p. cm.
 Includes bibliographical references and index.
 ISBN 1–58839–184–1 (hardcover)—ISBN 0–300–11143–6 (Yale University Press hardcover)
 1. Raqqa ware—Catalogs. 2. Pottery, Islamic—Syria—Raqqah—Catalogs. 3. Pottery, Medieval—Syria—Raqqah—Catalogs. 4. Syria—Antiquities—Catalogs. 5. Metropolitan Museum of Art (New York, N.Y.)—Catalogs. 6. Pottery—New York (State)—New York—Catalogs. I. Jenkins-Madina, Marilyn–II. Title.
 NK4289.J46 2006
 738.095691'2—dc22
 2006005184

Contents

Director's Foreword

The collection of Islamic art at the Metropolitan Museum is universally considered the largest comprehensive collection of this art anywhere in the world. Among the approximately 11,000 objects in the collection, the decorative arts are particularly notable, with ceramic holdings numbering more than 1,600. This volume is devoted to an important category within the medium that includes some of the most beautiful ceramics ever made by Islamic potters—three types manufactured during the early thirteenth century in the city of Raqqa, situated on the Euphrates River in present-day Syria.

Raqqa occupied a site first settled by the Babylonians and expanded during the Hellenistic and Byzantine periods. Taken by the Arabs in 639 or 640 A.D., by the late eighth century it had become, after Baghdad, one of the largest urban entities in Syria and northern Mesopotamia. Following this first Islamic flowering, nearly four hundred years were to pass before it would experience a second resurgence under the Zangids and the Ayyubids during the late twelfth and early thirteenth centuries. The city was destroyed by the Il-Khanids in 1265.

Although Muslim sources mention little about Raqqa after its medieval renaissance, a great interest in the city was rekindled in certain circles in the West starting at the end of the nineteenth century. Rooted in the nascent curiosity about the Islamic world in Europe and America at this time, the rebirth of interest in Raqqa in particular was connected to the publication of translations into French and English of the Arabic literary classic *The Thousand and One Nights*. One of the protagonists of this classic was the legendary Abbasid caliph Harun al-Rashid, who had chosen Raqqa as his royal city at the end of the eighth century. As this collection of imaginative stories was becoming a best seller in the West, as if on cue ceramic objects were being brought out from Raqqa that enterprising dealers and auction houses were connecting to this very caliph. A buying spree for this ware ensued.

Fortunately for the Metropolitan Museum, two of the institution's donors, H. O. Havemeyer and his wife, Louisine, developed a passion for this ware, an ardor that they passed on to their son, Horace. It is in large part thanks to these collectors' taste, intelligence, and generosity that the Museum's holdings of pottery from Raqqa is considered the world's most important. Twenty-eight of the group of forty-six objects from Raqqa that are the focus of this volume once belonged to a member of the Havemeyer family.

What follows is the often mesmerizing chronicle of ceramic objects unearthed in Raqqa in the first quarter of the twentieth century. Marilyn Jenkins-Madina, Curator Emerita of the Department of Islamic Art at the Metropolitan, has managed, through a complex and circuitous route, to place these objects into a secure and verified context. She explores as well the social and political history of the time and patterns of collecting that helped to form the Museum's renowned holdings of Islamic Art.

We are particularly indebted to The Adelaide Milton de Groot Fund, in memory of the de Groot and Hawley families, for making such important publications possible.

Philippe de Montebello
Director
The Metropolitan Museum of Art

Acknowledgments

The circuitous journey chronicled in this volume was a lengthy one that might very well have had a totally different conclusion were it not for the extraordinary number of individuals who came to my aid along its numerous and often surprising paths. I wish to express my gratitude to all these many colleagues and friends of Islamic art both here and abroad who helped me to revisit the subject of Raqqa.

In Egypt: Prof. George Scanlon, American University in Cairo.

In France: Noha Hosni Maillard, Institut du Monde Arabe, Paris; and Sophie Makariou, Musée du Louvre, Paris.

In Germany: Joachim Gierlichs and Julia Gonnella, Freie Universität Berlin; Gisela Helmecke and Jens Kröger, Museum für Islamische Kunst, Staatliche Museen zu Berlin; Andrea Becker; and Prof. Heinz Gaube, University of Tübingen.

In Greece: Stavros Vlizos, Benaki Museum, Athens; and Helen Philon.

In Italy: Umberto Sansone, Naples; Graziella Berti, Pisa; Monsignor Don Giuseppe Imperato, Ravello; Giuseppe Zampino and Rosanna Romano, Salerno.

In Kuwait: Sheikh Nasser Sabah al-Ahmad al-Sabah and Sheikha Hussa Sabah al-Salim al-Sabah.

In Syria: I am particularly indebted to Abdul Razzaq Moʿaz, Deputy Minister of Culture, and Kassem Toueir, former Director of the Center of Archaeological Research at the Directorate General of Antiquities and Museums. I would also like to thank, in Aleppo: Fadwa Abidou, Aleppo Museum, and Georges Antaki; in Damascus: Mona Mouadin, National Museum of Damascus, and Verena Daiber, Deutsches Archäologisches Institut; in Raqqa: Mohamed Maktash, Raqqa Museum.

In Turkey: I would like to express my sincere appreciation to Naci Bakırcı, Deputy Director, Mevlana Museum, Konya, Filiz Çağman, former director of the Topkapı Palace Museum, Istanbul, Prof. Talat Halman, Bilkent University, Ankara, Prof. Haşim Karpuz, Selçuk University, Konya, Havva Koç, Archaeological Museum of Istanbul, Nazan Ölçer, former director, Museum of Turkish and Islamic Art, Istanbul, and Fahri Yoltar for the special interest they took in my research. In Ankara: I acknowledge Prof. Rüçhan Arık, formerly Ankara University, the late Mehmet Önder, and Alpay Pasinli; in Bursa: Prof. Zeren Tanındı, Uludağ University; in Istanbul: Prof. Nurhan Atasoy and Prof. Sümer Atasoy, Istanbul University; Ismail Çakır, Museum of Turkish and Islamic Art; Prof. Günsel Renda, Koç University; Prof. Wendy Meryem Kural Shaw, Bilgi University; and Cihat Soyhan, formerly Museum of Turkish and Islamic Art; in

Izmir: Prof. Gönul Öney, Ege University; in Konya: Erdoğan Erol, Mevlana Museum; Prof. Levent Zoroğlu, Selçuk University; Mahmut Altuncan, Karatay Museum.

In the United Kingdom: Rebecca Naylor, formerly Victoria and Albert Museum, London, and Timothy Stanley, Victoria and Albert Museum; Prof. J. Michael Rogers, School of Oriental and African Studies, University of London; James Crowe, The Gertrude Bell Archive, Newcastle University, Newcastle upon Tyne; Prof. James Allan, formerly Ashmolean Museum, Oxford; and Oliver Watson, Ashmolean Museum.

In the United States: Prof. Walter B. Denny, University of Massachusetts, Amherst; Marianna Shreve Simpson, formerly The Walters Art Museum, Baltimore; and Hiram W. Woodword, The Walters Art Museum; Prof. Gülru Necipoğlu, Harvard University, Cambridge, Mass.; Prof. Heghnar Watenpaugh, Massachusetts Institute of Technology, Cambridge; Prof. Donald Whitcomb, The Oriental Institute, University of Chicago; David Rago, Rago Arts and Auction Center; Patricia A. McKiernan; Prof. Irene A. Bierman, University of California at Los Angeles; Linda Komaroff, Los Angeles County Museum of Art; Prof. William Tronzo, Tulane University, New Orleans; Prof. Priscilla P. Soucek, Institute of Fine Arts, New York University; Robert Ellison, Linda B. Fritzinger, Harry Havemeyer, and Solidelle Fortier Wasser; Prof. Thomas Leisten, Princeton University; Oleg Grabar, Professor Emeritus, Institute for Advanced Studies, Princeton; Elizabeth Ettinghausen; Esin Atil, Smithsonian Institution, Washington, D.C.; Julian Raby, Massumeh Farhad, and Linda Raditz, Freer Gallery of Art and Arthur M. Sackler Gallery, Smithsonian Institution; Prof. Scott N. Redford, Georgetown University, Washington, D.C.

Special thanks must be given to Prof. Jonathan Bloom, Boston College, who permitted me to consult his exhaustive Master's thesis on the subject of Raqqa ceramics in the Freer Gallery of Art; M. James Blackman, National Museum of Natural History, Smithsonian Institution, who offered to carry out neutron activation analysis on key objects in this study; and last, but not least, my husband, Maan Z. Madina, Professor Emeritus, Columbia University, who, through his systematic study of the calligraphic decoration on the objects in this book combined with his knowledge of classical Arabic and its scripts, managed to decipher many inscriptions that had hitherto defied accurate reading—or, indeed, any reading at all.

At the Metropolitan Museum, this publication would not have been possible without the support of Director Philippe de Montebello. I would also like to

thank Doralynn Pines for her encouragement throughout the project. Because of the multifaceted nature of my subject, colleagues from many different departments were called upon for help and advice: Jeanie M. James and Barbara File, Archives; Alice Cooney Frelinghuysen, American Decorative Arts; H. Barbara Weinberg, American Paintings and Sculpture; Katharine Baetjer and Keith Christiansen, European Paintings; Joan R. Mertens, and Christopher S. Lightfoot, Greek and Roman Art; Charles T. Little, Medieval Art; James H. Frantz and Mark Wypyski, Department of Scientific Research; Michele M. Lussier and Wojtek Batycki, Information Systems and Technology.

I also gratefully acknowledge the help of a number of individuals in the Department of Islamic Art: Timothy Caster, Annick Des Roches, Alessandra Cereda, Trinita Kennedy, and Denise Teece, formerly Hagop Kevorkian Fellow.

This book is the product of the Editorial Department, under the direction of John P. O'Neill, Editor in Chief and General Manager of Publications. Emily Walter served as the editor of this publication with the same remarkable insight, patience, and care I came to rely on when we worked together many years ago. In this endeavor, her skilled and attentive collaborator was Margaret Donovan. Jean Wagner served as bibliographic editor. The volume's handsome design is the work of Bruce Campbell. The book was guided through production by Douglas Malicki. Peter Zeray, Anwar Abdel-Ghafour, Tuğrul Çakar, and Mario Milo are to be thanked for their photography, and William Schenck and Annick Des Roches for their drawings.

The Hess Foundation under the guidance of its president, Norma W. Hess, provided financial support for my research. For this I am extremely grateful.

Finally, I would like to express my indebtedness to, appreciation of, and affection for my three assistants, Jaclynne Kerner, Nida Stankunas, and Aysin Yoltar-Yıldırım, and to thank my two collaborators, Dylan Smith and Dr. Yoltar-Yıldırım. All were wonderful companions on this journey. It would surely not have been the same—or as interesting—without them.

Marilyn Jenkins-Madina
December 2005

To the Kurd in my life, Maʿn Agha,
and to the memory of my parents.

Raqqa Revisited

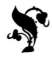

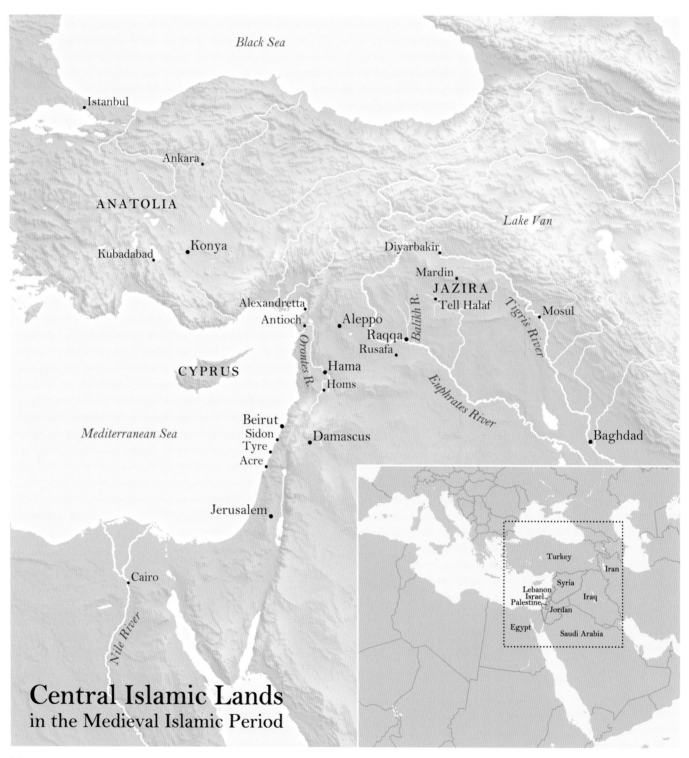

Black Sea

Istanbul

Ankara

ANATOLIA

Lake Van

Kubadabad

Konya

Diyarbakir

Mardin

JAZIRA

Tell Halaf

Mosul

Alexandretta

Antioch

Aleppo

Balikh R.

Raqqa

Tigris River

Rusafa

CYPRUS

Orontes R.

Hama

Homs

Euphrates River

Mediterranean Sea

Beirut

Sidon

Tyre

Acre

Damascus

Baghdad

Jerusalem

Cairo

Nile River

Central Islamic Lands
in the Medieval Islamic Period

Turkey

Iran

Lebanon

Syria

Israel

Iraq

Palestine

Jordan

Egypt

Saudi Arabia

Map

Introduction

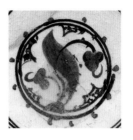

TWENTY YEARS AGO, during my first trip to central Anatolia, I visited the Karatay Museum in Konya, Turkey. In the galleries were two display cases that contained thirteen underglaze-painted ceramic bowls—all identified as Saljuq, Anatolian, thirteenth century—of two different types. One type bore designs painted in black (and sometimes further detailed by incising) under a clear turquoise glaze (fig. 1.1). The other exhibited underglaze-painted circles, roundels, or radiating stripes, in either turquoise or cobalt blue (figs. 1.2–1.4), and, in a single instance, a cursive inscription in cobalt (fig. 1.5), all on a white ground under a clear colorless glaze. Both categories incorporated two distinct profiles, one biconical and the other segmental with a flat rim. Of the thirteen pieces, several of both types and profiles were what are known as wasters, or kiln failures. Since wasters were unsalable and/or unusable because of their condition, they would not have been carried very far from the kiln site. Thus, it is generally safe to assume that they were produced in the vicinity where they were found.

The first, black-under-turquoise type was well known to me. The second underglaze-painted variety was not. Nor did the uncharacteristically sparse decoration of the latter strike me as particularly Islamic. Eventually, it became clear to me that the examples bearing turquoise and/or cobalt designs were another well-known type of pottery—that bearing both underglaze- and luster-painted decoration (fig. 1.6)—but that they were pieces that had remained unfinished (compare figs. 1.3 and 1.6). They were, in fact, wasters.

To clarify this last point, let me describe how underglaze- and luster-painted pottery was produced. On a vessel that had already been decorated with a painted design and subsequently covered with a glaze and fired, metallic oxides mixed with a medium were applied to produce an overglaze-painted decoration. During a second firing in a reducing kiln, oxygen was then drawn out of the metallic oxides, leaving the metal suspended on the surface to refract light and thus create the lustrous appearance of the so-called luster-painted design. Only ceramic objects that had survived the first firing in perfect or near-perfect condition were destined to receive the luster-painted overglaze decoration. It is for this reason that no excavation would ever yield wasters that incorporated this final step. What I had stumbled upon in Konya was a group of wasters that exhibited only the penultimate step: underglaze-painted bowls lacking the final, luster-painted stage in their decoration because their initial firing had failed.

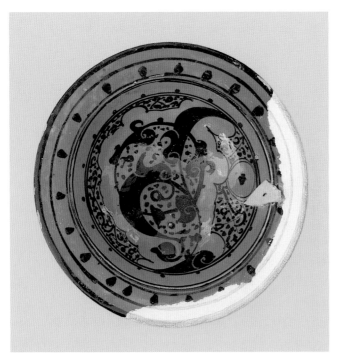

FIGURE I.1. Underglaze-painted segmental bowl with flat rim. Raqqa, Syria, 1200-1230 (chapter 3, w88). Karatay Museum, Konya, Turkey (6/3)

FIGURE I.2. Underglaze-painted biconical bowl. Raqqa, Syria, 1200-1230 (chapter 3, w7). Karatay Museum, Konya, Turkey (17/1)

I was later to learn that although this group of objects in the Karatay Museum had escaped the notice of most scholars, they had in fact been mentioned in print. Jean Soustiel (1985) regarded them as completed pieces and argued that they supported the existence of workshops in this region of Anatolia. He also related them to a biconical bowl in the Musée du Louvre, Paris (see chapter 3, w23).[1] Cristina Tonghini (1994) saw the bowls of the second kind "as a type of pottery which had been in use for a very limited time in southern Anatolia, Syria and Iran ... regarded by scholars as a possible prototype of the underglaze-painting technique,"[2] thus echoing Soustiel in her attribution of the group to central Anatolia and in viewing them as finished vessels. Michael Rogers addressed this group twice. In 1969, when discussing ceramics in Anatolia, he stated: "The chief finds to date have been at ... Kubadabad ..., at the Citadel of Konya ... and Kalehisar. ... The Konya material, which includes wasters, chiefly consists of fine black-painted wares under a transparent turquoise glaze, of a type very similar to Raqqa pottery of the same period." He mentioned them in much the same way in 1995, when he noted that they were "finds of fritware at the citadel in Konya, now in the Konya Museum, possibly made by craftsmen brought in from Rakka or other Euphrates potteries."[3] All these scholars attributed the group to Anatolia, the region in which they were found, and all viewed them as finished.

Venetia Porter (1981) also believed them to be completed objects, but suggested that rather than having been made in Anatolian kilns they could possibly have been produced in the Syrian center of Raqqa on the Euphrates. "The Konya region seems not only to have imported Raqqa ware, as evidenced by a few

1. Soustiel 1985: 129, fig. 139. While Soustiel believed the objects in Konya to be wasters, he did not regard them as half-finished.

2. Tonghini 1994: 253.

3. Rogers 1969: 141–42; Rogers 1995: 968. In a conversation with the author in August 2001, Rogers connected the group in the Karatay Museum with kilns mentioned by Halil Edhem (1947: 279–97) that were found in Konya in the 1930s near the railway station.

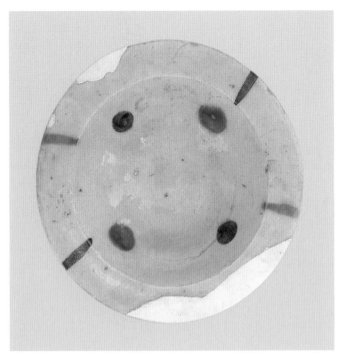

FIGURE I.3. Underglaze-painted segmental bowl with flat rim. Raqqa, Syria, 1200-1230 (chapter 3, w26). Karatay Museum, Konya, Turkey (20/2)

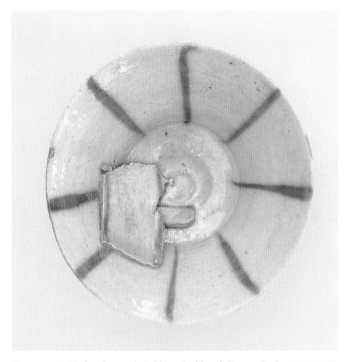

FIGURE I.4. Underglaze-painted biconical bowl. Raqqa, Syria, 1200-1230 (chapter 3, w19). Karatay Museum, Konya, Turkey (18/2)

4. Porter 1981: 12–13, 39. Friedrich Sarre (1909a: 45–47 and pls. xx, xxi), although not referring to the thirteen objects in Konya, seemed to anticipate Porter's comment when he suggested that a vase painted in black under a clear turquoise glaze found in Konya (pl. xx) might have been made in that city. He further suggested that the luster-painted fragment (pl. xxi,7), collected in Konya, might have been imported from Raqqa. The objects mentioned by Sarre are now in the Museum für Islamische Kunst, Staatliche Museen zu Berlin (nos. I.927, I.412). Dylan Smith, in the study undertaken for this publication, determined that both were made in Raqqa (see Appendix 2).

5. Riefstahl n.d., no pagination.

6. The term "medieval" is used in this context to connote an era coeval with the Romanesque and Early Gothic in the West and with the Song emperors in China.

7. The following history of medieval Raqqa is based on Meinecke 1995: 410–14.

vessels in the Konya museum, but to have imitated it as well."[4] Many years earlier, before 1927, Rudolf Riefstahl had similarly placed the manufacture of these objects in Syria: "The museum of Konia, Inner Anatolia, contains a series of 'Raqqa' potteries, mainly of turquoise blue glaze with black painting under the glaze, which has been found in Aleppo."[5] Neither scholar gave any reason for the attribution to Raqqa nor did either one suggest that the decoration on any of the pieces was half-finished.

With the knowledge that one of the waster types in Konya was a well-known category of medieval Islamic pottery,[6] and the new realization that the second waster type represented another, equally well known and contemporary category, I realized that both were very similar to pottery types that for more than a century had often been associated with the city of Raqqa and had in the literature been referred to, variously, as "Raqqa" ceramics or so-called Raqqa ware. Conclusive proof for such an attribution had, however, continued to elude scholars up to the present day.

Before discussing these problems of attribution, I would like to familiarize the reader with the history of Raqqa itself. Situated in Syria on the left bank of the Euphrates River, where the Euphrates meets the smaller Balikh River, the medieval Islamic city of Raqqa occupied a site first settled by the Babylonians (see map, page 2).[7] During the Hellenistic period, Seleucos I Nikator (r. 301–281 B.C.) founded a city in this location that he called Nikephorion. That city was expanded under Seleucos II Kallinikos (r. 246–226 B.C.), who in turn gave it his own name, Kallinikos. Destroyed by the Sasanian ruler Khusraw I Anushirwan

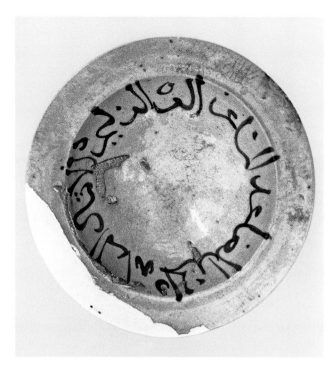

FIGURE I.5. Underglaze-painted segmental bowl with flat rim. Raqqa, Syria, 1200-1230 (chapter 3, w37). Karatay Museum, Konya, Turkey (22)

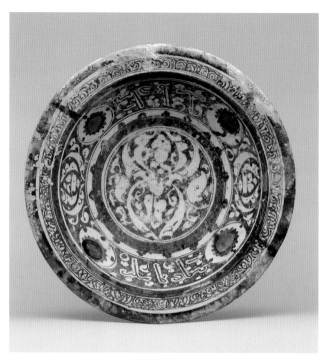

FIGURE I.6. Underglaze- and luster-painted segmental bowl with flat rim. Raqqa, Syria, 1200-1230 (chapter 4, MMA10). The Metropolitan Museum of Art, New York, H. O. Havemeyer Collection, Gift of Horace Havemeyer (48.113.5)

(r. 531–79) in A.D. 542, Kallinikos—by that time a part of the Byzantine Empire—was rebuilt by Emperor Justinian (r. 527–65).

About a century later, in either A.D. 639 or 640, this strategically well-situated city was taken by the Arabs and renamed al-Raqqa (meaning swamp or bog).[8] During the Umayyad period (661–750), despite the change in sovereignty, Raqqa remained much as it had been immediately before the Arab conquest. Then, early in the Abbasid period (750–1258), a new city, al-Rafiqa (the companion), was founded not far away by the caliph al-Mansur (r. 754–75). Heavily fortified, al-Rafiqa was modeled on the plan of Baghdad. The area between the new city and the old soon gave rise to a vast suq, or marketplace, which connected the sister cities.

Raqqa and al-Rafiqa together formed an immense urban entity surpassed in Syria and northern Mesopotamia only by the Abbasid center of power, Baghdad. In 796, the caliph Harun al-Rashid (r. 786–809) chose the area as his principal place of residence. He was to remain there for the next twelve years, living in the palatial complex that he built north of the two cities. Upon his death in 809, Baghdad once again became the administrative center of the caliphate and the political importance of Raqqa/al-Rafiqa was reduced to that of a provincial capital. It retained this status until the middle of the tenth century, when it went into a period of decline that was to last for nearly two centuries. Gradually, Raqqa fell to ruin. Its name, however, lived on, assumed henceforth by al-Rafiqa.

In 1135, the city was conquered by the atabeg of Mosul and Aleppo, ʿImad al-Din Zangi (r. 1127–46), a conquest that brought with it a change of fortune.

8. Throughout this book, this city will be referred to simply as Raqqa, the name most commonly used by Western scholars in art-historical literature.

Under the Zangids, especially during the reign of Zangi's son Nur al-Din Mahmud (r. 1146–74), an active building program was inaugurated and a period of revival began. Raqqa's importance as a provincial center continued under the Ayyubid ruler Salah al-Din (Saladin, r. 1171–93), and it appears safe to assume that this period of prosperity lasted at least through the first quarter of the thirteenth century since one of the Ayyubid princes, al-Malik al-Ashraf Musa, took up residence there between 1201 and 1229. The Ayyubids spent their final years in the city fending off attacks by the Saljuqs of Rum (1077–1307) and the Khwarazm-Shahs (ca. 1077–1231) before finally capitulating to the Il-Khanids (1256–1353), by whom the city was destroyed in 1265.

Raqqa is little noted in the sources over the following six centuries. We are told that the city remained practically deserted during the entire Mamluk period (1250–1517) and that during the early Ottoman period, sometime after the conquest of Syria by the Ottomans in 1517, it served as a military outpost and nominal administrative center. By 1649, it was once again abandoned. Not until the turn of the nineteenth century do we have any more substantial information.

Returning to the problem of the evidence of ceramic production in medieval Raqqa, let us now review the literature over the last four decades. One of the first scholars to rekindle an interest in this pottery after a long hiatus was Ernst Grube (1963). Basing his conclusions on those of Friedrich Sarre, who claimed to have found wasters in Raqqa, Grube argued that the majority of the ceramics found in Raqqa had been made there and had then traveled through Anatolia to Iran and Egypt. He dated the black-under-turquoise type to the twelfth century but without giving any explicit reason. The underglaze- and luster-painted type he dated to the first half of the thirteenth century, placing its manufacture in Syria. No specific locale, he noted, could yet be provided. Because Grube used an inscribed luster-painted vase mentioned three times in the literature but otherwise unknown (the so-called de Lorey object) to date the underglaze- and luster-painted group, his dating is not only unverified but unverifiable as well.[9]

Jonathan Bloom, in his exhaustive thesis (1975) on what he referred to as the "Raqqa" ceramics in the Freer Gallery of Art, Washington, D.C., was noncommittal, saying only that while ceramics were certainly produced at Raqqa, "I would be hard pressed to say which ones."[10]

Porter (1981) stated that while "the attribution of the ceramic industry to Raqqa rests primarily on the statements of Gertrude Bell, Jean Sauvaget, and Eustache de Lorey who noted great quantities of ceramic sherds and in some instances kiln wasters and other material that indicated local manufacture . . . [no] kilns have as yet been excavated scientifically at Raqqa, and the chance of locating the alleged kiln sites diminishes daily as the new town sprawls over the ruins of the old."[11]

Tonghini and Grube, in their very useful annotated bibliography, published in 1988–89, of Syrian Islamic pottery before 1500, wrote that "attempts to determine the origins of the various types of Syrian medieval pottery attributed to Raqqa, especially at a serious and scientific level, were not very successful."[12]

9. Grube 1963: 42–78. For the de Lorey object, see chapter 6, note 10, below.
10. Bloom 1975: 66.
11. Porter 1981: 10–11.

But by 1994, Tonghini, in connection with the Khalili collection, was prepared to further commit herself, saying that "the label 'Raqqa' is used to identify a group of pottery made in northern Syria in a number of ateliers that were located in Raqqa as well as in other sites of the Euphrates valley."[13]

Robert Mason, after citing Porter (1981), concluded in a 1995 article on Syrian ceramics that "the importance of Raqqa as a production centre seems somewhat diminished by these findings . . . although Raqqa should probably not be ruled out."[14] Two years later, his speculations did little to clarify the problem: "Traditional attribution of most material to Raqqa is now put in the context of important rival sites, especially Damascus."[15]

Oliver Watson addressed the question of ceramic production of Raqqa in 1999. He concluded, based on his and Porter's examination of finds from Qasr al-Banat, the early medieval palace inside Raqqa's city walls, that "evidence for the extraordinarily wide range of things made at Raqqa overturns the accepted art-historical view and indeed the very notion of an individual identifiable 'Raqqa' type has to be abandoned."[16] Watson's expansion of the definition of Raqqa ware to include not one type but "a wide range of things" was tantalizing. Its possibilities, however, were not realized, either in that work or in his most recent study of 2004.[17]

Another recent publication is by Porter, whose 2004 article about the medieval glazed pottery includes twenty-two fragmentary composite-bodied wasters belonging to six different types found in the Great Mosque at Raqqa/al-Rafiqa. Although these kiln failures are recognized as an important find, their potential is not developed in any way and thus the article does little to further our knowledge regarding ceramic production at that center.

More than a century has passed since the first glazed ceramic objects of the so-called Raqqa type came to light. Yet remarkably, no actual proof of manufacture in that center has been conclusively put forward. Indeed, doubts remain and questions continue to arise. Certain scholars have even backtracked on some of their earlier, strongly argued conclusions.[18]

It was clear to me that there were only two possible scenarios that could account for the presence of the thirteen ceramic bowls in Konya. Either they had been manufactured in central Anatolia and not on the Euphrates at all (this was the most logical interpretation, given the presence of wasters) or they had not been made in the Konya area but had for some reason been transported there. Given the fact that the existing literature on these bowls was either contradictory or incorrect, and on the subject of ceramic production in medieval Raqqa it was still inconclusive, I realized that, if I was to determine unequivocally where these objects had been made, I would have to approach the subject in an entirely new way.

I knew the task would be a difficult one. Nevertheless, unraveling the mystery seemed more than worth the effort involved. For if I could uncover the facts, not only would the provenance of the thirteen bowls be secure, but the provenance of all those objects whose types they represented would also be known.

12. Tonghini and Grube 1988–89: 59.

13. Tonghini 1994: 253.

14. Mason 1995: 16.

15. Mason 1997: 194.

16. Watson 1999: 425.

17. Watson 2004: 56, 288–301.

18. Mason (1997: 179), for example, states that what he labeled "Raqqa-1 petrofabric" in previous publications is now problematic and that what he will henceforth refer to as "Raqqa-2 petrofabric" is the "true" Raqqa petrofabric, "more confidently ascribed to Raqqa on the basis of analysis of wasters excavated by recent expeditions." To my knowledge, these analyses are not published nor, it would seem, are the wasters themselves (the status of the three Raqqa sherds in his figure 18 is unclear). And Watson (1999: 425) writes that contrary to his and Porter's 1987 findings, he now believes that the so-called Tell Minis wares were made in Raqqa.

19. See Appendix 1.
20. See Appendix 2.

Conservatively speaking, there were several thousand such pieces in collections worldwide. One of the most exceptional series of these objects was in The Metropolitan Museum of Art in New York. Having served as the curator of this collection for more than four decades, I was privileged to have an intimate knowledge of these pieces. With my newly defined task at hand, I set out to study these objects within the context of my recent discoveries. Forty-six of them would prove to be strikingly similar in profile, technique, and decorative style to the thirteen objects in Konya. I decided to use them as the core of my research. Little knowing where this quest would lead or how long it would take, I knew nevertheless that it was incumbent upon me to take up the challenge.

I would not embark on my journey for nearly two decades. But in the intervening years, the bowls in the Karatay Museum continued to occupy my thoughts. Thus, it was with a sense of excitement and anticipation that I finally began my research in earnest. It is this journey that I have set out in the chapters below. Along the path, I would meet a varied and interesting cast of characters and I would make many discoveries. My research would lead me to archival documents from the Ottoman Empire that had never before been published, to the earliest inventories of the Imperial Museum in Istanbul,[19] and to previously unknown early photographs of objects now in the Metropolitan's collection that turned up serendipitously on the Internet. I would visit museums in Syria, Germany, France, England, and Denmark, churches in Italy, and storerooms in the United States. In many instances, I was given samples from objects for scientific analysis in New York and Washington.[20]

The history of collecting also came into play. Interestingly, it was the social and political history of the years during which these objects were collected that eventually opened the way to solving the conundrum I had set out to answer. What I discovered was that the placing of the objects in the Karatay and other Turkish museums was the direct consequence of an intersecting of East and West, a collision of Orientalism in the West with Westernization in the East in the early years of the twentieth century.

In retrospect, it is very clear that the geographic point of departure for my journey—central Anatolia—enabled, indeed forced, me to approach these objects from a completely new angle. Had I not traveled to Raqqa via Turkey, this story of the ceramics of Ayyubid Syria could never have been told.

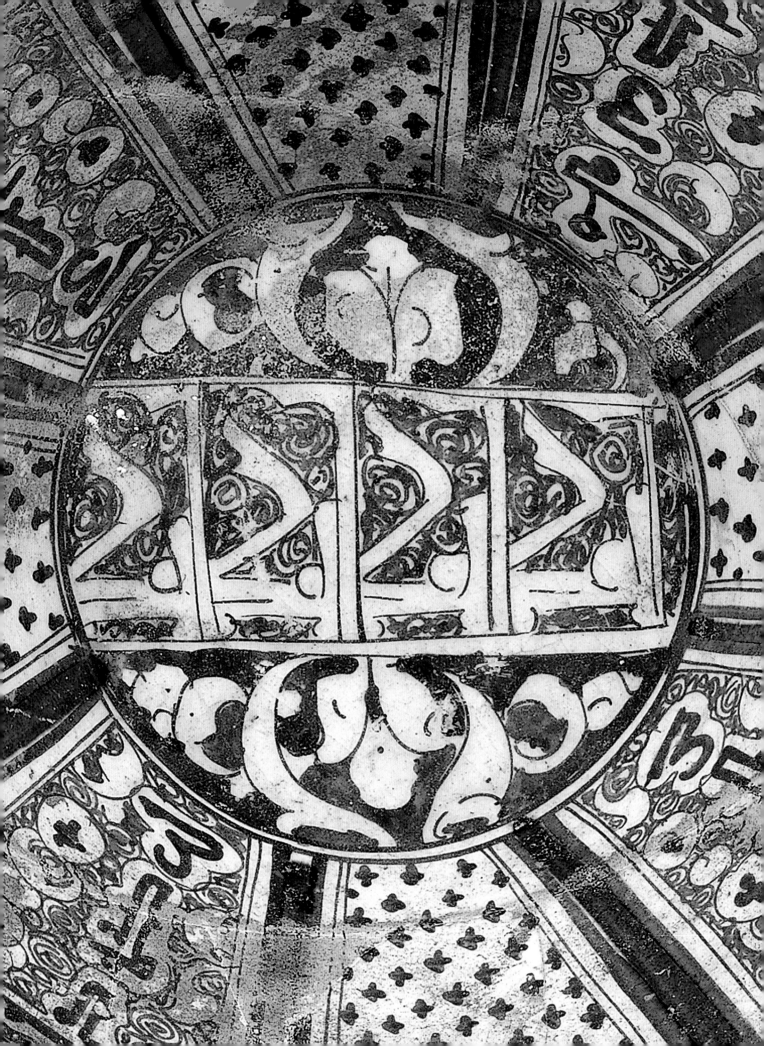

1. The Lore and Lure of Raqqa

 I HAVE DISCUSSED elsewhere the nascent curiosity in the United States about the Islamic world during the last quarter of the nineteenth and first quarter of the twentieth century.[1] This same enthusiasm occurred in Europe more or less concurrently or slightly earlier. Travel to the Middle East was much in vogue, and travel, in turn, spawned a vast travel literature. Some travelers were artists, and images of the places they visited and motifs they employed—drawn from buildings and objects they saw—further fueled this newly evolving curiosity about the Islamic world and its art. Four international art expositions held in Europe during this period—in London in 1885 (Burlington Fine Arts Club), in Paris in 1893 (Palais des Champs-Élysées) and 1903 (Union Centrale des Arts Décoratifs), and in Munich in 1910—added to the travel fever and were equally important in fueling a European interest in the Middle East.

Another source of interest in the Islamic world was the literary classic *Alf Layla wa-Layla* (*The Thousand and One Nights*). This renowned collection of stories written in Arabic first appeared in Europe in a French translation by Antoine Galland in the early eighteenth century. It is the late-nineteenth-century translations, however, that concern us here, especially the English translations of John Payne (1882–84) and Sir Richard Burton (1885–88) and the French translation by J. C. Mardrus (1898–1904). Six literary genres are included in the anthology: fairy tales, romances, legends, didactic stories, humorous tales, and anecdotes. The anecdotes are most relevant to our purposes, as they are often about the Abbasid caliphs and their courts. The caliph Harun al-Rashid makes the most frequent appearances. As if on cue, just as interest in the so-called Orient was beginning to develop into a passion in certain circles in the West, Raqqa on the Euphrates, Harun al-Rashid's principal place of residence from 796 until 808, began to yield ceramic objects.

What may well be the first object to enter the market that would come to be associated with Raqqa is also the earliest from that city to have been acquired by The Metropolitan Museum of Art, an underglaze- and luster-painted lantern in the shape of a square, domed building (chapter 4, MMA 1). Originally owned by the collector Albert Goupil, it was sold at auction in 1888 in Paris and described in the catalogue as "old faience from Persia."[2] Goupil's interest in the "Orient" was initiated during a three-and-a-half-month trip taken in 1868 that had been organized by his brother-in-law, the artist Jean-Léon Gérôme. The party of nine set

1. Jenkins-Madina 2000: 71. See also Roxburgh 2000: 9–38.
2. Goupil sale 1888, lot 55.

Opposite: Detail of MMA 11

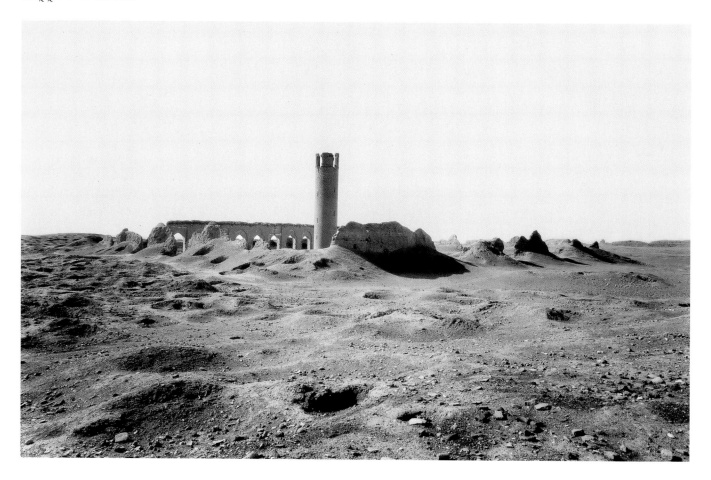

FIGURE 1.1. View of Raqqa showing the Great Mosque in the background and irregular holes and trenches of clandestine excavations in the foreground. Creswell Archives, Ashmolean Museum of Art and Archaeology, Oxford

off from Marseilles and traveled by ship to Alexandria (with an excursion up the Nile to Cairo, Giza, and the Fayyum), by train to Suez, by caravan to Mount Sinai, and thence to Aqaba, Petra, and Jerusalem. Goupil was the official photographer and the trip was well documented.[3]

We do not know where Goupil acquired the lantern, whether during his excursion with Gérôme or in Paris. As to the subsequent owner, who bought the piece at the 1888 auction, it was probably the silver manufacturer Edward C. Moore, who left it by bequest to the Museum three years later, in 1891.[4] What is clear, however, is that the auction predates any published accounts concerning Raqqa as a site of ceramic production.

But this was soon to change. In 1901, European scholars began writing about glazed ceramic objects that they believed had been found in the medieval city (fig. 1.1). The first of these was Gaston Migeon, who stated that examples of glazed objects from Raqqa had appeared on the market quite suddenly about three years earlier. He also claimed that Armenian dealers in Paris had orchestrated the debut of these objects—vases and bowls that had been skillfully restored—which had been sent to them by individuals who were excavating on their behalf. Migeon describes the objects as forming a coherent group in terms of material, decorative technique, and decoration. They are characterized as having coarse white bodies and a highly transparent glaze that often formed drips on the exterior near the foot. The purplish brown, luster-painted decoration is

3. Ackerman 1997: 80–85. See also Roxburgh 2000: 12–13 and fig. 1.
4. Jenkins-Madina 2000: 76–80. See also Kamerling 1977, part 1: 16–20; part 2: 8–13.

marred, he notes, by decay caused by chemical reactions with the soil during burial. Migeon also mentions Kufic inscriptions, simple rinceaux and stylized flowers, and bands of spirals divided by roundels or streaks in a light blue. He speculates that the objects are "probably the waste from a potter's kiln" and that they all have the same provenance. He goes on to accuse the unnamed Armenian dealers of keeping the findspot a secret but adds that the Turkish government has revealed that the objects were found in Raqqa, a town "about which it is unfortunately very difficult to obtain any historical information." He concludes by suggesting that the pieces may date from before the thirteenth century.[5]

When Migeon addressed the subject of this ware two years later, he wrote that it was "alleged" that the group had been found at Raqqa. In the context of Raqqa, he also discussed a carved vase with black decoration on a blue ground in the collection of the Comtesse de Béhague that he dated between the ninth and eleventh century and that had "evidently been found in an excavation. In the absence of a serious inquiry and without absolute faith in the statements made by the merchants, we must confine ourselves to studying them according to their style of decoration."[6]

Raymond Koechlin, writing in 1903, similarly stated that he would also describe the ware as "seeming" to have come from Raqqa, as the attribution was based only on hearsay.[7]

In the introduction to an auction catalogue also dating from 1903, the antiquarian Dikran Khan Kelekian spoke of a recent find that now appears to have come from Raqqa "which, it seems, may have been an outpost of the ancient Babylonian empire. Hence, the name 'Babylonian' has been given to the ware . . . though it manifestly is not all of the Babylonian period." He dates these objects, which exhibit a "decoration in black," to the tenth century. Kelekian appears to be the first to mention wasters as coming from the site. Some of these were included in the sale. One bore black decoration under a clear turquoise glaze (lot 692); another may have been a jug that was to have been luster-painted after a first firing (lot 693).[8]

Migeon takes up the subject again in 1907 in volume 2 of his *Manuel d'art musulman*.[9] In the section entitled "Ateliers de Rakka," he describes the luster-painted group in much the same way he did in 1901 and 1903, including the fact that he considers the pieces to be rejects from the potters' kilns in Raqqa. This is the first time the ware is associated with the court of Harun al-Rashid. Migeon also suggests that the vases with relief-carved decoration painted black against a monochrome blue ground may have been made there as well. However, the turquoise group with black underglaze-painted decoration he places, unequivocally, in Persia. This group he dates to the late twelfth century, based on their use as *bacini*, the bowls set into church façades and towers of the late eleventh to the fifteenth century (see figs. 6.7–6.27).

Four "very beautiful bowls of Rekka pottery" belonging to the dealer Azeez Khayat were sold at auction in New York the same year. They are described in the catalogue as having "inscription[s] and floral decoration; very fine glaze.

5. Migeon 1901: 192–208. These fragmentary luster-painted vessels were most definitely not wasters, since, as has been explained, glazed ceramic objects that were spoiled in the first firing did not receive luster-painted decoration and undergo a second firing.

6. Migeon 1903: 24.

7. Koechlin 1903: 409–20.

8. Kelekian sale 1903, no pagination (second page of section titled "Ancient Egyptian and 'Babylonian' Glazed Pottery: Damascus Tiles").

9. Migeon 1907: 258–59, 285–87.

Found at Rekka, near Aleppo, Syria." There is no indication of the decorative technique employed, and thus the specific type of ware cannot be ascertained.[10]

In 1908, two more collections belonging to Khayat were auctioned in New York. One of these included ten "Babylonian glazed iridescent potteries, found at Rekka, near Aleppo, Syria." From the descriptions in the catalogue, it appears that the objects were either of the monochrome glazed type or black painted under either a clear colorless or a clear turquoise glaze.[11]

The catalogue of a 1908 exhibition at the Burlington Fine Arts Club in London states that turquoise and black ceramics had been found "on the site of a pottery said to be at Rakka, near Aleppo." Because such quantities of sherds, many of which were wasters, came "with the same story during the last few years, . . . there can be no reasonable doubt that they were made on the spot."[12]

The same year, Garrett Chatfield Pier published two luster-painted bowls— one recently acquired by The Metropolitan Museum of Art (MMA2)—saying that "the provenance of the very few of these bowls that have come down to us is Rakka (Rekkha), a small town situated on the banks of the Euphrates, not far from Aleppo." He ascribed both bowls to the ninth century.[13]

In 1910, Khayat consigned for auction fifty ceramic objects from Raqqa. He described them in the catalogue as "a collection of Rekka iridescent potteries of beautiful glaze, with fine iridescence, found at Rekka, near Aleppo, and dating about the 8th Century A.D. Most of the pieces have been repaired. They come from the ruins and very seldom a piece is found intact."[14] It is apparent that as the number of Raqqa vessels reaching the West increased, interest in this ware increased as well.

Also in 1910, Kelekian stated, in the publication of his collection of ceramic objects acquired between 1885 and 1910, that "the first piece of pottery unearthed at Raqqa came to light in 1896."[15]

Apropos the above-mentioned exhibition in Munich, A. Nöldeke-Hannover noted that it was the antiques dealers who first introduced the pottery of "Rhages" (present-day Rayy), Sultanabad, and Raqqa.[16] The first two sites had not been scientifically explored, and the 1906 excavations in Raqqa had been carried out by the Imperial Museum, Istanbul, which, he speculated, stood to gain from the undertaking. Agents for the European dealers continued to conduct illicit digs there. Nöldeke-Hannover dated to the eleventh and twelfth centuries the ceramic objects decorated in black under clear turquoise and to the twelfth and thirteenth centuries the underglaze- and luster-painted variety.

In 1916, the galleries of Kouchakji Frères, at 719 Fifth Avenue in New York, mounted an exhibition that included fifty-one glazed ceramic objects described as from Raqqa and dated to the ninth century. From the very brief descriptions in the catalogue, it is impossible to ascertain anything about the objects, only one of which is illustrated, except their general shape. The introduction, however, is quite revealing:

The story of the Saracenic potteries begins in the 9th Century in the Ancient City of Rakka, founded by Alexander the Great, where the wide stream of the

10. Khayat sale 1907, lots 438–41. The pieces brought from $6 to $12 each.

11. Khayat sale 1908, lots 377–87.

12. Burlington Fine Arts Club 1908: xvi–xviii.

13. Pier 1908: 120–25. In a letter to *Burlington Magazine*, this dating is refuted by Friedrich Sarre, who places the bowls in the eleventh to the twelfth century; see Sarre 1909b: 388.

14. Khayat sale 1910, lots 111–35, 303–20, 322, 324–29.

15. Kelekian 1910, preface. Five objects "found at Rakka" are illustrated in plates 12 (fig. 3.4), 14, 21, 35, and 36.

16. Nöldeke-Hannover 1910–11: 16–17.

Euphratus meets that of the river Beles. Here it was that Haroun el-Rachid, a name familiar from our childhood's perusal of the "Arabian Nights," made his home on his withdrawal from Bagdad . . . and here for the delight of the great Khalif and his court were produced those examples of so varied beauty, vases whose gracefully swelling bodies are invested with a thick blue glaze . . . others which delight by the intricacies of the dark brown lustered interlacements, and yet others . . . [with] patterings of black on jewel-like grounds of turquoise blue.[17]

This text is notable for its romanticization and embellishment of the history of Raqqa, undoubtedly added to enhance the lure of its pottery, of which the Kouchakjis had a great deal to sell. The family, as we shall see, continued to capitalize for almost two decades on what was certainly an excellent advertising scheme—so good, in fact, that it was adopted by others as well.[18]

The following year, 1917, the collection of Thomas B. Clarke was auctioned at The American Art Galleries, New York.[19] It included eighty-four ceramic objects from Raqqa, all of which were dated to the ninth century and ranged in hammer price from $7.50 (for a 2½-inch fragment from an underglaze-painted jar) to $2,500 (for a complete jar of the same type). In the sale catalogue, it is noted that a number of the vessels had been found about a decade earlier in a large jar "in the cellar of a house in Rakka."[20] At least three of the objects became part of the Havemeyer collection and are today in The Metropolitan Museum of Art.[21]

Feeding what seems to have become a frenzy of Raqqa collecting, Kouchakji Frères held another sale at The American Art Galleries a year after Clarke's. The auction included seventy-one Raqqa ceramic objects, all dated to the ninth century. They realized from between $15 (for an underglaze-painted jar) to $1,800 (for a large underglaze- and luster-painted jar). Boasting that "it was a member of this firm who first brought the now famous Rakka pottery to the knowledge of Western art lovers and scientific students of the whole world," and that "the firm of Kouchakji Frères in Paris and New York has possessed exceptional facilities for collecting Syrian . . . works of art on account of its intimate connections with Syria, Egypt and Mesapotamia," the catalogue also told prospective buyers that "the source of the supply of ancient Rakka seems completely exhausted."[22]

The French scholar Maurice Pézard weighed in on the subject of Raqqa pottery in 1920, stating that he did not believe there was any particular school of ceramists in Raqqa.[23]

In 1922, Rudolf Riefstahl entered the fray. While not questioning the fact that ceramic objects had been made in Raqqa, he contested those who dated their manufacture to the time of Harun al-Rashid. Relying on Friedrich Sarre's firsthand account (see below), Riefstahl maintained that "the Raqqa wares which had been appearing for about thirty years in the art markets of Paris and London all came from a part of the city which was constructed during the eleventh, twelfth and thirteenth centuries. . . . These cold facts which destroy the poetical legend

17. Kouchakji Frères sale 1916.
18. The antiquities firm of Kouchakji Frères was established in Aleppo, Syria, in the nineteenth century by two brothers. Fahim Joseph Kouchakji (1886–1976), the son of one of the brothers, appears to have started his career as a dealer serving as the agent for his father and uncle. He later opened family-owned galleries in Paris and New York; see the obituary in the *New York Times* of August 21, 1976. (The dates given in this account for the opening of Kouchakji's galleries do not concur with those provided by the exhibition and auction catalogues cited herein.)
19. Thomas B. Clarke (1848–1931), a New Yorker by birth, was a prosperous dealer in dry goods, especially stiff linen collars. Beginning in 1872, he began to collect paintings by American artists and soon became a noteworthy collector in that field as well as an important figure on the New York art scene. His interest in this area was to continue until he disposed of his collection in 1899. Our focus, however, for the purposes of this study, was his opening of a gallery of Oriental art and Greek antiquities at 4 East Thirty-fourth Street, in 1891, after he had retired from the dry goods business. The gallery, Art House, resembled a small museum more than sales rooms. It is not known what caused this abrupt change in Clarke's artistic taste. Auctions of his collection in 1917 and 1925 included large numbers of glazed ceramics from Raqqa, and twelve of the Metropolitan Museum's forty-six objects discussed in this volume were at one time in his possession. See Weinberg 1976: 52–83.
20. Dana H. Carroll in Clarke sale 1917.
21. The three objects in the Metropolitan Museum are MMA15, MMA31, and MMA36. The importance attached to this type of pottery early in the twentieth century is also suggested by the fact that Louisine Havemeyer presented such pieces as gifts to her son, Horace, to mark special occasions in his life. For the Havemeyers' pattern of collecting Islamic art, see Jenkins-Madina 2000: 83–86.
22. Kouchakji Frères sale 1918. At least two of the objects in this sale became part of the Havemeyer collection and, eventually, that of The Metropolitan Museum of Art (MMA11, MMA23).
23. Pézard 1920: 175

of the potteries of the time of Harun al Rashid, associate the beautiful Raqqa potteries with the pre-Mongol ware in Persia and Egypt."[24]

The antiquarians, however, preferred the "poetical legend." In 1923, Fahim Kouchakji published an article on Raqqa pottery that must have seemed like a tale taken from *The Thousand and One Nights* itself. While he cited the fragments from Raqqa that had reached the West in 1895,[25] he claimed that complete objects from this site did not surface for another decade. The only sources "so far uncovered," he maintained, "have been the palace of Harun al-Rashid and a few jars, known as the Great Find, which contained some sixty unbroken articles."[26] Kouchakji goes on to describe several excavations that had been conducted at the site, specifically in the western part of the city, that is, in the area of al-Rafiqa. The excavation, carried out under the auspices of the Imperial Museum, Istanbul (here incorrectly set in 1903 rather than 1906 as noted above), is cited, as is the discovery of the palace of Harun al-Rashid "under thirty feet of soil" and the unearthing of the Great Find in the same area. Kouchakji assigns a terminus post quem of 1907 to the last two finds, using the date of Harun's palace as well as that of the palace of his grand vizier, Jaʿfar, to support a ninth-century date for the pottery.

The Great Find itself Kouchakji describes as having occurred when a colony of Circassians being relocated by the Ottomans, in need of building materials for the construction of their houses, was given permission to dig in the ruins. A trench was made in the vicinity of Harun al-Rashid's palace, and as luck would have it, the trench led directly to the old suq. In one of the shops was discovered the "series of huge jars, each of which contained perfectly preserved specimens of the finest Er Rakka pottery."

Among the varieties of pottery discussed in the article, one type appeared to be very similar to the second type of waster I had seen at the Karatay Museum, namely, that underglaze-painted on a white ground under a clear colorless glaze. Kouchakji designated the type as "one recognised category" of Raqqa pottery, characterizing it as a "white glazed ware with few decorations. It consists of large plates with rings of cobalt blue around the flanges and thin wheel spokes or stars covering the centres." Unfortunately, none of these pieces are illustrated.

In 1925, Thomas B. Clarke consigned for auction another group of his Raqqa pottery, again dating the pieces to the ninth century. The catalogue singles out part of this group for special praise. "Most important perhaps of all these are the Rakka potteries of supreme quality first revealed in the 'Great Find' . . . there can never be anything like them again." Ten objects from the Great Find were included, together with eleven additional pieces.[27] The twenty-one vessels ranged in price from \$35 (for a luster-painted bowl) to \$2,200 (for an underglaze- and luster-painted jar).

A. J. Butler entered the discussion in 1926. Openly dismissive of the dealers involved, he not only questioned the ninth-century dating but also stated that "[the] provenance [of Raqqa ware] may have no better warrant than the word of one of those dealers who freely connect their marketable possessions with any

24. Riefstahl 1922: xiii.
25. This date is one year earlier than the one given by Kelekian (see note 15, above).
26. Kouchakji 1923: 515–24. Two objects designated as part of the Great Find are now in The Metropolitan Museum of Art (MMA14, MMA38). A third object, also now in the Metropolitan, is described as from the palace of Harun al-Rashid and Wathiq (MMA9).
27. Clarke sale 1925, lots 639–48. All but two of the ten are today in The Metropolitan Museum of Art (MMA18–20, MMA35, MMA37, MMA40–42). One object from the second group is also in the Museum's collection (MMA30).

site attracting attention at the moment and so tending to enhance the value of their wares. A faked provenance is a common and fruitful source of profit to dealers and of error to historians. . . . Nevertheless there is a measure of convenience in the conventional ascription of certain wares to certain places such as Raqqah, Rhages, and Sultanabad. Of these three towns, however, it is most difficult to connect any very definite type of pottery with Raqqah, which was a half-way house between Aleppo and Baghdad and known rather as a place of traffic than as a place of manufacture."[28]

Before 1927, Riefstahl published a group of pottery "recently excavated on the site of ancient Raqqa."[29] In the article, he states that "in the language of the connoisseur several types of potteries are called 'Raqqa' which may as well have been made in Syrian towns. The museum of Konia, Inner Anatolia, contains a series of 'Raqqa' potteries, mainly of turquoise blue glaze with black painting under the glaze, which has been found in Aleppo." Riefstahl dismisses any connection between this ware and Harun al-Rashid, dating it from the twelfth to the fourteenth century. He also notes that such ware has "long attracted the attention of Museums and collectors."

Julian Garner, in his contribution of 1927, expanded somewhat on Riefstahl's arguments, adding that the objects had all been found together and had been buried with great care.[30]

Kouchakji Frères held a liquidation sale in 1927 at The Anderson Galleries in New York. The auction included ninety-three ceramic objects labeled as ninth-century Raqqa ware. In the catalogue, it is stated that the firm "has concentrated its entire resources and experience in the discovery and the bringing to America of the most important examples of Near Eastern art. . . . Rakka pottery was introduced to America by Kouchakji Frères. . . . The importance of this sale, and the unusual opportunity it offers, is doubly emphasized as the source of supply of ancient Rakka seems more or less exhausted and all excavations have become a state monopoly. We doubt very much if any such opportunity will ever be offered again."[31]

In 1928, a sale of objects from the collection of Azeez Khayat that included fifteen glazed ceramic vessels advertised as found in Raqqa was held at The Anderson Galleries, and the following year H. Khan Monif consigned to the same auction house a large group of "Near Eastern antiques" that included five glazed ceramic objects purported to be from the same site.[32]

These last three auctions at The Anderson Galleries provide a window on the American market for Raqqa ware at the end of the third decade of the twentieth century. The highest price fetched at the Kouchakji sale was $1,300; at the Khayat auction, the best price was $140; among the Monif group, only $65. The value of ceramic objects from Raqqa had declined precipitously.

The highest prices had been paid many years earlier—in 1908 by Charles Lang Freer to the firm of Tabbagh Frères and in 1911 to Kouchakji Frères by a member of the Havemeyer family, presumably Louisine. Freer paid $6,000 for a large underglaze- and luster-painted jar now in the Freer Gallery of Art

28. Butler 1926: 121–26, 147–48.
29. Riefstahl n.d. Wasters in the Karatay Museum are among the objects in this "series." It is notable that both the segmental bowls with wide flat rims and the biconical bowls in Riefstahl's group as well as those found in Baalbek by Sarre all have holes in the foot rings. These may have been used as a means of hanging the vessels on walls, for the purpose of displaying them as collectors' items. If this was the case, there would certainly have been an active export business in the ware.
30. Garner 1927: 52–59. One of these objects is now in the Freer Gallery of Art, Smithsonian Institution, Washington, D.C. (42.5), and another is in The Walters Art Museum, Baltimore (48.1044).
31. Kouchakji Frères sale 1927.
32. Khayat sale 1928; Monif sale 1929.

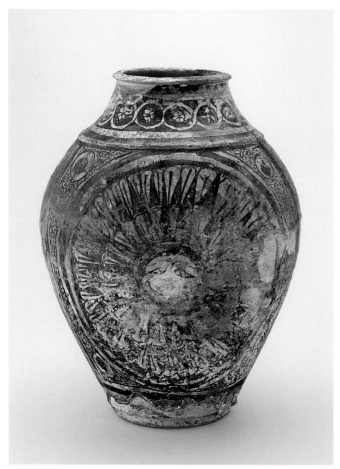

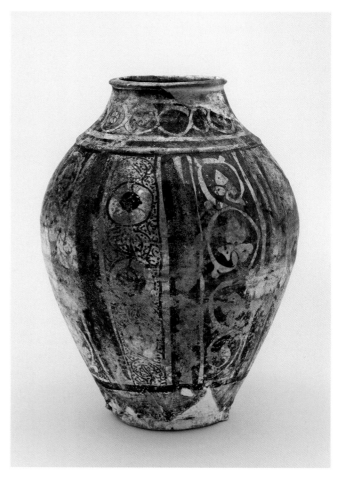

FIGURE 1.2. Underglaze- and luster-painted jar with molding at base of neck. Raqqa, Syria, 1200–1230. Freer Gallery of Art, Smithsonian Institution, Washington, D.C., Gift of Charles Lang Freer (1908.116)

FIGURE 1.3. Panel design on jar in figure 1.2

33. Freer Gallery of Art 1908.116; Metropolitan Museum of Art (MMA9, MMA32); and Metropolitan Museum of Art, 56.185.11 (not included in this publication). The 2003 price equivalents for the amounts quoted were kindly provided by Solidelle Fortier Wasser, senior economist, Economic Analysis and Information Section, U.S. Department of Labor, Bureau of Labor Statistics.

34. See the entries for MMA15, MMA18, and MMA20, respectively, for the penultimate price for Raqqa pottery in the 1917 Clarke sale and the two highest prices for these ceramics in his 1925 sale.

35. Raby 1989: 71–74.

36. Jenkins-Madina 2000: 72. See also Wood 2000: 113–30.

(figs. 1.2, 1.3), and Mrs. Havemeyer paid $15,000 for three objects now in the Metropolitan Museum—prices equivalent to $122,467 and $295,232 expressed in terms of the average purchasing power of the dollar in 2003 (fig. 1.4).[33] Although we know that Freer continued to buy Raqqa pottery until 1911, as did Mrs. Havemeyer at auction at least until 1925, never again did they have to pay such prices.[34] In fact, collectors would not pay equivalent prices for similar objects until the end of the twentieth century.

Julian Raby, in his article "Iznik: The European Perspective," states that by 1930, "the European attraction for Orientalism had run its course," citing World War I and the Great Depression as key factors in the demise of what he terms "the era of the great collectors."[35] What Raby describes as pertaining to the vogue for Iznik pottery would appear to be equally applicable to the passion for Raqqa ceramics. By the late 1920s, those dealers who had been busy fanning the interest of collectors in that pottery were now bemoaning the fact that the ware was no longer obtainable. The number of examples being auctioned diminished, and prices dropped. Collectors began turning their attention to another area of the Middle East, namely, Iran.[36]

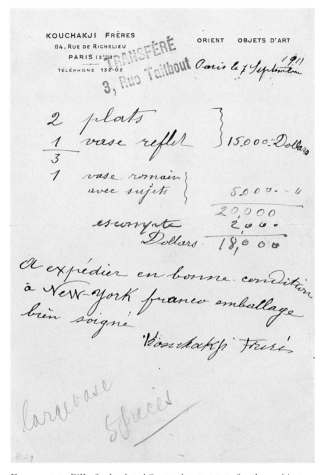

FIGURE 1.4. Bill of sale, dated September 7, 1911, for three objects now in The Metropolitan Museum of Art (56.185.11, and chapter 4, MMA9 and MMA32)

By this time, the antiquarians—Clarke, Kelekian, Khayat, Kouchakji Frères—were in agreement that Raqqa pottery should be dated to the tenth century or earlier and that it all came from the site of Raqqa. They also continued to promote what had long proved an excellent advertising pitch, namely, the association of the pottery they were attempting to sell with the popular lore of Raqqa and the caliph Harun al-Rashid.

On the other side were the scholars—Butler, Koechlin, Migeon, Nöldeke-Hannover, Pézard, Pier, and Riefstahl. Having no hidden agenda, they concurred on neither dating nor provenance. The net result, to paraphrase Raby, was a legacy of confusion. In the intervening decades, while an early date has been ruled out, the question of provenance has remained open. In the following pages I hope not only to resolve this question but also to suggest a precise date for the manufacture of these objects.

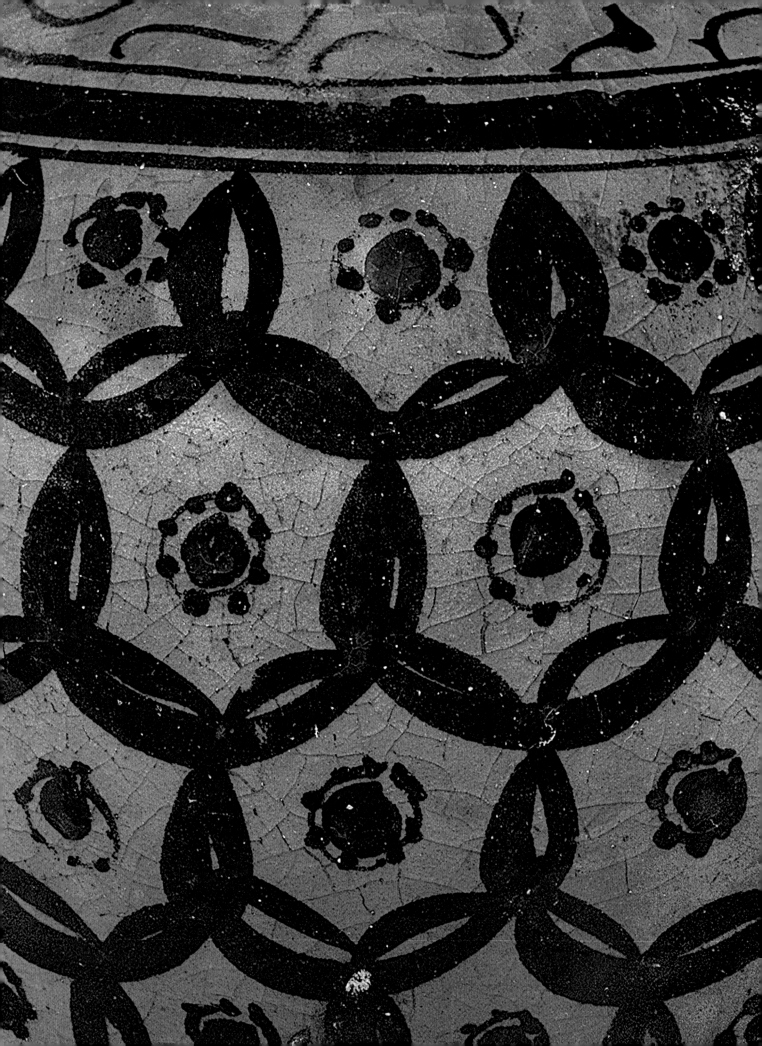

2. Raqqa Demythologized

WE HAVE LOOKED in chapter 1 at factors that contributed to creating a market for pottery found in Raqqa that was based more on lore and legend than on historical fact. To reevaluate this information and to establish what actually took place, we turn to archival documents that include what appear to be the first citations of ceramic objects originating at that site. The documents, the earliest of which date from 1899, are still in Istanbul, which during the time of our study was the capital of the Ottoman Empire.[1] One group of records, today housed in the Istanbul Archaeological Museum Library, is that of the Imperial Museum; a second, today in the Istanbul Prime Ministry Archives, is that of the Ministry of Internal Affairs. These records are written in Turkish in Arabic script.[2] The third group, written in French, comprises the earliest inventory books of Turkish Islamic objects in the Imperial Museum and is now in the Topkapı Palace Museum, Istanbul.

The story we are following is closely intertwined with the history of the Imperial Museum, and the first native director of the museum, Osman Hamdi, who served from 1881 until his death in 1910, is a major protagonist. Many of the events enumerated here took place during Hamdi's tenure, and it was his philosophy regarding antiquities found in the Ottoman Empire that shaped official policy toward these events. When Hamdi assumed the directorship, the museum's collection was housed in the Çinili Köşk (Tiled Pavilion), one of the buildings in the Topkapı Palace. However, at his instigation, construction of a new museum building was begun in 1888, directly across from the Çinili Köşk, and when it opened in 1891 most of the collection was moved there. The Islamic objects were displayed on the second floor. In addition to expanding the museum, Hamdi contributed to rewriting the antiquities laws, establishing government-sponsored archaeological expeditions, and founding a school for the arts. He also played a major role in establishing the museum as a locus for Ottoman culture, recognizing "the need to develop a place for the museum in the public psyche."[3]

Turning now to the documents, we learn from a letter dated May 10, 1899, that ceramic objects had been removed from the ruins of Raqqa and sold by a government officer to a merchant who had, in turn, sold them to a British traveler. The merchant was later forced to hand over to the Ministry of Finance the amount realized from the sale. Had the merchant still had the objects, it is noted, they would have been confiscated.[4]

1. The name Istanbul, instead of Constantinople or Istanbul/Constantinople, will be used throughout this publication for the capital of the Ottoman Empire even though the Ottomans used Konstantiniyya on their coinage and official documents.
2. Selections from these records appear, in translation, in Appendix 1.
3. Shaw 2003: 99, 105; Ölçer 2002: 10.
4. Appendix 1, no. 2, Istanbul Archaeological Museum Library (IAML).

5. Appendix 1, no. 3, IAML.

6. Registration nos. 1416–1568. See Appendix 1, p. 219. "Alep" refers to the Ottoman province of Aleppo. A *kaza* is an administrative district within a province, or *vilayet*. Unfortunately, the precise meaning of "kaza de Raqqa et de Maareh" remains unclear. However, as two wasters with this specific provenance (see chapter 3, w129, w135) are certainly part of the ceramic production of Raqqa (see Appendix 2), there appear to be only two explanations for this designation. Either Maareh is the partial name of the kaza or it is the name of another kaza in close proximity to Raqqa. The only site near Raqqa with a similar name is Tell Mahra (known today as Tell Sheikh Hassan), which is twenty-five miles due north.

7. Appendix 1, no. 4, IAML.

8. Appendix 1, nos. 6, 7, IAML. This is the first description of wasters originating in Raqqa known to me.

9. For these wasters, see chapter 3, w40, w46, w58, w60, w115, w120, w132, w136, w138. The records of the British Museum do not specify whether this was a ceramics factory, nor do they indicate whether "Aleppo" refers to the province or to the city. However, because the nine objects bear close comparison with the vessels discussed here, they can be assumed to have been produced at the same center.

10. See Appendix 1, nos. 1932–1983.

11. See Appendix 1, nos. 2027–2029.

12. Shaw 2003: 170.

13. Konyali 1964: 1130. This information contradicts Shaw 2003: 170.

14. Shaw 2003: 123.

A report dated December 20, 1900, states that members of the relocated Circassian colony who have been collecting bricks in the ruins of Raqqa to build their houses are, in the process, finding antiquities as well. Unfortunately, some of these are accidentally being destroyed. While the Circassians do not understand the significance of these pieces, others do, and the objects are falling into their hands. This report requests that the permits to dig for bricks be temporarily revoked until someone from the Imperial Museum can be dispatched to the site.[5]

The first mention of objects from Raqqa in the inventory books of the Imperial Museum occurs in the descriptions of 153 objects that entered the Imperial Museum in December 1900. The provenance is given as either "Alep, kaza de Raqqa et de Maareh" or simply "Alep, kaza de Rakka."[6] As no government-sponsored excavations had been made up to that time, it can be assumed this group consisted of objects confiscated from individuals conducting illegal excavations.

On February 16, 1901, in an addendum to the December 20 report, it is requested that an official from the Imperial Museum be sent to conduct excavations and inspect the site. Also requested are examples of the finds to be sent to Aleppo, the capital of the province, for government inspection.[7]

Two letters (one dated March 29, 1902, the other April 1, 1902) confirm that three small caskets containing ceramic objects from Raqqa confiscated from a government officer who planned to smuggle them for sale abroad are being shipped from Iskenderun to the Imperial Museum in Istanbul. A considerable number of these objects appear to be wasters, as they are described as intact but "crooked and bent."[8]

Also in 1902, nine wasters were acquired by the British Museum, London, from a London dealer. They were said to have been found on the site of a factory in Aleppo.[9]

Fifty-two objects from "Alep, kaza de Rakka"[10] are registered in the inventory books of the Imperial Museum as entering the museum in June 1903 and another three, from "Alep, kaza de Rakka et de Maareh"[11] in April 1904. Here again, we can assume that these were vessels smuggled out of Raqqa and later confiscated by government officials.

To consolidate the growing antiquities collections and to provide the much needed additional space to exhibit and store these objects, several regional museums were established during this period, thus "lighten[ing] the heavy stream of acquisitions entering the Istanbul museum."[12] The first was opened in Konya, in 1899.[13] Another opened in 1904, this time in Bursa, to be followed by others over the next few years.

We learn that on January 26, 1905, "because recently antiquities have been stolen by smugglers from the ruins of Rikka in the province of Aleppo, a royal decree [prohibiting such activity] . . . has been rumored. However, the encoded order telegraphed by the Ministry of Education has not arrived. Therefore the need for instructions is hereby expressed."[14]

15. Appendix 1, no. 11, IAML.

16. Trained as an archaeologist, Theodore Makridy was, at the time, keeper of the Greek and Byzantine Department of the Istanbul Archaeological Museum; in 1923, he was appointed assistant director of the museum. He later went on to become the first director of the Benaki Museum in Athens, a post he held from 1931 until 1940, when he returned to Istanbul where he died the same year.

17. For eleven examples of this pottery, see chapter 3, w10, w30, w41–w43, w61, w63, w86, w96, w103, w121.

18. National Archives (formerly Public Record Office), Kew, Surrey, England, FO371/149.

The first official Ottoman excavation of the city is documented in a telegram from Raqqa dated December 31, 1905.[15] In it, Theodore Makridy of the Imperial Museum reports that he has begun his excavation of the site.[16]

Although government-sponsored excavation had begun, the clandestine digging continued, and pilfered objects quickly found their way to the capital. In a letter to the Victoria and Albert Museum, London, dated January 7, 1906, Charles M. Marling of the British Embassy in Istanbul states that he had acquired "15 pieces of pottery from the site of an old pottery at Rakah. . . . I believe [Osman] Hamdi has dug there and these are stolen." Fourteen of these fifteen pieces were eventually given to the Victoria and Albert.[17] They consisted of thirteen wasters and one vessel of the so-called Miletus type that is now known to have been manufactured in Iznik.

The excavation in Raqqa under Makridy's direction is further confirmed in a report of April 2, 1906, sent from the British consul in Aleppo, Henry D. Barnham, to his ambassador in Istanbul, Sir N. R. O'Conor, and transmitted to the foreign secretary in London on April 11, 1906: "Rakka was formerly one of the summer residences of the Caliph Haroun-al-Raschid, who here established an earthenware factory, the remains of which were discovered a few years ago. Early this year, Mr. Macridis, of the Stamboul Museum, was engaged in collecting specimens of this work for removal to the Museum, and he passed through Aleppo a few weeks ago with three cases full. The specimens I have seen were urn-shaped vases from 6 inches to 9 inches high, of the colour of Etruscan pottery and covered with a beautiful glaze." Also noted is the presence of two hundred families, "being the larger part of the Circassian immigrants who arrived last November." Barnham writes that they "will leave Aleppo for Rakka next week. Suitable land for the erection of half-a-dozen villages has been found . . . the proposed Settlement being about half-way beween Rakka and Surondj."[18]

A more complete description of Makridy's excavation is to be found in a letter dated April 12, 1906, from the director of education of Aleppo Province to the

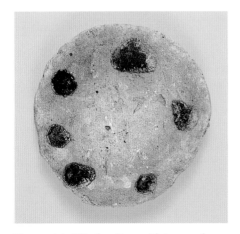

FIGURE 2.1. Kiln furniture with traces of aubergine glaze. Raqqa, Syria. Museum of Turkish and Islamic Art, Istanbul (1920/4143)

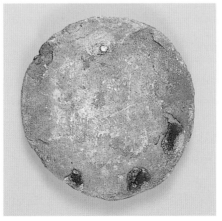

FIGURE 2.2. Kiln furniture with traces of turquoise glaze. Raqqa, Syria. Museum of Turkish and Islamic Art, Istanbul (1920/4143)

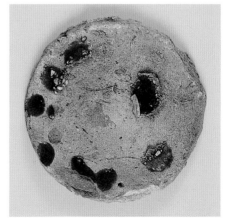

FIGURE 2.3. Kiln furniture with traces of green glaze. Raqqa, Syria. Museum of Turkish and Islamic Art, Istanbul (1920/4143)

Imperial Museum. Apparently, Makridy worked at this site over a period of fifteen to twenty days and found enough antiquities to fill fifteen caskets. He believed that roughly the same number still remained to be unearthed. The letter requested that another officer be appointed to continue the excavation, as the site could not be protected, and once the Circassian refugees were settled in the area it would be impossible to prevent smuggling.[19] The fifteen caskets were shipped to the Imperial Museum in March 1906.[20] Thirteen objects from the excavation were registered as entering the museum in March and another twenty-six in an unspecified month of the same year.[21] Included were four earthenware roundels with drops of glaze of various colors—aubergine, turquoise, and green—that served as kiln furniture, evidence that Makridy was excavating in the area of the city where glazed ceramics had been produced (see figs. 2.1–2.3).

The Circassian immigrants mentioned by both the British consul and the director of education deserve comment. The influx of this group of peoples from villages in the north central Caucasus appears to have played a considerable role in the unfolding story. In November 1905, 364 families, hoping to escape military service, forced religious conversion, and the imposition of the Russian language, arrived by ship at Iskenderun. They received a warm welcome in Syria. Forty-seven of the families were settled just west of Raqqa, and the new community was well planned. Each family was given land, a two-room cottage, a stable and a yard, a pair of bullocks, a plow, and five sacks of grain.[22] Their move from temporary quarters in Aleppo to Raqqa occurred within the week of April 2, 1906.

Against this backdrop, a law was passed on April 23, 1906, establishing a central commission for antiquities. Excavations were to be monitored locally by administrators in the Ministry of Education, also responsible for local museums, who would report to the central commission.[23]

Although by this time scholars as well as dealers were well aware that ceramic objects seemed to have been emerging from Raqqa for at least a decade and were starting to be associated with the Abbasid caliph Harun al-Rashid, Osman Hamdi appears to have remained in the dark. Writing in March 1907 to a certain Dr. Zambaco, Hamdi declares that he is about to reveal unpublished information of great interest. He goes on to describe a site in Mesopotamia, on the Euphrates, called Raqqa, that was the summer residence of the Abbasid caliphs and also "a ceramic center of the utmost importance. For some years, marvelous objects—vases, cups, dishes, etc.—have been found there." An agent sent to the site by the Imperial Museum the year before (Theodore Makridy) had discovered a multitude of ravishing objects, and these had now enriched and augmented the museum's collection in astonishing proportions. In a postscript, Hamdi adds that Raqqa has not previously been known as a ceramics center, and thus the information is completely new. He generously suggests that Zambaco's friend Y. Artin, undersecretary at the Ministry of Education in Cairo, be the first to publish these remarkable findings. Indeed, Hamdi himself will help him do so.[24]

19. Appendix 1, no. 14, IAML.
20. Appendix 1, no. 13, IAML.
21. See Appendix 1, nos. 2548, 3921–3932; 3998–4016, 4137, 4143, 4144, 4278, 4279.
22. Lewis 1987: 103–4. The report of the British consul differs somewhat from the account Lewis gives in this publication. Barnham lists the number of families in Raqqa as two hundred, cites half a dozen villages instead of one, and notes only the provision of land. The area from which these families emigrated is now the Russian republic of Kabardino-Balkaria.
23. Shaw 2003: 126.
24. Artin Pacha 1907: 89–90.

Less than a month after Hamdi wrote this letter, the director of education of Aleppo Province, in a state of alarm, informed the Ministry of Education in Istanbul, in a telegram dated April 22, 1907, that the Circassian refugees who had settled in Raqqa were cooperating with the locals and that more than five hundred robbers were removing objects from the ruins.[25]

We have a firsthand account of Raqqa from the archaeologist Friedrich Sarre, who visited the site for one week in the fall of 1907 during a six-month excursion (October 1907–March 1908) in the Jazira with his colleague Ernst Herzfeld. Sarre's description of this visit appears in three different publications, dating from 1908 to 1911.[26] In them, he states that the illicit excavations that had been ongoing for "about ten years," as well as the excavations carried out by the Imperial Museum from "time to time," were being conducted not in the ninth-century city of Harun al-Rashid, but in the "crescent-shaped site" of al-Rafiqa.[27] "The most remote date" of this area he considered to be A.H. 561/A.D. 1166 and, consequently, he dated the finds from this district from the eleventh to the twelfth century. In fact, Sarre was able to ascertain that, up to the time of his visit, Harun al-Rashid's city had not been excavated at all. Based on this account by a scholar in the field, it becomes clear that dealers, such as Fahim Kouchakji, and others who had attributed the finds to the palaces of Harun al-Rashid and members of his court had knowingly—or perhaps unknowingly—confused the different areas within the site itself.

Sarre did not consider the excavations of the Imperial Museum carried out under the direction of Theodore Makridy (which he incorrectly placed in 1909) scientific. Rather, he characterized them as explorations undertaken without attention to stratigraphy or architectural context. He thus believed that, up to the time of his writing, no scientific excavations had taken place at all. And while many of Makridy's finds had been housed and exhibited at the Çinili Köşk, the objects, Sarre claimed, had never been studied. He also believed that the illicit excavations undertaken at the site had been encouraged and perhaps even supported by antiques dealers.

The most common type of pottery being excavated, according to Sarre, was the luster-painted variety. He further observed that intact vessels were extremely rare. "The fragments and the spoilt vessels from the potteries are often most skilfully completed in Aleppo, whence they reach the European and American art markets." Sarre and Herzfeld had been eager to undertake an official excavation in Raqqa, but they knew, because of the commercial value of the finds, that the local residents would object. Consequently, they settled for gathering together a representative sampling of types found at the site—unglazed ware, undecorated monochrome glazed ware, molded or carved monochrome glazed ware, black painted under a clear turquoise glaze, and underglaze- and luster-painted ware. We also know that Sarre made at least four purchases during this trip, one in Raqqa and three in Aleppo.[28]

Sarre believed that the pottery found in Raqqa was not imported but had been made in the city. As proof, he cited kiln rejects[29] and the occasional find of a large

25. Appendix 1, no. 16, IAML.
26. Sarre 1909b: 388 (the letter is dated November 13, 1908); Sarre 1909a: 45–47, pls. XX, XXI; Sarre and Herzfeld 1911: 24–28 (republished in 1921).
27. Herzfeld (in Sarre and Herzfeld 1911: 158) states the "horseshoe town [is] burrowed through and through by treasure-seekers who search here for the Rakka ceramics which fetch exceedingly high prices."
28. All are now in the Museum für Islamische Kunst, Staatliche Museen zu Berlin. For I.3990, see chapter 5, pattern 25, note 3; for I.3991, see page 171, fig. 5.2; I.3992 is unpublished. One of the three objects he purchased in Aleppo (not included in the present study) he bought from the dealer Georges Marcopoli.
29. Unfortunately, these wasters are not described, so that we do not know the type of pottery, the date of manufacture, or if they were in fact wasters in the true sense of the word.

unglazed jar containing smaller, well-preserved glazed vessels. One such find, marketed by an Aleppine dealer, he connected to what he described as the "rich collection of beautiful Raqqah ceramics" owned by the important American collector Charles Lang Freer. In his concluding statements, however, he seems less certain about the provenance of these wares, saying they had been made not only in Raqqa but at other pottery centers as well and adding that they had been widely exported.

Meanwhile, in the capital, the Islamic objects on display in the new building of the Imperial Museum were moved back to the Çinili Köşk in 1908, thus giving the collection its own building and conferring a new status on the antiquities collection.[30]

In the wake of additional reports of smuggling and the request for another official excavation, the Imperial Museum dispatched the archaeologist Haydar Bey to Raqqa in August 1908.[31] On September 4, 1908, Haydar Bey wrote that although the excavations were going well, hundreds of local people were descending on the site at night, when the official work was over. Local officials could not stop the clandestine digging, the site was being destroyed, and soon there would be nothing left. His funds, he wrote, could sustain him for only three more weeks.[32] On November 21, 1908, Haydar Bey sent six caskets filled with objects from Raqqa to the Imperial Museum. Eighty-seven objects from the excavation were registered as entering the museum in 1908.[33]

In that same year, Charles L. Freer traveled to the Middle East, stopping in Cairo, Aleppo, Beirut, Jerusalem, and Istanbul.[34] For the purposes of this study, it is his stay in Aleppo that most interests us, for it is during this visit that Freer became acquainted with the Marcopolis, a family who played an important diplomatic role in Aleppo.[35] The year of Freer's trip, Georges Marcopoli was Spanish consul in the city. The family also ran an antiquities business, which by that time was in "full swing."[36] Freer was to buy seventy-two glazed ceramic objects from the firm, Vincenzo Marcopoli & Co., between 1908 and 1911.[37] Georges Marcopoli appears to have been the principal in the business, as it is to him in care of the Spanish consulate that Freer wrote after he returned to the States.

Some of the notes Freer made concerning his purchases help us to reconstruct the modus operandi of the Marcopoli firm: "This figure was exhumed at Raqqa, taken direct to Aleppo by Marcopoli's agent and by Marcopoli personally handed to me."[38] "All of these three pieces were purchased by me in Aleppo. . . . They were brought to Aleppo by the same caravan and unpacked and repaired during my visit."[39] "These seven specimens were all found at Raqqa and taken directly to Marcopoli in Aleppo and delivered by him to me."[40] In other words, Marcopoli had direct access to what was being excavated in Raqqa as well as a method in place to get the pieces to Aleppo, have them restored, and, in this case, immediately sold to his clients.

Three of the objects Freer purchased from Vincenzo Marcopoli & Co. were commented upon by Fahim Kouchakji. He attributed their good condition to the fact that "they were packed inside a large jar found at Raqqa, and were brought

30. Shaw 2003: 210.

31. Appendix 1, nos. 17–19, IAML.

32. Appendix 1, no. 22, IAML.

33. Registration nos. 2938, 2941–2944, 2953–3024, 4283, 4284, 4298–4305. See Appendix 1, pp. 216–18.

34. Bloom 1975: 3.

35. I wish to thank Georges Antaki, honorary consul of Italy in Aleppo, for providing information about the Marcopoli family. Originally from the Aegean island of Chios, the Marcopolis became established in Aleppo in 1835, with members serving in various diplomatic capacities until the second half of the twentieth century (letter of March 3, 2004). For additional information on the Marcopoli family, see *Almanach de Gotha* 1903.

36. Sarre 1921: 25. The "Aleppiner antiquar" mentioned by Sarre in connection with Freer must be Marcopoli.

37. Bloom 1975, Appendix A: 97.

38. Ibid.: 426 (Freer Gallery of Art, Smithsonian Institution, Washington, D.C., folder sheet for 1908.154).

39. Ibid.: 517 (Freer Gallery of Art folder sheet for 1910.34).

40. Ibid.: 601 (Freer Gallery of Art folder sheets for 1911.24, 1911.612–617).

from there to the Aleppo market."[41] This observation recalls that made by the same dealer in 1923 when he discussed the discovery of the Great Find, "the series of huge jars, each of which contained perfectly preserved specimens of the finest Er Rakka pottery." It was beginning to look as though the Great Find was not a myth after all. The date Freer made these purchases, 1908, provides the terminus ante quem for its discovery. Furthermore, since they were acquired from Vincenzo Marcopoli & Co., the find can somehow be connected to this Aleppine firm. Confirmation of such a connection is also provided by Sarre, who wrote that Freer's collection of Raqqa ceramics came, for the most part, from a find inside unglazed vessels that was brought to the market by an antiques dealer from Aleppo. Kouchakji assigned a terminus post quem of 1907 to the Great Find, stating that it had been made by one of the Circassian refugees, who, it will be remembered, were relocated to Raqqa in April 1906.[42] It would thus appear safe to assign the discovery of the find to the second half of 1906 or sometime in 1907.

As to the procedure followed when Freer was back in America, we learn from the correspondence between the collector (in English) and Georges Marcopoli (in French) that the dealer had photographs taken of the objects he wished his client to consider for purchase (see fig. 2.10).[43] Marcopoli also asked Freer for the addresses of English and American collectors to whom the firm might send photographs. Early in their correspondence, which dates from September 1, 1908, to July 5, 1911, Marcopoli supplies descriptions of the objects together with their prices, also pointing out those he finds the most interesting.[44] Later he appears to let Freer set his own prices.

In their letters, we also receive news of Raqqa. Marcopoli must have said something about the failure of Haydar Bey's excavations, begun in August 1908, for Freer wonders in a letter of December 2, 1908, whether this means that the supply of objects at the site is nearly exhausted. We further learn, in a letter by Freer of March 3, 1910, that Marcopoli had recently written of "the difficulty of carrying on excavations and in shipping pottery out of the country since the new government was established in Istanbul."[45] Nevertheless, in spite of the ever stricter surveillance by the Ottoman government that Marcopoli says is hindering the exportation of antiquities, in a letter of September 23, 1910, the dealer mentions that he has ninety-nine new pieces to show Freer; he will send photographs. And again, on May 30, 1911, Marcopoli tells Freer that many new pieces—interesting and in perfect condition—have been discovered.

It is clear from this correspondence that the emporium of Vincenzo Marcopoli & Co., while having access to an archaeological treasure, did not really know how important it was. Nor did they know how to market it. Asking Freer for addresses of prospective clients and allowing him to set prices are only two indications of their naïveté. Obviously, they needed help. It would seem that such help presented itself in the person of Fahim Kouchakji, a native of Aleppo as we have seen earlier, who was to open family-owned galleries in both Paris and New York. His firm's claims, noted above, that "it was a member of this firm who first

41. The three objects are now in the Freer Gallery of Art (1908.136, 1908.140, and 1908.148). The quotation is found on the folder sheets for 1908.136 (Bloom 1975: 366). In a note on these sheets dated October 20, 1941, it is stated that Mr. F. Kouchakji "recently" had provided this information.

42. Kouchakji 1923: 521, 524.

43. Letter dated September 1, 1908.

44. The correspondence is housed in the Archives Department of the Freer Gallery of Art.

45. This is a reference to the radical developments that took place in 1908, when the Young Turk revolutionary officers forced Sultan Abdülhamid II (r. 1876–1909) to restore the constitution of 1876, thus inaugurating the second interlude of constitutional government in Turkey.

brought the now famous Raqqa pottery to the knowledge of Western art lovers and scientific students of the whole world" and that Raqqa pottery "was introduced to America by Kouchakji Frères" were not idle boasts.[46]

Another firsthand report from Raqqa is provided by the English archaeologist, author, and government official Gertrude Bell (1868–1926).[47] Bell spent two days in Raqqa in 1909, February 27 and 28. Her diaries for these days, as well as for those preceding, which she spent in Aleppo, help to round out the picture we have been able to sketch thus far. The entry for February 7 recounts a visit she made to the house of André Marcopoli: "He has 2 stones one of which is certainly Hittite . . . a good Assyrian relief, lots of tiles, and Chinese china and one or two good pieces of Rakha. . . . Then on to Mr. Georges Marcopoli, but it was too late and dark to see his things." (One wonders if stopping by the Marcopoli residences to view—perchance to purchase—antiquities was not a sine qua non for European and American visitors to Aleppo.) The next day, Bell mentions that she went to the home of a certain Kostaki Homsi, where she bought some Hittite cylinders. Other pieces she saw there included "some Rakha things, not I thought very good." On February 10, she returned to the houses of both André and Georges Marcopoli: "I photographed André's Hittite stones, walked about on the roof of the bazaars, photographed the window of Khan es Sabun and then saw all Georges's Rakha—some very lovely." On February 12, she "went to the Khourys with Mme Koch. He had some lovely Rakha fragments. . . . But as he asked £20 for them I did not buy." Clearly, in Aleppo, it was not only members of the Marcopoli family who were selling ceramics from Raqqa. Bell reached Raqqa on February 27. "All the ground was covered with fragments of pottery," she wrote in her diary. And in a letter she exclaimed, "The people dig up the most beautiful pots which they sell to the dealers in Halab [Aleppo]. I saw a good many there but the price was far beyond my purse. Here however I rather hope to be able to buy something." The next day, as she wrote in her diary, she divided her time between "buying £43 worth of Rakka ware and planning the mosque. The bargaining for the pots was all done under the auspices of Selim, the agent for Forbes here who has been most obliging."[48]

In her book *Amurath to Amurath*, published in 1911, expanding on her short diary entries for Raqqa, she notes that "the greater part of the walled city . . . is honeycombed with irregular holes and trenches, the excavations of peasants in search of the now celebrated Rakkah ware. A few years ago their labours were rewarded by a large find of unbroken pieces, many of which made their way through the hands of Aleppo dealers to Europe." She further comments that the "original factories and kilns have been brought to light, and it is not unusual to see bowls or jars which have been spoilt in the baking and thrown away by the potter." There is no mention in this tantalizing passage about the decorative technique or color scheme of these wasters.[49]

In addition to the written record Bell provided, she also left a photographic record in the form of a series of albums. One album is of particular relevance to our study. Thirteen photographs in the album are labeled only as having been taken in

46. See chapter 1, notes 22 and 31.

47. Gertrude Bell's life was dominated by her love of the Middle East, its peoples, and its artistic past. Her travels are documented in 1,600 letters, 16 diaries, and 7,000 photographs, now in the Gertrude Bell Archive, Robinson Library, University of Newcastle, Newcastle upon Tyne, England. Recruited by British Intelligence during World War I, Bell was later to become political secretary in Baghdad. She was influential in the creation of the state of Iraq. Her first love, however, was archaeology. Bell was named honorary director of antiquities by King Faisal I of Iraq (r. 1921–33) in 1922 and in 1926 established the Baghdad Archaeological Museum, later the National Museum of Iraq.

48. The Gertrude Bell Archive, University of Newcastle.

49. Bell 1911: 59–60. As was the case with Sarre's description (see p. 25, above), we cannot be sure that the "spoilt" bowls or jars were truly wasters. It is clear, however, that "the large find of unbroken pieces" is a reference to the Great Find.

FIGURE 2.4. Photograph taken in Aleppo, 1909. Number 6 is now in The Metropolitan Museum of Art (chapter 4, MMA10). The Gertrude Bell Archive, University of Newcastle, Newcastle upon Tyne

FIGURE 2.5. Photograph taken in Aleppo, 1909. Number 19 is now in The Metropolitan Museum of Art (chapter 4, MMA30). The Gertrude Bell Archive, University of Newcastle, Newcastle upon Tyne

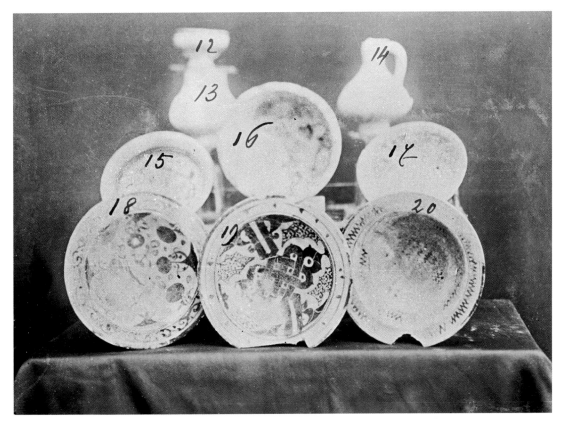

FIGURE 2.6. Photograph
taken in Aleppo, 1909.
Numbers 30 and 32 are
now in The Metropolitan
Museum of Art (chapter 4,
MMA16, MMA33). The
Gertrude Bell Archive,
University of Newcastle,
Newcastle upon Tyne

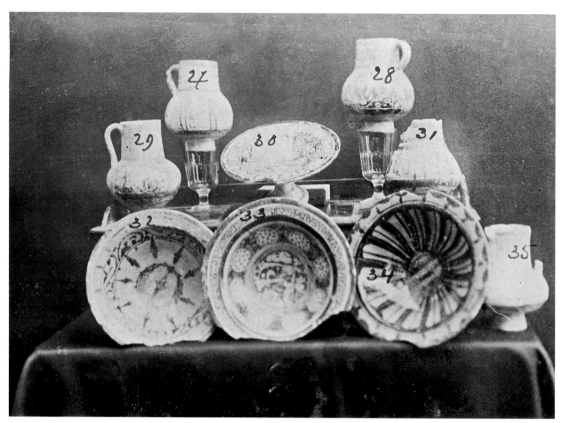

FIGURE 2.7. Photograph
taken in Aleppo, 1909.
Numbers 25 and 26 are
now in The Metropolitan
Museum of Art (chapter 4,
MMA19, MMA40). The
Gertrude Bell Archive,
University of Newcastle,
Newcastle upon Tyne

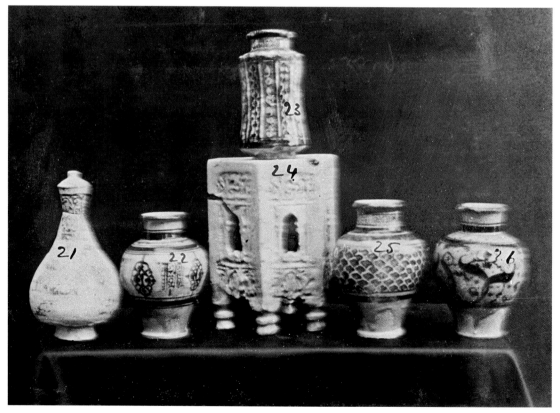

FIGURE 2.8. Photograph taken in Aleppo, 1909. These objects are now in The Metropolitan Museum of Art (chapter 4, MMA19, MMA16). The Gertrude Bell Archive, University of Newcastle, Newcastle upon Tyne

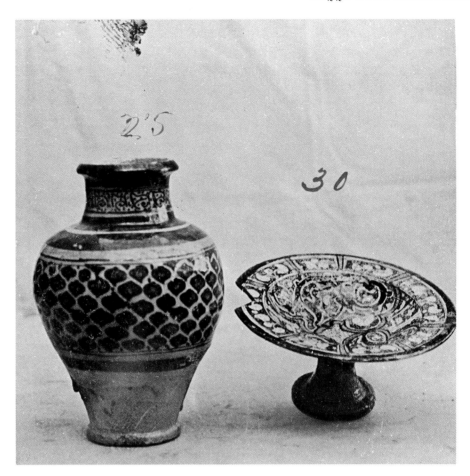

FIGURE 2.9. Photograph taken in Aleppo, 1909. Four of the objects shown are now in The Metropolitan Museum of Art: top row, far left (chapter 4, MMA21); top row, second from right (MMA24); large jar at center, bottom row (MMA41); drinking vessel, bottom row (immediately to right of latter jar) (MMA22). The Gertrude Bell Archive, University of Newcastle, Newcastle upon Tyne

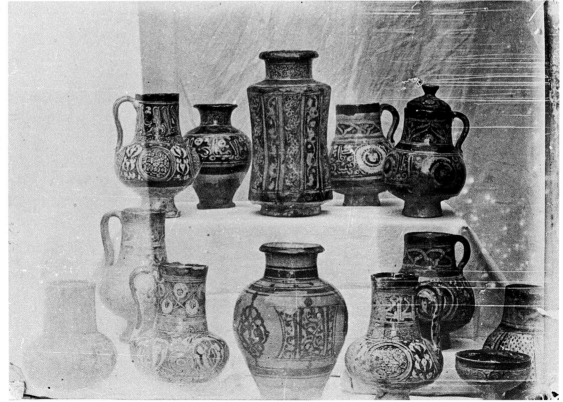

FIGURE 2.10. Photograph taken in Aleppo and sent by Vincenzo Marcopoli & Co. to Charles L. Freer. The numbers marked in red were written by the dealer for identification. Charles Lang Freer Papers. Freer Gallery of Art and Arthur M. Sackler Gallery Archives, Smithsonian Institution, Washington, D.C., Gift of the Estate of Charles Lang Freer (Art vouchers, June 1911)

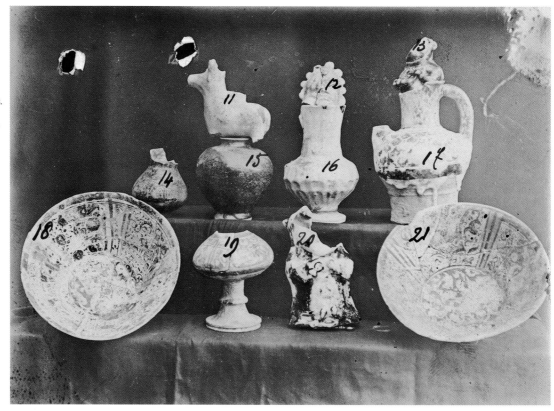

Turkey in 1909.[50] These thirteen photographs were not, in fact, taken in Turkey but in Aleppo. We know this because one of the Marcopolis, probably Georges, sent copies of eleven of them to Freer together with four other photographs of the same type.[51] (For a selection of these photographs, see figs. 2.4–2.10).[52]

Most likely, none of these photographs were taken by Gertrude Bell. Although we know that Bell had her camera with her when she visited the Marcopolis, she does not mention, as she does in other cases, anything about photographing objects at the home of Georges. Furthermore, Freer had begun receiving photographs of Georges's objects in Aleppo at least six months before Bell arrived in that city. Marcopoli must have given copies of these photographs to her when she visited him in 1909 and showed interest in Raqqa pottery and also perhaps so that she could show them to friends, since Marcopoli was, as we have seen, in need of new clients.

Returning now to Istanbul, we find that in 1909 the archaeologist Gustave Mendel wrote an article about the new Çinili Köşk galleries that had opened the previous year. In the article, he describes a group of Syrian pottery as having been manufactured in Raqqa. While he admits that it does not include many pieces that are still intact (these having found their way into European collections), he nevertheless regards it as important because of its size and provenance, namely, the Makridy excavations in Raqqa. His claim of local manufacture he supports by citing the large percentage of wasters among the thousands of vases and fragments found by Makridy heaped on the same spot. Mendel goes on to

50. Album O, nos. O213–224, 226, the Gertrude Bell Archive, University of Newcastle. The description written on each of these by the archivist reads: "Photograph of Islamic pottery. Individual pieces are marked in red ink . . . probably not in Gertrude Bell's writing." I would like to thank Ayşin Yoltar-Yıldırım for drawing these photographs to my attention.

51. These fifteen photographs are at present housed in the archives of the Freer Gallery of Art.

52. Ten of the objects seen in the photographs are today in The Metropolitan Museum of Art. See chapter 4, MMA10, MMA16, MMA19, MMA21, MMA22, MMA24, MMA30, MMA33, MMA40, MMA41.

describe the many different types of objects that have been discovered: amphoras without handles, large cups flaring at the foot, bottles with handles and lobed mouths, bulging convex vases, cups with flat shoulders, goblets, basins, bowls, and small lamps. While the vessels come in a great variety of colors, blue with black decoration predominates. Also common are green, an olive gray, and brown on a white ground, occasionally with what he calls *surcharges* in blue or green.[53]

A letter of February 24, 1910, from the Presidency of the Parliament confirms that illicit excavations are continuing in Raqqa and notes that objects being smuggled from Aleppo to Beirut are being seized.[54]

In a letter of September 23, 1910, Marcopoli tells Freer that three objects previously offered for sale are no longer available, as they have been bought by Kouchakji Frères (see nos. 22, 25, and 26 in fig. 2.7). That all three pieces ended up being sold in the Thomas B. Clarke sale of 1925 in New York (eventually to form part of the Islamic collection of the Metropolitan Museum) is further evidence that Kouchakji was acting as an important conduit to the West for Marcopoli—either buying objects outright from the firm or acting as its agent.

In October 1910, in a telegram to the Directorate of the Imperial Museum, the governor of Aleppo reports that (like Gertrude Bell) he has repeatedly seen valuable antiquities in many Aleppine homes. He continues: "Telegrams I receive from Raqqa indicate that antiquity smuggling is pervasive. Apparently, anyone who wishes to dig there takes valuable antiquities and sells them for profit. Since the gendarmes are limited in number and can hardly patrol the roads and villages, it is not possible to have guards on the site. Thus, people dig, steal, and sell." The site, he concludes, should certainly be protected.[55]

By March 1912, although those involved in illegal excavations are being prosecuted and their finds confiscated, "it is impossible to stop these activities completely so long as there are people who have acquired a taste for them. Valuable antiquities numbering in the hundreds have reached dealers in Halep."[56]

In June 1913, eleven caskets and five stone antiquities were being held in the center of Raqqa in the name of Baron Max von Oppenheim, a Prussian diplomat, archaeologist, collector, and explorer.[57] In a telegram and a letter of June 4 and 25, respectively, Oppenheim is quoted as having claimed that all these purchases had been made in Raqqa. Because the acquisition of such antiquities was prohibited, it had been determined that the government would take possession of them. Accordingly, these objects were confiscated from Oppenheim and deposited with the Directorate of Education in Aleppo.[58] Oppenheim later wrote a letter of protest to the consulate. Some of the objects, he wrote, he had bought from Bedouin Arabs during a trip from Tell Halaf to Raqqa and others had been surface finds. He had also purchased some—openly—in Raqqa itself from Arabs and Circassians with the help of his guide, who had been provided by the local administration. Because government officials had been among those who sold objects to him, he had assumed that there was nothing illegal in the transactions. Furthermore, similar objects were being sold in shops in Aleppo and Beirut. He was writing now to request the immediate return of his property.[59]

53. Mendel 1909: 344–46.
54. Appendix 1, no. 25, IAML.
55. Appendix 1, no. 26, IAML.
56. Appendix 1, no. 31, IAML.
57. Appendix 1, no. 33, IAML. Max von Oppenheim (1860–1946) discovered the important prehistoric site of Tell Halaf, north of Raqqa, in 1899, while on a journey in connection with the planning of the Berlin-Baghdad Railway. He would lead excavations at the site from 1910 to 1913 and again from 1927 to 1929.
58. Appendix 1, no. 40, IAML.
59. Appendix 1, no. 41, IAML.

Nevertheless, despite the baron's efforts, a letter in December of that year informs us that the caskets and stone objects were sent to the Imperial Museum in Istanbul, where they remained.[60]

Also to enter the museum that year, in September, were twenty-one objects that had been confiscated from N. Marcopoli.[61]

By April 1914, the Çinili Köşk was overflowing. To accommodate the rapidly expanding Islamic collections, a new building was needed. The unused imaret (public kitchen) of the Süleymaniye Mosque complex was chosen, the objects—including those excavated by Makridy—were moved, and the building became the Museum of Pious Foundations.[62]

By this time, the cost of excavating had become prohibitive, and in July 1914 the government suspended operations in Raqqa and elsewhere. Those found digging without a license were being prosecuted. Nevertheless, "local people continue to dig at the site and [they] sell the antiquities they find to smugglers for a pittance. Valuable antiquities are destroyed in this way and often they fall into the hands of foreigners." Some of the pieces, it is noted, are being smuggled to Paris.[63]

As we have seen, the provenance of Raqqa ceramics today housed in the Istanbul museums that are the successors to the Imperial Museum is adequately documented. Written sources on the provenance of the very similar objects in the Karatay Museum, Konya, on the other hand, appeared to be lacking, even well into my research. Something I had read, however, seemed to offer a clue. It was a reference to "another group of objects brought to Çinili Köşk [that was] less well-documented. Apart from the fact that they were found at Tell Halaf in Aleppo [the province of Aleppo is meant here], little is known about them."[64] The author of this quotation, Nazan Ölçer, then director of the Museum of Turkish and Islamic Art, makes no mention of these objects having been moved to the new Museum of Pious Foundations, as she does of those excavated by Makridy. It is tempting to speculate that this group consisted of the eleven caskets confiscated from Oppenheim and that at least some of these objects from the Çinili Köşk were sent not to the new museum in Istanbul but to Konya. We know that by December 27, 1913, the caskets had arrived in Istanbul from the province of Aleppo. This date accords well with the records in the Karatay register books, which state that the wasters under discussion here entered the museum in 1914 and, further, that they came from Aleppo Province.

The late Mehmet Önder, who in 1955 assumed the directorship of the Konya Museum—comprising the Mevlana Museum and the soon-to-be-opened Karatay—stated in interviews that when he took up his post the wasters were being stored in uninventoried caskets that had arrived in Konya circuitously, via Istanbul and Damascus, in 1914.[65] He said specifically that following a fire in the museum in Damascus, the Ottoman governor and army commander in chief of Syria, Cemal Pasha, had dispatched the caskets to the Imperial Museum in Istanbul, which had identified them as Raqqa ceramics and then sent them on to the Mevlana. Part of Önder's account does not accord with the facts, as there was no museum in Damascus when Cemal Pasha was in residence there, from 1914

60. Appendix 1, no. 46, IAML.

61. Nos. 3500–3520; see Appendix 1, p. 219. One of these objects, a tabouret (3511), is illustrated in Kuhnel 1938, pl. 22, right.

62. In 1923, the Museum of Pious Foundations was closed, reopening the following year with a new name, the Museum of Turkish and Islamic Art (Türk ve İslam Eserleri Müzesi), and a new affiliation, the Ministry of Education; see Ölçer et al. 2002: 8–26.

63. Appendix 1, no. 50, IAML. The individual mentioned in this letter by his last name, Demirciyan, has been identified by Torkom Demirjian, the owner of Ariadne Galleries in New York, as his grandfather, Benyamin (Peno) Demirjian, who moved to Aleppo in the 1890s and to Turkey in the 1920s. Not having a shop or gallery in either Aleppo or Paris, his business, which included the selling of ceramic objects made in Raqqa, was conducted privately. (Telephone conversation with author, December 21, 2004.)

64. Ölçer 2002: 17.

65. These interviews were conducted between August 2002 and April 2003 by Professor Talat Halman, Chairman of the Department of Turkish Language and Literature, Bilkent University, Ankara, and Dr. Ayşin Yoltar-Yıldırım.

66. Box 112, dossier 11920, IAML.

67. Yusuf 1930: 84.

68. The Konya Museum, originally the Mevlevi Tekke, was opened in 1926.

69. For the object in Istanbul, see chapter 3, w71. While the Karatay objects could possibly be from the Makridy excavation, the facts surrounding the Oppenheim confiscation, including the date, better concur with the accounts given by Önder and Mehmet Yusuf, as well as with the museum records for these objects themselves .

to 1917. As for the objects having been in a fire, this notion could have evolved from the fact that they were wasters, pieces that had become distorted in a kiln misfiring.

However, some of the information provided by Önder we have been able to confirm, from two different sources. The first confirmation is an archival record dated March 18, 1928, that pertains to objects in the Konya Museum: "There are also Arab ceramics which were brought during WWI from Halep. These consist of plates, bowls, jugs, etc. and come in various shapes and sizes. They are low quality—rough and irregular and help us understand the development of ceramic making in the Arab world."[66] Confirmation of Önder's statement appears also in a guidebook for the Asarı Atika Müzesi, Konya, published in 1930, by the then director of the museum, Mehmet Yusuf. In it, he states that both Turkish and Arab ceramic objects are housed in the museum. He describes Turkish tiles and ceramics, and among the objects of Arab origin he mentions plates, bowls, and jugs. The latter are described as produced in Aleppo and its environs ("Rakka") and as being brought from Aleppo during World War I.[67]

The objects discussed in these two sources were part of the ceramics collection of the Konya Museum.[68] This entire collection was moved to the Karatay Museum, which opened in December 1955.

The scientific analyses conducted by Dylan Smith for this project (Appendix 2) have determined conclusively that the wasters in the Karatay were indeed made in Raqqa. These analyses have determined as well that an object in the Museum of Turkish and Islamic Art, Istanbul, registered as being connected to Oppenheim (the provenance in the museum records is "Oppenheim mission") was also made in Raqqa. Thus, the objects sent to Konya and at least one of those that remained in Istanbul as part of those originally in Oppenheim's possession have the same provenance.[69]

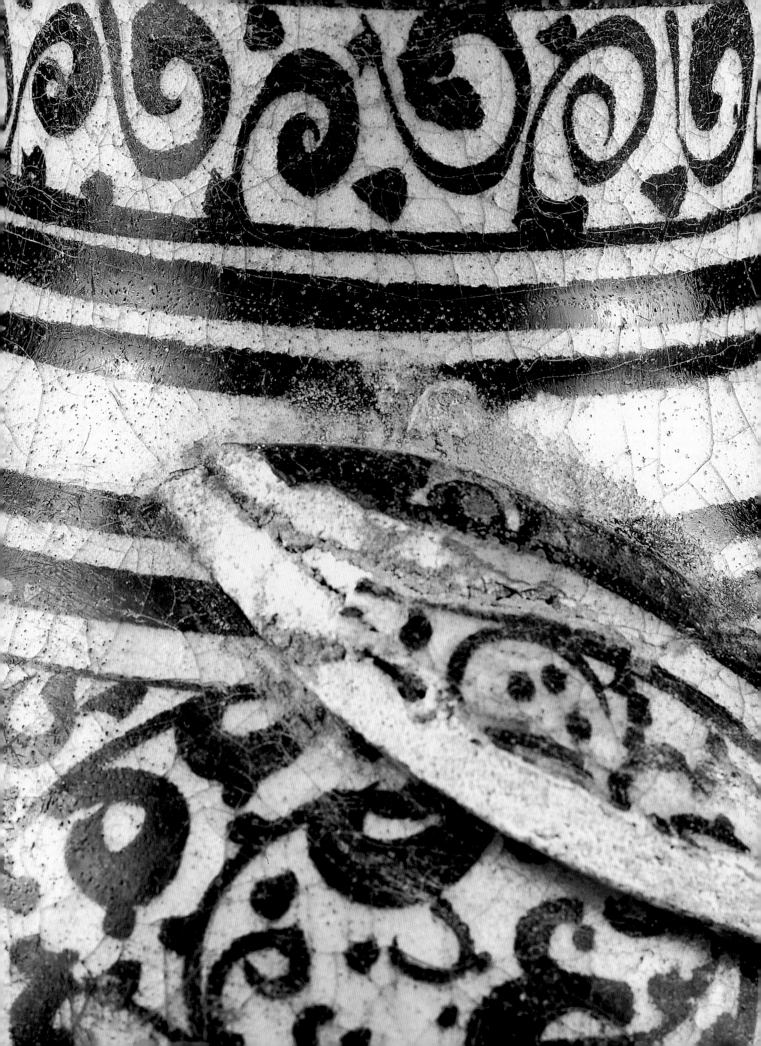

3. The Rejects of Raqqa

WE HAVE SEEN that the lore surrounding the ceramics of Raqqa was by and large a merchandising lure that for about a century had the effect of confusing both scholars and collectors, not only about what the kilns of Raqqa had produced and when they were active but also about the very existence of kilns in that city. Raqqa was indeed a center for ceramic manufacture, and in this chapter the rejects of its kilns—140 wasters—will be documented and examined in an effort to clarify the facts and thus to further demythologize the city.

Although many collections were studied during the course of my research, the number of wasters presented here is not exhaustive for the three types of pottery represented. The wasters are organized by decorative technique and, within each of these categories, by profile. Each entry includes my own description of the object, the effects of firing mishaps on its condition, the name of the institution in which it is housed, its inventory number, any relevant notation in the institution's records, and, when available, comparative references.

The composition of the following objects in this chapter was scientifically analyzed, with results as presented in Appendix 2: w9, w18, w21, w22, w28, w38, w48, w56, w62, w71, w75, w77, w80, w83, w89, w93, w117, w130, w131, and w135.

I. UNDERGLAZE- AND LUSTER-PAINTED OBJECTS

A. Biconical bowls

W1. Biconical bowl, profile 3 (waster)

Composite body, glazed
Height 3⅝ in. (9.2 cm), diameter 7⅝ in. (19.4 cm)
Condition: A firing mishap caused a triangular
fissure in the wall, resulting in distortion of the bowl.

Karatay Museum, Konya 17/7

There is no decoration on the interior or exterior.

Completed bowls exhibiting this profile, with no underglaze-painted program and with differing luster-painted decoration: Metropolitan Museum of Art 07.212.3 (chapter 4, MMA2); Aleppo National Museum 321, 448, 492; Ashmolean Museum of Art and Archaeology, Oxford, 1978.2175;[1] Museum für Islamische Kunst, Staatliche Museen zu Berlin 3992; Museum of Turkish and Islamic Art, Istanbul, 2126/1429.

MUSEUM REGISTER: "Arab ceramic. Entered 1914, during World War I; from Halep [Aleppo Province]" (written in modern Turkish alphabet).

1. Porter 1981: 27, pl. 18.

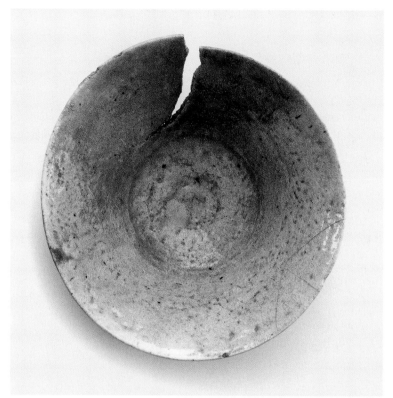

w1

W2. Biconical bowl, profile 3 (waster)

Composite body, glazed
Height 3¾ in. (9.5 cm), diameter 8¼ in. (21 cm)
Condition: A firing mishap caused the wall to
slump on one side and the entire vessel to warp.

Karatay Museum, Konya 17/8

There is no decoration on the interior or exterior.

Completed bowls exhibiting this profile, with no underglaze-painted program and with differing luster-painted decoration: Metropolitan Museum of Art 07.212.3 (chapter 4, MMA2); Aleppo National Museum 321, 448, 492; Ashmolean Museum of Art and Archaeology, Oxford, 1978.2175;[1] Museum für Islamische Kunst, Staatliche Museen zu Berlin, 3992; Museum of Turkish and Islamic Art, Istanbul, 2126/1429.

MUSEUM REGISTER: "Arab ceramic. Entered 1914, during World War I; from Halep [Aleppo Province]" (written in modern Turkish alphabet).

1. Porter 1981: 27, pl. 18.

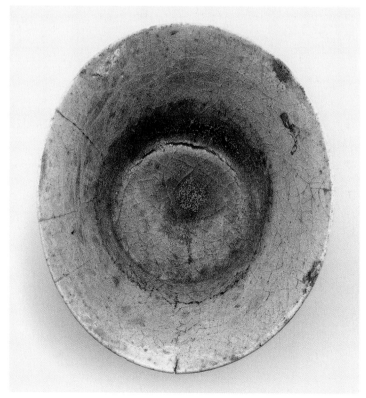

w2

W3. Biconical bowl, profile 3 (waster)

Composite body, glazed
Height 3 in. (7.6 cm), diameter 6 in. (15.2 cm)

Karatay Museum, Konya 19

There is no decoration on the interior or exterior.

Completed bowls exhibiting this profile, with no underglaze-painted program and with differing luster-painted decoration: Metropolitan Museum of Art 07.212.3 (chapter 4, MMA2); Aleppo National Museum 321, 448, 492; Ashmolean Museum of Art and Archaeology, Oxford, 1978.2175;[1] Museum für Islamische Kunst, Staatliche Museen zu Berlin, 3992; Museum of Turkish and Islamic Art, Istanbul, 2126/1429.

MUSEUM REGISTER: "Arab ceramic. Entered 1914, during World War I; from Halep [Aleppo Province]" (written in modern Turkish alphabet).

1. Porter 1981: 27, pl. 18.

W3

W4. Biconical bowl, profile 3 (waster)

Composite body, glazed
Height 2⅜ in. (6 cm), diameter 4¾ in. (12.1 cm)

Museum of Turkish and Islamic Art, Istanbul 1626/1470

There is no decoration on the interior or exterior.

Completed bowls exhibiting this profile, with no underglaze-painted program and with differing luster-painted decoration: Metropolitan Museum of Art 07.212.3 (chapter 4, MMA2); Aleppo National Museum 321, 448, 492; Ashmolean Museum of Art and Archaeology, Oxford, 1978.2175;[1] Museum für Islamische Kunst, Staatliche Museen zu Berlin, 3992; Museum of Turkish and Islamic Art, Istanbul, 2126/1429.

ORIGINAL RECORD BOOK (now in Topkapı Palace Museum, Istanbul): "Café au lait bowl. D. 0,12. Alep [Aleppo Province], kaza de Rekka et de Maareh, December 1900" (in French).

1. Porter 1981: 27, pl. 18.

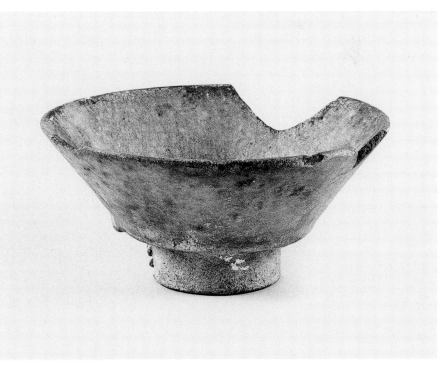

W4

W5. Biconical bowl, profile 3 (waster)

Composite body, underglaze-painted
Height 3¾ in. (9.5 cm), diameter 7⅝ in. (19.4 cm)
Condition: A firing mishap caused a triangular
fissure in the wall (now filled with plaster), result-
ing in distortion of the rim. The paint forming one
roundel has run toward the rim.

Karatay Museum, Konya 17/4

Interior decoration consists of four evenly
spaced turquoise blue roundels. The exterior is
undecorated.

Completed bowls exhibiting this profile, with
this underglaze-painted program and with
differing luster-painted decoration: Kuwait
National Museum, al-Sabah Collection
LNS24C;[1] Museum of Turkish and Islamic
Art, Istanbul, 1646/1499.

MUSEUM REGISTER: "Arab ceramic. Entered
1914, during World War I; from Halep [Aleppo
Province]" (written in modern Turkish
alphabet).

1. Jenkins 1983a: 51.

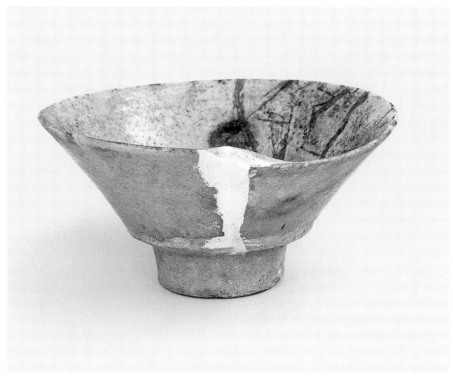

w5

W6. Biconical bowl, profile 3 (waster)

Composite body, underglaze-painted
Height 4¼ in. (10.8 cm), diameter 8½ in. (21.6 cm)
Condition: A firing mishap caused the entire vessel
to warp as well as the glaze to craze and pool.

Karatay Museum, Konya 17/6

Interior decoration consists of four evenly
spaced cobalt blue roundels. The exterior is
undecorated.

Completed bowls exhibiting this profile, with
this underglaze-painted program and with
differing luster-painted decoration: Kuwait
National Museum, al-Sabah Collection,
LNS24C;[1] Museum of Turkish and Islamic
Art, Istanbul, 1646/1499.

MUSEUM REGISTER: "Arab ceramic. Entered
1914, during World War I; from Halep [Aleppo
Province]" (written in modern Turkish
alphabet).

1. Jenkins 1983a: 51.

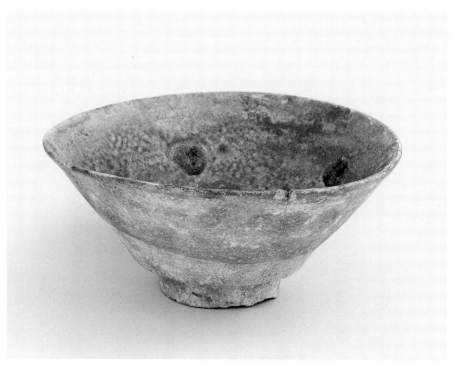

w6

W7. Biconical bowl, profile 3 (waster)

Composite body, underglaze-painted
Height 3⅝ in. (9.2 cm), diameter 7½ in. (19.1 cm)
Condition: A firing mishap caused a triangular fissure in the wall (now filled with plaster), resulting in a slight distortion of the rim.

Karatay Museum, Konya 17/1

Interior decoration consists of four evenly spaced turquoise blue circles. The exterior is undecorated.

Completed bowls exhibiting this profile, with this underglaze-painted program and with differing luster-painted decoration: Metropolitan Museum of Art 48.113.8 (chapter 4, MMA13); Ashmolean Museum of Art and Archaeology, Oxford, 1956.147; National Museum, Damascus, 9656; Freer Gallery of Art, Smithsonian Institution, Washington, D.C., 1908.145.

MUSEUM REGISTER: "Arab ceramic. Entered 1914, during World War I; from Halep [Aleppo Province]" (written in modern Turkish alphabet).

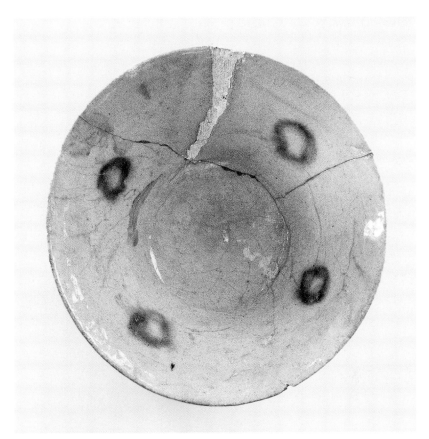

w7

W8. Biconical bowl, profile 3 (waster)

Composite body, underglaze-painted
Height 3⅝ in. (9.2 cm), diameter 7⅝ in. (19.4 cm)
Condition: A firing mishap caused warping of the entire vessel. The missing triangular area at the rim may be either an original gap caused by the mishap or a later loss. The paint forming all the circles has run toward the base.

Karatay Museum, Konya 17/2

Interior decoration consists of four evenly spaced turquoise blue circles. The exterior is undecorated.

Completed bowls exhibiting this profile, with this underglaze-painted program and with differing luster-painted decoration: Metropolitan Museum of Art 48.113.8 (chapter 4, MMA13); Ashmolean Museum of Art and Archaeology, Oxford, 1956.147; National Museum, Damascus, 9656; Freer Gallery of Art, Smithsonian Institution, Washington, D.C., 1908.145.

MUSEUM REGISTER: "Arab ceramic. Entered 1914, during World War I; from Halep [Aleppo Province]" (written in modern Turkish alphabet).

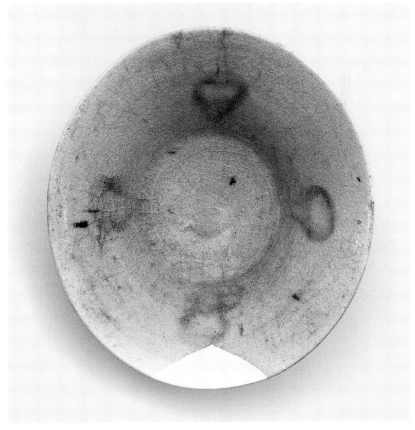

w8

W9. Biconical bowl, profile 3 (waster)

Composite body, underglaze-painted
Height 4⅝ in. (11.7 cm), diameter 9⅛ in. (23.2 cm)
Condition: A firing mishap caused a triangular fissure in the wall, resulting in distortion of the bowl. The paint forming the three circles has run toward the base.

Karatay Museum, Konya 18/3

Interior decoration consists of four evenly spaced turquoise blue circles. The exterior is undecorated.

Completed bowls exhibiting this profile, with this underglaze-painted program and with differing luster-painted decoration: Metropolitan Museum of Art 48.113.8 (chapter 4, MMA13); Ashmolean Museum of Art and Archaeology, Oxford, 1956.147; National Museum, Damascus, 9656; Freer Gallery of Art, Smithsonian Institution, Washington, D.C., 1908.145.

MUSEUM REGISTER: "Arab ceramic. Entered 1914, during World War I; from Halep [Aleppo Province]" (written in modern Turkish alphabet)

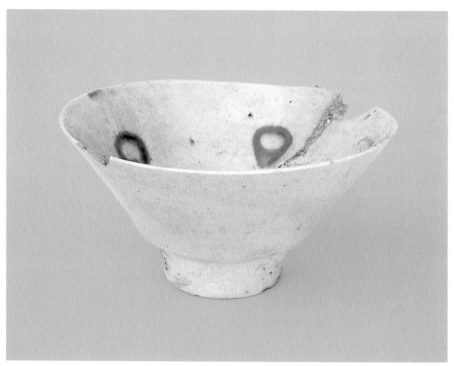

w9

W10. Biconical bowl, profile 3 (waster)

Composite body, underglaze-painted
Height 4⅞ in. (12.4 cm), diameter 9⅝ in. (24.4 cm)
Condition: The paint forming three circles has run slightly toward the base.

Victoria and Albert Museum, London c851-1922

Interior decoration consists of four evenly spaced turquoise blue circles. The exterior is undecorated.

Completed bowls exhibiting this profile, with this underglaze-painted program and with differing luster-painted decoration: Metropolitan Museum of Art 48.113.8 (chapter 4, MMA13); Ashmolean Museum of Art and Archaeology, Oxford, 1956.147; National Museum, Damascus, 9656; Freer Gallery of Art, Smithsonian Institution, Washington, D.C., 1908.145.

MUSEUM RECORDS: A. Garabed, London, August 1922.

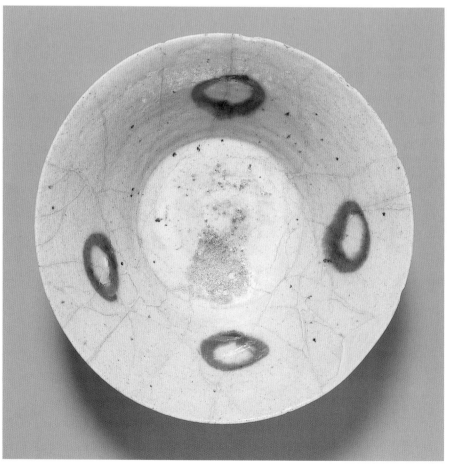

w10

W11. Biconical bowl, profile 3 (waster)

Composite body, underglaze-painted
Height 4¾ in. (12.1 cm), diameter 7½ in. (19 cm)

Ethnographical Museum, Ankara 7379

Interior decoration consists of four evenly spaced turquoise blue circles. The exterior is undecorated.

Completed bowls exhibiting this profile, with this underglaze-painted program and with differing luster-painted decoration: Metropolitan Museum of Art 48.113.8 (chapter 4, MMA13); Ashmolean Museum of Art and Archaeology, Oxford, 1956.147; National Museum, Damascus, 9656; Freer Gallery of Art, Smithsonian Institution, Washington, D.C., 1908.145.

MUSEUM REGISTER: "Ceramic bowl, Halep [Aleppo Province], four green circles over cream ground. Perfect. Gr. D. 19 cm; D. of foot 7 cm" (written in modern Turkish alphabet). Transferred from Asarı Atika Müzesi, Konya, February 1933.

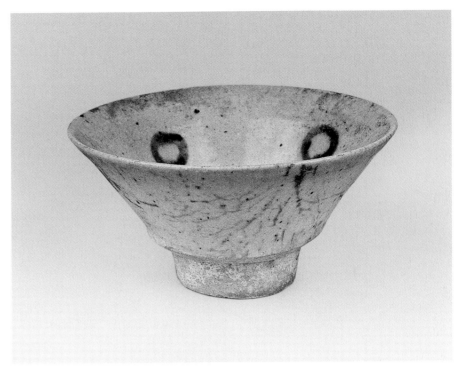

w11

W12. Biconical bowl, profile 3 (waster)

Composite body, underglaze-painted
Height 4½ in. (11.4 cm), diameter 9⅛ in. (23.2 cm)
Condition: A firing mishap caused a single fragment from the wall of another vessel to break off and become embedded in the interior wall.

Karatay Museum, Konya 18/1

Interior decoration consists of four evenly spaced teardrops outlined in turquoise blue. The exterior is undecorated.

MUSEUM REGISTER: "Arab ceramic. Entered 1914, during World War I; from Halep [Aleppo Province]" (written in modern Turkish alphabet).

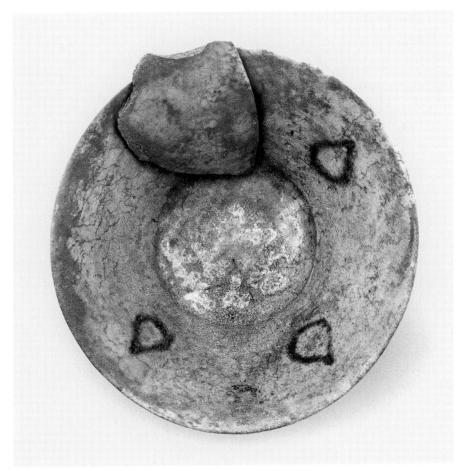

w12

W13. Biconical bowl, profile 3 (waster)

Composite body, underglaze-painted
No measurements available.

Aleppo National Museum 394

Interior decoration consists of four evenly spaced cobalt blue trilobed leaves. The exterior is undecorated.

MUSEUM REGISTER: Acquired, 1980.

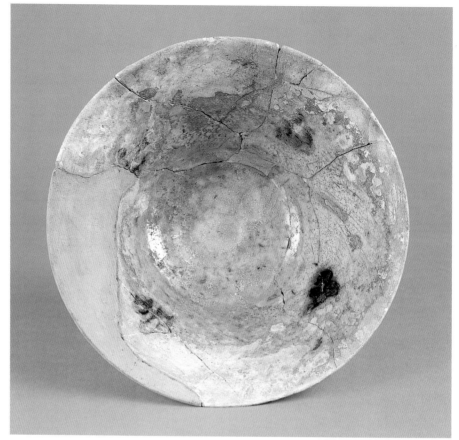

w13

W14. Biconical bowl, profile 3 (waster)

Composite body, underglaze-painted
Height 4 in. (10.2 cm), diameter 7½ in. (19.1 cm)
Condition: A firing mishap caused three rim frag-ments from one or more vessels to break off and become embedded in the base. Each fragment bears a single cobalt blue line at the edge of the rim.

Karatay Museum, Konya 17/3

Interior decoration consists of four evenly spaced turquoise blue trilobed leaves. The exterior is undecorated.

MUSEUM REGISTER: "Arab ceramic. Entered 1914, during World War I; from Halep [Aleppo Province]" (written in modern Turkish alphabet).

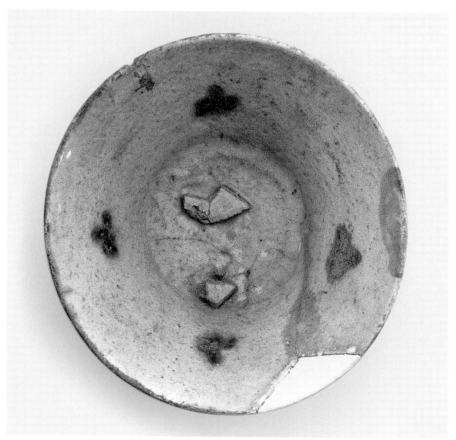

w14

W15. Biconical bowl, profile 3 (waster)

Composite body, underglaze-painted
Height 3¾ in. (9.5 cm), diameter 7¾ in. (19.7 cm)
Condition: The missing area at the rim may be either the result of a firing mishap or a later loss.

Karatay Museum, Konya 17/5

Interior decoration consists of four evenly spaced turquoise blue triple-hillock designs. The exterior is undecorated.

MUSEUM REGISTER: "Arab ceramic. Entered 1914, during World War I; from Halep [Aleppo Province]" (written in modern Turkish alphabet).

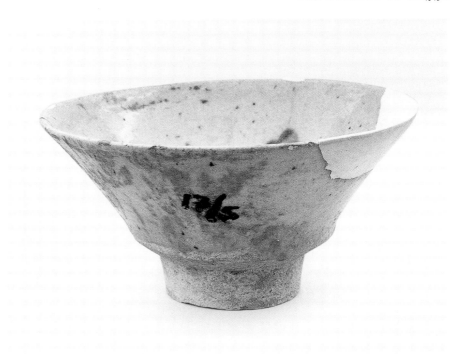

w15

W16. Biconical bowl, profile 3 (waster)

Composite body, underglaze-painted
Height 4 in. (10 cm), diameter 7½ in. (19 cm)
Condition: A firing mishap caused a triangular fissure in the wall.

Hetjens-Museum, Düsseldorf 1957/50

Interior decoration consists of four evenly spaced turquoise blue radiating stripes. The exterior is undecorated.

Completed bowls exhibiting this profile, with this underglaze-painted program and with differing luster-painted decoration: National-museet, Copenhagen, 8,2c161; Los Angeles County Museum of Art M.2002.1.196 (fig. 3.1).

MUSEUM RECORDS: Purchased from Mr. Reinheldt, Berlin, 1957.

FIGURE 3.1 Underglaze- and luster-painted biconical bowl. Raqqa, Syria, 1200–1230. Los Angeles County Museum of Art, Madina Collection of Islamic Art, Gift of Camilla Chandler Frost (M.2002.1.196)

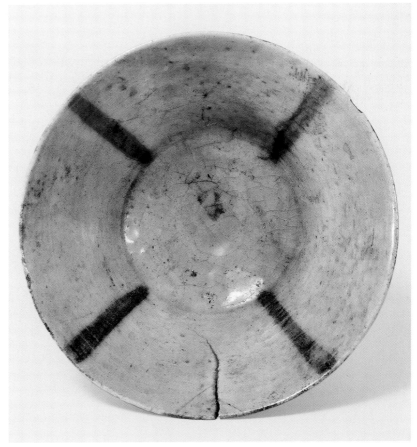

w16

45

W17. Biconical bowl, profile 3 (waster)

Composite body, underglaze-painted
Height 3¾ in. (9.5 cm), diameter 7¾ in. (19.7 cm)
Condition: A firing mishap caused two rim frag-
ments from one or more vessels to break off and
become embedded in the exterior wall, resulting in
distortion of the wall in that area.

Karatay Museum, Konya 17/9

Interior decoration consists of four evenly
spaced turquoise blue radiating stripes. The
exterior is undecorated.

Completed bowls exhibiting this profile, with
this underglaze-painted program and with
differing luster-painted decoration: National-
museet, Copenhagen, 8,2c161; Los Angeles
County Museum of Art M.2002.1.196 (fig. 3.1).

MUSEUM REGISTER: "Arab ceramic. Entered
1914, during World War I; from Halep [Aleppo
Province]" (written in modern Turkish
alphabet).

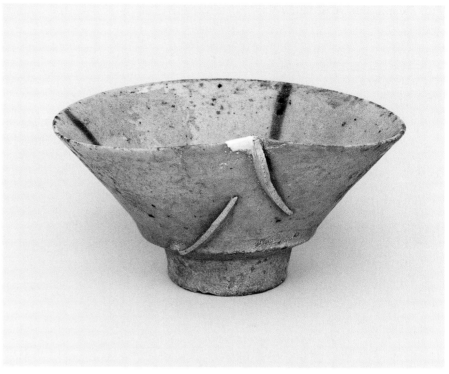

w17

W18. Biconical bowl, profile 3 (waster)

Composite body, underglaze-painted
Height 3⅞ in. (9.8 cm), diameter 7¾ in. (19.7 cm)
Condition: A firing mishap caused multiple frag-
ments from other vessels to break off and become
embedded in the interior.

Karatay Museum, Konya 17/12

Interior decoration consists of four evenly
spaced radiating stripes in cobalt blue alter-
nating with turquoise blue. The exterior is
undecorated.

Completed bowls exhibiting this profile,
with this underglaze-painted program and
with differing luster-painted decoration:
Ashmolean Museum of Art and Archaeology,
Oxford, x3130; Aleppo National Museum 422.

MUSEUM REGISTER: "Arab ceramic. Entered
1914, during World War I; from Halep [Aleppo
Province]" (written in modern Turkish
alphabet).

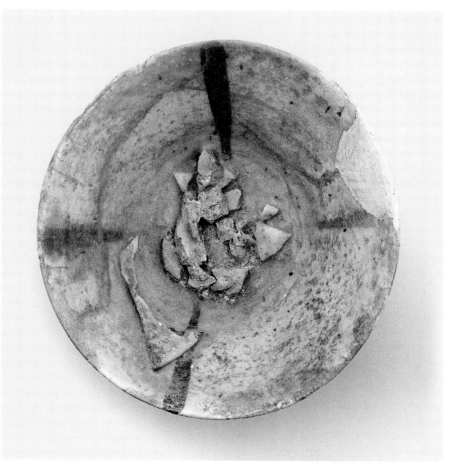

w18

W19. Biconical bowl, profile 3 (waster)

Composite body, underglaze-painted
Height 4½ in. (11.4 cm), diameter 9⅜ in. (23.8 cm)
Condition: A firing mishap caused two fragments from one or more vessels to break off and become embedded in the interior wall and the base.

Karatay Museum, Konya 18/2

Interior decoration consists of eight evenly spaced turquoise blue radiating stripes. The exterior is undecorated.

Completed bowls exhibiting this profile, with this underglaze-painted program and with differing luster-painted decoration: Metropolitan Museum of Art 48.113.6 (chapter 4, MMA11); Ashmolean Museum of Art and Archaeology, Oxford, x3067; Museum of Turkish and Islamic Art, Istanbul, 1657/1975.

MUSEUM REGISTER: "Arab ceramic. Entered 1914, during World War I; from Halep [Aleppo Province]" (written in modern Turkish alphabet).

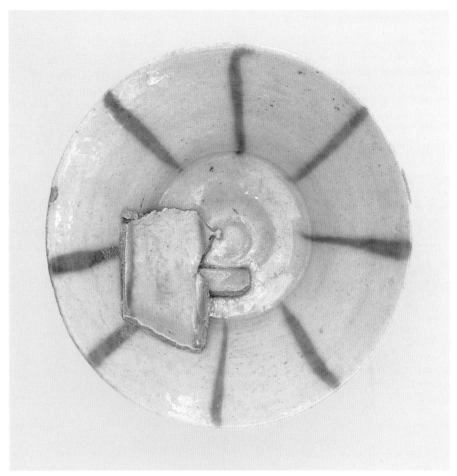

w19

W20. Biconical bowl, profile 3 (waster)

Composite body, underglaze-painted
Height 3⅝ in. (9.2 cm), diameter 7¼ in. (18.4 cm)
Condition: A firing mishap caused the bowl to warp.

Karatay Museum, Konya 17/10

A single cobalt blue ring circumscribes the interior wall. The exterior is undecorated.

MUSEUM REGISTER: "Arab ceramic. Entered 1914, during World War I; from Halep [Aleppo Province]" (written in modern Turkish alphabet).

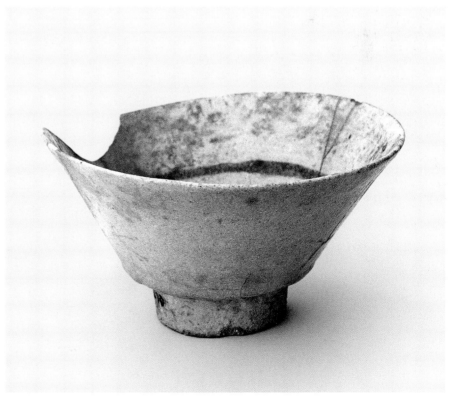

w20

W21. Biconical bowl, profile 3 (waster)

Composite body, underglaze-painted
Height 3⅞ in. (9.8 cm), diameter 7¾ in. (19.7 cm)
Condition: A firing mishap caused a single fragment from the wall and base of another vessel to break off and become embedded in the interior wall.

Karatay Museum, Konya 17/11

A single turquoise blue ring circumscribes the interior wall. The exterior is undecorated.

MUSEUM REGISTER: "Arab ceramic. Entered 1914, during World War I; from Halep [Aleppo Province]" (written in modern Turkish alphabet).

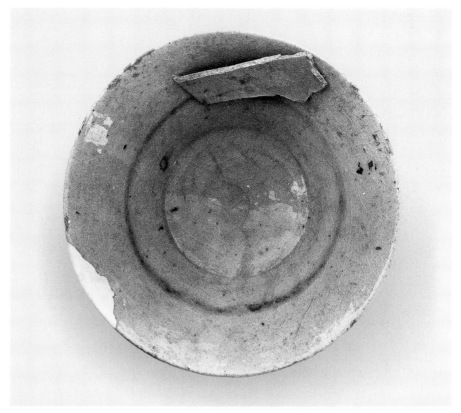

w21

W22. Biconical bowl, profile 3 (waster)

Composite body, underglaze-painted
Height 4⅝ in. (11.7 cm), diameter 9⅛ in. (23.2 cm)
Condition: A firing mishap caused a triangular fissure in the wall, resulting in a slight distortion of the rim. The paint forming the rings has run in places toward the base.

Los Angeles County Museum of Art M2002.1.262

Two turquoise blue rings circumscribe the interior wall. The exterior is undecorated.

PROVENANCE: New York art market, 1989.

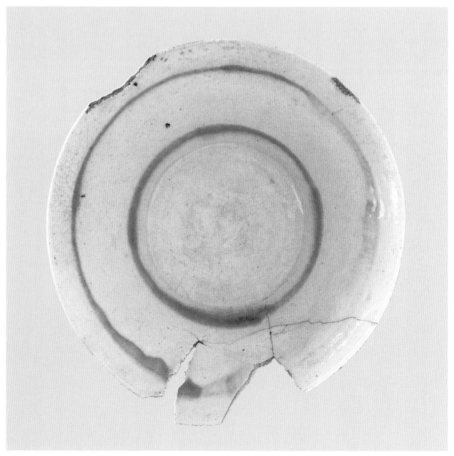

w22

W23. Biconical bowl, profile 3 (waster)

Composite body, underglaze-painted
Diameter 9½ in. (24 cm)
Inscribed: al-ʿizz al-dāʾim waʾl-iqbāl al-zāʾid
waʾl-ʿumr al-sālim waʾl-jadd al-ṣāʿid waʾl-dahr
al-musāʿid (Lasting glory, increasing prosperity,
model life, mounting good fortune, and auspicious
times)

Musée du Louvre, Paris MAO 250

Interior decoration consists of a cursive inscription in cobalt blue. The exterior is undecorated.

MUSEUM RECORDS: Bequest of François Chandon de Briailles, 1955 (acquired in Beirut, 1937).

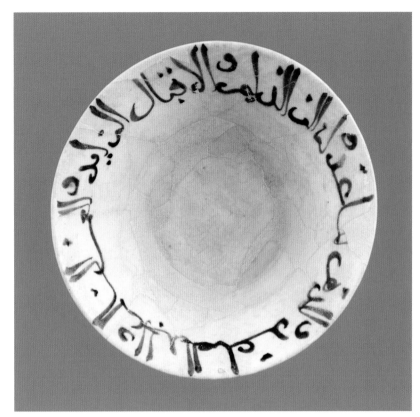

W23

B. Segmental bowls with flat rim

W24. Segmental bowl with flat rim, profile 2 (waster)

Composite body, glazed
Height 2¼ in. (5.7 cm), diameter 9⅞ in. (25.1 cm)
Condition: A firing mishap prevented the glaze from fluxing properly, caused the rim to slump and areas to be missing at the rim, and resulted in fragments from one or more vessels breaking off and becoming embedded in the base.

Karatay Museum, Konya 20/5

There is no decoration on the interior or exterior.

Completed bowls exhibiting this profile, with no underglaze-painted program and with differing luster-painted decoration: National Museum, Damascus, 6838, 17886, 5408/1676; Nationalmuseet, Copenhagen, 103F139; Walters Art Museum, Baltimore, 48.1044, 48.1231;[1] Aleppo National Museum 561;[2] Ashmolean Museum of Art and Archaeology, Oxford, x3068;[3] Metropolitan Museum of Art 1970.24 (chapter 4, MMA28).

MUSEUM REGISTER: "Arab ceramic. Entered 1914, during World War I; from Halep [Aleppo Province]" (written in modern Turkish alphabet).

1. Sarre 1927: 9–10, fig. 7.
2. *Land des Baal* 1982: 236, no. 255.
3. Allan 1991: 40–41, illus. 23.

w24

W25. Fragmentary segmental bowl with flat rim, profile 2 (waster)

Composite body, glazed
Height 3⅞ in. (9.7 cm), diameter 5⅞ in. (15 cm)

Museum of Turkish and Islamic Art, Istanbul 1610/1502

There is no decoration on the interior or exterior.

Completed bowls exhibiting this profile, with no underglaze-painted program and with differing luster-painted decoration: National Museum, Damascus, 6838, 17886, 5408/1676; Nationalmuseet, Copenhagen, 103F139; Walters Art Museum, Baltimore, 48.1044 and 48.1231;[1] Aleppo National Museum 561;[2] Ashmolean Museum of Art and Archaeology, Oxford, x3068;[3] Metropolitan Museum of Art 1970.24 (chapter 4, MMA28).

ORIGINAL RECORD BOOK (now in Topkapı Palace Museum, Istanbul): "Broken white dish. D. 0,15. Alep [Aleppo Province], December 1900" (in French).

w25

1. Sarre 1927: 9–10, fig. 7.
2. *Land des Baal* 1982: 236, no. 255.
3. Allan 1991: 40–41, illus. 23.

W26. Segmental bowl with flat rim, profile 2 (waster)

Composite body, underglaze-painted
Height 3 in. (7.6 cm), diameter 10⅛ in. (27 cm)

Karatay Museum, Konya 20/2

Interior decoration consists of four evenly spaced roundels on the cavetto and four stripes on the rim, all in turquoise blue alternating with cobalt blue. The exterior is undecorated.

Completed bowl exhibiting this profile, with this underglaze-painted program: Metropolitan Museum of Art 48.113.5 (chapter 4, MMA10).

MUSEUM REGISTER: "Arab ceramic. Entered 1914, during World War I; from Halep [Aleppo Province]" (written in modern Turkish alphabet).

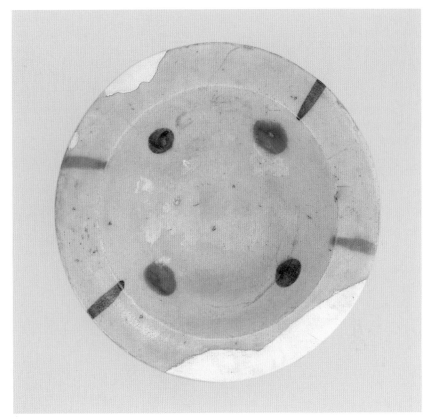

w26

W27. Segmental bowl with flat rim, profile 2 (waster)

Composite body, underglaze-painted
Height 2¾ in. (7 cm), diameter 10½ in. (26.7 cm)

Karatay Museum, Konya 20/4

Interior decoration consists of four evenly spaced roundels on the cavetto and four evenly spaced stripes on the rim, all in turquoise blue. The exterior is undecorated.

Completed bowl exhibiting this profile, with very similar underglaze-painted program: Metropolitan Museum of Art 48.113.5 (chapter 4, MMA10).

MUSEUM REGISTER: "Arab ceramic. Entered 1914, during World War I; from Halep [Aleppo Province]" (written in modern Turkish alphabet).

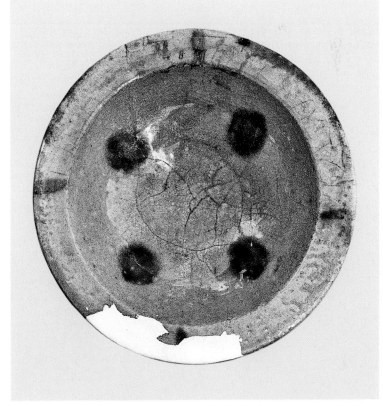

w27

W28. Segmental bowl with flat rim, profile 2 (waster)

Composite body, underglaze-painted
Height 3 in. (7.6 cm), diameter 10¾ in. (27.3 cm)
Condition: A firing mishap caused a fissure below and within the rim.

Karatay Museum, Konya 20/1

Interior decoration consists of four evenly spaced circles on the cavetto and four evenly spaced stripes on the rim, all in turquoise blue. The exterior is undecorated.

MUSEUM REGISTER: "Arab ceramic. Entered 1914, during World War I; from Halep [Aleppo Province]" (written in modern Turkish alphabet).

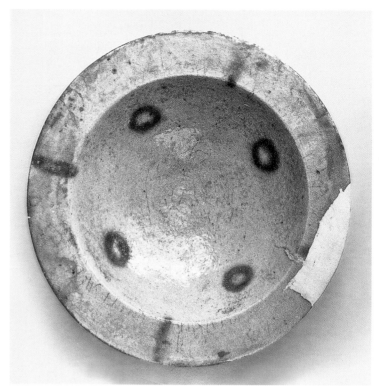

w28

W29. Segmental bowl with flat rim, profile 2 (waster)

Composite body, underglaze-painted
No measurements available.
Condition: A firing mishap caused several fragments from one or more vessels to break off and become embedded in the cavetto.

Aleppo National Museum 415

Interior decoration consists of four evenly spaced turquoise blue radiating stripes on the cavetto. The exterior is undecorated.

MUSEUM REGISTER: From an unknown excavation.

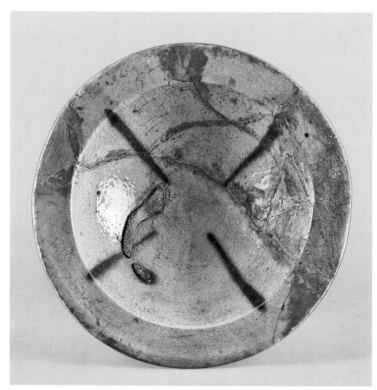

w29

W30. Segmental bowl with flat rim, profile 2 (waster)

Composite body, underglaze-painted
Diameter 9½ in. (24.1 cm)
Condition: A firing mishap caused numerous fragments from one or more vessels to break off and become embedded in the cavetto and interior rim.

Victoria and Albert Museum, London 113-1909

Interior decoration consists of four evenly spaced radiating stripes on the cavetto and four on the rim, all in cobalt blue. The exterior is undecorated.

MUSEUM RECORDS: "I have acquired . . . 15 pieces of pottery from the site of an old pottery at Rakah. . . . I believe Hamdi has dug there and these are stolen." Charles M. Marling, British Embassy, Istanbul, letter of January 7, 1906, to A. B. Skinner, Victoria and Albert Museum. (Only fourteen of these pieces came into and were ultimately given to the museum; one is of the so-called Miletus type.)

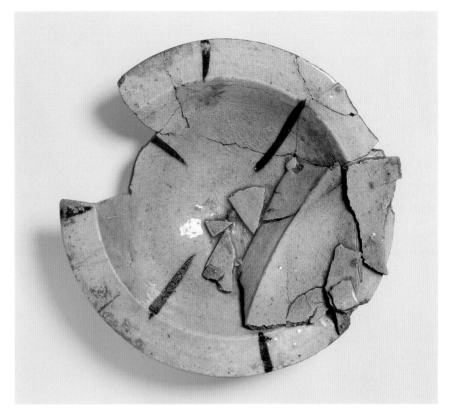

w30

W31. Fragment from broad flat rim and cavetto of segmental bowl (waster)

Composite body, underglaze-painted
No measurements available.
Condition: A firing mishap caused a single fragment from another vessel to break off and become embedded in this fragment.

Musée National de Céramique de Sèvres

Traces of cobalt blue decoration appear on the interior. The exterior is undecorated.

The information provided here is derived from a previously published source.[1] Efforts to ascertain the inventory number and obtain a current photograph of this fragment from the Musée National de Céramique de Sèvres were unsuccessful.

PROVENANCE: al-Rafiqa or its eastern suburb.

1. See Sauvaget 1948, no. 84, fig. 10.

w31

W32. Segmental bowl with flat rim, profile 2 (waster)

Composite body, underglaze-painted
No measurements available.
Condition: A firing mishap caused a rim fragment from another vessel, decorated with a single cobalt blue circle, to break off and become embedded in the rim.

Aleppo National Museum 390

Interior decoration consists of eight radiating arched segments in cobalt blue. The exterior is undecorated.

MUSEUM REGISTER: No information.

W33. Fragment from broad flat rim and cavetto of segmental bowl (waster)

Composite body, underglaze-painted
No measurements available.
Condition: A firing mishap caused a single fragment from a turquoise glazed vessel to break off and become embedded in this fragment.

Raqqa Museum 8955

Interior decoration consists of a pair of cobalt blue stripes extending from the inner edge of the rim into the cavetto. The exterior is undecorated.

Completed bowl exhibiting this profile, with this underglaze-painted program: Karatay Museum, Konya, 21 (fig. 3.2).

PROVENANCE: Excavated at Raqqa.

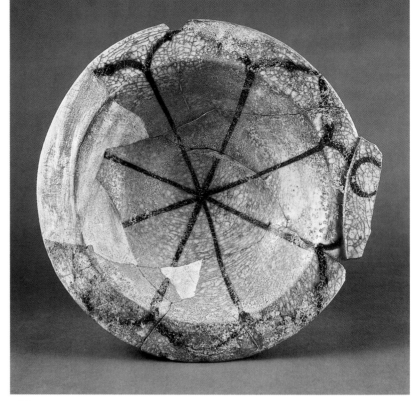

w32

w33

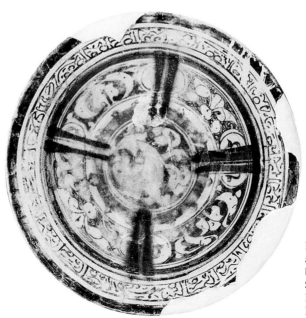

FIGURE 3.2 Underglaze- and luster-painted segmental bowl with flat rim. Raqqa, Syria, 1200–1230. Karatay Museum, Konya (21). Photo: Marilyn Jenkins-Madina

W34. Segmental bowl with flat rim, profile 2 (waster)

Composite body, underglaze-painted
Height 2¾ in. (7 cm), diameter 10 in. (25.4 cm)

Karatay Museum, Konya 20/3

A single cobalt blue ring circumscribes the interior wall. The exterior is undecorated.

Completed bowls exhibiting this profile, with this underglaze-painted program and with differing luster-painted decoration: Freer Gallery of Art, Smithsonian Institution, Washington, D.C., 1908.126, 1911.11 (both unpublished).

MUSEUM REGISTER: "Arab ceramic. Entered 1914, during World War I; from Halep [Aleppo Province]" (written in modern Turkish alphabet).

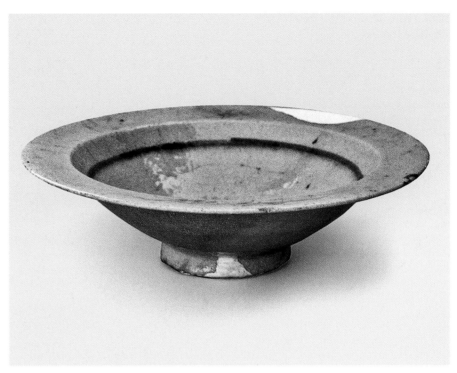

W34

W35. Segmental bowl with flat rim, profile 2 (waster)

Composite body, underglaze-painted
Height 2 in. (5.1 cm), diameter 8⅝ in. (21.9 cm)
Inscribed: ʿizz yadūm (Lasting glory)

Freer Gallery of Art, Smithsonian Institution, Washington, D.C. 1905.240

Interior decoration consists of a cursive inscription in cobalt blue on the base and eight radiating stripes in turquoise blue alternating with cobalt blue on the rim. The exterior is undecorated.

MUSEUM RECORDS: Acquired from D. K. Kelekian, 1905.

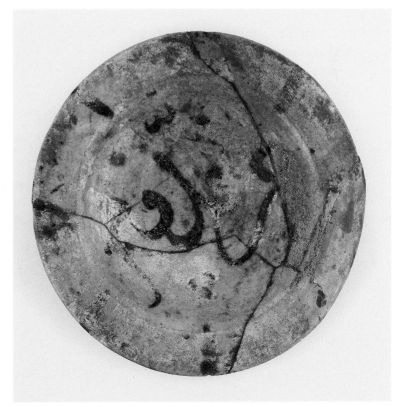

W35

W36. Fragment from wide rim of segmental bowl (waster)

Composite body, underglaze-painted
Length 6½ in. (16.5 cm)
Inscribed: al-dahr . . . (. . . times)
Condition: A firing mishap caused a fragment from a turquoise glazed vessel to break off and become embedded in the exterior of the rim.

Museum of Turkish and Islamic Art, Istanbul
1606/1544

Interior decoration consists of a cursive inscription in cobalt blue. The exterior is undecorated.

ORIGINAL RECORD BOOK (now in Topkapı Palace Museum, Istanbul): "Fragment of vase with illegible Arabic inscription. Alep [Aleppo Province], kaza de Rekka, December 1900" (in French).

w36, interior

w36, exterior

W37. Segmental bowl with flat rim, profile 2 (waster)

Composite body, underglaze-painted
Height 3 in. (7.6 cm), diameter 10½ in. (26.7 cm)
Inscribed: al-ʿizz al-dāʾim waʾl-iqbāl al-zāʾid waʾl-jadd al-ṣāʿid al-musāʿid (Lasting glory, increasing prosperity, and rising, auspicious good fortune)
Condition: A firing mishap caused several fragments from one or more vessels to break off and become embedded in the cavetto and the interior of the rim.

Karatay Museum, Konya 22

Interior decoration consists of a cursive inscription in cobalt blue at the top of the cavetto. The exterior is undecorated.

MUSEUM REGISTER: "Arab ceramic. Entered 1914, during World War I; from Halep [Aleppo Province]" (written in modern Turkish alphabet).

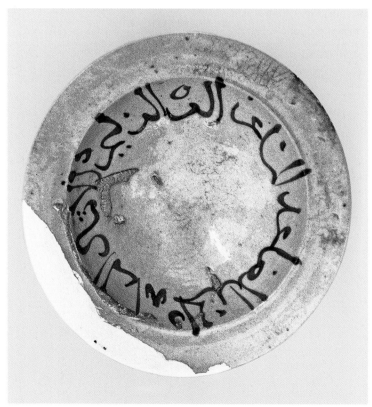

w37

W38. Fragment from rim of bowl of unascertainable shape (waster)

Composite body, underglaze-painted
Height 2¾ in. (7 cm), width 4 in. (10.2 cm)
Inscribed: . . . [a]l-iqbāl . . . (. . . prosperity . . .)
Condition: A firing mishap caused a single frag-
ment from another vessel to break off and become
attached to the underside of this fragment.

Museum für Islamische Kunst, Staatliche Museen
zu Berlin I.411

Interior decoration consists of a cursive inscrip-
tion in cobalt blue at the edge of the rim. There
is no decoration on the visible area of the
underside.

Museum records: No information in central
archives or departmental files.[1]

1. Jens Kröger, e-mail communications, September
 25 and October 2, 2003.

w38, interior

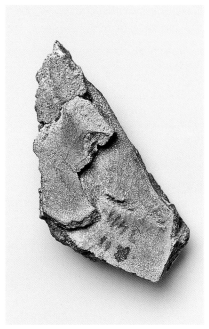

w38, exterior

W39. Wide-based dish with low vertical walls and broad flat rim (waster)

Composite body, underglaze-painted
No measurements available.

Aleppo National Museum 173

Interior decoration consists of six evenly spaced
radiating stripes in cobalt blue alternating with
turquoise blue on the rim. The exterior is
undecorated.

Museum register: Confiscated by police, 1965.

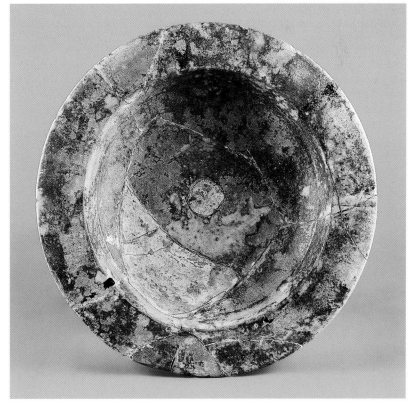

w39

C. Hemispherical bowls

W40. Hemispherical bowl, profile 12 (waster)

Composite body, glazed
Height 1¾ in. (4.6 cm), diameter 4⅝ in. (11.6 cm)
Condition: A firing mishap caused the bowl to slump as well as body material from one or more vessels to break off and become embedded in its lower exterior wall.

British Museum, London 1902 5-19 9

There is no decoration on the interior or exterior.

Completed bowls exhibiting this profile, with no underglaze-painted program, three of which bear the same interior decoration: Aleppo National Museum 491; Metropolitan Museum of Art 09.51 (chapter 4, MMA3); Museum of Turkish and Islamic Art, Istanbul, 1645/1969; Nationalmuseet, Copenhagen, 13,4D78a.

MUSEUM RECORDS: Said to have been found on site of factory (of unspecified nature) in Aleppo; purchased from J. J. Naaman, London.

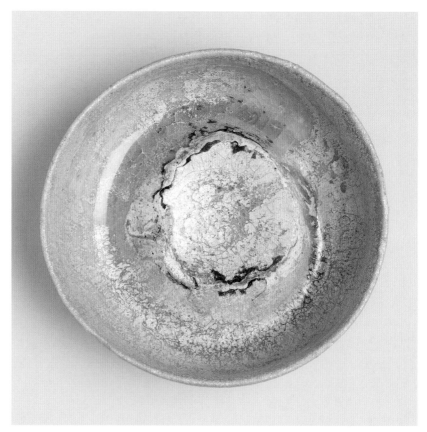

W40

W41. Hemispherical bowl, profile 12 (waster)

Composite body, glazed
Height 3 in. (7.6 cm), diameter 4⅝ in. (11.7 cm)
Condition: A firing mishap caused the bowl to curl and slump as well as fragments from one or more vessels to break off and become embedded in its exterior.

Victoria and Albert Museum, London 106-1909

There is no decoration on the interior or exterior.

Completed bowls exhibiting this profile, with no underglaze-painted program, three of which bear the same interior decoration: Aleppo National Museum 491; Metropolitan Museum of Art 09.51 (chapter 4, MMA3); Museum of Turkish and Islamic Art, Istanbul, 1645/1969; Nationalmuseet, Copenhagen, 13,4D78a.

MUSEUM RECORDS: "I have acquired . . . 15 pieces of pottery from the site of an old pottery at Rakah. . . . I believe Hamdi has dug there and these are stolen." Charles M. Marling, British Embassy, Istanbul, letter of January 7, 1906, to A. B. Skinner, Victoria and Albert Museum. (Only fourteen of these pieces came into and were ultimately given to the museum; one is of the so-called Miletus type.)

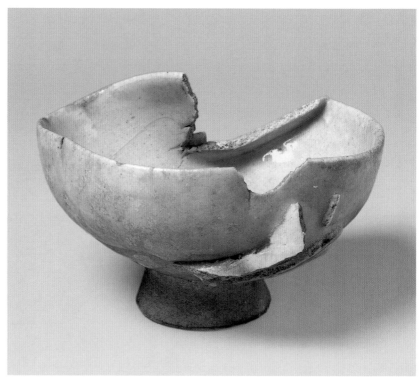

W41

W42. Hemispherical bowl, profile 12 (waster)

Composite body, glazed
Height 2¾ in. (7 cm), diameter 4½ in. (11.4 cm)
Condition: A firing mishap caused the bowl to slump.

Victoria and Albert Museum, London 107-1909

There is no decoration on the interior or exterior.

Completed bowls exhibiting this profile, with no underglaze-painted program, three of which bear the same interior decoration: Aleppo National Museum 491; Metropolitan Museum of Art 09.51 (chapter 4, MMA3); Museum of Turkish and Islamic Art, Istanbul, 1645/1969; Nationalmuseet, Copenhagen, 13,4D78a.

MUSEUM RECORDS: "I have acquired . . . 15 pieces of pottery from the site of an old pottery at Rakah. . . . I believe Hamdi has dug there and these are stolen." Charles M. Marling, British Embassy, Istanbul, letter of January 7, 1906, to A. B. Skinner, Victoria and Albert Museum. (Only fourteen of these pieces came into and were ultimately given to the museum; one is of the so-called Miletus type.)

W42

W43. Hemispherical bowl, profile 12 (waster)

Composite body, glazed
Height 2⅜ in. (6 cm), diameter 4⅞ in. (12.4 cm)
Condition: A firing mishap caused the bowl to slump.

Victoria and Albert Museum, London 108-1909

There is no decoration on the interior or exterior.

Completed bowls exhibiting this profile, with no underglaze-painted program, three of which bear the same interior decoration: Aleppo National Museum 491; Metropolitan Museum of Art 09.51 (chapter 4, MMA3); Museum of Turkish and Islamic Art, Istanbul, 1645/1969; Nationalmuseet, Copenhagen, 13,4D78a.

MUSEUM RECORDS: "I have acquired . . . 15 pieces of pottery from the site of an old pottery at Rakah. . . . I believe Hamdi has dug there and these are stolen." Charles M. Marling, British Embassy, Istanbul, letter of January 7, 1906, to A. B. Skinner, Victoria and Albert Museum. (Only fourteen of these pieces came into and were ultimately given to the museum; one is of the so-called Miletus type.)

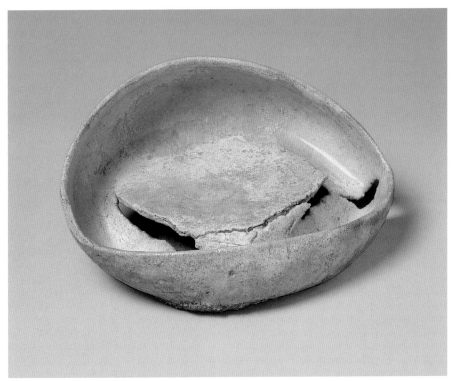

W43

W44. Hemispherical bowl, profile 12 (waster)

Composite body, glazed
Height 1⅜ in. (3.5 cm), length 5⅞ in. (15 cm)
Condition: A firing mishap caused the bowl to slump and curl into an elliptical shape as well as fragments from one or more vessels to break off and become embedded in its lower exterior wall.

Museum of Turkish and Islamic Art, Istanbul
1614/1946

There is no decoration on the interior or exterior.

Completed bowls exhibiting this profile, with no underglaze-painted program, both of which bear the same interior decoration: Aleppo National Museum 491; Museum of Turkish and Islamic Art, Istanbul, 1645/1969.

ORIGINAL RECORD BOOK (now in Topkapı Palace Museum, Istanbul): "Gray-green saucer. L. 0,15. Alep [Aleppo Province], kaza de Rakka et de Maareh, June 1903" (in French).

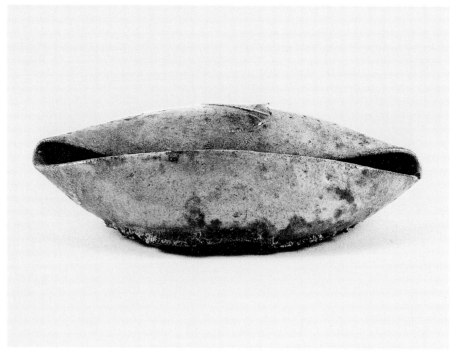

W44

W45. Fragmentary hemispherical bowl, profile 12 (waster)

Composite body, underglaze-painted
Diameter 4⅜ in. (11 cm)
Inscribed: ʿizz yadūm (Lasting glory)

Museum of Turkish and Islamic Art, Istanbul
1604/1529

Interior decoration consists of a cursive inscription in cobalt blue at the center. The exterior is undecorated.

ORIGINAL RECORD BOOK (now in Topkapı Palace Museum, Istanbul): "White glazed bowl fragment with inscription in blue at base 'Feriddoun.' D. 0,11. Alep [Aleppo Province], December 1900" (in French).

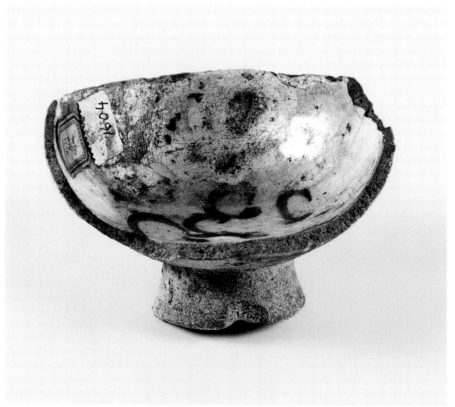

W45

W46. Hemispherical bowl, profile 12 (waster), with incurving rim

Composite body, glazed
Height 2⅜ in. (6.1 cm), diameter 4⅜ in. (11.2 cm)

British Museum, London 1902 5-19 8

There is no decoration on the interior or exterior.

MUSEUM RECORDS: Said to have been found on the site of a factory (of unspecified nature) in Aleppo; purchased from J. J. Naaman, London.

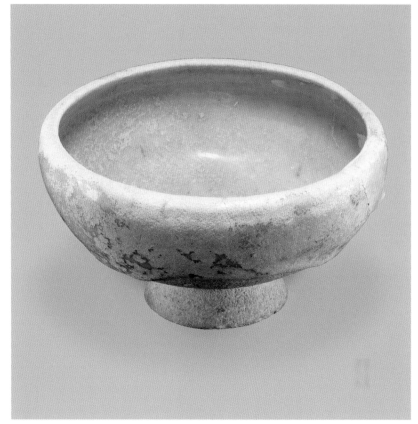

W46

W47. Hemispherical bowl with overhanging rim, profile 16 (waster)

Composite body, glazed
Height 2 in. (5.1 cm), diameter 7¼ in. (18.4 cm)
Condition: A firing mishap caused the bowl to slump.

Ashmolean Museum of Art and Archaeology, Oxford 1980.67

There is no decoration on the interior or exterior.

MUSEUM RECORDS: Said to have been excavated near Maʿarrat al-Nuʿman, Syria.

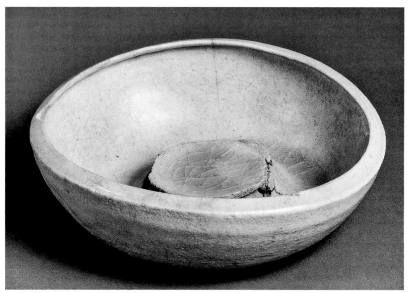

W47

W48. Hemispherical bowl with overhanging rim, profile 16 (waster)

Composite body, glazed
Height 1¾ in. (4.5 cm), diameter 3½ in. (9 cm)
Condition: A firing mishap caused two fragments from one or more vessels to break off and become embedded in the interior.

Museum of Turkish and Islamic Art, Istanbul
1549/4053

The interior bears possible faint traces of cobalt blue decoration. The exterior is undecorated.

ORIGINAL RECORD BOOK (now in Topkapı Palace Museum, Istanbul): "Small bowl; two adhering fragments on the interior. D. 0.09. Rakka, Makridy Bey excavations, 1906" (in French).

W49. Hemispherical bowl with lobed rim, profile 17 (waster)

Composite body, aubergine glaze
Diameter 4¾ in. (12.2 cm)
Condition: A firing mishap caused a triangular fissure in the wall as well as the slumping and warping of the bowl.

Ethnographical Museum, Ankara 1852

There is no decoration on the interior or exterior of this seven-lobed bowl.

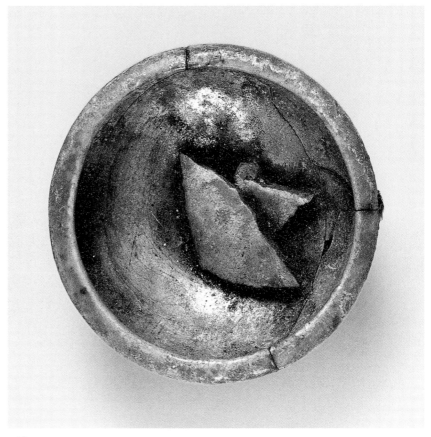

w48

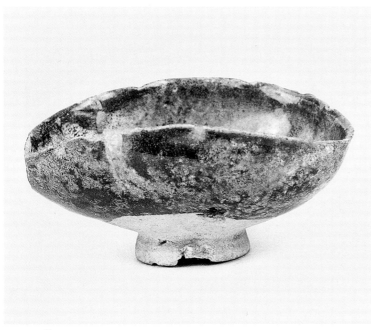

w49, profile

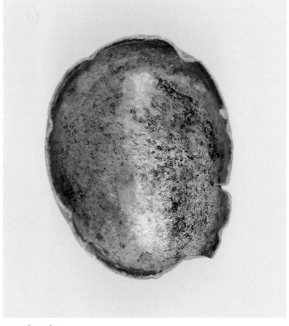

w49, interior

THE REJECTS OF RAQQA

Museum register: "Raka bowl, broken, black colored, broken and missing parts" (written in modern Turkish alphabet). Transferred from Asarı Atika Müzesi, Istanbul, in 1928 upon opening of Ethnographical Museum.

W50. Hemispherical bowl, profile 12 (waster)

Composite body, aubergine glaze
Height 1¾ in. (4.4 cm), diameter 4¾ in. (12 cm)
Condition: A firing mishap caused the bowl to slump as well as fragments from one or more vessels to break off and become embedded in its outer wall.

Museum of Turkish and Islamic Art, Istanbul
2229/1486

There is no decoration on the interior or exterior.

Original record book (now in Topkapı Palace Museum, Istanbul): "Blackish Bowl. D. 0,12. Alep [Aleppo Province], kaza de Rakka et de Maareh" (in French).

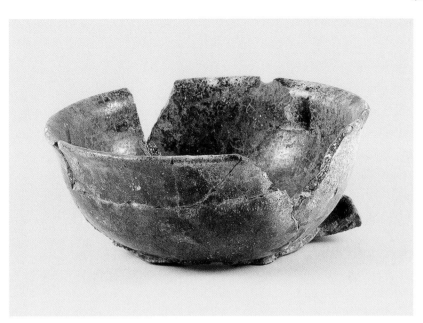

w50

D. Jugs

W51. Medium-neck jug, profile 7 (waster)

Composite body, glazed
Height 5¾ in. (14.6 cm)

Freer Gallery of Art, Smithsonian Institution, Washington, D.C. 1910.31

The jug is undecorated.

Completed handled jugs exhibiting this profile, with no underglaze-painted program and differing luster-painted decoration: National Museum, Damascus, 5939, 430/131; Museum of Turkish and Islamic Art, Istanbul, 1647/1514.

Museum records: Acquired from Vincenzo Marcopoli & Co., Aleppo, 1910.

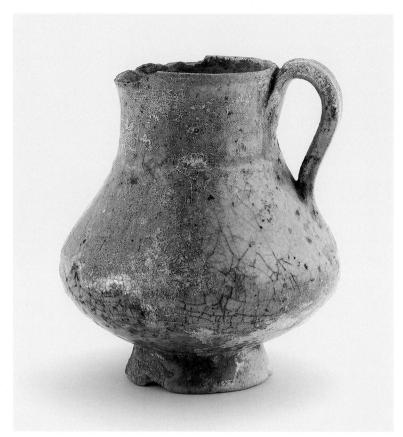

w51

W52. Medium-neck jug, profile 7 (waster)

Composite body, glazed
Height 5⅛ in. (13 cm), diameter at rim 2⅞ in. (7.2 cm)
Condition: A firing mishap caused the body to slump.

Museum of Turkish and Islamic Art, Istanbul 1570/1435

The jug is undecorated.

Completed handled jugs exhibiting this profile, with no underglaze-painted program and differing luster-painted decoration: National Museum, Damascus, 5939, 430/131; Museum of Turkish and Islamic Art, Istanbul, 1647/1514.

Original record book (now in Topkapı Palace Museum, Istanbul): "Vase, the handle missing; café au lait. H. 0,13. Alep [Aleppo Province], kaza de Rekka et de Maareh, December 1900" (in French).

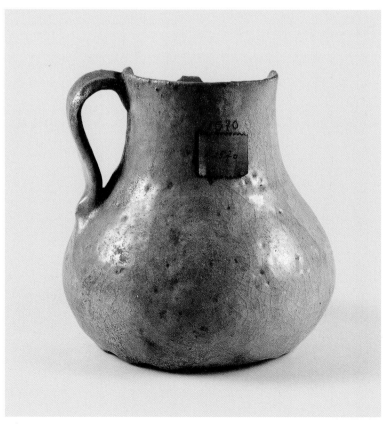

w52

W53. Medium-neck jug, profile 7 (waster)

Composite body, underglaze-painted
Height 5⅛ in. (13 cm), diameter at rim 3 in. (7.7 cm)
Condition: A firing mishap caused the body to slump as well as fragments from one or more vessels to break off and become embedded in its lowest section.

Museum of Turkish and Islamic Art, Istanbul
1573/1433

Decoration consists of evenly spaced vertical stripes in cobalt blue alternating with turquoise blue on the body.

Oʀɪɢɪɴᴀʟ ʀᴇᴄᴏʀᴅ ʙᴏᴏᴋ (now in Topkapı Palace Museum, Istanbul): "Vase, the handle missing; café au lait. H. 0,13. Alep [Aleppo Province], kaza de Rekka et de Maareh, December 1900" (in French).

W54. Medium-neck jug, profile 7 (waster)

Composite body, underglaze-painted
Height 4¾ in. (12 cm), diameter at rim 2⅞ in. (7.4 cm)
Condition: A firing mishap caused the body to slump.

Museum of Turkish and Islamic Art, Istanbul
1578/1424

Decoration consists of four evenly spaced turquoise blue inverted-teardrop shapes on the body.

Oʀɪɢɪɴᴀʟ ʀᴇᴄᴏʀᴅ ʙᴏᴏᴋ (now in Topkapı Palace Museum, Istanbul): "White vase with metallic reflections; one handle. H. 0,12. Alep [Aleppo Province], kaza de Rekka et de Maareh, December 1900" (in French).

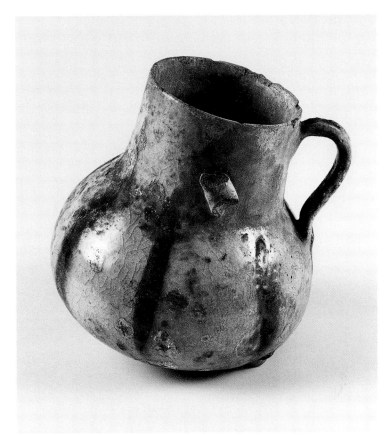

w53

w54, base

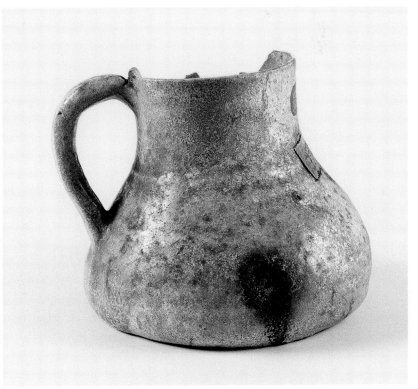

w54, profile

W55. Medium-neck jug, profile 7 (waster)

Composite body, underglaze-painted
Height 5⅛ in. (13 cm), diameter at rim 3⅛ in.
(7.8 cm)
Condition: A firing mishap caused the body to
slump and the glaze to flux improperly.

Museum of Turkish and Islamic Art, Istanbul
1577/1434

Decoration consists of four evenly spaced inverted
trilobed leaves in turquoise blue alternating with
cobalt blue on the body.

ORIGINAL RECORD BOOK (now in Topkapı
Palace Museum, Istanbul): "Vase, the handle
missing; café au lait. H. 0,13. Alep [Aleppo
Province], kaza de Rekka et de Maareh,
December 1900" (in French).

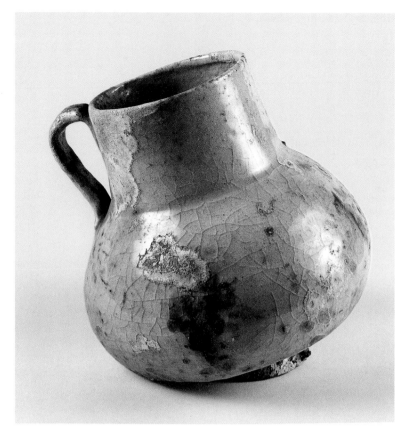

w55

W56. Medium-neck jug, profile 7 (waster)

Composite body, underglaze-painted
Height 5½ in. (14 cm)
Inscribed: al-saʿāda al-shāmila al-sul[āla] . . .
(Total happiness, . . . progeny)
Condition: A firing mishap caused the body to slump.

Los Angeles County Museum of Art M.2002.1.211

Decoration consists of a cursive inscription in
cobalt blue on the neck.

PROVENANCE: New York art market, 1986.

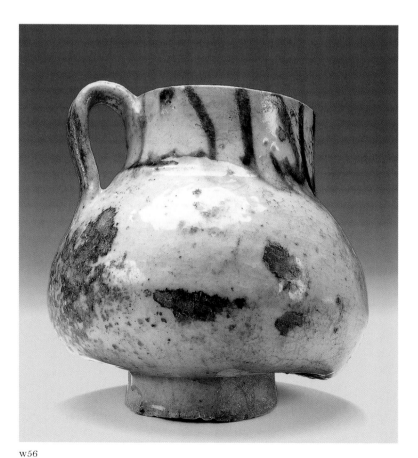

w56

W57. Medium-neck jug, profile 7 (waster)

Composite body, underglaze-painted
Height 5¾ in. (14.5 cm), diameter at rim 3 in.
(7.7 cm)
Condition: A firing mishap caused the body to slump and the paint forming the circles to run toward the foot.

Museum of Turkish and Islamic Art, Istanbul
1555/2483

Decoration consists of four evenly spaced circles in cobalt blue alternating with turquoise blue on the body.

Completed handled jug exhibiting this profile, with this underglaze-painted program: Walters Art Museum, Baltimore, 48.1177 (unpublished).

ORIGINAL RECORD BOOK (now in Topkapı Palace Museum, Istanbul): "Vase with broken handle. H. 0,145. kaza of Ischarah, August 1905" (in French).

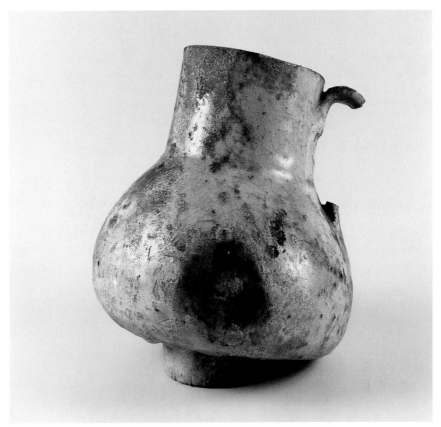

w57

W58. Fragmentary medium-neck jug, profile 7 (waster)

Composite body, underglaze-painted
Height 5¾ in. (14.5 cm), diameter 5¼ in. (13.3 cm)

British Museum, London 1902 5-19 6

Decoration consists of evenly spaced roundels in turquoise blue alternating with cobalt blue on the body.

MUSEUM RECORDS: Said to have been found on the site of a factory (of unspecified nature) in Aleppo; purchased from J. J. Naaman, London.

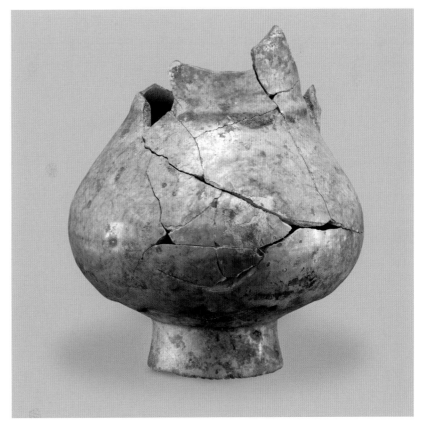

w58

W59. Medium-neck jug, profile 7 (waster)

Composite body, underglaze-painted
No measurements available.

Aleppo National Museum 105

Decoration consists of four evenly spaced cobalt blue roundels on the body.

Completed jug exhibiting this profile, with this underglaze-painted program: National Museum, Damascus, 2033/9655.

MUSEUM REGISTER: Bought from Jamil Baroody (active in Damascus and Hama), 1962.

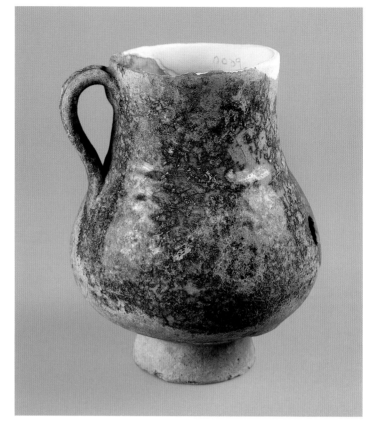

W59

W60. Medium-neck jug, profile 7 (waster)

Composite body, underglaze-painted
Height 5½ in. (14.1 cm), diameter 6¼ in. (16 cm)
Condition: A firing mishap caused the body to slump.

British Museum, London 1902 5-19 3

Decoration consists of four evenly spaced pairs of stripes on the body, a cobalt blue pair alternating with a turquoise blue pair.

MUSEUM RECORDS: Said to have been found on the site of a factory (of unspecified nature) in Aleppo; purchased from J. J. Naaman, London.

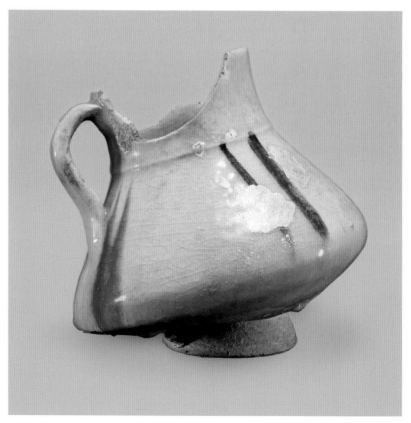

W60

W61. Short-neck jug, profile 18 (waster)

Composite body, underglaze-painted
Height 4⅜ in. (11.1 cm), diameter 5½ in. (14 cm)
Condition: A firing mishap caused the vessel to slump.

Victoria and Albert Museum, London 110-1909

Decoration consists of three evenly spaced cobalt blue roundels on the body.

MUSEUM RECORDS: "I have acquired . . . 15 pieces of pottery from the site of an old pottery at Rakah. . . . I believe Hamdi has dug there and these are stolen." Charles M. Marling, British Embassy, Istanbul, letter of January 7, 1906, to A. B. Skinner, Victoria and Albert Museum. (Only fourteen of these pieces came into and were ultimately given to the museum; one is of the so-called Miletus type.)

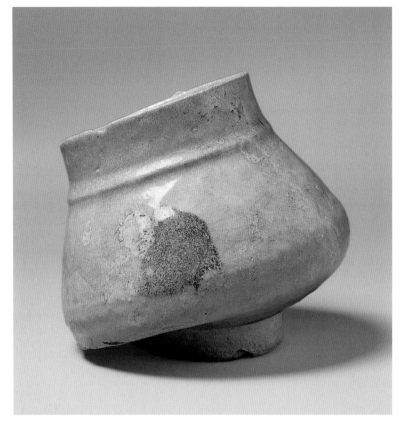

w61

W62. Short-neck jug with sharply angled body faceted on both upper and lower sections (waster)

Composite body, underglaze-painted
Height 5½ in. (14 cm)
Condition: A firing mishap caused the vessel to slump.

Los Angeles County Museum of Art M.2002.1.180

Decoration consists of a cobalt blue stripe outlining each facet.

PROVENANCE: New York art market, 1983.

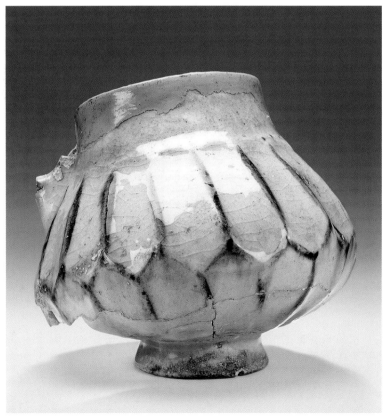

w62

E. Jars

W63. Inverted pear-shaped jar with cylindrical neck and everted rim, profile 1 (waster)

Composite body, underglaze-painted
Height 5 in. (12.7 cm), diameter 4¼ in. (10.8 cm)
Condition: A firing mishap caused a fragment from another vessel to break off and become embedded in the shoulder, the paint to run, and the glaze to flux improperly.

Victoria and Albert Museum, London 109-1909

Decoration consists of a pair of turquoise blue bands on the body.

Completed jars exhibiting this profile, with this underglaze-painted program and with differing luster-painted decoration: Metropolitan Museum of Art 48.113.14, 57.61.3 (chapter 4, MMA19, MMA27); National Museum, Damascus, 10446.

MUSEUM RECORDS: "I have acquired . . . 15 pieces of pottery from the site of an old pottery at Rakah. . . . I believe Hamdi has dug there and these are stolen." Charles M. Marling, British Embassy, Istanbul, letter of January 7, 1906, to A. B. Skinner, Victoria and Albert Museum. (Only fourteen of these pieces came into and were ultimately given to the museum; one is of the so-called Miletus type.)

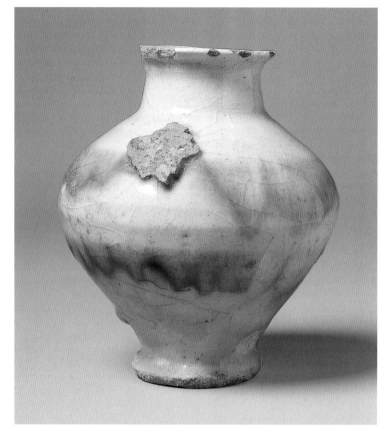

w63

W64. Inverted pear-shaped jar with cylindrical neck and everted rim, profile 1 (waster)

Composite body, underglaze-painted
Height 5⅜ in. (13.5 cm), diameter at rim 2¼ in. (5.7 cm)
Condition: A firing mishap caused a fragment from another vessel to break off and become embedded in the body.

Museum of Turkish and Islamic Art, Istanbul 1554/4044

Decoration consists of cobalt blue vertical stripes on the body.

Completed jars exhibiting this profile, with this underglaze-painted program and with differing luster-painted decoration: Metropolitan Museum of Art 48.113.15 (chapter 4, MMA20); Aleppo National Museum 616; National Museum, Damascus, 6711, 5946; Freer Gallery

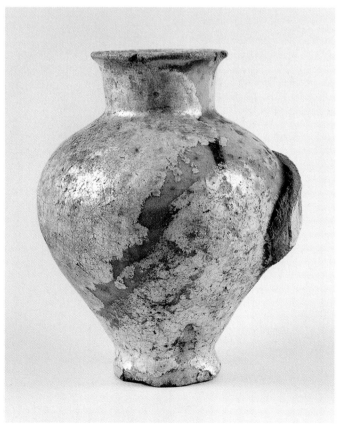

w64

of Art, Smithsonian Institution, Washington, D.C., 1908.137.

ORIGINAL RECORD BOOK (now in Topkapı Palace Museum, Istanbul): "Vase without handle; part of another vase adhering to side; white, iridesced ground; traces of blue decoration. Ht. 0.135. Tell-Halaf, Oppenheim mission, 1912" (in French).

W65. Inverted pear-shaped jar with cylindrical neck and everted rim, profile 1 (waster)

Composite body, underglaze-painted
No measurements available.
Condition: The paint forming some roundels has run toward the base.

National Museum, Damascus 156

Decoration consists of three staggered rows of roundels, the central row in cobalt blue, the others in turquoise blue.

MUSEUM RECORDS: Ministry of Education.

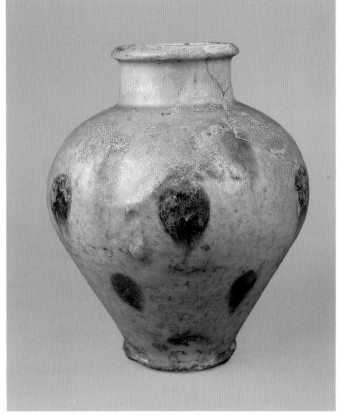

w65

W66. Jar (waster)

Composite body, underglaze-painted
Height 5⅛ in. (13 cm), diameter at rim 2⅜ in. (6 cm)

Karatay Museum, Konya 34/2

Decoration consists of turquoise blue vertical stripes evenly spaced on the body.

MUSEUM REGISTER: "Arab ceramic. Entered 1914, during World War I; from Halep [Aleppo Province]" (written in modern Turkish alphabet).

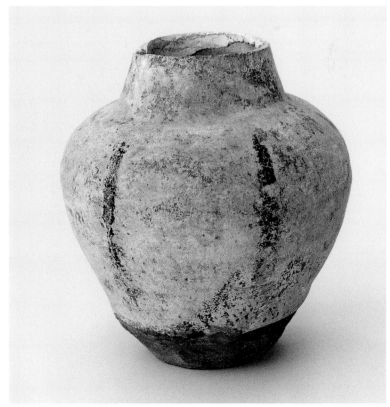

w66

W67. Inverted pear-shaped jar with cylindrical neck and everted rim, profile 1 (waster)

Composite body, underglaze-painted
Height 9⅜ in. (23.8 cm)

Present location unknown

Decoration consists of four evenly spaced blue circles on the body.

Completed jars exhibiting this profile, with this underglaze-painted program and with differing luster-painted decoration: Metropolitan Museum of Art 48.113.13 (chapter 4, MMA18); National Museum, Damascus, 6712 (fig 3.3).

PROVENANCE: Formerly collection of Sir Eldred Hitchcock.

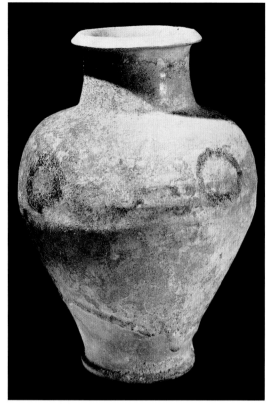

W67

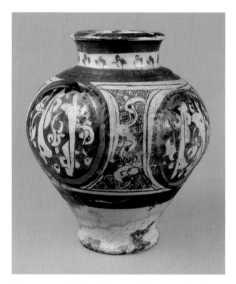

FIGURE 3.3 Underglaze- and luster-painted inverted pear-shaped jar with cylindrical neck and everted rim. National Museum, Damascus (6712)

W68. Jar (waster)

Composite body, underglaze-painted
Height 6⅞ in. (17.4 cm), diameter 6⅜ in. (16.3 cm)

Ashmolean Museum of Art and Archaeology,
Oxford 1978.2216

Decoration consists of blue stripes alternating
around the body with applied and tooled verti-
cal ornament.

MUSEUM RECORDS: Reitlinger gift (Reitlinger
Collection NE.289); bought from Garabed, 1937.

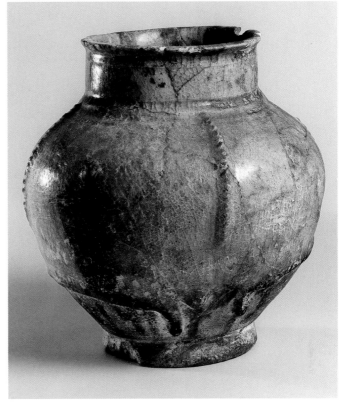

w68

W69. Inverted pear-shaped jar with angular molding at base of neck (waster)

Composite body, underglaze-painted
Height 15⅜ in. (39.7 cm), diameter 12⅜ in.
(31.4 cm)
Inscribed: waʾl-ʿumr al-sālim waʾl-saʿāda
al-shāmila (Model life and total happiness)

Freer Gallery of Art, Smithsonian Institution,
Washington, D.C. 1904.143

Decoration consists of a cursive inscription in
cobalt blue on the body.

MUSEUM RECORDS: Acquired from S. Bing,
1904.

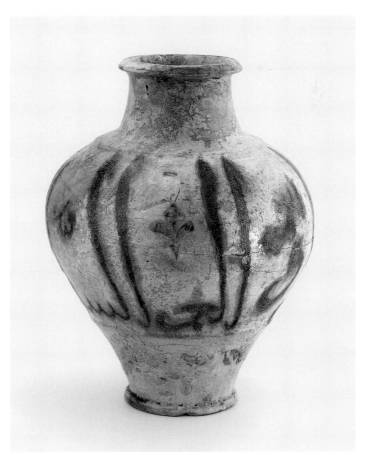

w69

F. Handled pouring vessels

W70. Handled pouring vessel, profile 15, with rounded molding at base of neck (waster)

Composite body, glazed
Height 9½ in. (24 cm), diameter at rim 3⅛ in. (8 cm)
Condition: A firing mishap caused the body to slump and fragments from one or more vessels to break off and become embedded in the lowest section of the body. The foot is missing.

Museum of Turkish and Islamic Art, Istanbul 1569/1431

There is no decoration on the neck or body.

Completed luster-painted handled pouring vessel exhibiting very similar profile: Los Angeles County Museum of Art M.2002.1.168 (fig. 3.4; published in 1910 as "found at Raqqa").[1]

ORIGINAL RECORD BOOK (now in Topkapı Palace Museum, Istanbul): "Deformed vase with one handle; café au lait glaze, the base is missing. H. 0,24. Alep [Aleppo Province], kaza de Rekka et de Maareh, December 1900" (in French).

1. Kelekian 1910, pl. 12.

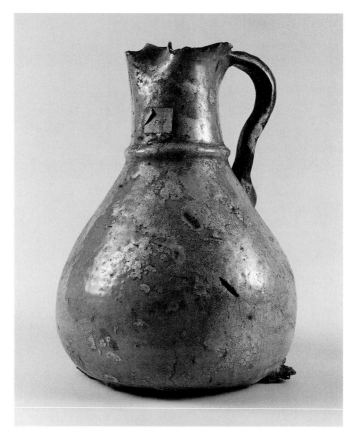

w70

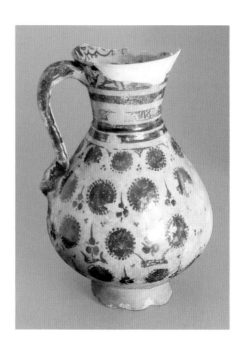

FIGURE 3.4 Luster-painted handled pouring vessel. Raqqa, Syria, 1200–1230. Los Angeles County Museum of Art, Madina Collection of Islamic Art, Gift of Camilla Chandler Frost (M.2002.1.168)

W71. Handled pouring vessel, profile 15, with angled molding at base of neck (waster)

Composite body, underglaze-painted
Height 5⅞ in. (15 cm), diameter at foot 1¾ in. (4.6 cm)
Condition: The handle is missing.

Museum of Turkish and Islamic Art, Istanbul 1558/4058

Decoration consists of evenly spaced roundels in cobalt blue alternating with turquoise blue on the body.

Original record book (now in Topkapı Palace Museum, Istanbul): "Ewer with broken handle and spout; white with green and blue spots. H. 0.15. Tell Halaf, Oppenheim mission, 1912" (in French).

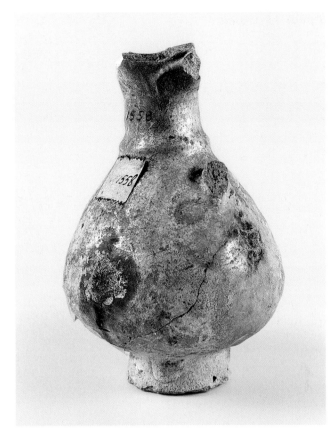

w71

G. Miscellaneous objects, fragments, and tiles

W72. Large fragment from side of vessel (waster)

Composite body, underglaze-painted
Height 5⅝ in. (14.2 cm), width 7¾ in. (19.7 cm)
Inscribed: . . . al-dāʾim waʾl- . . . (Lasting . . . and . . .)

Museum of Turkish and Islamic Art, Istanbul 1605/1545

The exterior is decorated with a cursive inscription in cobalt blue.

Original record book (now in Topkapı Palace Museum, Istanbul): "Fragment of vase with illegible Arabic inscription. Alep [Aleppo Province], kaza de Rekka, December 1900" (in French).

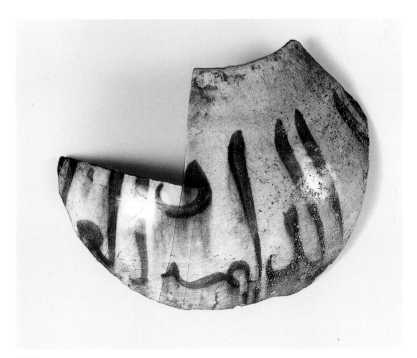

w72

W73. Faceted vase (waster)

Composite body, underglaze-painted
Height 7½ in. (19.2 cm)

Ashmolean Museum of Art and Archaeology,
Oxford 1978.2215

Decoration consists of a cobalt blue stripe alternating with a turquoise blue stripe highlighting each facet.

Completed vase exhibiting very similar profile, with this underglaze-painted program: National Museum, Damascus, 1438.

Museum records: Reitlinger gift (Reitlinger collection NE.288); bought from Garabed, 1937.

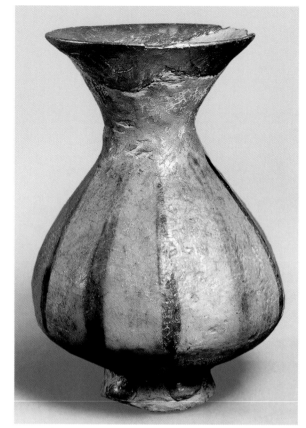

W73

W74. Eight-sided albarello (waster)

Composite body, glazed
Height 5½ in. (14 cm)

Freer Gallery of Art, Smithsonian Institution,
Washington, D.C. 1910.36

The vessel is undecorated.

Museum records: Acquired from Vincenzo Marcopoli & Co., Aleppo, 1910.

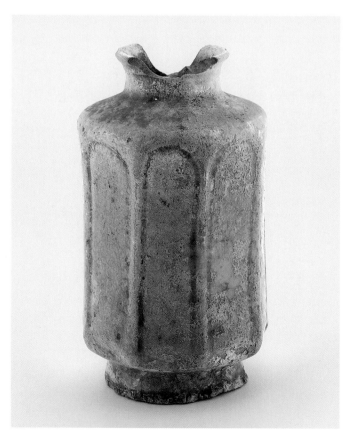

W74

W75. Square tile (waster)[1]

Composite body, incised and underglaze-painted
8⅝ in. (21.9 cm) square
Condition: A firing mishap caused several frag-
ments from one or more objects to break off and
become embedded in the obverse, as well as the
glaze to flux improperly.

Los Angeles County Museum of Art M.2002.1.41

Decoration consists of an incised eight-pointed
star painted in cobalt blue.

PROVENANCE: Aleppo art market, 1979.

1. See Sauvaget 1948, no. 85, fig. 10, for a fragment
 of an identical tile collected in al-Rafiqa or its
 eastern suburb.

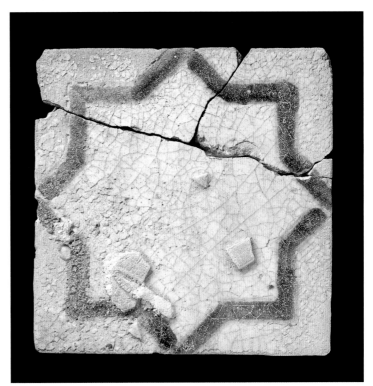

w75

W76. Fragment of polygonal tile (waster)

Composite body, incised and underglaze-painted
Height 5⅛ in. (13 cm), width 6⅞ in. (17.5 cm)
Condition: A firing mishap caused the glaze to flux
improperly.

Museum of Turkish and Islamic Art, Istanbul
2139/2942

Decoration consists of an incised geometric
interlace design, areas of which are painted in
turquoise blue and cobalt blue.

ORIGINAL RECORD BOOK (now in Topkapı
Palace Museum, Istanbul): "Fragment of
tabouret (?). Rakka, Excavations Haidar Bey,
1908" (in French).

w76

A. Biconical bowls

W77. Biconical bowl, profile 3 (waster)

Composite body, underglaze-painted
Height 3¾ in. (9.5 cm), diameter 7⅝ in. (19.4 cm)
Condition: A firing mishap caused multiple fragments from one or more vessels to break off and become embedded in the interior.

Karatay Museum, Konya 25/5

Interior decoration consists of a dotted double circle (pattern 11) circumscribing a bisected roundel (pattern 21) and contoured fillers in roundel (pattern 12), all circumscribed by a band on the cavetto. This band, bordered above and below by three concentric circles, bears four cartouches with a motif of pseudo-cursive inscription on sketchy vegetal ground (pattern 14) alternating with a highly stylized palmette leaf. The rim has a wide black band extending onto the exterior. The exterior has a doubled circular band (line back, pattern 3).

MUSEUM REGISTER: "Arab ceramic. Entered 1914, during World War I; from Halep [Aleppo Province]" (written in modern Turkish alphabet).

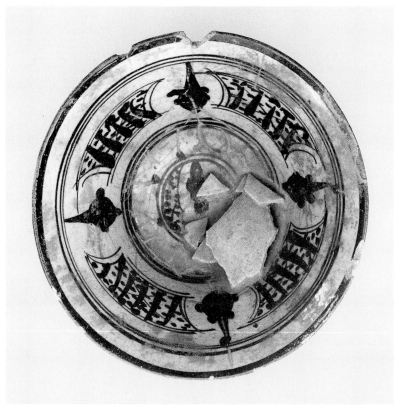

w77

W78. Biconical bowl, profile 3 (waster)

Composite body, underglaze-painted
Height 3⅞ in. (9.8 cm), diameter 8 in. (20.3 cm)
Condition: A firing mishap caused a triangular fissure in the wall, resulting in distortion of the rim.

Karatay Museum, Konya 25/6

Interior decoration consists of a dotted double circle (pattern 11) circumscribing a bisected roundel (pattern 21) and contoured fillers in roundel (pattern 12). The walls bear a cross-hatched design. The exterior has only a single circular band (line back, pattern 3).

MUSEUM REGISTER: "Arab ceramic. Entered 1914, during World War I; from Halep [Aleppo Province]" (written in modern Turkish alphabet).

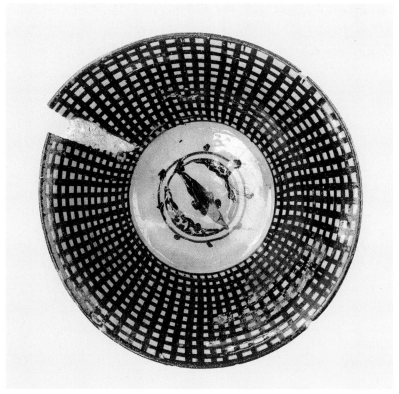

w78

W79. Biconical bowl, profile 3 (waster)

Composite body, underglaze-painted
Height 3¾ in. (9.5 cm), diameter 7⅝ in. (19.4 cm)
Condition: A firing mishap caused a triangular fissure in the wall, resulting in a slight distortion of the rim.

Karatay Museum, Konya 25/1

Interior decoration consists of a dotted double circle (pattern 11) circumscribing a bisected roundel (pattern 21) and contoured fillers in roundel (pattern 12). Radiating from the central roundel are seven dagger shapes (pattern 15). The wall bears graduated swirling diagonal strokes bordered by narrow black bands, one plain above and two plain and one scalloped below. The exterior has only a single circular band (line back, pattern 3).

MUSEUM REGISTER: "Arab ceramic. Entered 1914, during World War I; from Halep [Aleppo Province]" (written in modern Turkish alphabet).

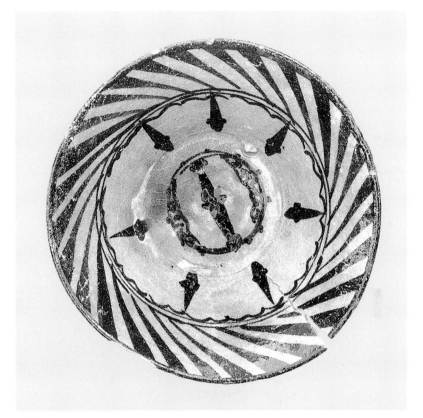

w79

W80. Biconical bowl, profile 3 (waster)

Composite body, underglaze-painted
Height 3⅞ in. (9.8 cm), diameter 7¾ in. (19.7 cm)
Condition: A firing mishap caused the glaze to flux improperly.

Karatay Museum, Konya 25/2

Interior decoration consists of a roundel containing a variant of the hillock with three leaves (pattern 5) and contoured fillers in interstices, circumscribed by two concentric circles. Radiating from the roundel are twelve dagger shapes (pattern 15), circumscribed by a wide band bordered above and below by two narrow bands, the outermost and innermost beaded. The rim bears a band with pendant triangles. The exterior has only a single circular band (line back, pattern 3).

MUSEUM REGISTER: "Arab ceramic. Entered 1914, during World War I; from Halep [Aleppo Province]" (written in modern Turkish alphabet).

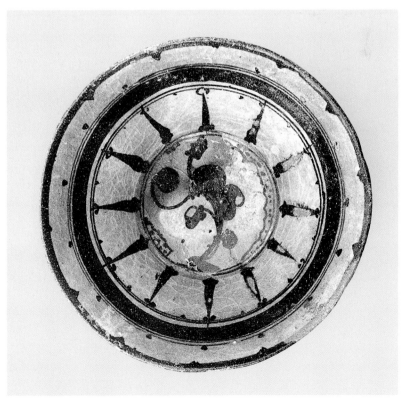

w80

W81. Fragmentary biconical bowl, profile 3 (waster)

Composite body, underglaze-painted
Height 2½ in. (6.4 cm), diameter 5⅛ in. (13 cm)
Condition: A firing mishap caused a large frag-
ment from another vessel to break off and become
embedded in the interior.

Museum of Turkish and Islamic Art, Istanbul
2175/1493

Interior decoration consists of a roundel with an indecipherable design circumscribed by three concentric circles. The wall bears graduated swirling diagonal strokes. The exterior has only a single circular band (line back, pattern 3).

ORIGINAL RECORD BOOK (now in Topkapı Palace Museum, Istanbul): "Deformed and broken bowl, black and blue. D. 0,13. Alep [Aleppo Province], kaza de Rakka et de Maareh, December 1900" (in French).

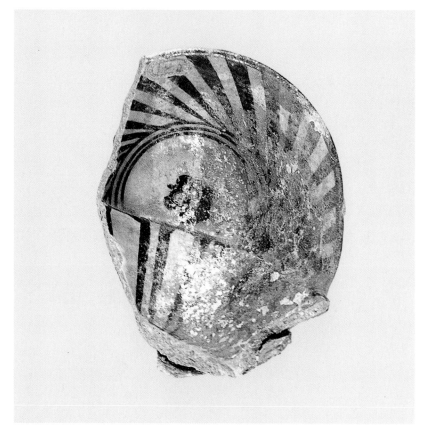

w81

W82. Fragmentary biconical bowl, profile 3 (waster)

Composite body, underglaze-painted
Height 3½ in. (9 cm), diameter 6¾ in. (17 cm)
Condition: A firing mishap caused multiple frag-
ments from one or more vessels to break off and
become embedded in the interior.

Museum of Turkish and Islamic Art, Istanbul
1971/4957

Interior decoration consists of a series of contiguous bisected arches (pattern 23). The exterior has only a single circular band (line back, pattern 3).

ORIGINAL RECORD BOOK (now in Topkapı Palace Museum, Istanbul): No information. Present-day museum records: "Halep [Aleppo Province]."

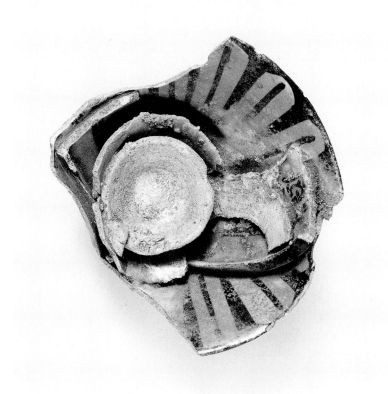

w82

W83. Biconical bowl, profile 3 (waster)

Composite body, underglaze-painted
Height 4¾ in. (12.1 cm), diameter 9⅝ in. (24.4 cm)
Condition: A firing mishap caused the bowl to warp as well as multiple fragments from vessels of several different color schemes to break off and become embedded in its interior.

Karatay Museum, Konya 25/7

Interior decoration consists of a dotted double circle (pattern 11) circumscribing contoured fillers in a roundel (pattern 12). This central design is circumscribed by three narrow bands, two with zigzags flanking one with a triple guilloche (pattern 24). The exterior has a doubled circular band (line back, pattern 3).

Museum register: "Arab ceramic. Entered 1914, during World War I; from Halep [Aleppo Province]" (written in modern Turkish alphabet).

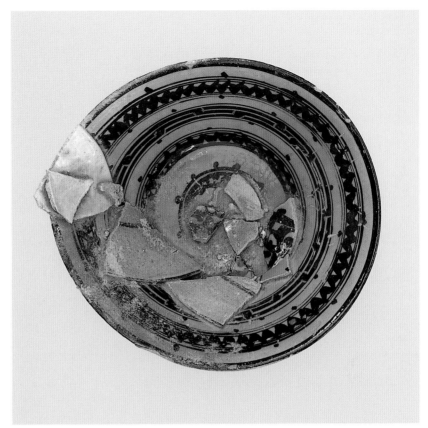

w83

W84. Fragmentary biconical bowl, profile 3 (waster)

Composite body, underglaze-painted
Height 4 in. (10 cm), diameter 6¾ in. (17 cm)
Condition: A firing mishap caused the glaze at the center to lift away from the body.

Museum of Turkish and Islamic Art, Istanbul 1704/1521

The only ascertainable interior decoration, on the cavetto, consists of a quadripartite interlace design circumscribing a central roundel and outlined by a wide black band, with details incised through the paint. A horseshoe-like design fills each of the four circles of interlace, and contoured filler motifs fill the interstices. The exterior has only a single circular band (line back, pattern 3).

Original record book (now in Topkapı Palace Museum, Istanbul): "Fragment of bowl, blue and black. D. 0,17. Alep [Aleppo Province], December 1900" (in French).

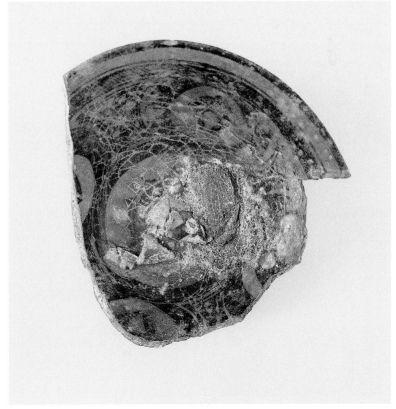

w84

W85. Fragmentary biconical bowl, profile 3 (waster)

Composite body, underglaze-painted
Height 3¼ in. (8.3 cm), diameter 7½ in. (19 cm)
Condition: A firing mishap caused the bowl to slump as well as fragments from several vessels to break off and become embedded in its interior and exterior.

Museum of Turkish and Islamic Art, Istanbul
1708/1553

Interior decoration consists of a grid circumscribed in a scalloped and rayed roundel, with dots marking each juncture of the grid. The wall bears a wide band with diagonally arranged ogives and reserved vegetal interstitial designs. On the exterior, a band of diagonal stripes fills the upper third of the wall.

ORIGINAL RECORD BOOK (now in Topkapı Palace Museum, Istanbul): "Fragment of bowl, broken and deformed. Blue and black. Alep [Aleppo Province], kaza de Rakka, December 1900" (in French).

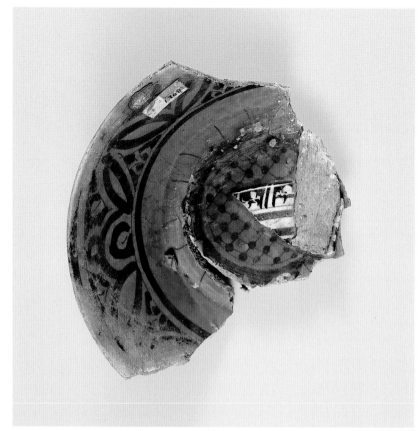

w85

W86. Bowl with flaring walls and high flaring foot of unascertainable shape (waster)

Composite body, underglaze-painted
Height 4⅜ in. (11 cm), diameter 10 in. (25.4 cm)
Condition: A firing mishap caused the bowl to slump and warp.

Ethnographical Museum, Ankara 1846

Interior decoration consists of five concentric rings on the wall and rim; the central design is impossible to decipher. The exterior has a wide band with evenly spaced diagonal lines bordered at the bottom by two bands.

MUSEUM REGISTER: "Raka bowl, shapeless, green" (written in modern Turkish alphabet). Transferred from Asarı Atika Müzesi, Istanbul, in 1928 upon the opening of the Ethnographical Museum.

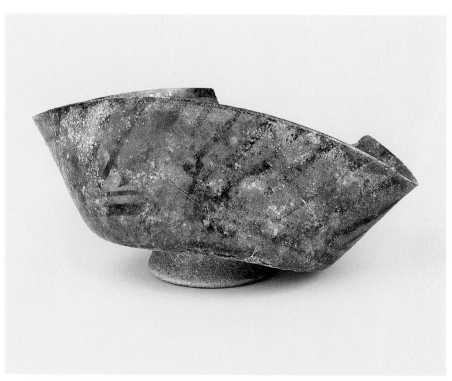

w87

W87. Fragmentary biconical bowl, profile 3 (waster)

Composite body, underglaze-painted
Height 4½ in. (11.4 cm), diameter 9⅛ in. (23.2 cm)
Condition: A firing mishap caused a small fissure in the wall and warping of the bowl.

Victoria and Albert Museum, London 119-1909

The interior decoration is difficult to decipher because of heavy iridescence. The exterior has only a single circular band (line back, pattern 3).

MUSEUM RECORDS: "I have acquired . . . 15 pieces of pottery from the site of an old pottery at Rakah. . . . I believe Hamdi has dug there and these are stolen." Charles M. Marling, British Embassy, Istanbul, letter of January 7, 1906, to A. B. Skinner, Victoria and Albert Museum. (Only fourteen of these pieces came into and were ultimately given to the museum; one is of the so-called Miletus type.)

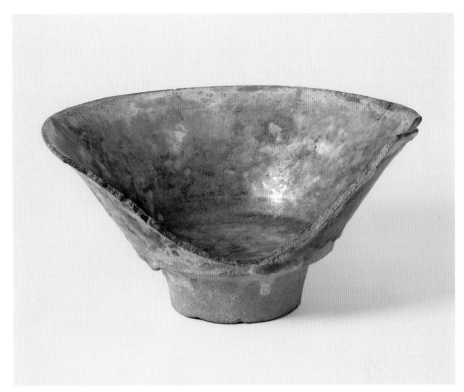

w86, profile

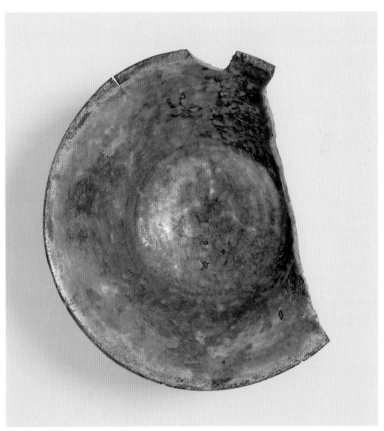

w86, interior

B. Segmental bowls with flat rim

W88. Segmental bowl with flat rim, profile 2 (waster)

Composite body, underglaze-painted
Height 3 in. (7.6 cm), diameter 10⅝ in. (27 cm)
Condition: A firing mishap caused a single fragment from the rim of another vessel to break off and become embedded in the interior.

Karatay Museum, Konya 26/3

Interior decoration consists of a dotted double circle (pattern 11) bearing the motif of a hillock with three leaves (pattern 5) bordered at the left by a contoured filler and at the right by a contoured filler with a leaf in concentric circles (pattern 8); the central design is also filled with dots and dashes. The rim is divided into three sections, the innermost section with evenly spaced lozenge shapes (lozenge rim, pattern 9), the middle section plain, and the outer section with a broad plain band. The exterior has only a single circular band (line back, pattern 3).

Museum register: "Arab ceramic. Entered 1914, during World War I; from Halep [Aleppo Province]" (written in modern Turkish alphabet).

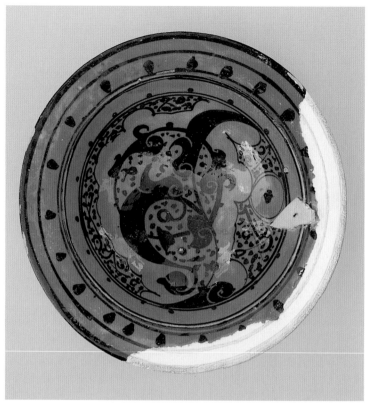

w88

W89. Segmental bowl with flat rim, profile 2 (waster)

Composite body, underglaze-painted
Diameter 10⅝ in. (27 cm)
Condition: A firing mishap caused a single fragment from another vessel to break off and become embedded in the rim as well as the rim to become slightly distorted.

Los Angeles County Museum of Art M.2002.1.75

The entire concave area of the interior bears an arabesque design on a dotted ground, with details incised through the paint. The rim is divided into three sections, the innermost section with evenly spaced lozenge shapes (lozenge rim, pattern 9), the middle section plain, and the outer section with a broad plain band. The exterior has only a single circular band (line back, pattern 3).

Provenance: Can be traced through its penultimate private owner to Charles D. Kelekian Gallery, New York.

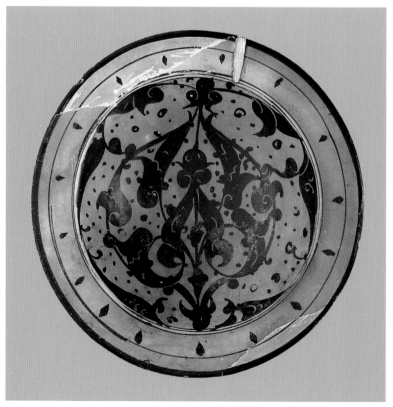

w89

W90. Segmental bowl with flat rim, profile 2 (waster)

Composite body, underglaze-painted
Height 3⅞ in. (9.8 cm), diameter 14 in. (35.6 cm)
Inscribed: al-ʿizz al-dāʾim waʾl-iqbāl al-zāʾid waʾl-jadd al-ṣāʿid al-saʿāda al-shāmila (Lasting glory, increasing prosperity, mounting good fortune, total happiness)
Condition: A firing mishap caused multiple fragments from one or more vessels to break off and become embedded in the interior. One of these is underglaze-painted in black and cobalt blue on a white ground under a clear colorless glaze.

Walters Art Museum, Baltimore 48.1117

Interior decoration consists of a central roundel with a stylized vegetal design surrounded by contoured filler motifs. The cavetto has a band with a cursive Arabic inscription on a ground of dots, dashes, commas, and large Xs. The rim, bearing evenly spaced trefoils (pattern 7), is circumscribed by a plain band. The exterior has only a single circular undulating band (line back, pattern 3).

MUSEUM RECORDS: Acquired by Henry Walters, before 1931.

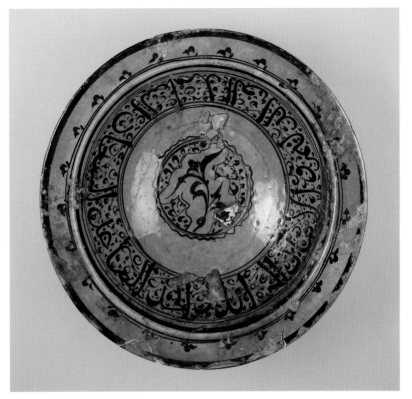

w90

W91. Segmental bowl with flat rim, profile 2 (waster)

Composite body, underglaze-painted
No measurements available.
Condition: A firing mishap caused an area of the rim to curl.

Aleppo National Museum 379

Interior decoration consists of a single long-stemmed large feathery leaf circumscribed by a teardrop with a dotted ground. This central design is flanked by contoured filler motifs circumscribed by paired lines that define the inner edge of the rim. The rim is divided into three sections, the innermost section with evenly spaced lozenge shapes (lozenge rim, pattern 9), the middle section plain, and the outer section with a broad plain band. The exterior has only a single circular band (line back, pattern 3).

MUSEUM REGISTER: Accessioned, 1980.

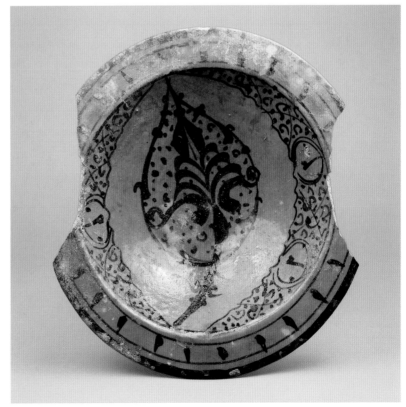

w91

85

W92. Segmental bowl with flat rim, profile 2 (waster)

Composite body, underglaze-painted
No measurements available.
Condition: A firing mishap caused a triangular fissure in the wall, resulting in a slight distortion of the rim.

Aleppo National Museum 385

Interior decoration consists of a quadripartite radiating design, each section containing a highly stylized palmette framed by a dotted circle and flanked right and left by a single long pointed leaf, all growing from a long dotted stem emanating from the center. The rim is divided into three sections, the innermost section with evenly spaced lozenge shapes (lozenge rim, pattern 9), the middle section plain, and the outer section with a broad plain band. Iridescence has made the exterior decoration indecipherable.

MUSEUM REGISTER: Accessioned, 1980.

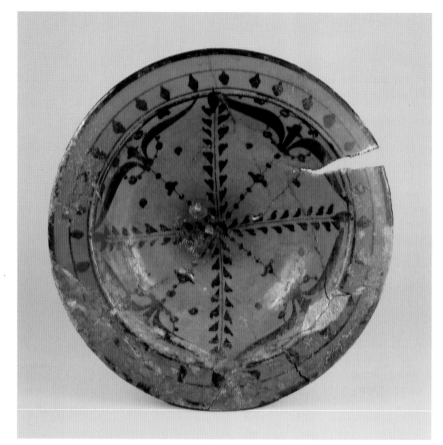

w92

W93. Segmental bowl with flat rim, profile 2 (waster)

Composite body, underglaze-painted
Height 3¼ in. (8.3 cm), diameter 10½ in. (26.7 cm)
Inscribed: al-ʿāfiya (Good health)
Condition: A firing mishap caused multiple fragments from other vessels to break off and become embedded in the interior. One of these has an underglaze-painted cobalt blue line at the rim, another a touch of turquoise blue.

Karatay Museum, Konya 26/5

Interior decoration consists of a large roundel with a cursive inscription on a ground of dots, dashes, and vegetal scrolls. The rim is divided into three sections, the innermost section with evenly spaced rounded lozenge shapes (lozenge rim, pattern 9), the middle section plain, and the outer section with a broad plain band. The exterior has only a single circular band (line back, pattern 3).

MUSEUM REGISTER: "Arab ceramic. Entered 1914, during World War I; from Halep [Aleppo Province]" (written in modern Turkish alphabet).

w93

C. Hemispherical bowls

W94. Fragmentary hemispherical bowl, profile 12 (waster)

Composite body, underglaze-painted
Height 2½ in. (6.4 cm), width 4¼ in. (10.8 cm)
Condition: A firing mishap caused the bowl to curl inward.

Museum of Turkish and Islamic Art, Istanbul
1698/1959

Interior decoration consists of a grid circumscribed in a roundel, with dots anchored by four lines in certain sections. The rim bears a reserved Kufesque band. The exterior has a row of diagonal slashes (dash back).[1]

ORIGINAL RECORD BOOK (now in Topkapı Palace Museum, Istanbul): "Fragment of a saucer, green with black design. Alep [Aleppo Province], kaza de Rakka et de Maareh, June, 1903" (in French).

1. See Mason 1997, fig. 3, SM.12, 13.

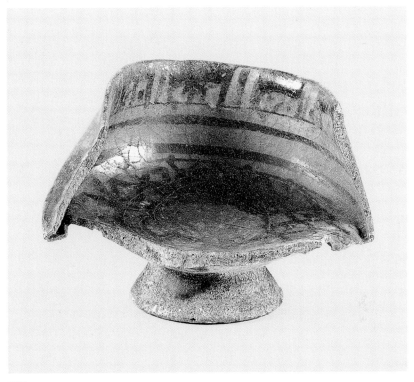

W94

W95. Hemispherical bowl, profile 12 (waster)

Composite body, underglaze-painted
Height 2¼ in. (5.8 cm), diameter 4 in. (10 cm)
Condition: A firing mishap caused the bowl to slump slightly.

Ethnographical Museum, Ankara 5171

Interior decoration consists of a central roundel circumscribed by a ring of dots, with a pseudo-calligraphic design on a dotted ground. The upper wall and rim bear concentric rings. The exterior has only a single circular band (line back, pattern 3).

MUSEUM REGISTER: "Raka bowl, inside green, broken" (written in modern Turkish alphabet). Transferred from Asarı Atika Müzesi, Istanbul, in 1928 upon the opening of the Ethnographical Museum.

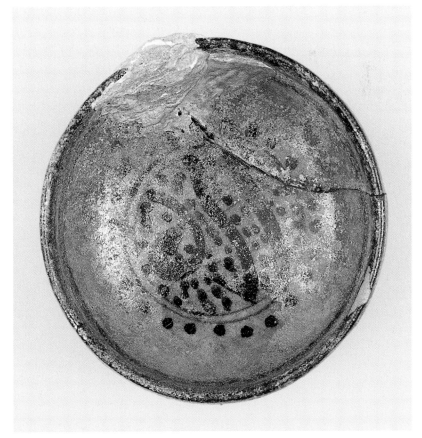

W95

W96. Hemispherical bowl with slightly everted rim, profile 14 (waster)

Composite body, underglaze-painted
Height 2¾ in. (7 cm), diameter 4½ in. (11.4 cm)
Condition: A firing mishap caused the bowl to slump.

Victoria and Albert Museum, London 103-1909

Interior decoration consists of a central large feathery leaf circumscribed within an oval from which other vegetal designs emanate. The upper wall and rim bear four concentric rings. The exterior has a row of diagonal slashes (dash back).

MUSEUM RECORDS: "I have acquired . . . 15 pieces of pottery from the site of an old pottery at Rakah. . . . I believe Hamdi has dug there and these are stolen." Charles M. Marling, British Embassy, Istanbul, letter of January 7, 1906, to A. B. Skinner, Victoria and Albert Museum. (Only fourteen of these pieces came into and were ultimately given to the museum; one is of the so-called Miletus type.)

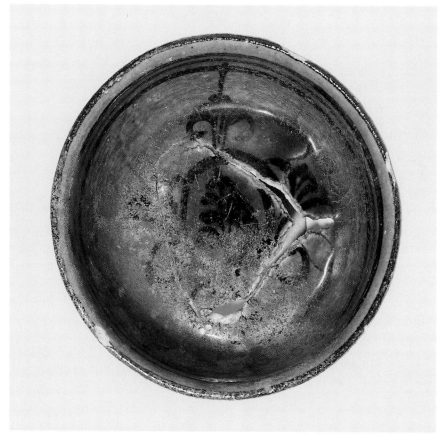

w96

W97. Fragmentary hemispherical bowl with slightly everted rim, profile 14 (waster)

Composite body, underglaze-painted
Height 2⅜ in. (6 cm), diameter 4¾ in. (12.2 cm)
Condition: A firing mishap caused the bowl to slump as well as a fragment from another vessel to break off and become embedded in its outside wall.

Ethnographical Museum, Ankara 1844

Interior decoration consists of a series of five evenly spaced concentric rings on the wall and rim; the central design is indecipherable. The exterior bears a series of oblique lines.

MUSEUM REGISTER: "Raka bowl, broken" (written in modern Turkish alphabet). Transferred from the Asarı Atika Müzesi, Istanbul, in 1928 upon the opening of the Ethnographical Museum.

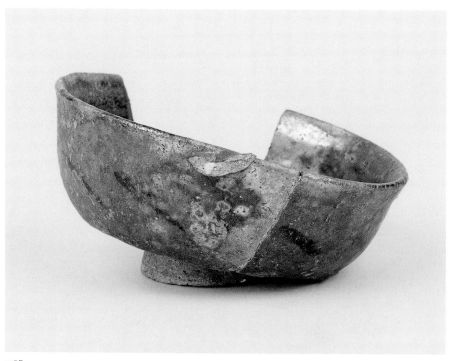

w97

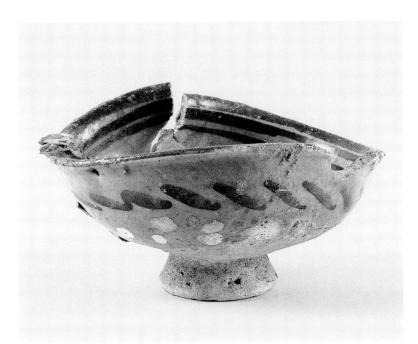

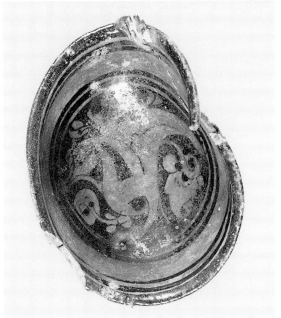

W98. Hemispherical bowl, profile 12 (waster)

Composite body, underglaze-painted
Height 3⅜ in. (8.5 cm), diameter 5⅛ in. (13 cm)
Condition: A firing mishap caused a triangular fissure in the wall, resulting in slumping and curling of the bowl. Fragments from other vessels are embedded in the interior and exterior.

Museum of Turkish and Islamic Art, Istanbul
1699/1471

Interior decoration consists of reserved whole and split palmettes in a roundel circumscribed by two pairs of concentric circles. The exterior bears a row of diagonal slashes (dash back).

ORIGINAL RECORD BOOK (now in Topkapı Palace Museum, Istanbul): "Blue and black bowl, deformed. D. 13. Alep [Aleppo Province], kaza de Rakka et de Maareh, December 1900" (in French).

W99. Fragmentary hemispherical bowl with slightly everted rim, profile 14 (waster)

Composite body, underglaze-painted
Height 2 in. (5 cm), diameter 5½ in. (14 cm)
Condition: A firing mishap caused the bowl to slump and body material from one or more vessels to adhere to its exterior.

Museum of Turkish and Islamic Art, Istanbul
2178/1428

Heavy iridescence obscures all interior decoration except for a reserved Kufesque band at the rim. The exterior has only a single band composed of overlapping Ss (S back).[1]

ORIGINAL RECORD BOOK (now in Topkapı Palace Museum, Istanbul): "Deformed bowl with inscription on the bottom; green on blue ground. Alep [Aleppo Province], kaza de Rakka et de Maareh. December 1900. D. 0,14" (in French).

1. See Mason 1997, fig. 3, SM.10.

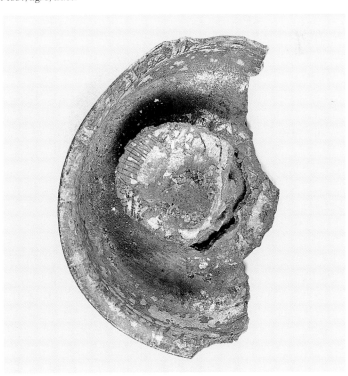

w99

W100. Fragmentary hemispherical bowl, profile 12 (waster)

Composite body, underglaze-painted
Diameter 4¾ in. (12 cm)
Condition: A firing mishap caused the bowl to curl inward as well as a fragment from another vessel to break off and become embedded in its outer wall.

Museum of Turkish and Islamic Art, Istanbul
2215/1473

Interior decoration consists of a central roundel and a band at the rim. Iridescence has made the designs indecipherable.

ORIGINAL RECORD BOOK (now in Topkapı Palace Museum, Istanbul): "Bowl, blue and black, D. 0,12. Alep [Aleppo Province], kaza de Rakka et de Maareh, December 1900" (in French).

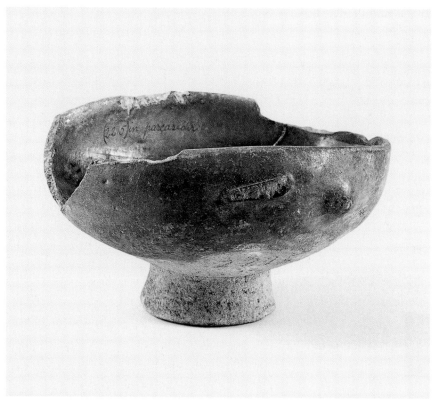

w100

W101. Hemispherical bowl with slightly everted rim, profile 14 (waster)

Composite body, underglaze-painted
Height 3⅞ in. (9.8 cm), diameter 7⅛ in. (18.1 cm)
Condition: A firing mishap caused the bowl to warp.

Freer Gallery of Art, Smithsonian Institution, Washington, D.C. 1910.30

Interior decoration consists of a peacock, with details incised through the paint, and sketchy vegetal designs, all circumscribed by a roundel with an outer border of evenly spaced trefoils (pattern 7). The exterior has only a single circular undulating band (line back, pattern 3).

MUSEUM RECORDS: Acquired from Vincenzo Marcopoli & Co., Aleppo, 1910.

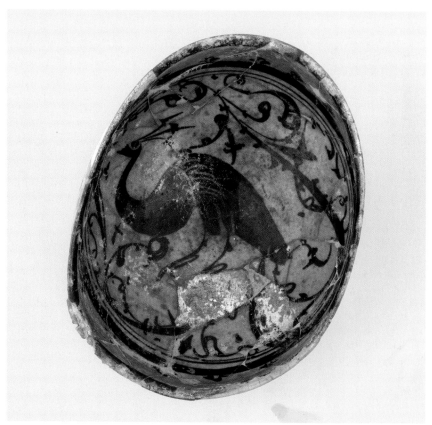

w101

W102. Hemispherical bowl with slightly everted rim, profile 14 (waster)

Composite body, underglaze-painted
Height 4⅛ in. (10.5 cm), diameter 6⅜ in. (16.2 cm)
Condition: A firing mishap caused the bowl to slump.

Freer Gallery of Art, Smithsonian Institution, Washington, D.C. 1905.258

Interior decoration consists of a roundel circumscribing (?) a vegetal design set in a triple arch with filler motifs in spandrels. The exterior has only a single circular band (line back, pattern 3).

MUSEUM RECORDS: Acquired from Kalebdjian, Paris, 1905.

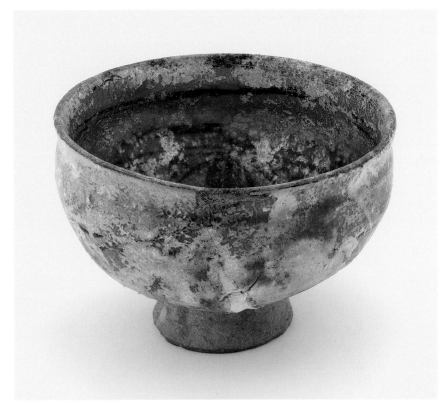

w102

W103. Hemispherical bowl with slightly everted rim, profile 14 (waster)

Composite body, underglaze-painted
Height 2¾ in. (7 cm), diameter 5 in. (12.7 cm)
Condition: A firing mishap caused the entire bowl to warp as well as fragments from one or more vessels to break off and become embedded in its interior and exterior.

Victoria and Albert Museum, London 104-1909

Interior decoration consists of a vegetal design at the center and three concentric rings on the upper wall and rim. The exterior has a row of diagonal slashes (dash back or S back [?]).

MUSEUM RECORDS: "I have acquired . . . 15 pieces of pottery from the site of an old pottery at Rakah. . . . I believe Hamdi has dug there and these are stolen." Charles M. Marling, British Embassy, Istanbul, letter of January 7, 1906, to A. B. Skinner, Victoria and Albert Museum. (Only fourteen of these pieces came into and were ultimately given to the museum; one is of the so-called Miletus type.)

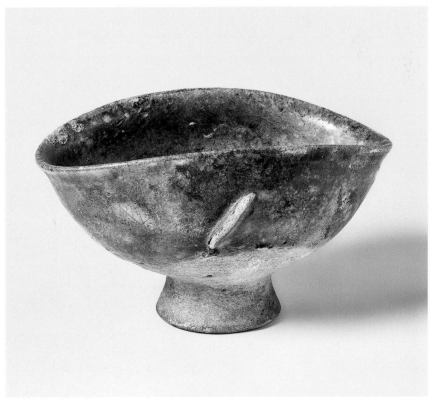

w103

W104. Fragmentary hemispherical bowl, profile 12 (waster)

Composite body, underglaze-painted
Height 2¼ in. (5.8 cm), diameter 4⅝ in. (11.7 cm)
Condition: A firing mishap caused fragments from one or more vessels to break off and become embedded in the exterior wall.

Museum of Turkish and Islamic Art, Istanbul
2216/1518

Interior decoration consists of a central vegetal design circumscribed by two bands. The exterior has only a single circular band composed of overlapping Ss (S back).

ORIGINAL RECORD BOOK (now in Topkapı Palace Museum, Istanbul): "Base of bowl, blue and black. Alep [Aleppo Province], kaza de Rakka et de Maareh, December 1900" (in French).

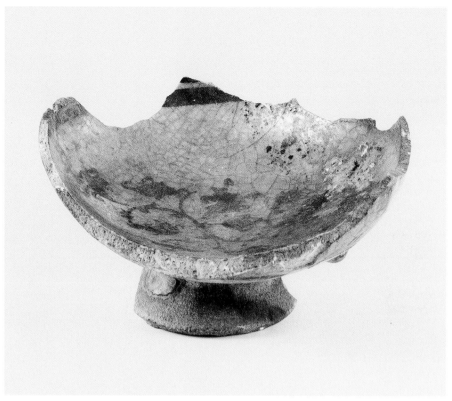

w104

W105. Fragment from wall and rim of hemispherical bowl with overhanging rim, profile 16 (waster)

Composite body, underglaze-painted
Length 5⅞ in. (14.8 cm), width 3¾ in. (9.5 cm)
Condition: A firing mishap caused the bowl to slump.

Museum of Turkish and Islamic Art, Istanbul
1694/1953

The only decipherable decoration is a contoured filler motif on the interior, just below the rim.

ORIGINAL RECORD BOOK (now in Topkapı Palace Museum, Istanbul): "Fragment of saucer. Turquoise with black designs. Alep [Aleppo Province], kaza de Rakka et de Maareh, June 1903" (in French).

w105

W106. Fragment from wall and rim of hemispherical bowl with overhanging rim, profile 16 (waster)

Composite body, underglaze-painted
Length 5⅛ in. (13 cm), width 3¾ in. (9.5 cm)
Condition: A firing mishap caused a fragment from another vessel to break off and become embedded in the exterior, resulting in distortion of the wall in that area.

Museum of Turkish and Islamic Art, Istanbul
1702/1948

The only decipherable decoration is a contoured filler motif on the interior, just below the rim, circumscribed at the top by a triple band.

ORIGINAL RECORD BOOK (now in Topkapı Palace Museum, Istanbul): "Fragment of saucer; green with black designs. Alep [Aleppo Province], kaza de Rakka et de Maareh, June 1903" (in French).

w106

W107. Fragment from wall and rim of hemispherical bowl with overhanging rim, profile 16 (waster)

Composite body, underglaze-painted
Length 6⅞ in. (17.5 cm), width 2¾ in. (7 cm)
Condition: A firing mishap caused the bowl to slump as well as a fragment from another vessel to break off and become embedded in its exterior.

Museum of Turkish and Islamic Art, Istanbul
1710/1957

The only decipherable decoration is tips of leaves on a dotted background on the interior; one leaf has details incised through the paint.

ORIGINAL RECORD BOOK (now in Topkapı Palace Museum, Istanbul): "Fragment of a saucer, green with black design. Alep [Aleppo Province], kaza de Rakka et de Maareh, June 1903" (in French).

w107

W108. Modified hemispherical bowl, profile 12 (waster)

Composite body, underglaze-painted
Height 5 in. (12.6 cm), diameter 8⅛ in. (20.5 cm)
Condition: A firing mishap caused fragments from one or more vessels to break off and become embedded in the interior. The largest of these incorporates incising through the paint.

Museum of Turkish and Islamic Art, Istanbul
1713/1494

Interior decoration consists of radiating highly stylized palmette leaves on the cavetto, circumscribed by a band of pseudo-cursive inscription on a sketchy vegetal ground (pattern 14) that is bordered above and below by three lines; the outermost line of each group is beaded. The rim bears a single band with evenly spaced pendant triangles. The central decoration is covered by an adhering fragment. The exterior has a calligraphic band identical to that on the interior.

ORIGINAL RECORD BOOK (now in Topkapı Palace Museum, Istanbul): "Two bowls adhering in kiln, deformed, blue and black. Alep [Aleppo Province], kaza de Rakka et de Maareh, December 1900" (in French).

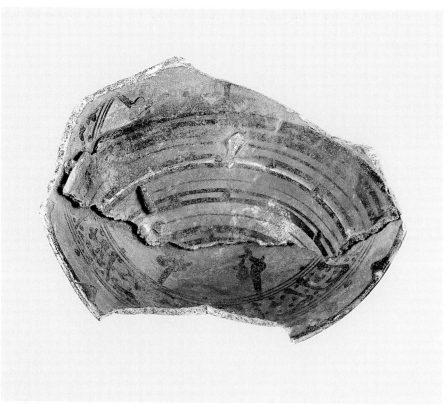

w108, interior

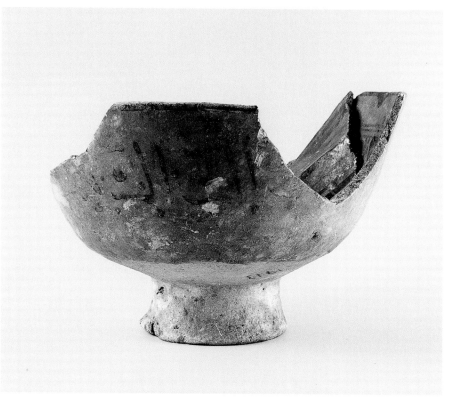

w108, profile

D. Segmental bowl with upper section sloping to small rimless opening

W109. Segmental bowl with upper section sloping to small rimless opening, profile 6 (waster)

Composite body, underglaze-painted
Height 5⅛ in. (13 cm), diameter 7⅞ in. (20 cm)
Condition: A firing mishap caused a fragment from another vessel to break off and become embedded in the lower section.

Ashmolean Museum of Art and Archaeology, Oxford x3027

Decoration consists of a wide band with a bold scrolling arabesque design as well as a secondary vegetal motif, all on a dotted ground and bordered above and below by one wide and three narrow lines.

MUSEUM RECORDS: Gift of Sir Frank Brangwyn (Brangwyn no. 28).

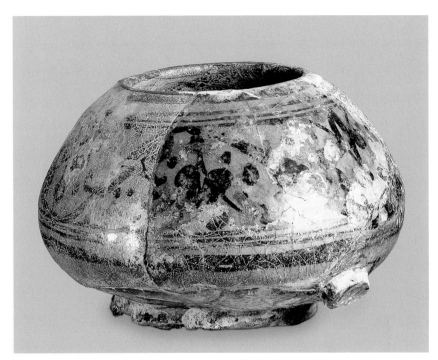

w109

E. Bowl fragments

W110. Fragments of two vessels, one from rim and other from wall (waster)

Composite body, underglaze-painted
Height 2 in. (5.1 cm), width 2½ in. (6.4 cm)
Condition: A firing mishap caused the fragments to adhere.

Museum für Islamische Kunst, Staatliche Museen zu Berlin I.431

The decoration on both fragments is indecipherable.

MUSEUM RECORDS: Object said to have come from Raqqa when it entered the museum in 1904.

w110

W111. Two fragments, one base of bowl and other from rim and part of wall of same or another bowl (waster)

Composite body, underglaze-painted
No measurements available.
Condition: A firing mishap caused the fragments to adhere.

Raqqa Museum 770

The reverse of the rim and wall fragment bears a single circular band (line back, pattern 3).

PROVENANCE: Excavated at Raqqa.

w111

W112. Fragments from three vessels, two apparently from rims (waster)

Composite body, underglaze-painted
No measurements available.
Condition: A firing mishap caused the fragments to adhere.

Raqqa Museum 775

The decoration on all three fragments is indecipherable.

PROVENANCE: Excavated at Raqqa.

w112

W113. Base of bowl (waster)

Composite body, underglaze-painted
No measurements available.
Condition: A firing mishap caused multiple fragments from one or more vessels to break off and become embedded in the interior as well as the foot ring to warp.

Raqqa Museum 777

The interior decoration is indecipherable.

PROVENANCE: Excavated at Raqqa.

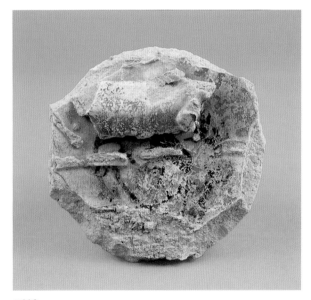

w113

W114. Fragments from three vessels (waster)

Composite body, underglaze-painted
No measurements available.
Condition: A firing mishap caused the fragments to adhere.

Raqqa Museum 778

The decoration is indecipherable.

PROVENANCE: Excavated at Raqqa.

w114

F. Jugs, handled pouring vessels, and lamps

W115. Medium-neck jug, profile 7 (waster)

Composite body, underglaze-painted
Height 5½ in. (14 cm), diameter 5½ in. (14 cm)
Condition: A firing mishap caused the jug to slump.

British Museum, London 1902 5-19 4

Decoration consists of a wide band on the body with quadrupeds running to the left, bordered above and below, as is the rim, by three concentric rings.

MUSEUM RECORDS: Said to have been found on the site of a factory (of unspecified nature) in Aleppo; purchased from J. J. Naaman, London.

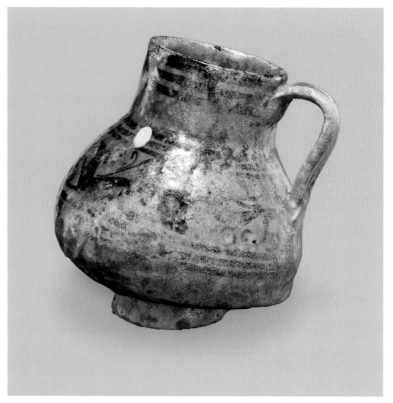

w115

W116. Medium-neck jug, profile 7 (waster)

Composite body, underglaze-painted
Height 5⅝ in. (14.3 cm), diameter 5⅜ in. (13.5 cm)
Condition: A firing mishap caused the jug to slump. The handle is missing.

Freer Gallery of Art, Smithsonian Institution, Washington, D.C. 1908.69

The decoration is indecipherable.

MUSEUM RECORDS: Acquired from M. Nahan, 1908.

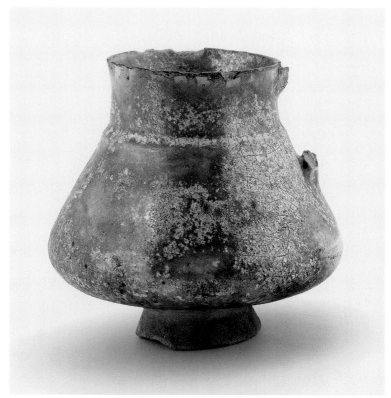

w116

w117, base

W117. Fragmentary handled pouring vessel, profile 15 (waster)

Composite body, underglaze-painted
Height 4 in. (10 cm), diameter 4¾ in. (12 cm)
Condition: A firing mishap caused the vessel to slump, the glaze to flux improperly, and fragments from several vessels to break off and become embedded in the base. The handle is missing.

Museum of Turkish and Islamic Art, Istanbul 2224/1448

Decoration consists of a series of arabesque medallions (pattern 16) on the body, separated by two stylized palmette leaves placed one above the other.

ORIGINAL RECORD BOOK (now in Topkapı Palace Museum, Istanbul): "Vase, deformed and broken, blue ground, black ornaments, H. 0.10. Alep [Aleppo Province], December 1900" (in French).

W118. Fragmentary handled pouring (?) vessel (waster)

Composite body, underglaze-painted
Height 3 in. (7.5 cm), diameter 3½ in. (9 cm)
Condition: A firing mishap caused the vessel to slump. The handle is missing.

Freer Gallery of Art, Smithsonian Institution, Washington, D.C. 1908.112

Decoration consists of a band of pseudo-inscription in cursive script (?).

MUSEUM RECORDS: Acquired from "[an] Arab in the street at Aleppo," 1908.

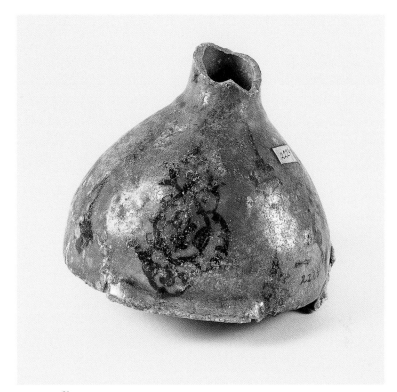

w117, profile

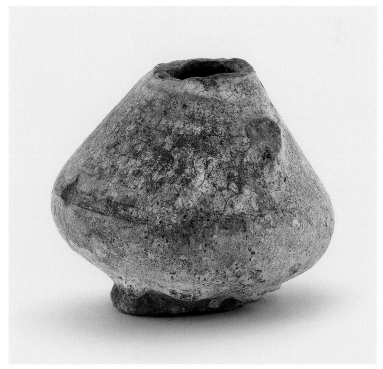

w118

99

W119. Fragmentary handled vessel (waster)

Composite body, underglaze-painted
Height 4⅝ in. (11.7 cm), diameter 4¾ in. (12 cm)
Condition: A firing mishap caused the vessel to slump. The handle is missing.

Freer Gallery of Art, Smithsonian Institution, Washington, D.C. 1909.376

The decoration is indecipherable.

Museum records: Acquired from N. Ohan, Jerusalem, 1909.

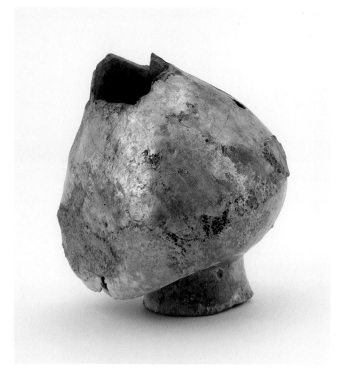

w119

W120. Handled vessel with pinched spout (waster)

Composite body, underglaze-painted
Height 4⅜ in. (11 cm), diameter 4½ in. (11.5 cm)
Condition: A firing mishap caused the vessel to slump.

British Museum, London 1902 5-19 5

The decoration is indecipherable.

Museum records: Said to have been found on the site of a factory (of unspecified nature) in Aleppo; purchased from J. J. Naaman, London.

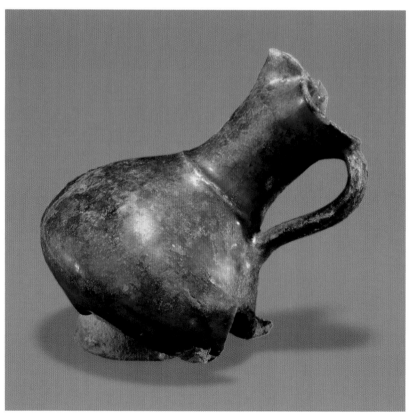

w120

W121. Oil lamp with pinched spout, profile 19 (waster)

Composite body, underglaze-painted
Height 1¾ in. (4.5 cm), width 3¾ in. (9.5 cm)
Condition: A firing mishap caused one side to slump, as well as several fragments from one or more vessels to break off and become embedded in the interior. The handle is missing.

Victoria and Albert Museum, London 105-1909

Decoration consists of a spiral decorating the interior wall on each side of the now missing handle. The edge of the spout and the exterior of the two pinched areas are decorated with a single line.

MUSEUM RECORDS: "I have acquired . . . 15 pieces of pottery from the site of an old pottery at Rakah. . . . I believe Hamdi has dug there and these are stolen." Charles M. Marling, British Embassy, Istanbul, letter of January 7, 1906, to A. B. Skinner, Victoria and Albert Museum. (Only fourteen of these pieces came into and were ultimately given to the museum; one is of the so-called Miletus type.)

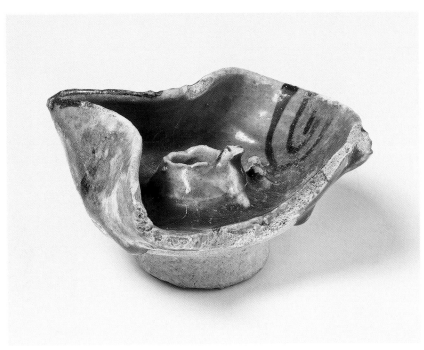

w121, profile

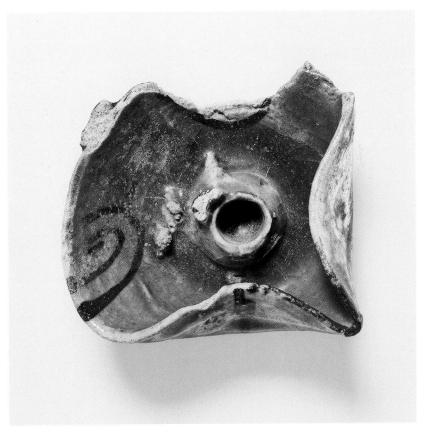

w121, interior

III. BICHROME OR POLYCHROME UNDERGLAZE-PAINTED OBJECTS

A. Biconical bowls

W122. Biconical bowl, profile 3 (waster)

Composite body, underglaze-painted in cobalt blue and black, with some details incised through the paint
Height 4 in. (10 cm), diameter 7½ in. (19 cm)
Condition: A firing mishap caused a fragment from another vessel to break off and become embedded in the outside wall of the bowl, resulting in a slight distortion of the rim.

Ashmolean Museum of Art and Archaeology, Oxford 1978.2354

The center of the base is decorated with a variation of the motif of two intertwined leaves (pattern 22) with contoured fillers in the interstices, circumscribed by a dotted double circle (pattern 11). The cavetto bears a wide band with two alternating designs, one similar to that on the central roundel, the other a true two intertwined leaves motif (pattern 22). The exterior has only a single circular band (line back, pattern 3).

MUSEUM RECORDS: Reitlinger gift (Reitlinger Collection NE.260); bought from A. Garabed, London, 1936.

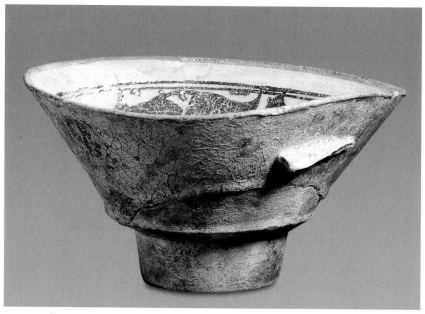

w122, profile

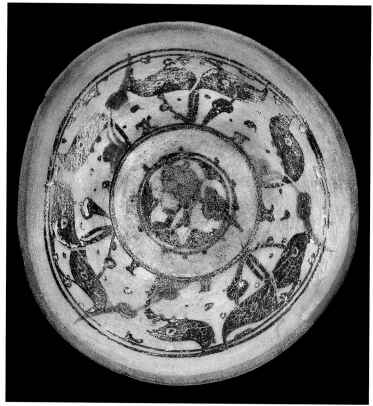

w122, interior

W123. Biconical bowl, profile 3 (waster)

Composite body, underglaze-painted in cobalt blue and black
Height 4⅝ in. (11.7 cm), diameter 9⅜ in. (23.8 cm)
Condition: A firing mishap caused fragments from one or more vessels to break off and become embedded in the wall. One of these is from the wall of a vessel with a wide calligraphic band on the interior.

Karatay Museum, Konya 23

Interior decoration at the base of the bowl consists of a roundel circumscribed by a circle and bearing the motif of a hillock with three leaves (pattern 5) that is bordered at the top, right, and left by contoured fillers; this is circumscribed by radiating contiguous bisected arches (pattern 23). The exterior is undecorated.

MUSEUM REGISTER: "Arab ceramic. Entered 1914, during World War I; from Halep [Aleppo Province]" (written in modern Turkish alphabet).

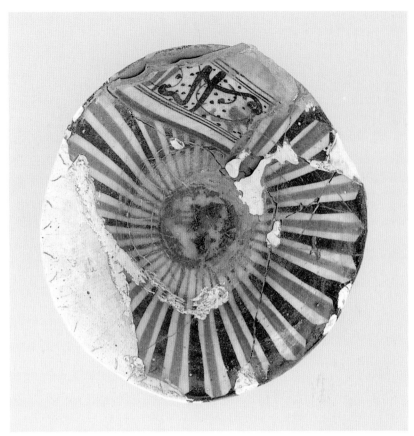

w123

W124. Biconical bowl, profile 3 (waster)

Composite body, underglaze-painted in cobalt blue and black
No measurements available.
Condition: A firing mishap caused a fragment from another vessel to break off and become embedded in the exterior wall, resulting in distortion of the wall in that area.

Raqqa Museum 153/788

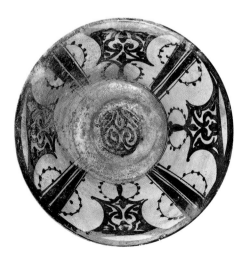

FIGURE 3.4. Underglaze-painted biconical bowl. Raqqa, Syria, 1200–1230. The Walters Art Museum, Baltimore (48.1078)

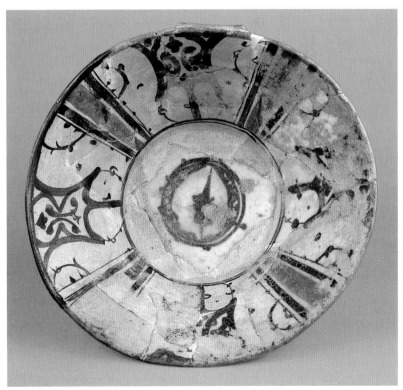

w124

Interior decoration at the base of the bowl consists of a dotted double circle (pattern 11) circumscribing a bisected roundel (pattern 21) and contoured fillers in a roundel (pattern 12). The walls bear four radiating panels with a highly stylized palmette tree alternating with four bands composed of five radiating lines of three differing widths. The exterior has only a single circular band (line back, pattern 3).

Bowl exhibiting an identical profile and decoration (except for the design on the base) but painted in black under a clear turquoise glaze: Walters Art Museum, Baltimore, 48.1078 (fig. 3.4).

PROVENANCE: Excavated at Raqqa.

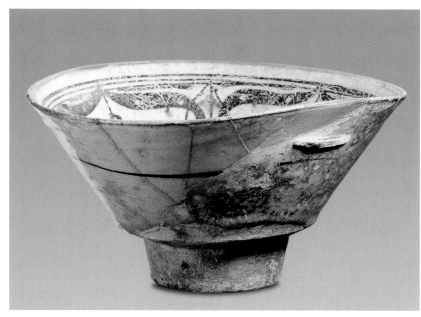

w125

W125. Biconical bowl, profile 3 (waster)

Composite body, underglaze-painted in cobalt blue and black, with details incised through the paint
Height 4¼ in. (10.8 cm), diameter 9 in. (22.9 cm)
Condition: A firing mishap caused a fragment from another vessel to break off and become embedded in the outside wall, resulting in a slight distortion of the rim.

Ashmolean Museum of Art and Archaeology, Oxford 1978.2196

Interior decoration consists of an eight-petaled rosette surrounded by three concentric staggered four-petaled blossoms, each progressively larger in scale and all overlaid with a skeletal design of eight radiating wedges. The exterior has only a single circular band (line back, pattern 3).

MUSEUM RECORDS: Bought from A. Garabed, London, 1931.

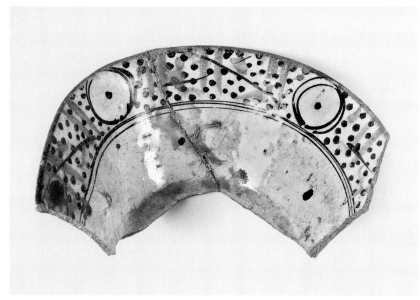

w126

W126. Large fragment of biconical bowl, profile 3 (waster)

Composite body, underglaze-painted in cobalt blue and black
Length 7½ in. (19 cm), width 2⅝ in. (6.5 cm)
Condition: A firing mishap caused the bowl to slump and consequently to warp.

Museum of Turkish and Islamic Art, Istanbul 1607/1538

Interior decoration consists of a wide band of pseudo-cursive inscription with superimposed large Xs on a dotted ground divided by a series of two concentric circles with a dot in the center. The exterior has only a single circular band (line back, pattern 3).

ORIGINAL RECORD BOOK (now in Topkapı Palace Museum, Istanbul): "Fragment of bowl, broken and deformed. Alep [Aleppo Province], kaza de Rakka et de Maareh, December 1900" (in French).

W127. Fragmentary biconical bowl, profile 3 (waster)

Composite body, underglaze-painted in cobalt blue and black
Height 3⅞ in. (9.9 cm), diameter 7½ in. (19 cm)
Condition: A firing mishap caused fragments from one or more vessels to break off and become embedded in the interior.

Museum of Turkish and Islamic Art, Istanbul
1723/1460

Interior decoration consists of a dotted double circle (pattern 11) bearing a pseudo-calligraphic motif with a superimposed large X on a dotted ground. This is circumscribed by a wide band on the wall with three identical dotted double circles (pattern 11) alternating with spandrel-like elements, each with a highly stylized palmette tree. The exterior is undecorated.

ORIGINAL RECORD BOOK (now in Topkapı Palace Museum, Istanbul): "Broken bowl, decorated in blue and black. D. 0,19. Alep [Aleppo Province], kaza de Rakka et de Maareh, December 1900" (in French).

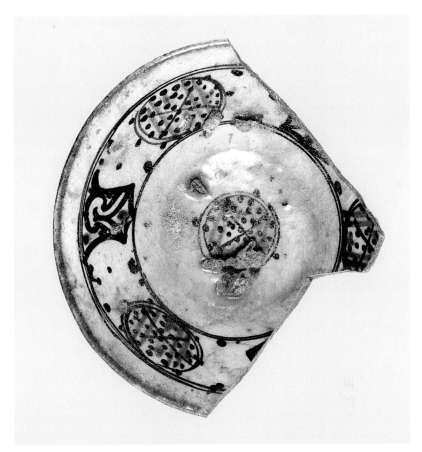

w127

W128. Fragmentary biconical bowl, profile 3 (waster)

Composite body, underglaze-painted in black, red, and cobalt blue
Height 3¼ in. (8.3 cm), diameter 7⅝ in. (19.4 cm)
Condition: A firing mishap caused the bowl to slump, resulting in the loss of the foot.

Freer Gallery of Art, Smithsonian Institution, Washington, D.C. 1904.293

Interior wall decoration consists of a wide band, bordered above and below by three rings, with two alternating designs, one a roundel containing a highly stylized palmette tree, the other a highly stylized vegetal design. The exterior has sketchy contiguous ellipses (arc back).[1]

MUSEUM RECORDS: Acquired from S. Bing, 1904.

1. See Mason 1997, fig. 3, SM.11.

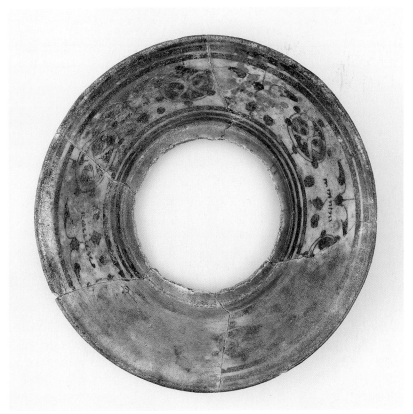

w128

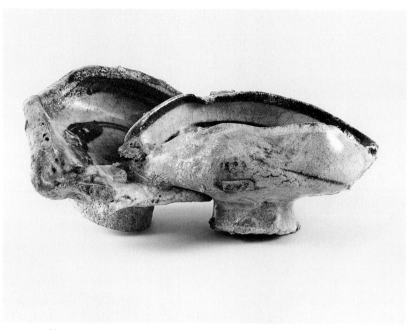

w129, profile

W129. Two hemispherical bowls, profile 12 (waster)

Composite body, underglaze-painted in chrome green
Maximum width 7⅜ in. (18.8 cm)
Condition: A firing mishap caused the bowls to become embedded in each other as well as to slump, curl, and warp.

Museum of Turkish and Islamic Art, Istanbul 2193/1539

The interior decoration of one bowl consists of a beaded central roundel bearing the motif of two intertwined leaves (pattern 22) bordered right and left by a contoured filler motif. The other bears a bisected roundel (pattern 21) and contoured fillers in a roundel (pattern 12). The exterior of each has only a single circular band (line back, pattern 3).

ORIGINAL RECORD BOOK (now in Topkapı Palace Museum, Istanbul): "Fragment of deformed bowl; luster. Alep [Aleppo Province], kaza de Rakka et de Maareh, December 1900" (in French).

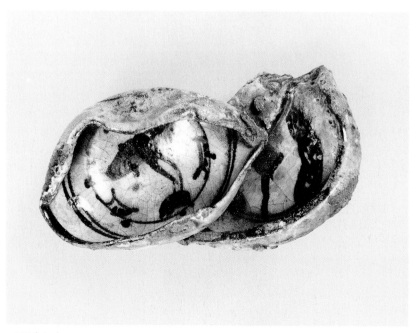

w129, interior

W130. Hemispherical bowl, profile 12 (waster)

Composite body, underglaze-painted in black
Height 2⅜ in. (6 cm), diameter 4⅝ in. (11.7 cm)
Condition: A firing mishap caused the bowl to slump and curl.

Museum für Islamische Kunst, Staatliche Museen zu Berlin I.1240

Interior decoration consists of a central roundel highlighted at regular intervals by evenly spaced dots and containing the motif of a hillock with three leaves (pattern 5) with contoured fillers in the interstices. The cavetto bears two rings, and the rim a single wide ring. The exterior has only a single circular band (line back, pattern 3).

MUSEUM RECORDS: No information in central museum archives or departmental files.[1]

1. Jens Kröger, e-mail communication, September 25, 2003.

W131. Hemispherical bowl, profile 12 (waster)

Composite body, underglaze-painted in black
Height 2½ in. (6.4 cm), diameter 5¼ in. (13.3 cm)
Condition: A firing mishap caused the bowl to slump and curl.

Museum für Islamische Kunst, Staatliche Museen zu Berlin I.1239

Interior decoration consists of a central roundel highlighted at regular intervals by evenly spaced dots and containing the motif of two intertwined leaves (pattern 22) with contoured fillers in the interstices. The cavetto bears two rings, and the rim a single wide ring. The exterior has only a single circular band (line back, pattern 3).

MUSEUM RECORDS: No information in central museum archives or departmental files.[1]

1. Jens Kröger, e-mail communication, September 25, 2003.

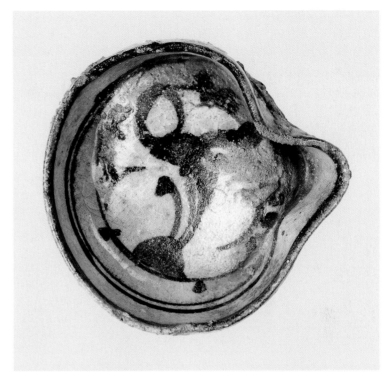

w130

w131, interior

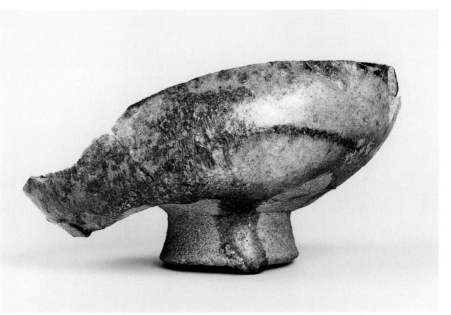

w131, profile

W132. Fragmentary hemispherical bowl with slightly everted rim, profile 14 (waster)

Composite body, underglaze-painted in black and cobalt blue
Height 2¾ in. (7 cm), diameter 4⅜ in. (11 cm)
Condition: A firing mishap caused numerous fragments from one or more vessels to break off and become embedded in the foot and wall.

British Museum, London 1902 5-19 7

Interior decoration consists of a central roundel with two contiguous half-circles, each bearing a reserved palmette leaf. The rim bears a reserved Kufesque band. The exterior has only a single circular band composed of a series of overlapping Ss (S back).

MUSEUM RECORDS: Said to have been found on the site of a factory (of unspecified nature) in Aleppo; purchased from J. J. Naaman, London.

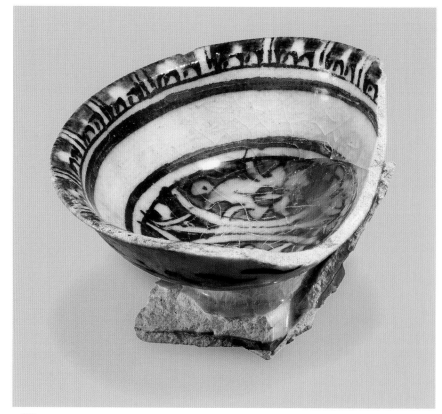

W132

C. Segmental bowl with flat rim

W133. Large fragment of cavetto and broad flat rim of segmental bowl (waster)

Composite body, underglaze-painted in cobalt blue, black, and yellow
Height 1⅝ in. (4 cm), diameter 10⅝ in. (27 cm)
Condition: A firing mishap caused the bowl to slump and a fragment from another vessel to break off and become embedded in its exterior wall.

Museum of Turkish and Islamic Art, Istanbul
1721/1464

Interior decoration consists of a wide band with diagonally arranged ogives and reserved vegetal interstial designs. The wide flat rim bears a reserved Kufesque band. The exterior has only a single circular band composed of a series of overlapping Ss (S back).

ORIGINAL RECORD BOOK (now in Topkapı Palace Museum, Istanbul): "Fragment of a plate, white ground with black ornaments. D. 0,27. Alep [Aleppo Province], kaza de Rakka et de Maareh, December 1900" (in French).

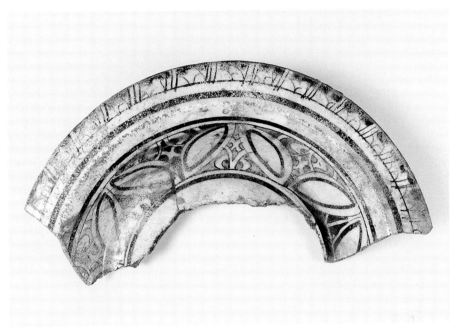

w133

D. Bowl fragment

W134. Base of bowl of unascertainable shape (waster)

Composite body, underglaze-painted in cobalt blue, black, and aubergine
Length 3 ½ in. (9 cm), height 1 ⅝ in. (4 cm)
Condition: A firing mishap caused a fissure in the base and consequent curling.

Museum of Turkish and Islamic Art, Istanbul 1715/1520

Interior decoration consists of a roundel circumscribing a four-petaled rosette with reserved vegetal designs in the interstices.

ORIGINAL RECORD BOOK (now in Topkapı Palace Museum, Istanbul): "Base of vase, white and black. Alep [Aleppo Province], kaza de Rakka et de Maareh, December 1900" (in French).

W134

E. Jugs

W135. Fragmentary medium-neck jug, profile 7 (waster)

Composite body, underglaze-painted in black and cobalt blue
Height 4¼ in. (10.7 cm), diameter 5 in. (12.6 cm)
Condition: A firing mishap caused the jug to slump.

Museum of Turkish and Islamic Art, Istanbul
2188/1447

Decoration consists of vertical stripes on the body and diagonal stripes on the neck.

ORIGINAL RECORD BOOK (now in Topkapı Palace Museum, Istanbul): "Fragment of a vase. Alep [Aleppo Province], kaza de Rakka et de Maareh, December 1900" (in French).

W136. Medium-neck jug, profile 7 (waster)

Composite body, underglaze-painted in black and cobalt blue
Height 4⅛ in. (10.5 cm), diameter 5¾ in. (14.5 cm)
Condition: A firing mishap caused the jug to slump as well as a fragment from another vessel, painted in black under a clear turquoise glaze, to break off and become embedded near the handle.

British Museum, London 1902 5-19 2

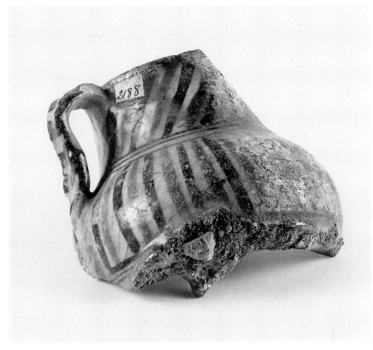

w135

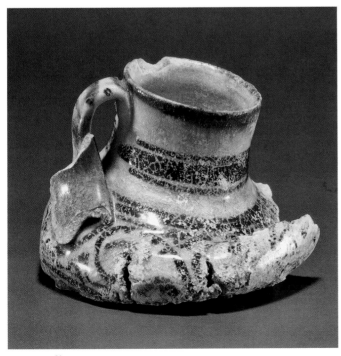

w136, profile

w136, base

Decoration on the body consists of a wide band with a vegetal scroll bordered above and on the neck by a series of rings of varying widths. The handle bears a series of horizontal lines.

MUSEUM RECORDS: Said to have been found on the site of a factory (of unspecified nature) in Aleppo; purchased from J. J. Naaman, London.

W137. Medium-neck jug, profile 7 (waster)

Composite body, underglaze-painted in black
No measurements available.
Condition: A firing mishap caused a fragment from another vessel, underglaze-painted in black and cobalt blue, to break off and become embedded in the body.

Aleppo National Museum 10

Decoration on the body and neck consists of a wide band with a spindly vegetal design bordered above and below by a series of rings of varying widths. The handle bears a series of horizontal lines.

MUSEUM REGISTER: Purchased, 1988.

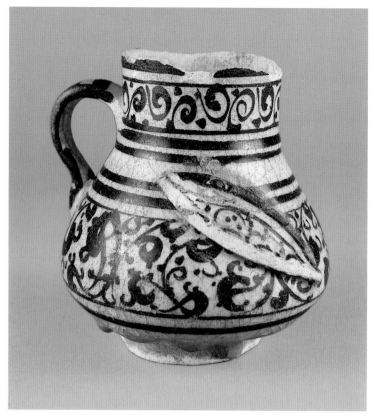

w137

W138. Short-neck jug, profile 18 (waster)

Composite body, underglaze-painted in black and cobalt blue
Height 5½ in. (14.1 cm), diameter 6½ in. (16.5 cm)
Condition: A firing mishap caused the jug to slump.

British Museum, London 1902 5-19 1

Decoration on the body consists of a band with a pseudo-inscription in cursive script containing split palmette leaves at regular intervals. The slightly flaring rim bears a reserved Kufesque band.

MUSEUM RECORDS: Said to have been found on the site of a factory (of unspecified nature) in Aleppo; purchased from J. J. Naaman, London.

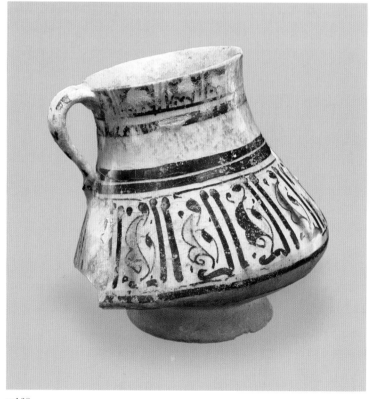

w138

F. Jars

W139. Inverted pear-shaped jar with cylindrical neck and everted rim, profile 1 (waster)

Composite body, underglaze-painted in cobalt blue and black
No measurements available.
Condition: A firing mishap caused a fragment from another vessel to break off and become embedded in the body.

Aleppo National Museum 262

Decoration on the body consists of a series of contiguous bisected arches (pattern 23). The sloping shoulder bears a broad band with evenly spaced dots circumscribed by bands above and below. The cylindrical neck has a broad plain band bordered at the top by a narrow band.

MUSEUM REGISTER: Purchased from Kaysun, 1976.

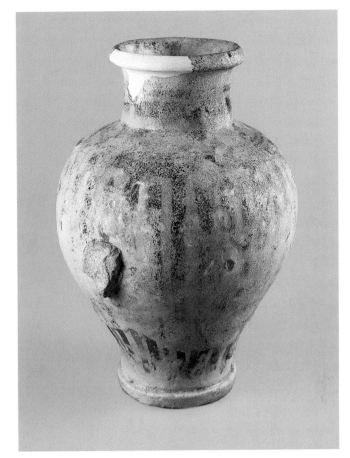

w139

W140. Shoulder and neck of jar (waster)

Composite body, underglaze-painted in cobalt blue, black, and yellow
Maximum diameter 7½ in. (19 cm), diameter at rim 3¾ in. (9.6 cm)
Condition: A firing mishap caused many fragments from one or more vessels to break off and become embedded in the jar, especially on the interior.

Museum of Turkish and Islamic Art, Istanbul 2165/1542

Remaining decoration consists of three bands, one on the neck with a series of diagonal lines, a second on the shoulder with vegetal designs in cartouches separated by pairs of vertical lines, and a third on the body with an indecipherable design.

ORIGINAL RECORD BOOK (now in Topkapı Palace Museum, Istanbul): "The upper part of a deformed vase. Alep [Aleppo Province], kaza de Rakka, December 1900" (in French).

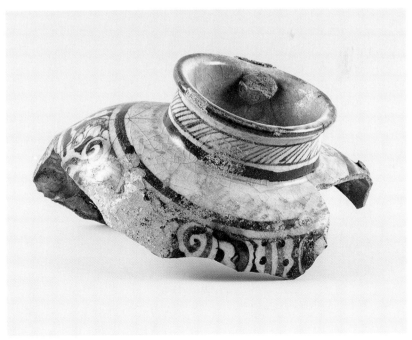

w140

113

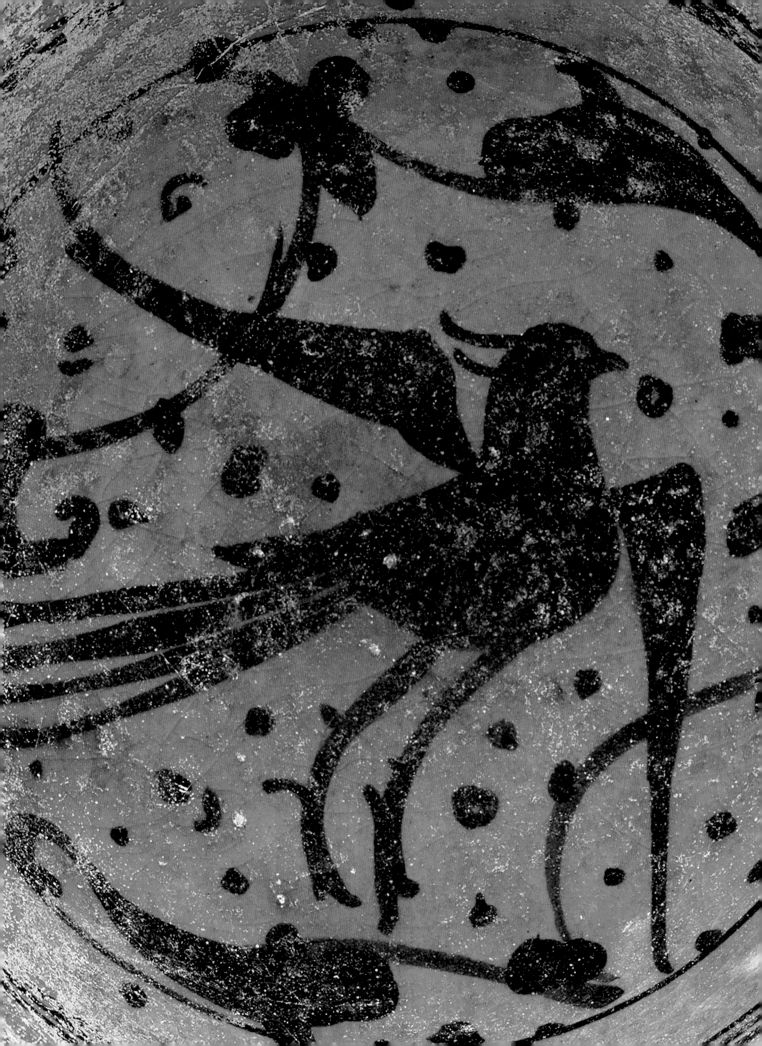

4. Raqqa Ceramics in The Metropolitan Museum of Art

 HAVING SURVEYED THE scope of production in Raqqa of three different types of pottery through the wasters of these types, we turn now to the forty-six objects in the Department of Islamic Art in the Metropolitan Museum that fall within these three categories. In both quality and number, this group forms the most important collection of ceramic objects belonging to these decorative types.

Not only do the objects epitomize the best that were produced, but most of the forty-six were collected during the period when the passion for Raqqa pottery was at its height. It is indeed fortunate, therefore, that the collectors and dealers who formed this collection were highly discerning in their choices, for they had a staggering array of objects from which to choose.

The circle of individuals interested in acquiring Raqqa pottery at that time was small enough that many of those we have already encountered in earlier chapters are connected in some way to a large percentage of the Museum's objects. The antiquarians Thomas B. Clarke, Dikran Khan Kelekian, and Fahim Kouchakji, for example, figure prominently in their history. Twelve of the forty-six were acquired from Clarke. Ten came from the Great Find. And ten appear in the Marcopoli photographs, now housed in the Gertrude Bell Photographic Archive (see pages 29–31, figs. 2.4–2.9), and in the photographs sent by Marcopoli to Charles L. Freer, now in the archives of the Freer Gallery of Art, Smithsonian Institution, Washington, D.C. (see page 32, fig. 2.10).

As was the case with the wasters in chapter 3, these objects are organized by the three decorative techniques represented and accession number. Fragments of two wasters (RA1, RA4) collected in connection with this project are also included in this chapter.

The following objects were scientifically analyzed, with results as presented in Appendix 2: MMA1, MMA4, MMA6, MMA7, MMA10, MMA11, MMA13, MMA24, MMA28–MMA30, MMA32–MMA34, MMA41, MMA44–MMA46, RA1, and RA4.

I. UNDERGLAZE- AND LUSTER-PAINTED OBJECTS

MMA1. Lantern, profile 10

Composite body, underglaze- and luster-painted
Height 9⅜ in. (23.7 cm), diameter 6 in. (15.1 cm)

The Metropolitan Museum of Art, Edward C.
Moore Collection, Bequest of Edward C. Moore,
1891 91.1.138

This lantern is in the form of a square domed
building with corner columns supporting
pear-shaped finials. Two opposing sides each
bear an arch, one with two outlining bands,
the other with three that interlace at the top
and become the border of the flat face. The
other two opposing sides bear rosettes with
eight lobes pierced and covered from the back
with panes of colored glass. The outlining
bands of the rosette and face are identical to
the outlining bands on the other two faces.
The spandrels of the arches and the ground
for the rosettes are sprinkled with dots of
varying sizes, commas, spiraling lines, and
large Xs. The dome is pierced with twelve
round openings, each outlined with an
underglaze-painted circle circumscribed by
a luster-painted circle, and is decorated
with four large and four smaller arabesque
designs on a ground sprinkled with dots of
varying sizes. The columns and the lower
part of the finials are luster-painted, and the
upper section of the finials are underglaze-
painted. The lantern is underglaze-painted in
cobalt blue under a clear colorless glaze with
a slight greenish tint and luster-painted in
chocolate brown.

No waster of this object type is known.

RELATED WORKS: For the only other similar
objects known, see Dumbarton Oaks,
Washington, D.C., 50.39 (acquired from Elie
Bustros, Beirut, 1950) and another lantern
whose present whereabouts are unknown.[1] A
letter dated June 21, 1910, to Charles L. Freer
from Vincenzo Marcopoli & Co., Aleppo,
mentions three objects called "lampadaires"
(lampposts) recently discovered in Raqqa, one
of which appears to be quite close to that dis-
cussed here: "Square shape, mounted with a
cupola, little holes through it, brown decoration
luster and designs in blue over the brown."[2]

PROVENANCE: Sold in Goupil sale, 1888;
Edward C. Moore.

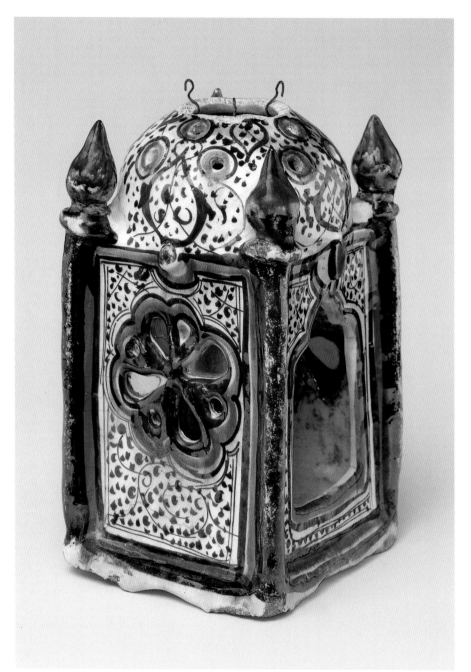

MMA1

REFERENCES: Soustiel 1985: 122, no. 134; *Orient de Saladin* 2001, no. 234.

1. Sotheby's sale 1986, lot 157.
2. Original in French. Charles Lang Freer Papers. Freer Gallery of Art and Arthur M. Sackler Gallery Archives, Smithsonian Institution, Washington, D.C.

MMA2

MMA2. Fragmentary biconical bowl, profile 3

Composite body, glazed and luster-painted
Height 3½ in. (9 cm), maximum width 6¾ in. (17.2 cm)
Inscribed: al-ʿizz (Glory) [repeated eight times]

The Metropolitan Museum of Art, Rogers Fund, 1907 07.212.3

Interior decoration consists of a reserved vegetal design of one principal leaf set within a leaf scroll, all circumscribed by three concentric bands, two narrow and the outermost broad, and highlighted at regular intervals by evenly spaced trefoils (pattern 7). The cavetto bears a wide decorative band with the inscription *al-ʿizz* on a spiraling ground (pattern 4) bordered above and below by two narrow bands and at the top by evenly spaced trefoils (pattern 7) and a broad plain band at the rim. The exterior has a spiral back (pattern 6) at the top of the wall just below the rim and a broad plain band below. The bowl is glazed with a clear colorless glaze with a greenish tint and luster-painted in chocolate brown.

RELATED WORKS: For wasters of this type, see Karatay Museum, Konya, 17/7, 17/8, 19, and Museum of Turkish and Islamic Art, Istanbul, 1626/1470 (chapter 3, w1–w4).

PROVENANCE: Sold by A. Filippo, London.

REFERENCES: Pier 1908: 120–21, pl. 1.

MMA3. Hemispherical bowl, profile 12

Composite body, glazed and luster-painted
Height 2½ in. (6.5 cm), diameter 4⅜ in. (11.1 cm)
Inscribed: surr (Joy)
Condition: Both the interior and exterior indicate
that this bowl slumped in the kiln during firing.
However, because there was only minimal distor-
tion, luster-painted decoration was applied and
the bowl was not relegated to the rubbish heap as
other wasters would have been.

The Metropolitan Museum of Art, Gift of W. R.
Valentiner, 1909 09.51

Interior decoration consists of the inscription
surr with vegetation in a roundel (pattern 25)
silhouetted on a luster-painted ground. The
design is circumscribed by three bands, one
narrow and two broad, one of the latter
surrounding the rim. The exterior bears a
wide band bordered above and below by a
broad plain band and containing evenly
spaced vertically aligned ellipses (arc back).
The bowl is glazed with a clear colorless
glaze with a greenish tint and luster-painted
in chocolate brown.

RELATED WORKS: For wasters of this type, see
British Museum, London, 1902 5-19 9, Victoria
and Albert Museum, London, 106-1909, 107-
1909, 108-1909, and Museum of Turkish and
Islamic Art, Istanbul, 1614/1946 (chapter 3,
w40–w44). For complete examples, see Aleppo
National Museum 491 (excavation CA20 but site
unknown) and an identical bowl brought, accord-
ing to museum records, from "Alep [Aleppo
Province], kaza de Rakka et de Maareh" in 1903;
now in the Museum of Turkish and Islamic Art,
1645/1969.

PROVENANCE: W. R. Valentiner.

REFERENCES: Unpublished.

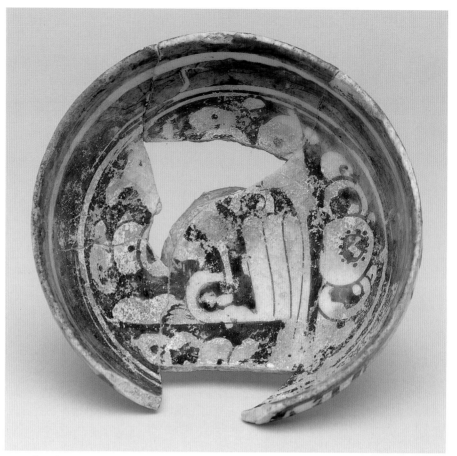

MMA3, interior

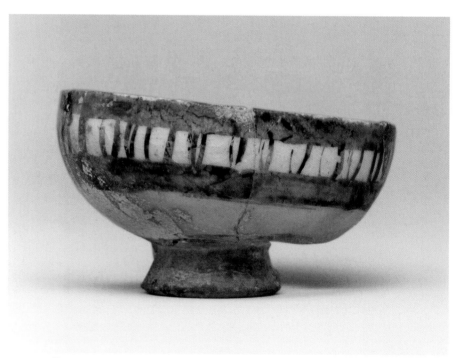

MMA3, profile

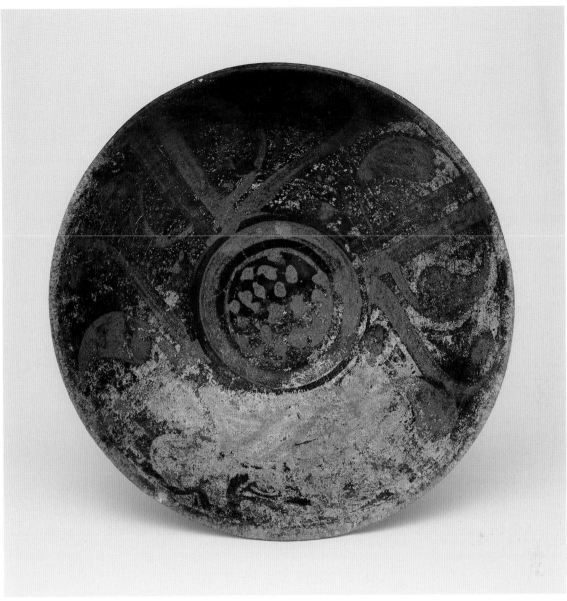

MMA4

MMA4. Conical bowl, profile 11
Composite body, glazed and luster-painted
Height 3⅜ in. (8.5 cm), diameter 8¼ in. (21 cm)

The Metropolitan Museum of Art, Rogers Fund,
1910 10.44.2

Interior decoration consists of a roundel with one broad and one narrow plain band circumscribing randomly placed dots. The walls bear a single wide band of pseudo-calligraphic decoration highlighted with split palmettes having filler motifs in the interstices. The exterior is undecorated. The bowl is luster-painted in khaki green over an opaque aubergine glaze.

RELATED WORKS: For opaque aubergine-glazed wasters, see Ethnographical Museum, Ankara, 1852, and Museum of Turkish and Islamic Art, Istanbul, 2229/1486 (chapter 3, w49, w50). For complete objects with similar color scheme, see formerly Los Angeles County Museum of Art M.2002.1.106 (no provenance information available) and Raqqa Museum 480 (also with similar decorative motifs; see page 176, fig. 5.4).

REFERENCES: Dimand 1944: 215 (no illustration).

MMA5. Inverted pear-shaped jar with cylindrical neck and everted rim, profile 1

Composite body, underglaze- and luster-painted
Height 8⅞ in. (22.5 cm), diameter 6⅞ in.
(17.6 cm)
Inscriptions are indecipherable.
Condition: The object has been heavily restored.

The Metropolitan Museum of Art, Rogers Fund,
1917 17.74.2

Body decoration consists of four principal bands. The band on the shoulder bears cursive-script panels on a spiraling ground (pattern 2) divided into four sections by underglaze-painted roundels. This area is bordered above and below by a band with reserved interlace on a spiraling ground (pattern 20). The last principal band, containing cursive-script panels on a spiraling ground (pattern 2), appears on the lower body and is bordered above by a plain underglaze-painted band and below by another such band, as well as by a broad plain luster-painted band followed by two staggered rows of vegetal motifs. The neck bears a band with cursive-script panels on a spiraling ground (pattern 2). The rim has a broad plain band. The jar is underglaze-painted in cobalt blue under a clear colorless glaze with a slight greenish tint and is luster-painted in chocolate brown. It is made in two sections joined at the middle.

The high price for this heavily restored object is indicative of the interest in this type of pottery and the lengths antiquarians went to in order to keep up with the expanding market. The purchase form for this jar in the Museum's archives states that "the vendor of this important jar has only recently arrived from Paris." Documents 1, 10, and 15 in Appendix 1 of this volume mention two merchants with the surname "Tabah": Cemil bin Lupka Tabah and Corci (Georges) Yusuf Tabah. One wonders if "Tabah" is another spelling for "Tabbagh," as suggested by Ayşin Yoltar-Yıldırım,[1] and if the merchant named Corci and the merchant referred to in the purchase form are the same individual. Also, could "Cemil" have become "Émile"? If so, Cemil and Corci Tabah could be Émile and Georges Tabbagh of the well-known firm Tabbagh Frères.

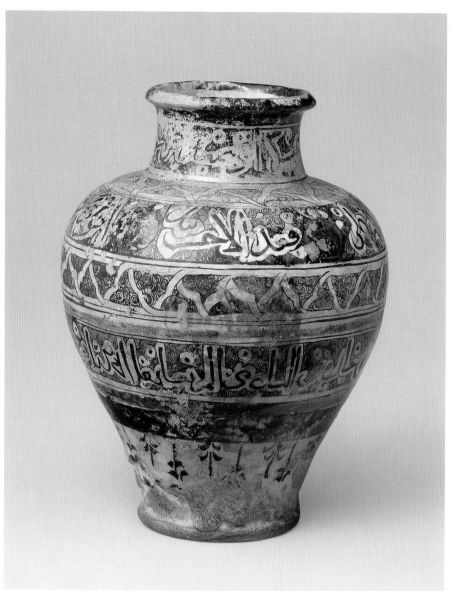

MMA5

RELATED WORKS: For a similar waster, see Victoria and Albert Museum, London, 109-1909 (chapter 3, w63).

PROVENANCE: Sold by Georges Tabbagh, New York, 1917, for $1,300 (equivalent to $18,688 in 2003).

REFERENCES: Dimand 1936b, fig. 4; Dimand 1944: 190, fig. 120; Grube 1963: 63, fig. 20.

1. Personal communication.

MMA6. Jar with molding at base of neck, profile 5

Composite body, carved, glazed, and luster-painted
Height 13½ in. (34.4 cm), diameter 10 in.
(25.5 cm)

The Metropolitan Museum of Art, Mr. and Mrs.
Isaac D. Fletcher Collection, Bequest of Isaac D.
Fletcher, 1917 17.120.36

Body decoration consists of two designs alternating twice around the vessel, one a floriated *alif-lām* (pattern 13), the other a trilobed palmette set into each of two contiguous arch-shaped compartments with another, smaller trilobed palmette in the spandrel. The base of the neck bears heavy molding topped by a wide band, the neck traces of additional decoration. The decoration is carved under a clear colorless glaze with a greenish tint; raised areas are luster-painted in reddish brown, with the lower background areas bearing luster-painted dots. The jar is made in two sections joined at the middle.

It is not certain if wasters of this type exist.

RELATED WORKS: Monochrome-glazed jars exhibiting a similar shape and carved decoration may be wasters of this type or may never have been intended to be luster-painted; for example, Freer Gallery of Art, Smithsonian Institution, Washington, D.C., 1908.113 (acquired from a "street dealer in Aleppo"), 1908.134, 1908.155, 1908.184 (all acquired from Vincenzo Marcopoli & Co., Aleppo), another jar (from the palace of Harun al-Rashid; present whereabouts unknown),[1] and Los Angeles County Museum of Art M.2002.1.229 (acquired on the New York art market). For glazed and luster-painted examples, see National Museum, Damascus, 5903 (purchased), formerly Homaizi Collection, Kuwait, 1/97 (present whereabouts unknown), Kunstgewerbe Museum, Cologne, E2944, and a fragment acquired by Friedrich Sarre in Raqqa.[2]

PROVENANCE: Mr. and Mrs. Isaac D. Fletcher.

REFERENCES: Dimand 1944: 191, fig. 121.

1. Kouchakji 1923: 521.
2. Sarre 1921, fig. XXI5.

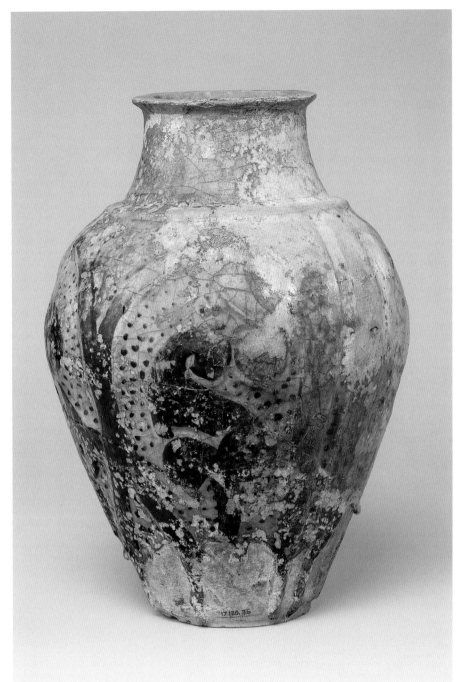

MMA6

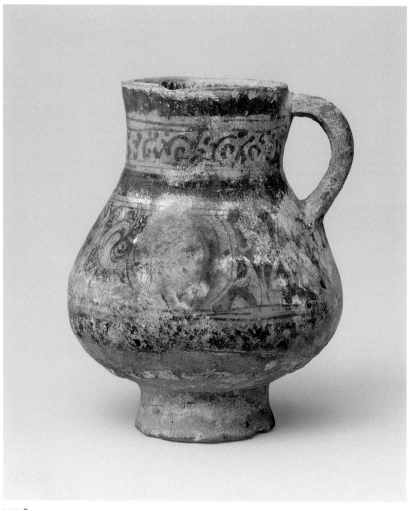

MMA7

MMA7. Medium-neck jug, profile 7

Composite body, underglaze- and luster-painted
Height 4⅞ in. (12.5 cm), diameter 4 in. (10.3 cm)
Condition: The handle is completely restored, making the original profile impossible to ascertain.

The Metropolitan Museum of Art, Grinnell Collection, Bequest of William Milne Grinnell, 1920 20.120.225

Body decoration consists of a wide band divided by evenly spaced teardrop shapes—with an underglaze-painted outline and filled with no longer decipherable motifs—into four cartouches. Two cartouches contain a reserved arabesque design, the others an indecipherable design on a spiraling ground. This band is bordered above and below by a broad plain band. The cylindrical neck bears a calligraphy band (pattern 1) with a broad plain band above encircling the rim and extending onto the interior of the neck. The

jug is underglaze-painted in turquoise under a clear colorless glaze with a greenish tint and is luster-painted in chocolate brown.

RELATED WORKS: For similar but not identical wasters, see Museum of Turkish and Islamic Art, Istanbul, 1578/1424, 1555/2483 (chapter 3, w54, w57).

PROVENANCE: Grinnell collection.

REFERENCES: Unpublished.

MMA8. Jar with molding at base of neck, profile 5

Composite body, carved, glazed, and luster-painted
Height 16½ in. (41.9 cm), diameter 11⅞ in.
(30.3 cm)

The Metropolitan Museum of Art, Gift of John D.
Rockefeller Jr., 1938 38.84.2

Body decoration consists of two designs alternating three times around the vessel, one a floriated *alif-lām* (pattern 13), the other a palmette tree. The base of the neck bears heavy molding topped by a wide band, the neck traces of two other wide bands, one horizontal and one vertical; the remainder of the design on the neck is indecipherable. The decoration is carved under a clear turquoise glaze; raised areas are luster-painted in a greenish brown, with lower background areas bearing luster-painted dots. The jar is made in two sections joined at the middle.

It is not certain if wasters of this type exist.

RELATED WORKS: Monochrome-glazed jars exhibiting a similar shape and carved decoration may be wasters of this type or may never have been intended to be luster-painted; see, for example, Freer Gallery of Art, Smithsonian Institution, Washington, D.C., 1908.113 (acquired from a "street dealer in Aleppo"), 1908.134, 1908.155, 1908.184 (all acquired from Vincenzo Marcopoli & Co., Aleppo), another jar (from the palace of Harun al-Rashid; present whereabouts unknown),[1] and Los Angeles County Museum of Art M.2002.1.229 (acquired on the New York art market). For glazed and luster-painted examples, see National Museum, Damascus, 5903 (purchased), formerly Homaizi Collection, Kuwait, I/97 (present whereabouts unknown), Kunstgewerbe Museum, Cologne, E2944, and a fragment acquired by Friedrich Sarre in Raqqa.[2]

PROVENANCE: John D. Rockefeller Jr.

REFERENCES: McAllister 1938: 243; Dimand 1944: 191.

1. Kouchakji 1923: 521.
2. Sarre 1921, fig. XII5.

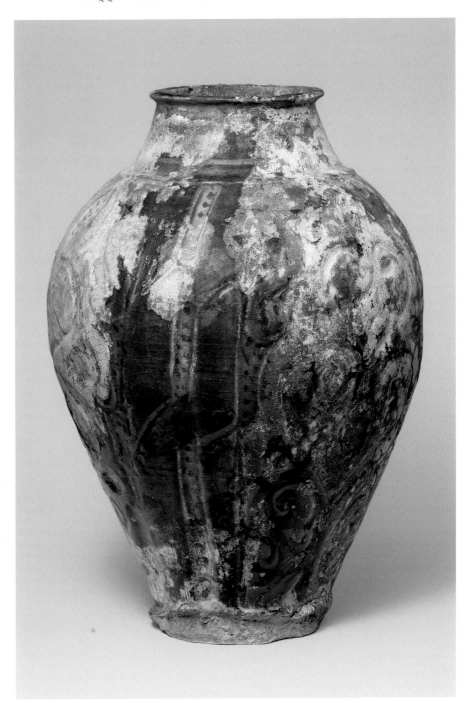

MMA8

MMA9. Jar with molding at base of neck, profile 5

*Composite body, underglaze- and luster-painted
Height 16¼ in. (41.2 cm), diameter 12⅞ in.
(32.8 cm)*

*The Metropolitan Museum of Art, H. O. Havemeyer
Collection, Gift of Horace Havemeyer, 1948
48.113.4*

The body is divided into eight decorative
panels with four designs, each repeated twice
and separated by an underglaze-painted
stripe flanked by luster-painted stripes. The
designs consist of an arabesque silhouetted
on a luster-painted ground; six diagonally
arranged panels with a scrolling vegetal
design on a dotted ground; Xs in staggered
rows (pattern 19); and a large circular design
with a smaller circular design above and
below, all three set in larger circular frames,
on a ground of dots and commas partitioned
into hexagonal sections. The neck, springing
from a pronounced molding, bears seven
panels, each with a vegetal design set into a
circular frame reserved on a luster-painted
ground. The jar is underglaze-painted in
cobalt blue under a clear colorless glaze with
a slight greenish tint and luster-painted in
chocolate brown. It is made in two sections
joined at the middle.

No waster of this type is known.

RELATED WORKS: For the only other example
of similar scale and type, see Freer Gallery of
Art, Smithsonian Institution, Washington, D.C.,
1908.116 (acquired from Tabbagh Frères; see
page 18, figs. 1.2, 1.3), which bears the same
principal decoration as Aleppo National Museum
561,[1] namely, a radiating sunburst with a human
face circumscribed in a circle. For a much smaller
luster-painted jar bearing three of the same
designs as the New York jar, see Aleppo National
Museum 292 (excavated in al-Ramallah by a
Japanese team). For a slightly warped conical
bowl of this type, see Museum für Islamische
Kunst, Staatliche Museen zu Berlin I.3991
(purchased by Friedrich Sarre in Aleppo; see
page 171, fig. 5.2).

PROVENANCE: Said to be from the palace of
Harun al-Rashid and Wathiq; acquired with
MMA32 and a third object from Kouchakji
Frères, September 1911, for $15,000 (equiva-
lent to $295,232 in 2003; see page 19, fig. 1.4);
H. O. Havemeyer; Horace Havemeyer.

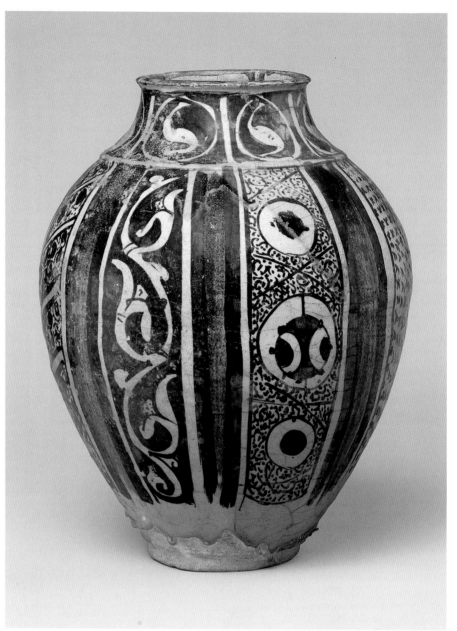

MMA9

REFERENCES: Kouchakji 1923: 522; Dimand
1949: 140; Grube 1963: 60, fig. 16.

1. *Land des Baal* 1982: 236, no. 255.

MMA10. Segmental bowl with flat rim, profile 2

Composite body, underglaze- and luster-painted
Height 4⅛ in. (10.5 cm), diameter 13¾ in. (34.9 cm)
Inscribed: sa'āda kāmila (Consummate happiness) [repeated twice]

The Metropolitan Museum of Art, H. O. Havemeyer Collection, Gift of Horace Havemeyer, 1948
48.113.5

Interior decoration consists of a symmetrical reserved arabesque (pattern 18) and reserved split palmettes, all circumscribed by two concentric bands, one narrow, the outermost broad and highlighted by evenly spaced trefoils (pattern 7). The cavetto has a wide decorative band divided by circular motifs into four cartouches, two containing cursive-script panels on spiraling ground (pattern 2) with randomly placed reserved vegetal designs and circles, the others an abbreviated symmetrical reserved arabesque design (pattern 18). Each circular motif comprises a roundel, with the outermost edge high-lighted by evenly spaced dots circumscribed by two concentric circles and the innermost with dots at each of the cardinal points. The flat rim has a calligraphy band (pattern 1) bordered above and below by a broad plain band. The exterior decoration consists of a spiral back (pattern 6) at the top of the wall just below the rim. A broad plain band is set below this decorative band and again around the edge of the rim. The bowl is underglaze-painted in cobalt and turquoise blue under a clear colorless glaze and luster-painted in chocolate brown.

This bowl appears in the Marcopoli photographs (see page 29, fig. 2.4).

RELATED WORKS: For wasters of this type, see Karatay Museum, Konya, 20/2, 20/4 (chapter 3, w26, w27).

PROVENANCE: In possession of Kouchakji Frères, Paris, 1910; H. O. Havemeyer; Horace Havemeyer.

REFERENCES: Sarre and Martin 1912, pl. 94, no. 1084; Grube 1963: 64, fig. 22.

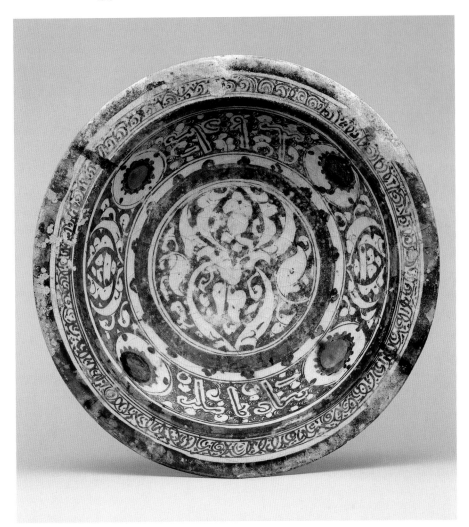

MMA10, interior

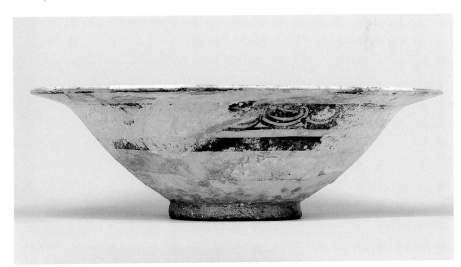

MMA10, profile

MMA11. Biconical bowl, profile 3

Composite body, underglaze- and luster-painted
Height 4¾ in. (11.9 cm), diameter 9¼ in.
(23.6 cm)
Inscribed: at center, al-ʿizz (Glory [repeated]); on
four radiating panels, baraka kāmila (Consummate
blessing) [in two abbreviated forms]

The Metropolitan Museum of Art, H. O. Havemeyer
Collection, Gift of Horace Havemeyer, 1948
48.113.6

Interior decoration consists of a tripartite design circumscribed in a circle consisting of the inscription *al-ʿizz* on a spiraling ground (pattern 4) bordered above and below by abbreviated symmetrical reserved arabesque designs (pattern 18). Eight panels with two alternating designs radiate from the central roundel. One design consists of Xs in staggered rows (pattern 19), the second comprises cursive-script panels on a spiraling ground (pattern 2) with randomly placed reserved split palmettes and circles, sometimes containing stylized vegetal designs. A broad plain band encircles the rim; panels are separated by two thin bands and one wider band flanking an underglaze-painted band. The exterior decoration consists of a spiral back (pattern 6) bordered above and below by three bands, two plain and one wavy. A broad plain band encircles the rim and decorates the lower wall. The bowl is underglaze-painted in cobalt blue under a clear colorless glaze and luster-painted in chocolate brown.

RELATED WORKS: For a waster of this type, see Karatay Museum, Konya, 18/2 (chapter 3, w19). For a fragmentary bowl of this type brought from Raqqa in 1903, see Museum of Turkish and Islamic Art, Istanbul, 1657/1975. For a complete example of this type, see Ashmolean Museum of Art and Archaeology, Oxford, x3067.

PROVENANCE: Sold in Kouchakji Frères sale, 1918, lot 301, to Joseph Brummer, for $525 (equivalent to $6,415 in 2003); H. O. Havemeyer; Horace Havemeyer.

REFERENCES: Dimand 1949: 140; Mayor 1957: 97 (illustration at lower right); Grube 1963: 64, fig. 21.

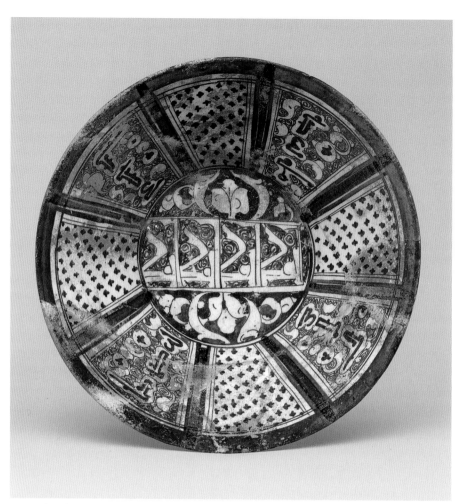

MMA11, interior

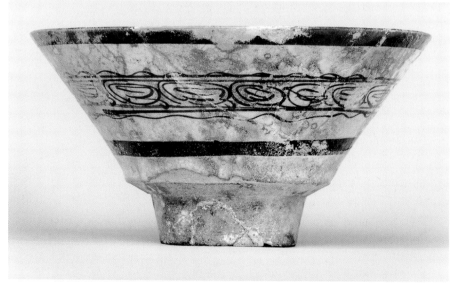

MMA11, profile

MMA12. Modified hemispherical bowl, profile 12

Composite body, underglaze- and luster-painted
Height 4⅝ in. (11.7 cm), diameter 8¼ in. (21 cm)
Inscribed: on interior, ʿizz yadūm (Lasting glory);
on exterior, . . . dāʾima (Lasting . . .)

The Metropolitan Museum of Art, H. O. Havemeyer
Collection, Gift of Horace Havemeyer, 1948
48.113.7

Interior decoration consists of a roundel with an Arabic inscription in cursive script within contour panels reserved on a spiraling ground that also silhouettes randomly placed vegetal motifs. The roundel is circumscribed by three decorative bands, one with evenly spaced spiral-filled quadrilaterals (pattern 10), one with a calligraphy band (pattern 1), and the uppermost with evenly spaced trefoils (pattern 7) bordered above and below by a broad plain band. The exterior has a wide decorative band divided by circular motifs into four cartouches. Two cartouches contain cursive-script panels on a spiraling ground (pattern 2), the other two have an abbreviated symmetrical reserved arabesque design (pattern 18, possibly reserved on a spiraling ground). Circular motifs separating the cartouches each contain an underglaze-painted roundel circumscribed by a circle (the outer edge of which is highlighted by evenly spaced dots) and by two concentric circles. The principal band is bordered above and below by a broad plain band. The bowl is underglaze-painted in cobalt blue under a clear colorless glaze with a greenish tinge and luster-painted in chocolate brown.

RELATED WORKS: For wasters of this type but not of the same shape, see Museum of Turkish and Islamic Art, Istanbul, 1604/1529 (chapter 3, w45), and Freer Gallery of Art, Smithsonian Institution, Washington, D.C., 1905.240 (w35). For a waster of the same shape but with different decoration and color scheme, see Museum of Turkish and Islamic Art, Istanbul, 1713/1494 (w108).

PROVENANCE: H. O. Havemeyer; Horace Havemeyer.

REFERENCES: Unpublished.

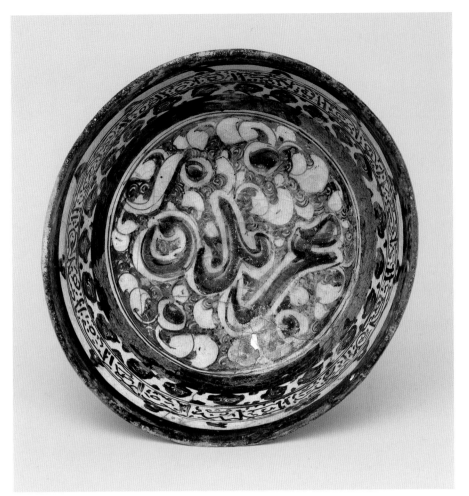

MMA12, interior

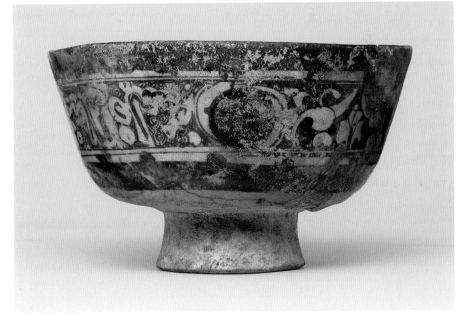

MMA12, profile

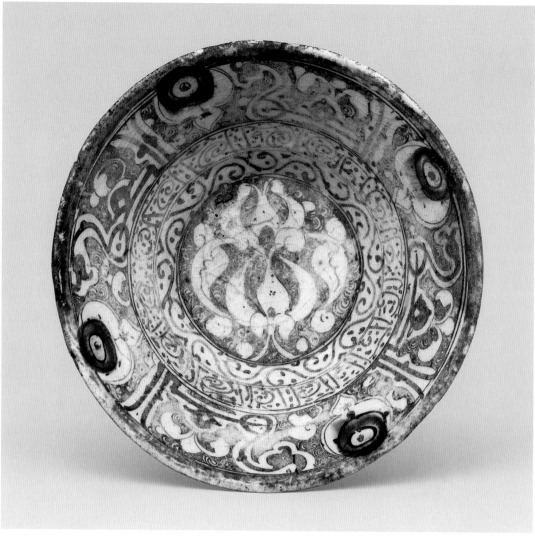

MMA13

MMA13. Biconical bowl, profile 3

Composite body, underglaze- and luster-painted
Height 3⅛ in. (7.8 cm), diameter 5⅞ in. (15 cm)
Inscribed: al-ʿizz (Glory) [repeated four times]

The Metropolitan Museum of Art, H. O. Havemeyer
Collection, Gift of Horace Havemeyer, 1948
48.113.8

Interior decoration consists of a palmette tree reserved on a spiraling ground circumscribed by four concentric bands. The first band has a vegetal scroll reserved on a luster-painted ground, the second is a calligraphy band (pattern 1). The broad third band is divided by circular motifs into four cartouches, each bearing the inscription *al-ʿizz* on a spiraling ground (pattern 4). Each circular motif separating the cartouches consists of an underglaze-painted circle outlined in luster and framed by a pendant medallion. The rim is encircled by a fourth band that is broad and plain. The exterior decoration consists of a band of spiral back (pattern 6) bordered above and below with a broad plain band, the former surrounding the edge of the rim. The bowl is underglaze-painted in cobalt blue under a clear colorless glaze with a greenish tint and luster-painted in chocolate brown.

RELATED WORKS: For wasters of this type, see Karatay Museum, Konya, 17/1, 17/2, 18/3, Victoria and Albert Museum, London, c851-1922, and Ethnographical Museum, Ankara, 7379 (chapter 3, W7–W11). For complete examples of this type, see National Museum, Damascus, 9656 (purchased), Freer Gallery of Art, Smithsonian Institution, Washington, D.C., 1908.145 (acquired from Vincenzo Marcopoli & Co., Aleppo), Walters Art Museum, Baltimore, 48.1084, and Ashmolean Museum of Art and Archaeology, Oxford, 1956.147.

PROVENANCE: H. O. Havemeyer; Horace Havemeyer.

REFERENCES: Unpublished.

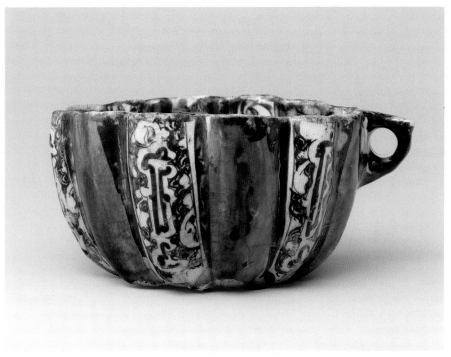

MMA14

MMA14. Lobed cup with handle, profile 9

Composite body, underglaze- and luster-painted
Height 3¼ in. (8.4 cm), diameter 6⅛ in. (15.7 cm)
Inscribed: baraka (Blessing).

The Metropolitan Museum of Art, H. O. Havemeyer
Collection, Gift of Horace Havemeyer, 1948
48.113.9

This twelve-lobed cup bears two alternating patterns on the exterior: one, a cursive-script panel on a spiraling ground (pattern 2), the other, an underglaze-painted petal pattern. The interior of the lobes bears a leaf scroll reserved on a spiraling ground alternating with luster-painted lobes with an incised, illegible design. An underglaze-painted cobalt blue stripe highlights each interior rib. The central design on the interior is no longer visible. The ring handle is luster-painted. The cup is underglaze-painted in cobalt blue under a clear colorless glaze with a slight greenish tint and luster-painted in chocolate brown.

No waster of this type is known.

RELATED WORKS: For a cup of this shape, decoration type, and technique but forming part of a tall-stemmed goblet with no handle, see Freer Gallery of Art, Smithsonian Institution, Washington, D.C., 1908.152 (acquired from Vincenzo Marcopoli & Co., Aleppo).

PROVENANCE: Great Find; H. O. Havemeyer; Horace Havemeyer.

REFERENCES: Kouchakji 1923: 523; Dimand 1931: 38, no. 166 (no illustration); Grube 1963: 61, fig. 18.

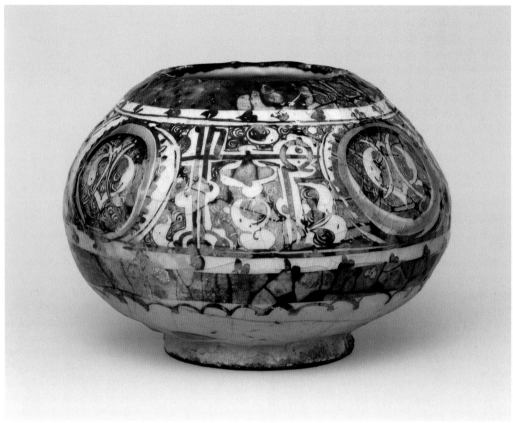

MMA15

MMA15. Segmental bowl with upper section sloping to small rimless opening, profile 6

Composite body, underglaze- and luster-painted
Height 5 in. (12.8 cm), diameter 7¼ in. (18.3 cm)
Inscribed: al-ʿizz (Glory) [repeated four times];
on paper label on interior: To Horace/from
Mother/March 19 191[7?]

The Metropolitan Museum of Art, H. O. Havemeyer
Collection, Gift of Horace Havemeyer, 1948
48.113.10

Decoration consists of a wide band divided into four cartouches by evenly spaced circular motifs, each bearing a split palmette design reserved on a spiraling ground and circumscribed by an underglaze-painted circular frame, as well as by one wide and two thin luster-painted frames. The wide luster-painted border is outlined with a series of evenly spaced dots. Cartouches have the inscription *al-ʿizz* on a spiraling ground (pattern 4), the word inverted and framed in contour panels. The principal band is highlighted above and below by evenly spaced trefoils (pattern 7), and the whole is bordered above and below by broad plain bands. A narrow scalloped band appears below the broad plain band at the bottom. The bowl is underglaze-painted in cobalt blue under a clear colorless glaze with a slight greenish tint and luster-painted in chocolate brown. It is made in two sections joined at the middle.

RELATED WORKS: For a waster of this shape but in black under a turquoise glaze, see Ashmolean Museum of Art and Archaeology, Oxford, x3027 (chapter 3, w109). For complete examples of this type, see Freer Gallery of Art, Smithsonian Institution, Washington, D.C., 1908.138,[1] 10.28AB (both acquired from Vincenzo Marcopoli & Co., Aleppo), and Metropolitan Museum of Art 57.61.2, 45.153.3 (MMA26, MMA31, the latter in black under a clear turquoise glaze).

PROVENANCE: Sold in Clarke sale 1917, lot 610, for $2,100 (equivalent to $30,138 in 2003); H. O. Havemeyer; Horace Havemeyer.

REFERENCES: Jenkins-Madina 2000: 86, fig. 18.

1. Atil 1973: 142, no. 64.

MMA16. Tazza

Composite body, underglaze- and luster-painted
Height 4¼ in. (10.8 cm), diameter 8½ in. (21.6 cm)
Inscribed: al-ʿizz (Glory) [repeated twice]

The Metropolitan Museum of Art, H. O. Havemeyer
Collection, Gift of Horace Havemeyer, 1948
48.113.11

The concave central area of the interior decoration consists of a symmetrical design, each half outlined in underglaze-painted blue and having an arabesque design in a contour panel reserved on a spiraling ground. The interstitial areas bear *al-ʿizz* on spiraling ground (pattern 4). The center is marked with a stylized vegetal design filled with dot clusters. The wide flat rim is divided by underglaze-painted stripes into eight sections of varying width, each containing split palmette designs silhouetted on a spiraling ground. A plain broad band encircles the rim. The exterior has a band of modified spiral back (pattern 6)—the large spiral alternating fourteen times with two smaller spirals, one above the other—bordered top and bottom by evenly spaced tripartite spiral designs. A broad plain band encircles the stem of the tall foot and rim. The tazza is underglaze-painted in medium blue under a clear colorless glaze with a greenish tint and luster-painted in chocolate brown.

This tazza appears in the Marcopoli photographs (see page 30, fig. 2.6, and page 31, fig. 2.8).

No waster of this object type is known, but segmental bowls with a flat rim (profile 2) are common.

PROVENANCE: H. O. Havemeyer; Horace Havemeyer.

REFERENCES: Dimand 1931, no. 167; Dimand 1949: 140; Grube 1963: 65, fig. 23.

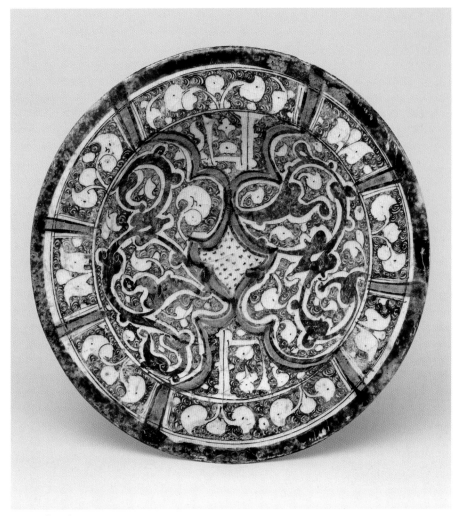

MMA16, interior

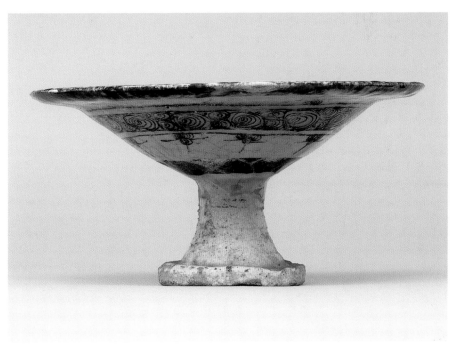

MMA16, profile

MMA17. Albarello, profile 8

*Composite body, underglaze- and luster-painted
Height 9¾ in. (24.9 cm), diameter 5⅜ in.
(13.8 cm)*

*The Metropolitan Museum of Art, H. O. Havemeyer
Collection, Gift of Horace Havemeyer, 1948
48.113.12*

This polygonal albarello has a slightly sloping
shoulder, cylindrical neck, and flaring rim on
a low, slightly flaring foot. The twelve flutes
on the body are decorated with two alternat-
ing vegetal designs, one an arabesque scroll
reserved on a spiraling ground, the other a
reciprocal luster-painted feathery leaf design
and a thin contoured band running between
leaves on a dotted ground. A broad luster-
painted band flanks flutes above and below.
The neck has a calligraphy band (pattern 1).
The shoulder and rim each bear a broad plain
band. The albarello is underglaze-painted in
cobalt blue under a clear colorless glaze with
a slight greenish tint and luster-painted in
chocolate brown. It is made in two sections
joined near the middle.

RELATED WORKS: For a waster of this type
but without an underglaze-painted program, see
Freer Gallery of Art, Smithsonian Institution,
Washington, D.C., 1910.36 (acquired from
Vincenzo Marcopoli & Co., Aleppo; chapter 3,
w74). For complete examples of this type, see
Museum of Islamic Art, Doha, Qatar, PO-68-1999,
and a second albarello whose present where-
abouts are unknown.[1]

PROVENANCE: H. O. Havemeyer; Horace
Havemeyer.

REFERENCES: Grube 1963: 61, fig. 17; Hess
2004: 138–39, pl. 32.

1. Kelekian 1910, pl. 36.

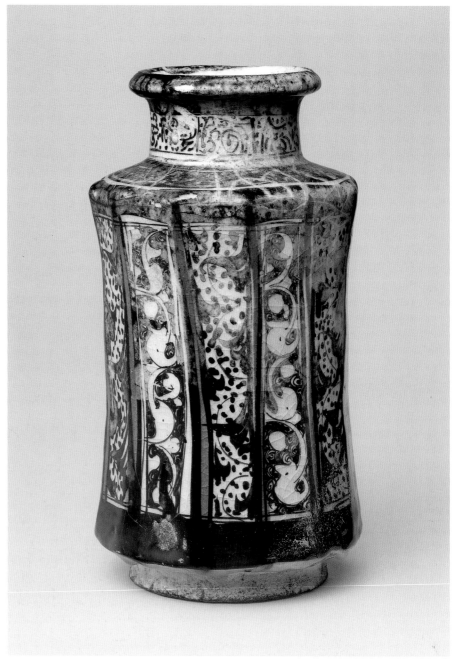

MMA17

MMA18. Inverted pear-shaped jar with cylindrical neck and everted rim, profile 1

Composite body, underglaze- and luster-painted
Height 9¾ in. (24.8 cm), diameter 6⅞ in.
(17.5 cm)
Inscribed: saʿāda . . . niʿma (Happiness . . . grace)
[repeated twice, once in each cartouche]

The Metropolitan Museum of Art, H. O. Havemeyer
Collection, Gift of Horace Havemeyer, 1948
48.113.13

Body decoration consists of a wide band divided by circular motifs into four cartouches. Two cartouches contain cursive-script panels on a spiraling ground (pattern 2); the others include a reserved arabesque design composed of paired split palmettes that, in one cartouche, are enclosed by another pair of split palmettes. The circular motifs that separate the cartouches each surround a central roundel filled with Xs and bordered by an underglaze-painted circular band (turquoise alternating with cobalt) flanked by luster-painted bands, the outermost band with evenly spaced dots on its outer edge. The principal band is bordered above and below by a calligraphy band (pattern 1) followed by a broad plain band. The cylindrical neck is decorated with a calligraphy band (pattern 1) bordered above and below by a broad plain band. The jar is underglaze-painted in cobalt and turquoise blue under a clear colorless glaze with a greenish tint and luster-painted in chocolate brown. It is made in two sections joined at the middle.

RELATED WORKS: For a waster of this type, see the vase formerly in the Sir Eldred Hitchcock collection (chapter 3, w66). For complete but smaller examples of this type, see Freer Gallery of Art, Smithsonian Institution, Washington, D.C., 1908.141 (acquired from Vincenzo Marcopoli & Co., Aleppo),[1] and National Museum, Damascus, 6712 (purchased).

PROVENANCE: Great Find; sold in Clarke sale 1925, lot 645, for $2,000 (equivalent to $20,994 in 2003); H. O. Havemeyer; Horace Havemeyer.

REFERENCES: Dimand 1931, no. 164 (no illustration).

1. Atıl 1973: 148, no. 67.

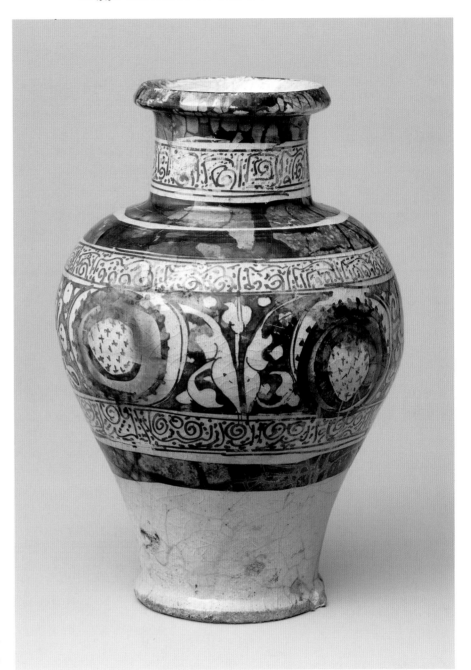

MMA18

MMA19. Inverted pear-shaped jar with cylindrical neck and everted rim, profile 1

Composite body, underglaze- and luster-painted
Height 9⅝ in. (24.3 cm), diameter 6¾ in.
(17.1 cm)

The Metropolitan Museum of Art, H. O. Havemeyer
Collection, Gift of Horace Havemeyer, 1948
48.113.14

The principal band of decoration consists of six staggered rows of spiral-filled quadrilaterals (pattern 10) framed above and below by narrow underglaze-painted and broad luster-painted bands. The cylindrical neck bears a calligraphy band (pattern 1) bordered by a broad plain band above and below, the former extending to the top of the rim. The jar is underglaze-painted in cobalt blue under a clear colorless glaze with a slight greenish tint and luster-painted in chocolate brown. It is made in two sections joined at the middle.

This jar appears in the Marcopoli photographs (see page 30, fig. 2.7).

RELATED WORKS: For a waster of this type, see Victoria and Albert Museum, London, 109-1909 (chapter 3, w63). For a complete, very similar example of this type, see National Museum, Damascus, 10446 (purchased).

PROVENANCE: Great Find; sold in Clarke sale 1925, lot 647, for $1,200 (equivalent to $12,597 in 2003); H. O. Havemeyer; Horace Havemeyer.

REFERENCES: *Islamische Kunst* 1981: 128–29; *Orient de Saladin* 2001: 178, no. 176.

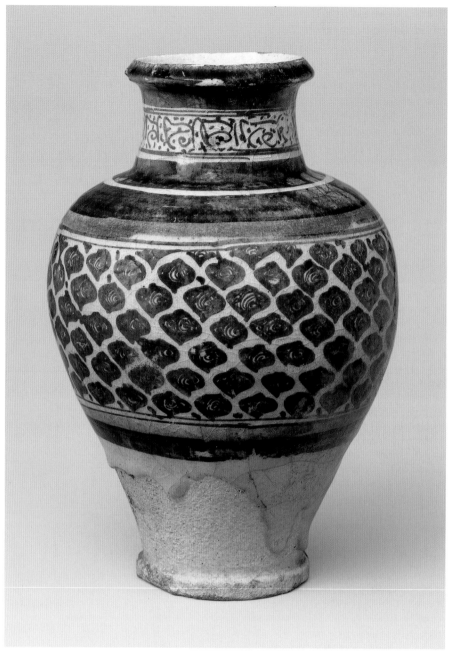

MMA19

MMA20. Inverted pear-shaped jar with cylindrical neck and everted rim, profile 1

Composite body, underglaze- and luster-painted
Height 9⅜ in. (23.9 cm), diameter 6⅝ in.
(16.9 cm)

The Metropolitan Museum of Art, H. O. Havemeyer
Collection, Gift of Horace Havemeyer, 1948
48.113.15

The principal band of decoration consists of five staggered rows of spiral-filled quadrilaterals (pattern 10) framed above and below by a calligraphy band (pattern 1). A similar band decorates the cylindrical neck and is bordered by a broad plain band above and below, the former extending to the top of the rim. Four randomly spaced vertical underglaze-painted stripes extend through the principal band and its pseudo-calligraphic frames. The jar is underglaze-painted in cobalt blue under a clear colorless glaze with a greenish tint and luster-painted in chocolate brown. It is made in two sections joined at the middle.

RELATED WORKS: For wasters of very similar type, see Museum of Turkish and Islamic Art, Istanbul, 1554/4044, and Karatay Museum, Konya, 34/2 (chapter 3, w64, w66). For related complete examples, see Aleppo National Museum 616 (gift), National Museum, Damascus, 6711, 5946 (former, purchase; latter, gift), and Freer Gallery of Art, Smithsonian Institution, Washington, D.C., 1908.137 (acquired from Vincenzo Marcopoli & Co., Aleppo).

PROVENANCE: Great Find; sold in Clarke sale 1925, lot 646, for $2,200 (equivalent to $23,094 in 2003); H. O. Havemeyer; Horace Havemeyer.

REFERENCES: Grube 1963: 62, fig. 19.

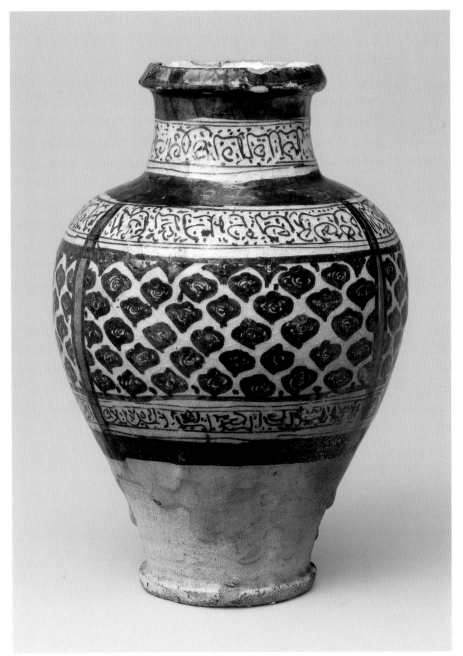

MMA20

MMA21. Tall-neck jug on high foot, profile 4

*Composite body, underglaze- and luster-painted
Height 7½ in. (18.9 cm), diameter 5¼ in. (13.3 cm)
Inscribed: al-baraka al-dāʾima waʾl-sulāla al-dāʾima waʾl-jadd . . . (Lasting blessing, lasting progeny, and [good] fortune)*

*The Metropolitan Museum of Art, H. O. Havemeyer Collection, Gift of Horace Havemeyer, 1948
48.113.16*

Body decoration consists of a wide band containing four evenly spaced roundels with a geometric repeat pattern circumscribed by an underglaze-painted frame and bordered by thin luster-painted lines. The interstitial areas bear an inverted palmette tree reserved on a spiraling ground. The principal band is bordered at the bottom by a broad plain band and at the top by a calligraphy band (pattern 1). The slightly tapering neck is decorated with an underglaze-painted cursive inscription in contour panels reserved on a spiraling ground. The broad plain band at the rim extends onto the interior of the neck. The underglaze-painted handle is decorated with four luster-painted horizontal stripes. The jug is underglaze-painted in cobalt blue under a clear colorless glaze with a greenish tint and luster-painted in chocolate brown.

This jug appears in the Marcopoli photographs (see page 31, fig. 2.9).

RELATED WORKS: For a waster of this type with a slightly different shape and underglaze-painted program, see Los Angeles County Museum of Art M.2002.1.211 (chapter 3, W56; provenance unknown). Three additional objects of identical shape are in the Metropolitan Museum: 48.113.17 (exhibiting decoration very similar to that of the present vessel), 48.113.18, 57.61.1 (MMA22, MMA23, MMA25). See also Raqqa Museum 930. Vessels of this shape are among those from the Great Find.

PROVENANCE: H. O. Havemeyer; Horace Havemeyer.

REFERENCES: Dimand 1958: 370, fig. 237; Grube 1963: 66, fig. 24; Jenkins, Meech-Pekarik, and Valenstein 1977, fig. 247; Jenkins 1983b: 24, no. 26: Frelinghuysen et al. 1993: 120, pl. 110.

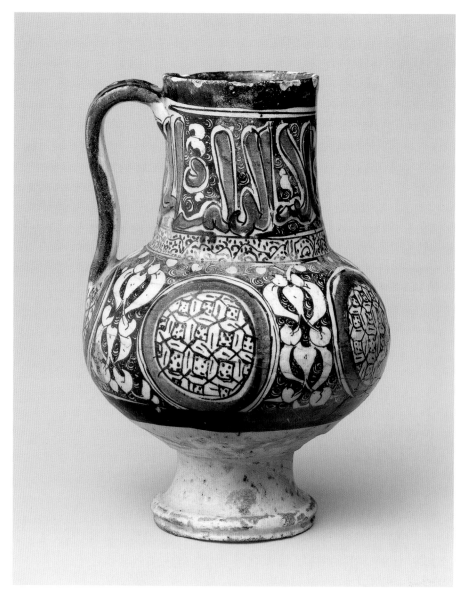

MMA21

MMA22. Tall-neck jug on high foot, profile 4

Composite body, underglaze- and luster-painted
Height 7½ in. (18.9 cm), diameter 5⅜ in. (13.8 cm)
Inscribed: al-ʿizz (Glory) [repeated]

The Metropolitan Museum of Art, H. O. Havemeyer
Collection, Gift of Horace Havemeyer, 1948
48.113.17

Body decoration consists of a wide band
containing four evenly spaced roundels with
a geometric repeat pattern circumscribed
by an underglaze-painted frame bordered by
thin luster-painted lines. The interstitial
areas bear an inverted palmette tree reserved
on a spiraling ground. The principal band is
bordered at the bottom by a broad plain band
and a narrow scalloped band, and at the top
by a calligraphy band (pattern 1). The slightly
tapering neck is decorated with the inscription
al-ʿizz on spiraling ground (pattern 4) and
bordered above and below by an underglaze-
painted band. The broad plain band at the
rim extends onto the interior of the neck. The
underglaze-painted handle is decorated with
five luster-painted horizontal stripes. The jug
is underglaze-painted in cobalt blue under a
clear colorless glaze with a greenish tint and
luster-painted in chocolate brown.

This jug appears in the Marcopoli photo-
graphs (see page 31, fig. 2.9).

No waster of this type is known.

RELATED WORKS: Three additional objects of
identical shape are in the Metropolitan Museum:
48.113.16 (exhibiting decoration very similar to
that of the present vessel), 48.113.18, and 57.61.1
(MMA21, MMA23, MMA25). Vessels of this shape
are among those from the Great Find.

PROVENANCE: H. O. Havemeyer; Horace
Havemeyer.

REFERENCES: Unpublished.

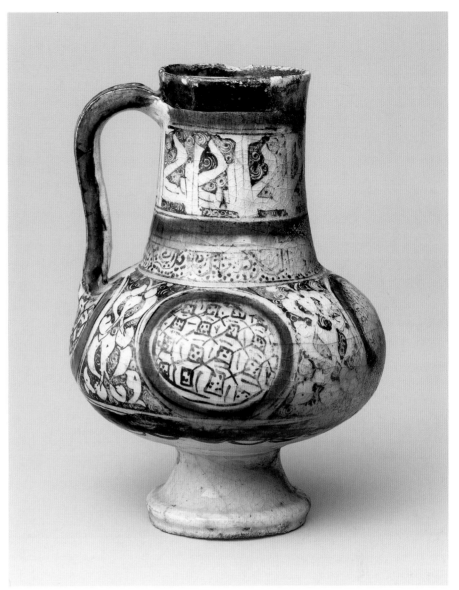

MMA22

MMA23. Tall-neck jug on high foot, profile 4

Composite body, underglaze- and luster-painted
Height 7¼ in. (18.4 cm), diameter 5⅛ in.
(13.1 cm)
Inscribed: al-ᶜizz . . . (. . . glory . . .)

The Metropolitan Museum of Art, H. O. Havemeyer
Collection, Gift of Horace Havemeyer, 1948
48.113.18

Body decoration consists of a wide band containing lattice silhouetted on a spiraling ground. Each section of lattice encloses a "haloed" vegetal design. The band is bordered at the bottom by one narrow and one wide luster-painted band flanking an underglaze-painted band, and at the top by a band bearing the inscription *al-ᶜizz* on a spiraling ground (pattern 4) divided into sections by four groups of circles with an underglaze-painted roundel at the center of each group. The slightly tapering neck bears *al-ᶜizz* on a spiraling ground, as well as two additional words interspersed with arabesque designs in contour panels. The rim has a plain broad luster-painted band above a narrower underglaze-painted band. The luster-painted handle is decorated with three underglaze-painted horizontal stripes. The jug is underglaze-painted in cobalt blue under a clear colorless glaze with a greenish tint and luster-painted in chocolate brown.

No waster of this type is known.

RELATED WORKS: Three additional objects of identical shape are in the Metropolitan Museum: 48.113.16, 48.113.17, 57.61.1 (MMA21, MMA22, MMA25). For another, quite similar example of this type, see Freer Gallery of Art, Smithsonian Institution, Washington, D.C., 1908.140 (acquired from Vincenzo Marcopoli & Co., Aleppo, and among objects from the Great Find).[1] According to records at the Freer Gallery, Fahim Kouchakji stated that the jug and certain other pieces owe their good condition to having been packed inside a large jar found at Raqqa, from which location they were brought to the Aleppo market. The interior decoration on a segmental bowl with flat rim (profile 2), also in the Freer Gallery and acquired from the same dealer (1908.151), is very similar to that on the body of the present jug. Vessels of this shape are among those from the Great Find.

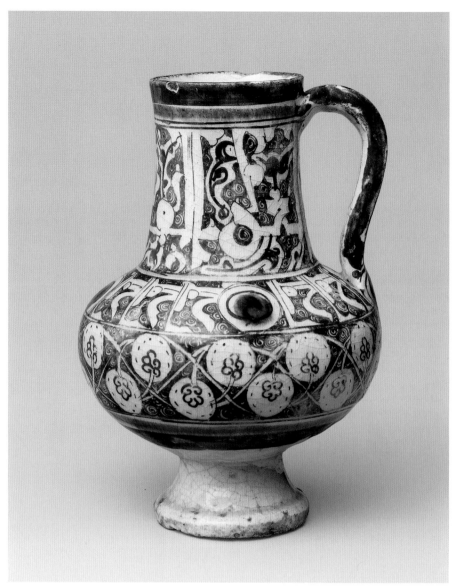

MMA23

PROVENANCE: Sold in Kouchakji Frères sale 1918, lot 308, for $1,525 (equivalent to $18,635 in 2003); H. O. Havemeyer; Horace Havemeyer.

REFERENCES: Dimand 1931: 37, no. 161 (no illustration); Dimand 1949: 140 (illustration in lower right corner); Grube 1963: 68, fig. 25.

1. Atil 1975: 81, no. 35.

MMA24. Medium-neck jug, profile 7

Composite body, underglaze- and luster-painted
Height 6⅝ in. (16.7 cm), diameter 5¼ in.
(13.2 cm)
Inscribed: niʿma kāfiya (Abundant grace); jadd
shāmil (Total good fortune); niʿma kāfiya
(Abundant grace) [A fourth inscription is illegible.]

The Metropolitan Museum of Art, H. O. Havemeyer
Collection, Gift of Horace Havemeyer, 1948
48.113.19

Body decoration consists of a wide band containing four evenly spaced roundels composed of two dotted circles, the innermost circle circumscribing an inverted trilobed leaf reserved in a roundel with spiraling ground. The interstitial areas bear cursive-script panels on a spiraling ground (pattern 2). The decorative band is bordered above and below by an underglaze-painted band bordered in turn by luster-painted bands of varying widths. The slightly tapering neck bears reserved interlace on a spiraling ground (pattern 20) bordered at the top by underglaze-painted and luster-painted bands; the rim is surrounded by a luster-painted band. The handle is luster-painted. The jug is underglaze-painted in cobalt blue under a clear colorless glaze with a greenish tint and luster-painted in chocolate brown.

This jug appears in the Marcopoli photographs (see page 31, fig. 2.9).

No waster of this shape with such underglaze-painted decoration is known.

PROVENANCE: H. O. Havemeyer; Horace Havemeyer.

REFERENCES: Unpublished.

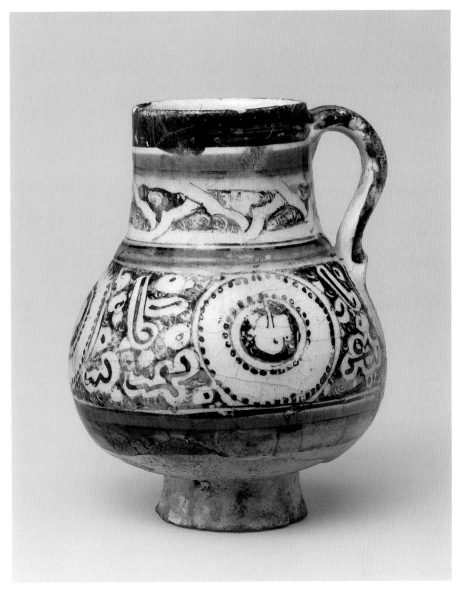

MMA24

MMA25. Tall-neck jug on high foot, profile 4

Composite body, underglaze- and luster-painted
Height 7¼ in. (18.5 cm), diameter 5⅛ in. (13 cm)
Inscribed: al-ᶜizz . . . (. . . glory . . .)

The Metropolitan Museum of Art, Henry G.
Leberthon Collection, Gift of Mr. and Mrs. A.
Wallace Chauncey, 1957 57.61.1

Body decoration consists of a wide band with
an elaborate arabesque design reserved on a
spiraling ground highlighted with four evenly
spaced underglaze-painted vegetal motifs. A
broad plain band borders the principal band
at the bottom. The slightly tapering neck
bears a reserved *al-ᶜizz* on a spiraling ground
(pattern 4), as well as two additional words
in contour panels bordered above by a much
simpler version of the design on the principal
band. The broad plain band at the rim extends
onto the interior of the neck. The luster-painted
handle is highlighted with two underglaze-
painted vegetal motifs. The jug is underglaze-
painted in cobalt blue under a clear colorless
glaze with a greenish tint and luster-painted
in chocolate brown.

RELATED WORKS: For a waster of this type
with slightly different shape, see Museum of
Turkish and Islamic Art, Istanbul, 1577/1434
(chapter 3, w55). Three additional objects of
identical shape are in the Metropolitan Museum:
48.113.16, 48.113.17, 48.113.18 (MMA21–MMA23).
Vessels of this shape are among those from the
Great Find.

PROVENANCE: H. G. Leberthon; Mrs. A. W.
Chauncey.

REFERENCES: Dimand 1931: 37, no. 160;
Lukens 1965: 12, fig. 21; *Islamische Kunst* 1981:
126–27, no. 46.

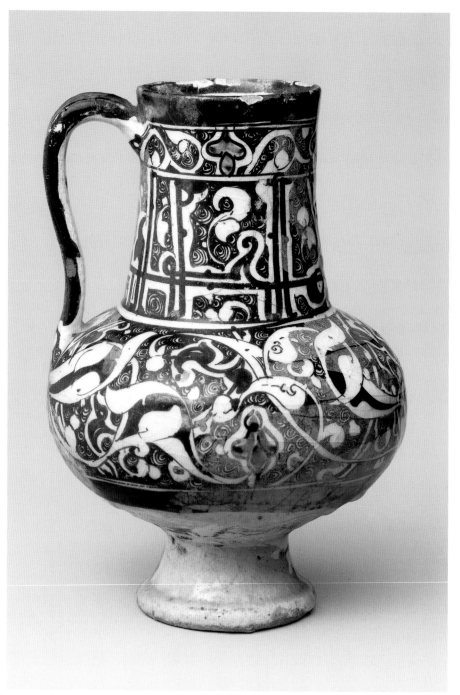

MMA25

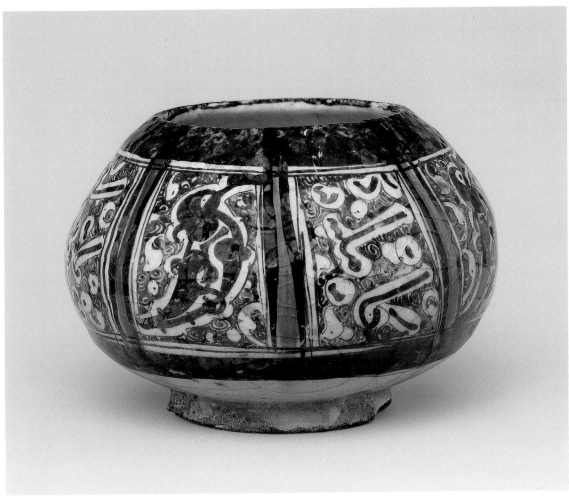

MMA26

MMA26. Segmental bowl with upper section sloping to small rimless opening, profile 6

Composite body, underglaze- and luster-painted
Height 4¾ in. (12.1 cm), diameter 7 in. (17.7 cm)
Inscribed: niʿma shāfiya (Healing grace) [repeated twice]; kāmila (Consummate); niʿma bāqiya lahu (Continuing grace to him [its owner])

The Metropolitan Museum of Art, Henry G. Leberthon Collection, Gift of Mr. and Mrs. A. Wallace Chauncey, 1957 57.61.2

Body decoration consists of a wide band divided by vertical underglaze-painted stripes into eight panels that contain two alternating designs. One design is a variant of the hillock with three leaves (pattern 5) in a contour panel reserved on a spiraling ground and extending diagonally from upper right to lower left. The second design comprises vertically aligned cursive-script panels on a spiraling ground (pattern 2). A wide plain band borders the principal band above and below. The bowl is underglaze-painted in cobalt blue under a clear colorless glaze with a greenish tint and luster-painted in chocolate brown. It is made in two sections joined at the middle.

RELATED WORKS: For a waster of this shape but in black under turquoise glaze, see Ashmolean Museum of Art and Archaeology, Oxford, x3027 (chapter 3, w109). For complete examples of this type, see Freer Gallery of Art, Smithsonian Institution, Washington, D.C., 1908.138,[1] 10.28AB (both acquired from Vincenzo Marcopoli & Co., Aleppo), and Metropolitan Museum of Art, 48.113.10, 45.153.3 (MMA15, MMA31; latter in black under clear turquoise glaze).

PROVENANCE: H. G. Leberthon; Mrs. A. W. Chauncey.

REFERENCES: Unpublished.

1. Atil 1973: 142, no. 64.

MMA27. Inverted pear-shaped jar with cylindrical neck and everted rim, profile 1

Composite body, underglaze- and luster-painted
Height 6⅜ in. (16.1 cm), diameter 4¾ in. (12 cm)
Inscribed: saʿada shāmila sulāla dāʾima (Total happiness, lasting progeny) [repeated, with one indecipherable word between the two pairs]

The Metropolitan Museum of Art, Henry G. Leberthon Collection, Gift of Mr. and Mrs. A. Wallace Chauncey, 1957 57.61.3

The principal decorative band consists of a cursive Arabic inscription in contour panels reserved on a spiraling ground framed above and below with narrow underglaze-painted and broad luster-painted bands. The cylindrical neck bears a calligraphy band (pattern 1) bordered by a broad plain band above and below, the former extending onto the inside of the rim. The jar is underglaze-painted in cobalt blue under a clear colorless glaze with a greenish tint and luster-painted in chocolate brown.

RELATED WORKS: For a waster of this type, see Victoria and Albert Museum, London, 109-1909 (chapter 3, w63). For a very similar complete example, see Freer Gallery of Art, Smithsonian Institution, Washington, D.C., 1908.141 (acquired from Vincenzo Marcopoli & Co., Aleppo).[1]

PROVENANCE: H. G. Leberthon; Mrs. A. W. Chauncey.

REFERENCES: Dimand 1931: 37, no. 163.

1. Atil 1973: 148, no. 67.

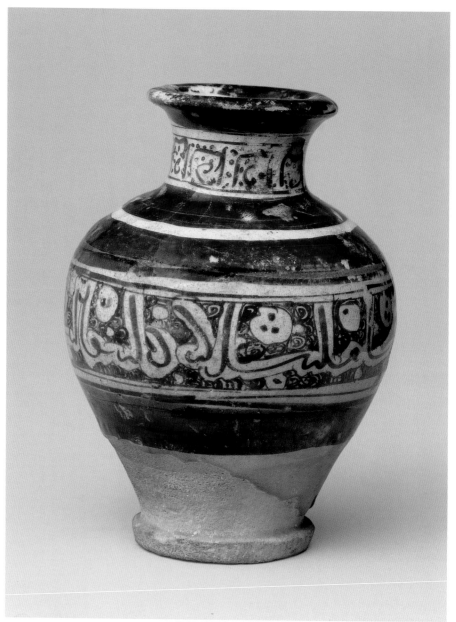

MMA27

MMA28. Segmental bowl with flat rim, profile 2

Composite body, glazed and luster-painted
Height 3½ in. (8.9 cm), diameter 12⅜ in. (31.5 cm)

The Metropolitan Museum of Art, Rogers Fund,
1970 1970.24

Interior decoration consists of a duck with a dotted body reserved on a luster-painted ground highlighted with reserved palmette leaves. The wide flat rim is divided by paired broad lines into eight sections, each bearing vegetal scrolls and large Xs on a dotted ground. The exterior is undecorated except for a plain band at the rim. The bowl is covered with a clear colorless glaze with a greenish tint and is luster-painted.

FIGURE 4.1. Luster-painted segmental bowl with flat rim. Raqqa, Syria, 1200–1230. National Museum, Damascus (6838). Photo: Marilyn Jenkins-Madina

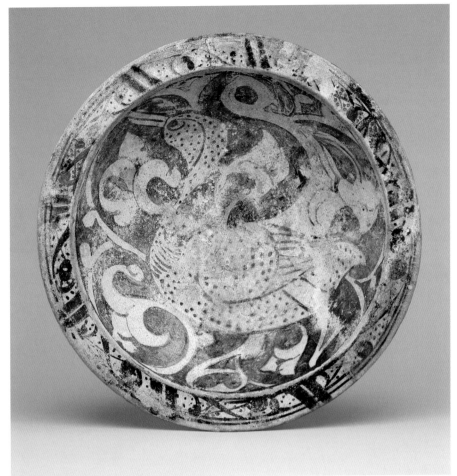

MMA28

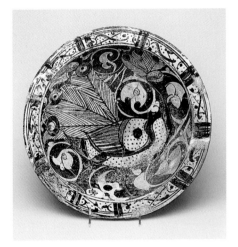

FIGURE 4.2. Underglaze- and luster-painted segmental bowl with flat rim. Raqqa, Syria, 1200–1230. Brooklyn Museum, Gift of Mr. and Mrs. Carl L. Selden (78.81)

RELATED WORKS: For two wasters of this type, see Karatay Museum, Konya, 20/5, and Museum of Turkish and Islamic Art, Istanbul, 1610/1502 (chapter 3, w24, w25). For seven bowls of this type, see National Museum, Damascus, 6838 (purchased; fig. 4.1), Aleppo National Museum 561 (excavated but no site given),[1] Walters Art Museum, Baltimore, 48.1231 (acquired from Dikran Khan Kelekian, 1927),[2] Nationalmuseet, Copenhagen, 10-3F139,[3] Çinili Köşk, Istanbul, 41/1486, Brooklyn Museum 78.81 (fig. 4.2), and Cleveland Museum of Art 44.75.[4] For another bowl of this type but exhibiting a different color scheme, see Raqqa Museum 480 (page 176, fig. 5.4). For a tile with a similar style of decoration, see Raqqa Museum 417.[5]

PROVENANCE: Charles D. Kelekian.

REFERENCES: *Islamische Kunst* 1981: 130–31, no. 48.

1. *Land des Baal* 1982: 236, no. 255.
2. Sarre 1927: 7–10, fig. 7.
3. Riis and Poulsen 1957: 199, pl. 667.
4. Lane 1947, illus. 59A.
5. Watson 1999, pl. 55b (illus. at lower right).

MMA29. Cono-segmental bowl, profile 13

Composite body, underglaze-painted
Height 4¼ in. (10.8 cm), diameter 9⅜ in. (23.7 cm)

The Metropolitan Museum of Art, Rogers Fund, 1922 22.196.1

Interior decoration consists of a hillock with three leaves (pattern 5) circumscribed by three concentric circles, the outermost circle bordered by a continuous wavy line. The interstitial areas to the right and left of the main design bear a filler with a leaf in concentric circles (pattern 8). The area within the central design is also filled with dots of varying sizes. The cavetto bears a triple guilloche (pattern 24) created by incising through the paint. The rim is circumscribed by a broad band. The exterior has only a single circular band (line back, pattern 3). The bowl is painted in black under a clear turquoise glaze.

The purchase form for this object, dated December 4, 1922, reads: "Bowl, Persian (so-called Rakka type), 10th–11th century. $450.00" (equivalent to $4,940 in 2003).

RELATED WORKS: For two wasters exhibiting both a similar decoration and color scheme, see Karatay Museum, Konya, 25/2, 26/3 (chapter 3, w80, w88). For wasters exhibiting a similar decorative motif, see Ashmolean Museum of Art and Archaeology, Oxford, 1978.2354, Karatay Museum, Konya, 23, and Museum für Islamische Kunst, Staatliche Museen zu Berlin I.1240 (chapter 3, w122, w123, w130). For complete examples exhibiting similar decoration and color scheme, see Victoria and Albert Museum, c417-1940 (Gift of Mr. Frank Brangwyn, R.A.), Walters Art Museum, Baltimore, 48.1059 (acquired in Clarke sale 1917), British Museum, London 1926 4-231,[1] a fourth bowl whose present whereabouts are unknown,[2] and Metropolitan Museum of Art 56.185.20 (MMA40); exhibiting similar decoration, Metropolitan Museum of Art 08.102.4 and 42.113.3 (MMA44, MMA45).

PROVENANCE: Dikran Khan Kelekian.

REFERENCES: Dimand 1944: 192, fig. 122; Grube 1963: 57, fig. 13.

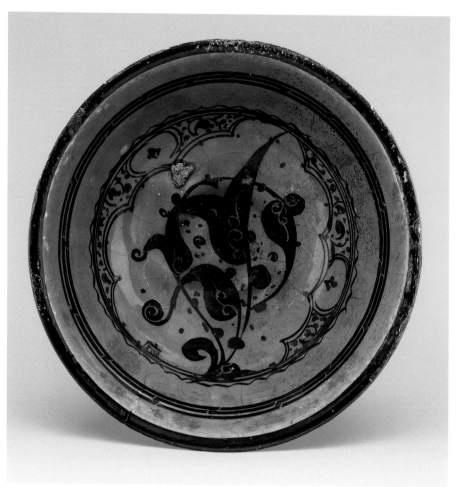

MMA29, interior

MMA29, profile

1. Hobson 1932, fig. 26.
2. Sotheby's sale 1986, lot 147.

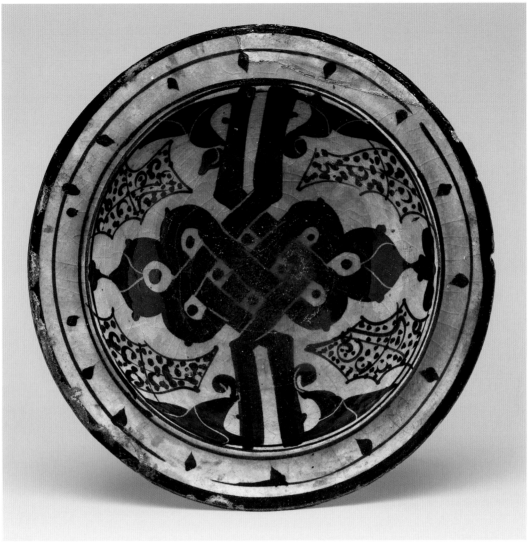

MMA30

MMA30. Segmental bowl with flat rim, profile 2

Composite body, underglaze-painted
Height 2⅞ in. (7.2 cm), diameter 10⅜ in.
(26.4 cm)

The Metropolitan Museum of Art, Fletcher Fund,
1934 34.71

Interior decoration consists of a roundel circumscribed by two circles and bearing a floriated *alif-lām* (pattern 13) highlighted with incisions through the paint. Each open section of interlace is filled with a dot. The interstitial areas have contoured fillers containing dots, dashes, commas, and large Xs. The broad flat rim is divided into three sections, the innermost section has evenly spaced lozenge-shaped motifs (lozenge rim,

pattern 9), the middle section is left plain, and the outer section has a broad plain band. The exterior has only a single circular band (line back, pattern 3). The bowl is painted in black under a clear turquoise glaze.

This bowl appears in the Marcopoli photographs (see page 29 fig. 2.5).

No waster with this type of decoration is known.

RELATED WORKS: For a complete example of this type, see Sotheby's sale 1986, lot 148. Among the numerous large storage jars extant with carved decoration incorporating a very similar pseudo-calligraphic design are Metropolitan Museum of Art 17.120.36, 38.84.2 (MMA6, MMA8), 38.84.1, 48.113.2, 48.113.3, Freer Gallery of Art, Smithsonian Institution, Washington, D.C.,

1908.113 (acquired from a "street dealer in Aleppo"), 1908.134, 1908.155, and 1908.184 (all acquired from Vincenzo Marcopoli & Co., Aleppo), another such jar (from the palace of Harun al-Rashid; present whereabouts unknown),[1] and Los Angeles County Museum of Art M.2002.1.229 (acquired on the New York art market).

PROVENANCE: Sold to unknown buyer in Clarke sale 1925, lot 633, for $380 (equivalent to $3,989 in 2003); H. K. Monif, New York.

REFERENCES: Dimand 1936a: 146; Grube 1963: 56, fig. 12; *Islamische Kunst* 1981: 132–33, no. 49; Ettinghausen, Grabar, and Jenkins-Madina 2001: 250, fig. 413; *Orient de Saladin* 2001: 161, no. 147.

1. Kouchakji 1923: 521.

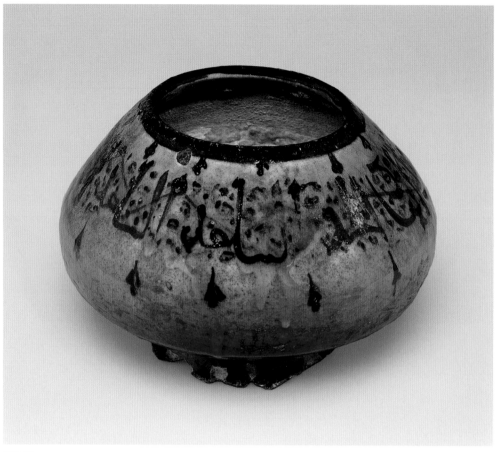

MMA31

MMA31. Segmental bowl with upper section sloping to small rimless opening, profile 6

Composite body, underglaze-painted
Height 4¾ in. (12.2 cm), diameter 7¼ in.
(18.3 cm)
Inscribed, on sticker near foot: To Horace from
Mother/Xmas 1916

The Metropolitan Museum of Art, H. O. Havemeyer
Collection, Gift of Horace Havemeyer, 1945
45.153.3

Exterior decoration consists of a pseudo-cursive inscription on sketchy vegetal ground (pattern 14) bordered above and below by highly stylized, evenly spaced vegetal designs. The rim is circumscribed by a broad band. The bowl is painted in black under a clear turquoise glaze. It is made in two sections joined at the middle.

RELATED WORKS: For a waster of this type, see Ashmolean Museum of Art and Archaeology, Oxford, x3027 (chapter 3, w109). For complete examples of this type, see Freer Gallery of Art, Smithsonian Institution, Washington, D.C., 1908.138,[1] 1910.28AB (both acquired from Vincenzo Marcopoli & Co., Aleppo), National Museum, Damascus, 17875 (no provenance information available), and Metropolitan Museum of Art 48.113.10, 57.61.2 (MMA15, MMA26; both underglaze- and luster-painted).

PROVENANCE: Bought in Clarke sale 1917, lot 588, for $690 (equivalent to $9,903 in 2003); H. O. Havemeyer; Horace Havemeyer.

REFERENCES: Frelinghuysen et al. 1993: 110, pl. 100.

1. Atil 1973: 142, no. 64.

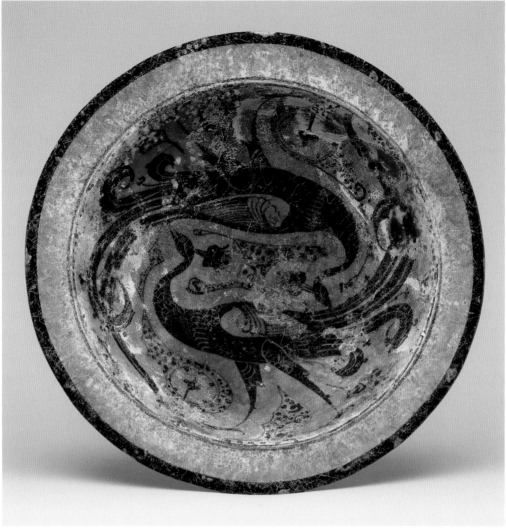

MMA32

MMA32. Segmental bowl with flat rim, profile 2

Composite body, underglaze-painted
Height 4⅜ in. (11 cm), diameter 13¾ in. (35 cm)
Sticker on foot: International Exhibition of
Persian Art, London 1931/US 391
Condition: An x-ray made in June 2001 confirms
that the bowl at time of purchase from Kouchakji
Frères had been reconstructed along the entire
upper edge. A new rim was reconstructed in 2001
to conform to the original profile.

The Metropolitan Museum of Art, H. O. Havemeyer
Collection, Bequest of Horace Havemeyer, 1956
56.185.6

Interior decoration consists of two reciprocal strutting peacocks, with numerous decorative details incised through the paint, filling the entire bowl except for the wide rim. The interstitial areas within the principal design bear contoured fillers containing dots, dashes, and curved lines; the two largest are of the filler with leaf in concentric circles type (pattern 8). The exterior has only a single circular band (line back, pattern 3) at the springing of the rim. The bowl is painted in black under a clear turquoise glaze.

A 1911 photograph of the bowl exists in the archives of the Metropolitan Museum.

No waster with a similar bird motif is known.

RELATED WORKS: For a complete example exhibiting a similar decoration and color scheme, see Freer Gallery of Art, Smithsonian Institution, Washington, D.C., 1947.8 (acquired by former owner from G. J. Demotte in 1912).[1] A fragmentary luster-painted object in the same collection, 1911.23 (acquired from Vincenzo Marcopoli & Co., Aleppo), bears a similar bird.

PROVENANCE: Acquired from Kouchakji Frères with MMA9 and a third object, September 1911, for $15,000 (equivalent to $295,232 in 2003); bill of sale does not mention Raqqa (see page 19, fig. 1.4); H. O. Havemeyer; Horace Havemeyer.

REFERENCES: Rivière 1913, pl. 12; Dimand 1931: 35, no. 151; Lane 1947, fig. 77B; Dimand 1957: 208–9; Dimand 1958: 371, fig. 238; Grube 1963: 58, fig. 14; Lukens 1965: 13, fig. 22; Keene 1977: 60–61; Jenkins, Meech-Pekarik, and Valenstein 1977: fig. 248; Metropolitan Museum 1983: 302, no. 16; Soustiel 1985: 134, no. 153.

1. Atil 1975: 76, no. 31.

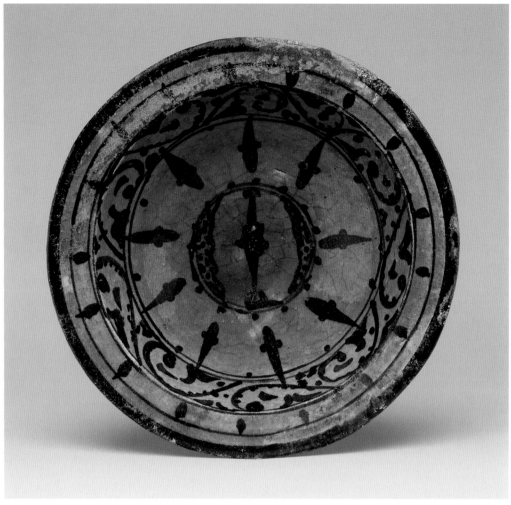

MMA33

MMA33. Segmental bowl with flat rim, profile 2

Composite body, underglaze-painted
Height 3⅛ in. (7.9 cm), diameter 9¾ in. (24.7 cm)

The Metropolitan Museum of Art, H. O. Havemeyer
Collection, Bequest of Horace Havemeyer, 1956
56.185.9

Interior decoration consists of a roundel circumscribed by a circle decorated with evenly spaced dots (dotted double circle, pattern 11) and bisected by a stylized palmette design flanked by a contoured filler motif (bisected roundel, pattern 21). Radiating from the central roundel are nine vegetal designs of dagger shape (pattern 15) similar to the central design and also circumscribed by a circle edged with evenly spaced dots. A band of a reciprocal vegetal scroll (pattern 17) frames the radiating design. The broad flat rim is divided into three sections, the innermost section with evenly spaced lozenge-shaped motifs

(lozenge rim, pattern 9), the middle section left plain, and the outer section a broad plain band. The exterior has only a single circular band (line back, pattern 3) at the springing of the rim. The bowl is painted in black under a clear turquoise glaze.

This bowl appears in the Marcopoli photographs (see page 30, fig. 2.6).

RELATED WORKS: For wasters exhibiting one or more similar designs and color scheme, see Karatay Museum, Konya, 25/1, 25/2, 25/5, 25/6 (chapter 3, W77–W80); for additional wasters exhibiting one or more similar designs but a different color scheme, see Raqqa Museum 153/788 and Museum of Turkish and Islamic Art, Istanbul, 2193/1539 (chapter 3, W124, W129). For complete examples exhibiting one or more similar designs and color scheme, see Karatay Museum, Konya, 25/3, 26/1, Ashmolean Museum of Art and Archaeology, Oxford, 1978.1628 (purchased from A. Garabed, 1934), 1978.2180 (purchased from Moussa and

Meskine, 1937),[1] and 1978.2197 (purchased from A. Garabed, 1931), Freer Gallery of Art, Smithsonian Institution, Washington, D.C., 1908.136 (acquired from Vincenzo Marcopoli & Co., Aleppo),[2] and Walters Art Museum, Baltimore, 48.1078 (acquired in Clarke sale 1917). For an example exhibiting one or more similar designs but a different color scheme, see National Museum, Damascus, 9684 (purchased).

PROVENANCE: H. O. Havemeyer; Horace Havemeyer.

REFERENCES: Unpublished.

1. Porter 1981: 27, pl. 18.
2. Atil 1975: 78, no. 33.

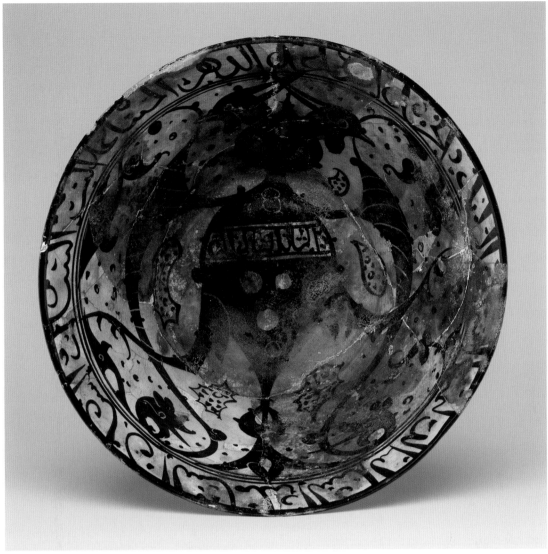

MMA34

MMA34. Biconical bowl, profile 3

Composite body, underglaze-painted
Height 6 in. (15.3 cm), diameter 12¼ in. (31 cm)
Inscribed: around rim, al-iqbāl al-zāʾid al-jadd
al-ṣāʿid al-dahr al-musāʿid al-ʿumr al-sālim al-
saʿāda al-shāmila al-sulāla al-dāʾima (Increasing
prosperity, rising good fortune, auspicious times,
model life, total happiness, perpetual progeny);
on chest of bird, baraka kāmila iqbāl zāʾid
(Consummate blessing, increasing prosperity)

The Metropolitan Museum of Art, H. O. Havemeyer
Collection, Bequest of Horace Havemeyer, 1956
56.185.14

Interior decoration, highlighted by incising
through the paint, consists of a double-headed
eagle circumscribed by a calligraphic band at
the rim. The bird's wings give rise at the top

to split palmettes and at the bottom to a
dragon's head. A calligraphic band decorates
the bird's chest. The exterior decoration has
only a single circular band (line back, pat-
tern 3). The bowl is painted in black under a
clear turquoise glaze.

No waster with a similar motif is known.

RELATED WORKS: For a similar example of this
type, see Walters Art Museum, Baltimore,
48.1220.

PROVENANCE: H. O. Havemeyer; Horace
Havemeyer.

REFERENCES: Unpublished.

Figure 4.3. Interior decoration of MMA34.
Drawing: Annick des Roches

MMA35. Inverted pear-shaped jar with cylindrical neck and everted rim, profile 1

Composite body, underglaze-painted
Height 11½ in. (29.2 cm), diameter 8½ in.
(21.6 cm)

The Metropolitan Museum of Art, H. O. Havemeyer
Collection, Bequest of Horace Havemeyer, 1956
56.185.15

Body decoration consists of four staggered rows of hexagons, each with a dotted circle circumscribing a large dot at center, bordered above and below by narrow and broad plain bands. The sloping shoulder bears a sketchy guilloche design and the cylindrical neck a reciprocal vegetal scroll (pattern 17). The flaring rim has a broad plain band. The jar is painted in black under a clear turquoise glaze. It is made in two sections joined at the middle.

No waster of this type is known.

RELATED WORKS: For vases with a similar neck and shoulder decoration and color scheme, see Walters Art Museum, Baltimore, 48.1247, and Freer Gallery of Art, Smithsonian Institution, Washington, D.C., 1908.136 (acquired from Vincenzo Marcopoli & Co., Aleppo).[1] According to records at the Freer Gallery, Fahim Kouchakji stated that the latter jar and certain other pieces owe their good condition to having been packed inside a large jar found at Raqqa, from which location they were brought to the Aleppo market.

PROVENANCE: Great Find; sold to unknown buyer in Clarke sale 1925, lot 643, for $900 (equivalent to $9,447 in 2003); H. O. Havemeyer; Horace Havemeyer.

REFERENCES: Dimand 1957: 211; Grube 1963: 54, fig. 10; Frelinghuysen et al. 1993: 98, pl. 88.

1. Atil 1975: 78, no. 33.

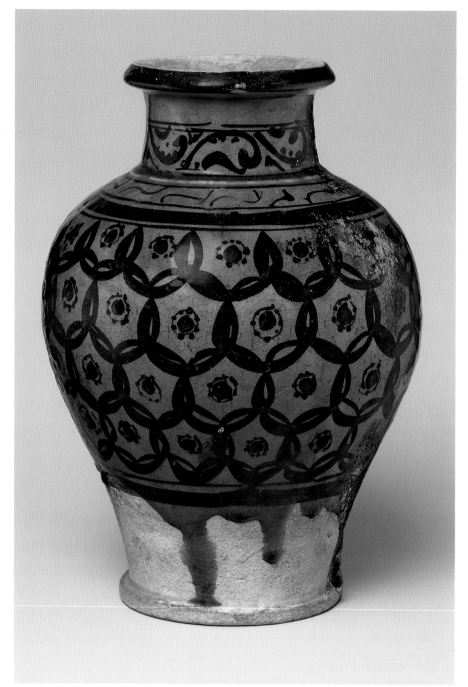

MMA35

MMA36. Inverted pear-shaped jar with cylindrical neck and everted rim, profile 1

Composite body, underglaze-painted
Height 9⅛ in. (23.1 cm), diameter 6⅞ in. (17.6 cm)

The Metropolitan Museum of Art, H. O. Havemeyer Collection, Bequest of Horace Havemeyer, 1956 56.185.16

Body decoration consists of eighteen contiguous bisected arches (pattern 23). The sloping shoulder bears a broad plain band with a narrow band below and a band of evenly spaced dots above circumscribed by a narrow band above and below. The cylindrical neck has a broad plain band bordered above and below by a narrow band. A broad band appears on the flaring rim. The jar is painted in black under a clear turquoise glaze. It is made in two sections joined at the middle.

RELATED WORKS: For a waster exhibiting a similar decoration and color scheme, see Museum of Turkish and Islamic Art, Istanbul, 1971/4957 (chapter 3, w82). For wasters exhibiting a similar decoration but a different color scheme, see Karatay Museum, Konya, 23, and Aleppo National Museum 262 (chapter 3, w123, w139). For a segmental bowl with flat rim bearing a very similar decoration and color scheme, see Walters Art Museum, Baltimore, 48.1056 (acquired in Clarke sale 1917; see page 168, fig. 5.1). For a bowl of the same shape and with similar decoration but a different color scheme, see Ashmolean Museum of Art and Archaeology, Oxford, 1978.2187 (acquired from A. Garabed, 1931).[1]

PROVENANCE: Sold in Clarke sale 1917, lot 599, for $350 (equivalent to $5,023 in 2003); H. O. Havemeyer; Horace Havemeyer.

REFERENCES: Jenkins 1983b: 20, no. 20.

1. Porter 1981: 25, pl. 16.

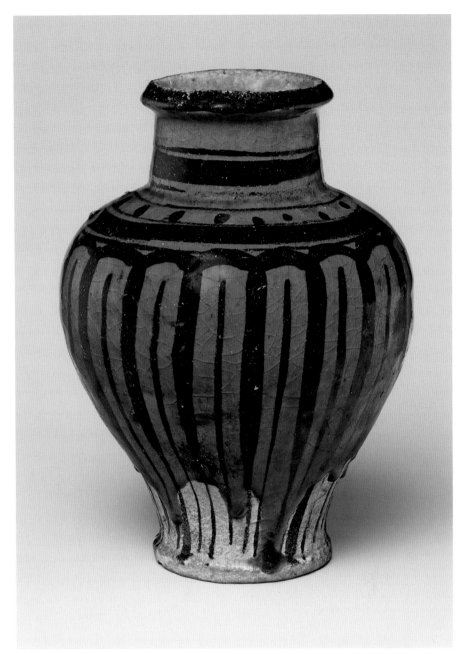

MMA36

MMA37. Inverted pear-shaped jar with cylindrical neck and everted rim, profile 1

Composite body, underglaze-painted
Height 9⅝ in. (24.3 cm), diameter 6⅝ in.
(16.7 cm)

The Metropolitan Museum of Art, H. O. Havemeyer
Collection, Bequest of Horace Havemeyer, 1956
56.185.17

Body decoration consists of diagonal rows of evenly spaced lozenge-shaped motifs bordered at the bottom by narrow and broad plain bands. The sloping shoulder bears a broad plain band with a narrow band below, and a band with evenly spaced dots above circumscribed by narrow bands above and below. The cylindrical neck has a broad plain band bordered above and below by a narrow band. A broad band appears on the flaring rim. The jar is painted black under a clear turquoise glaze. It is made in two sections joined at the middle.

No waster with a similar motif is known.

RELATED WORKS: For complete examples exhibiting a similar decoration and color scheme, see National Museum, Damascus, 7018 (purchased), in which the same decoration covers the entire jar and the shape is somewhat different, and Freer Gallery of Art, Smithsonian Institution, Washington, D.C., 1908.136 (acquired from Vincenzo Marcopoli & Co., Aleppo).[1] According to records at the Freer Gallery, Fahim Kouchakji stated that the jar and certain other pieces owe their good condition to having been packed inside a large jar found at Raqqa, from which location they were brought to the Aleppo market.

PROVENANCE: Great Find; sold to unknown buyer in Clarke sale 1925, lot 639, for $1,000 (equivalent to $10,497 in 2003); H. O. Havemeyer; Horace Havemeyer.

REFERENCES: Unpublished.

1. Atil 1975: 78, no. 33.

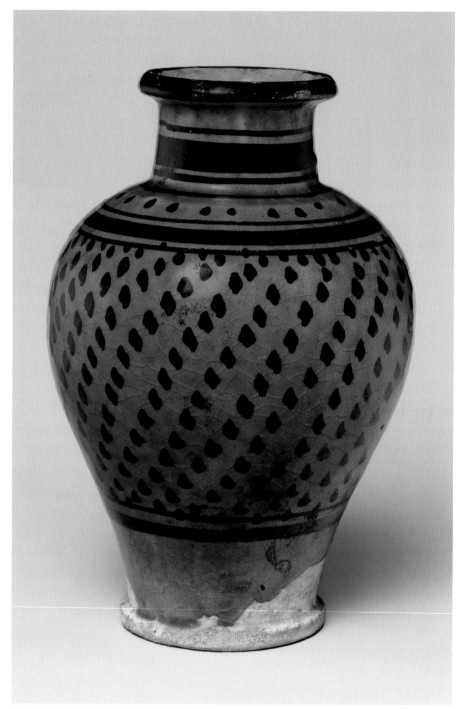

MMA37

MMA38. Inverted pear-shaped jar with cylindrical neck and everted rim, profile 1

Composite body, underglaze-painted
Height 9¾ in. (24.6 cm), diameter 6⅜ in.
(16.1 cm)
Inscribed: al-ʿizz al-dāʾim waʾl-iqbāl wa (Lasting glory and prosperity and)

The Metropolitan Museum of Art, H. O. Havemeyer Collection, Bequest of Horace Havemeyer, 1956 56.185.18

Body decoration consists of a cursive Arabic inscription on a ground sprinkled with dots of varying sizes, commas, and spiraling lines. The inscription band is circumscribed by a narrow band with a broad plain band below. The sloping shoulder bears a broad plain band with a narrow band below, and above a band with evenly spaced dots circumscribed by narrow bands above and below. The cylindrical neck has a broad plain band bordered above and below by a narrow band. A broad plain band appears on a flaring rim. The jar is painted in black under a clear turquoise glaze. It is made in two sections joined at the middle.

No waster of this type is known.

PROVENANCE: Great Find; H. O. Havemeyer; Horace Havemeyer.

REFERENCES: Kouchakji 1923: 522; Grube 1963: 54, fig. 9.

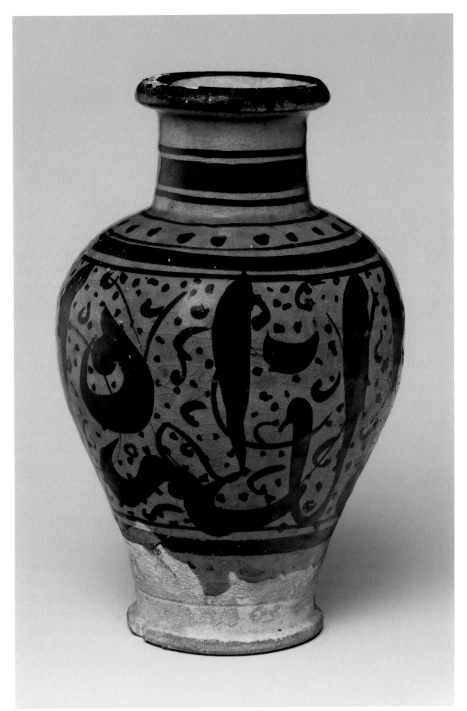

MMA38

MMA39. Inverted pear-shaped jar with cylindrical neck and everted rim, profile 1

Composite body, underglaze-painted
Height 9 in. (22.8 cm), diameter 6⅞ in. (17.5 cm)

The Metropolitan Museum of Art, H. O. Havemeyer Collection, Bequest of Horace Havemeyer, 1956
56.185.19

Body decoration consists of a single wide band with a horizontally oriented reciprocal feathery leaf design and a plain contoured band running between leaves. The principal band is bordered above and below by one narrow and one broad plain band. A pair of plain bands decorates the cylindrical neck, and the flaring rim bears a broad plain band. The jar is painted in black under a clear turquoise glaze. It is made in two sections joined at the middle.

No waster of this type is known.

PROVENANCE: H. O. Havemeyer; Horace Havemeyer.

REFERENCES: Unpublished.

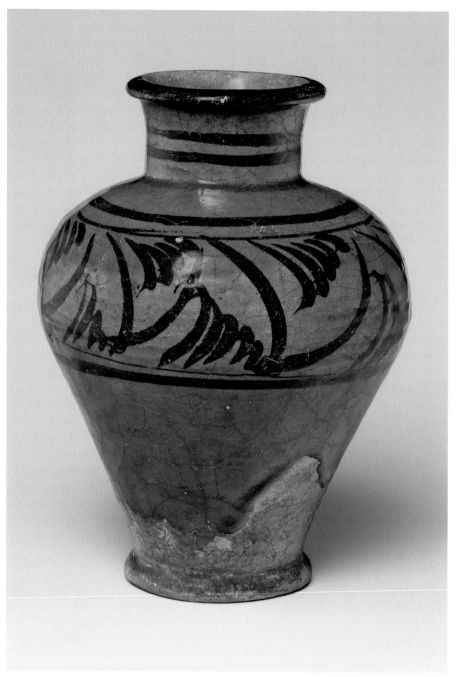

MMA39

MMA40. Inverted pear-shaped jar with cylindrical neck and everted rim, profile 1

Composite body, underglaze-painted
Height 9¼ in. (23.5 cm), diameter 6⅝ in.
(16.8 cm)

The Metropolitan Museum of Art, H. O. Havemeyer Collection, Bequest of Horace Havemeyer, 1956 56.185.20

Body decoration consists of two vegetal designs alternating three times—the hillock with three leaves (pattern 5) and two intertwined leaves (pattern 22), the latter partially enclosed in a spiraling tendril that gives rise to a shorter tendril enclosing a stylized vegetal element. A narrow band with a broad plain band below circumscribes the bottom of the decorative band. The larger leaves in both designs are highlighted by incising through the paint. The sloping shoulder bears below a broad plain band with a narrow band and above a band of evenly spaced dots circumscribed by narrow bands above and below. The cylindrical neck has a broad plain band bordered above and below by a narrow band. The flaring rim bears a broad plain band. The jar is painted in black under a clear turquoise glaze. It is made in two sections joined at the middle.

This jar appears in the Marcopoli photographs (see page 30, fig. 2.7).

RELATED WORKS: For wasters exhibiting one or more similar designs and color scheme, see Karatay Museum, Konya, 25/2, 26/3 (chapter 3, w80, w88); for additional wasters exhibiting one or more similar designs but a different color scheme, see Ashmolean Museum of Art and Archaeology, Oxford, 1978.2354, Karatay Museum, Konya, 23, Museum of Turkish and Islamic Art, Istanbul, 2193/1539, and Museum für Islamische Kunst, Staatliche Museen zu Berlin, I.1239, I.1240 (chapter 3, w122, w123, w129, w131, w130). For complete examples exhibiting one or more similar designs and color scheme, see Çinili Köşk, Istanbul, 41/1438, National Museum, Damascus, 17875 (no provenance information), and especially Walters Art Museum, Baltimore, 48.1059 (acquired in Clarke sale, 1917). For another complete example exhibiting one or more similar designs but a different color scheme, see Aleppo National Museum 384 (no provenance information).

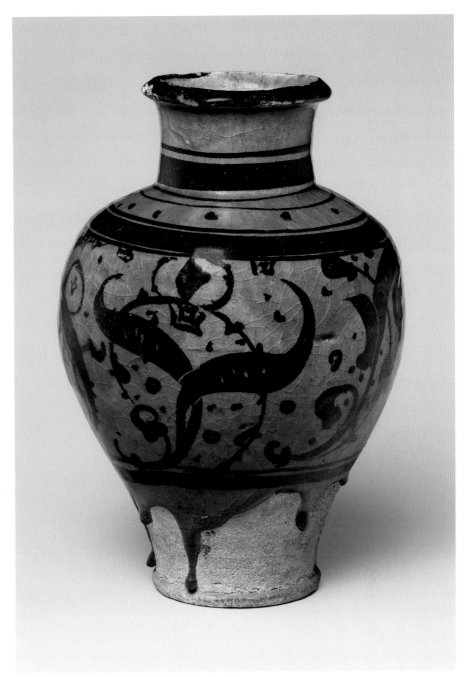

MMA40

PROVENANCE: Great Find; sold to unknown buyer in Clarke sale 1925, lot 642, for $950 (equivalent to $9,972 in 2003); H. O. Havemeyer; Horace Havemeyer.

REFERENCES: Grube 1963: 53, fig. 8.

MMA41. Inverted pear-shaped jar with cylindrical neck and everted rim, profile 1

Composite body, underglaze-painted
Height 8⅞ in. (22.5 cm), diameter 6½ in. (16.4 cm)

The Metropolitan Museum of Art, H. O. Havemeyer
Collection, Bequest of Horace Havemeyer, 1956
56.185.21

Body decoration consists of three evenly spaced quadrilateral cartouches bearing a pseudo-cursive inscription on a sketchy vegetal ground (pattern 14) separated by arabesque medallions (pattern 16). The sloping shoulder bears a broad plain band with a narrow band below and a band of evenly spaced dots above, circumscribed by narrow bands above and below. The cylindrical neck has a broad plain band bordered above and below by a narrow band, a combination repeated on the lower part of the body. A broad plain band appears on the flaring rim. The jar is painted in black under a clear turquoise glaze. It is made in two sections joined at the middle.

This jar appears in the Marcopoli photographs (see page 31, fig. 2.9).

RELATED WORKS: For a waster exhibiting one or more similar designs and color scheme, see Museum of Turkish and Islamic Art, Istanbul, 2224/1448 (chapter 3, w117). For a complete object exhibiting one or more similar designs and color scheme, see Karatay Museum, Konya, 25/8.

PROVENANCE: Great Find; sold to unknown buyer in Clarke sale 1925, lot 641, for $650 (equivalent to $6,823 in 2003); H. O. Havemeyer; Horace Havemeyer.

REFERENCES: Unpublished.

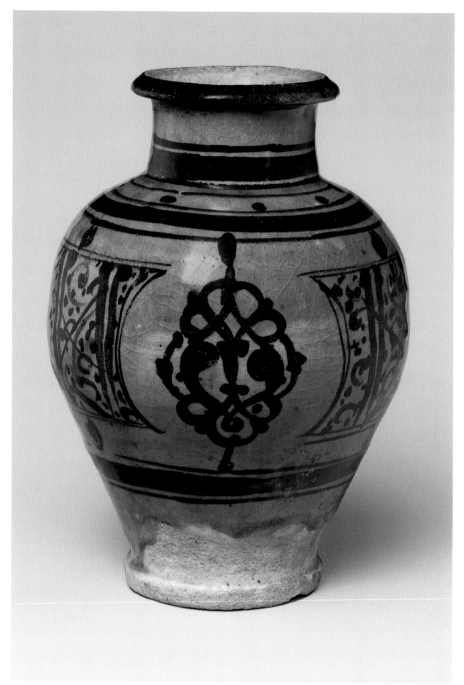

MMA41

MMA42. Inverted pear-shaped jar with cylindrical neck and everted rim, profile 1

Composite body, underglaze-painted
Height 9¼ in. (23.4 cm), diameter 6⅝ in. (16.8 cm)

The Metropolitan Museum of Art, H. O. Havemeyer Collection, Bequest of Horace Havemeyer, 1956 56.185.22

Body decoration consists of four staggered rows of teardrop-shaped designs diminishing in size from top to bottom, with each interstitial area filled with a large dot. A narrow scalloped band with a dot at the juncture of each segment circumscribes the bottom of the decorative band. The sloping shoulder bears a broad plain band with a narrow band below and a band of evenly spaced dots above circumscribed by a narrow band above and below. The cylindrical neck has a broad plain band bordered above and below by a narrow band. A broad plain band appears on the flaring rim. The jar is painted in black under a clear turquoise glaze. It is made in two sections joined at the middle.

RELATED WORKS: For a jar with similar decoration but different color scheme and somewhat different shape, see National Museum, Damascus, 6612 (purchased).

PROVENANCE: Great Find; sold to unknown buyer in Clarke sale 1925, lot 640, for $1,550 (equivalent to $16,271 in 2003); H. O. Havemeyer; Horace Havemeyer.

REFERENCES: Grube 1963: 53, fig. 7.

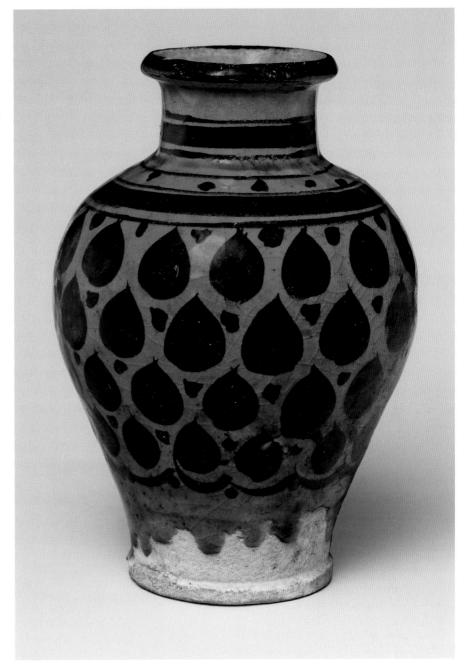

MMA42

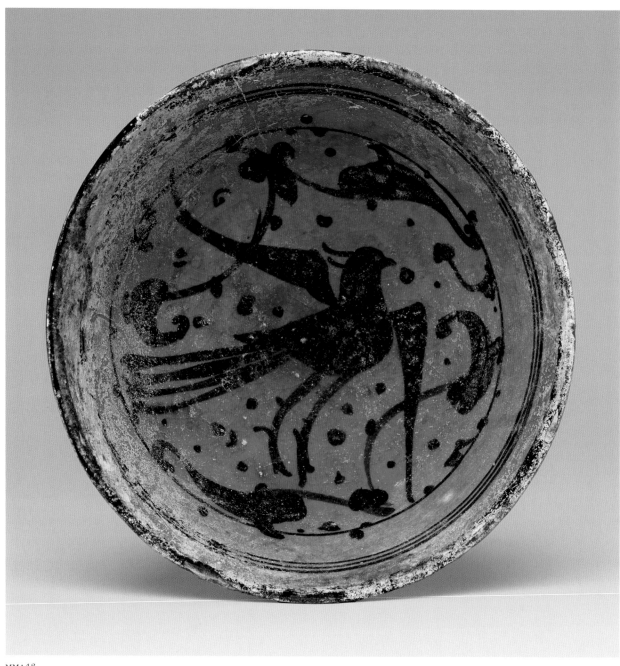

MMA43

MMA43. Modified hemispherical bowl, profile 12

Composite body, underglaze-painted
Height 4 in. (10.2 cm), diameter 6⅞ in. (17.3 cm)

The Metropolitan Museum of Art, Gift of Lester Wolfe, 1968 68.223.7

Interior decoration consists of a bird facing right on a dotted ground and set within a dotted circle with two opposing three-leaf clusters springing toward the center from the edge of a ring. Three narrow concentric bands decorate the cavetto, and the rim is adorned with a wide plain band. Decoration on the exterior consists of a band of wide, evenly spaced diagonal strokes. The bowl is painted in black under a clear turquoise glaze.

No waster of this type is known.

RELATED WORKS: For a complete but fragmentary object exhibiting similar designs and color scheme, see page 184, figure 6.11. For complete objects exhibiting one or more similar designs but a different color scheme, see Ashmolean Museum of Art and Archaeology, Oxford, 1978.2183, and a second bowl whose present whereabouts are unknown.[1]

PROVENANCE: Lester Wolfe.

REFERENCES: Unpublished.

1. Lane 1947, pl. 29B.

MMA44. Segmental bowl with flat rim, profile 2

Composite body, underglaze-painted
Height 2⅞ in. (7.3 cm), diameter 10¼ in.
(26.1 cm)

The Metropolitan Museum of Art, Rogers Fund,
1908 08.102.4

Interior decoration consists of a hillock with three leaves (pattern 5) circumscribed by two concentric circles with contoured fillers in a roundel (pattern 12). The outermost circle is highlighted by evenly spaced dots (dotted double circle, pattern 11). The cavetto bears a band of pseudo-cursive inscription on a sketchy vegetal ground (pattern 14). The rim is divided into three sections, the innermost section with evenly spaced lozenge-shaped designs (lozenge rim, pattern 9), the middle section left plain, and the outermost section a wide band extending onto the exterior. The exterior has only a single circular band (line back, pattern 3) near the top of the wall. The bowl is painted in black and cobalt blue under a clear colorless glaze with a greenish tint.

A sample was drilled from this bowl and subjected to neutron-activation analysis in connection with a project undertaken by the author on the subject of Mamluk underglaze-painted pottery. The sample was found to fall outside the groupings relevant for the study.[1]

RELATED WORKS: For wasters exhibiting one or more similar decorative motifs and color scheme, see Ashmolean Museum of Art and Archaeology, Oxford, 1978.2354, Karatay Museum, Konya, 23, Museum of Turkish and Islamic Art, Istanbul, 1607/1538, and Museum für Islamische Kunst, Staatliche Museen zu Berlin I.1240 (chapter 3, w122, w123, w126, w130). For a complete example exhibiting similar decorative motifs and color scheme, see Ashmolean Museum of Art and Archaeology, Oxford, 1978.2188 (acquired from Moussa and Meskine, 1937).[2]

PROVENANCE: Dikran Khan Kelekian.

REFERENCES: Aanavi 1968: 356, fig. 6.

1. See Jenkins 1984, fig. 1, no. 47.
2. Porter 1981: 19, pl. 10.

MMA44

MMA45

MMA45. Biconical bowl, profile 3

Composite body, underglaze-painted
Height 4⅝ in. (11.8 cm), diameter 9⅛ in. (23.3 cm)

The Metropolitan Museum of Art, Gift of Estate of J. Zado Noorian, 1942 42.113.3

Interior decoration consists of a hillock with three leaves (pattern 5) circumscribed by three concentric circles with contoured fillers in a roundel (pattern 12). The outermost circle is highlighted by evenly spaced dots (dotted double circle, pattern 11). The cavetto bears a band with two reciprocal vegetal designs, one highlighted with incising, on a ground of dots, commas, and curving lines. The rim is circumscribed by a single band. The exterior has only a single circular band (line back, pattern 3) at the middle of the wall. The bowl is painted in black and cobalt blue under a clear colorless glaze with a greenish tint.

RELATED WORKS: For wasters exhibiting a similar decoration and color scheme, see Ashmolean Museum of Art and Archaeology, Oxford, 1978.2354, Karatay Museum, Konya, 23, and Museum für Islamische Kunst, Staatliche Museen zu Berlin I.1240 (chapter 3, w122, w123, w130).

PROVENANCE: J. Zado Noorian.

REFERENCES: Unpublished.

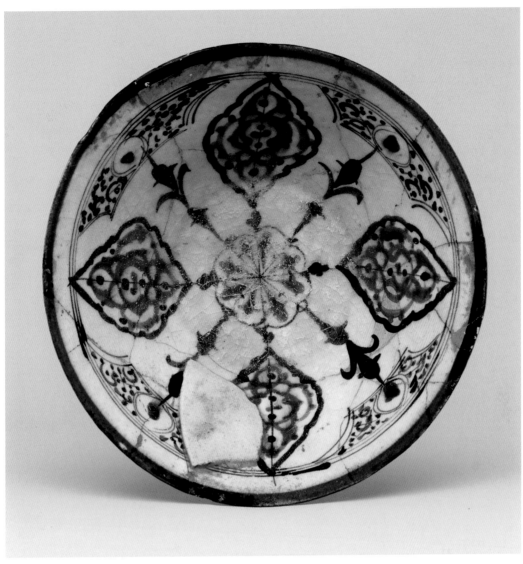

MMA46

MMA46. Biconical bowl, profile 3

Composite body, underglaze-painted
Height 4⅜ in. (11 cm), diameter 9⅛ in. (23.1 cm)
Condition: Although this object is technically a
waster, it could have been used as a bowl.

The Metropolitan Museum of Art, Milton A. Rauh
and Florence L. Goldmark Collection, Bequest of
Florence L. Goldmark, 1974 1974.161.11

Interior decoration consists of an eight-lobed rosette, each lobe bearing a dagger-shape (pattern 15) vegetal motif from which radiate four arabesque medallions (pattern 16), each extending to just below the rim. The areas between the medallions are filled with two dagger shapes and a pair of leaves. Just below the three concentric circles that circumscribe the entire decoration are four designs of the filler with a leaf in concentric circles type (pattern 8). The exterior has only a single circular band (line back, pattern 3) near the top of the wall. The bowl is painted in black and cobalt blue under a clear colorless glaze with a greenish tint.

RELATED WORKS: For a waster exhibiting one or more similar designs but with a different shape and color scheme, see Museum of Turkish and Islamic Art, Istanbul, 2224/1448 (chapter 3, W117). For a complete object exhibiting one or more similar designs but a different color scheme, see Karatay Museum, Konya, 25/8.

PROVENANCE: Milton A. Rauh and Florence L. Goldmark.

REFERENCES: Unpublished.

RA1. Fragment of waster

Composite body, underglaze-painted
Height 1 ⅝ in. (4.1 cm), maximum width 2 ¼ in.
(5.8 cm)

Collection of Marilyn Jenkins-Madina

This piece comprises fragments from three
vessels, two with painting in black under a
clear turquoise glaze, the third appearing to
bear only a monochrome turquoise glaze.
The underglaze painting on the uppermost
fragment, visible only from the front, consists
of a single narrow band at the edge of the
rim. The middle fragment, seen clearly only
from the back, bears two underglaze-painted
wide parallel lines. The third fragment, also
visible only from the back, has no underglaze-
painted decoration on the exposed area.

PROVENANCE: Collected at the site of Raqqa by
the author in 2002, with the permission of the
Syrian Department of Antiquities and Museums.

RA1, interior

RA1, exterior

RA4. Fragment from rim of vessel

Composite body, underglaze-painted
Height 1 ⅛ in. (2.8 cm); maximum width 2 in.
(5 cm)
Condition: Owing to the improper fluxing of the
glaze on both front and back, this fragment should
be considered a waster. Nevertheless, despite the
firing mishap, the vessel could probably still be used.

Collection of Marilyn Jenkins-Madina

The fragment is decorated in black under a
clear turquoise glaze. The decoration on both
the obverse and reverse consists of radiating
lines; those on the obverse are considerably
wider. The rim is circumscribed with an
underglaze-painted black band.

RELATED WORKS: For wasters exhibiting a
similar decoration on the obverse and the same
color scheme, see Karatay Museum, Konya,
25/1, and Museum of Turkish and Islamic Art,
Istanbul, 2175/1493 (chapter 3, w79, w81).

PROVENANCE: Collected at the site of Raqqa by
the author in 2002, with the permission of the
Syrian Department of Antiquities and Museums.

RA4, interior

RA4, exterior

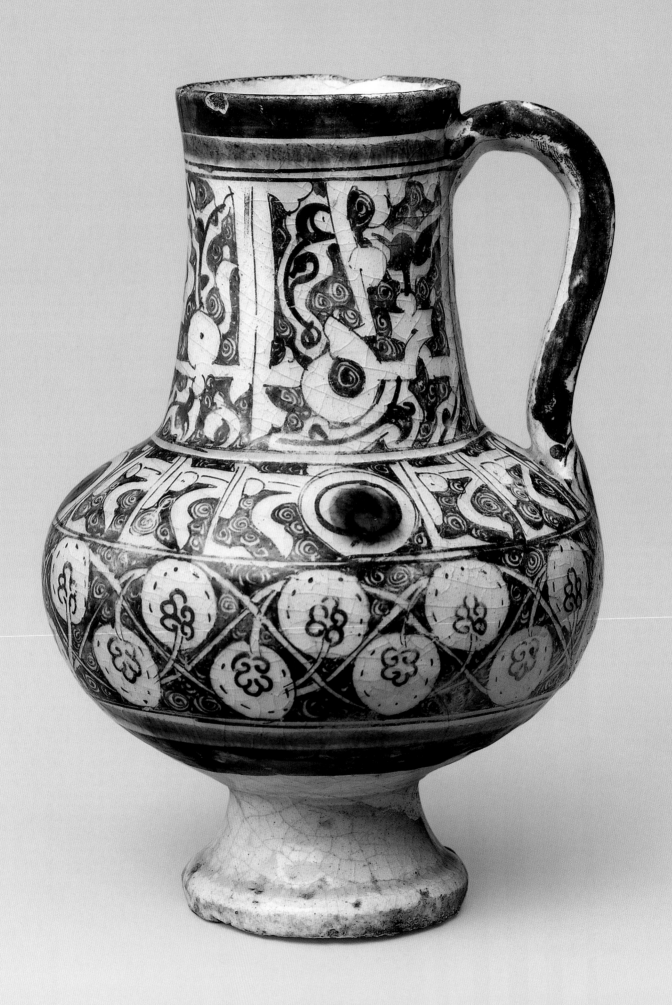

5. Patterns, Profiles, and Provenance

THE CHAPTER THAT follows is intended to provide a synthesis of the information presented thus far combined with scientific data (see Appendix 2) with the purpose of defining three different types of glazed pottery manufactured in Raqqa: that with underglaze- and luster-painted decoration, that with black-painted decoration under a clear turquoise glaze, and that with black-and-cobalt-painted or simply black-painted decoration under a clear, colorless glaze.

The first section identifies twenty-five patterns with a verifiable Raqqa provenance. These designs are all drawn from the forty-six objects in the collection of the Metropolitan Museum that constitute the focus of this study. As such, their number is incomplete. Nevertheless, by association with other patterns not found in the New York group, these motifs—presented in the order of the frequency of their appearance—can be utilized to greatly expand the number of designs verifiable to this ceramic center. It should be noted that only three patterns—5, 7, and 13—are found both on objects with luster-painted decoration and on those incorporating only underglaze-painted decoration. The remaining twenty-two appear to be exclusive to one type or the other. Although this could have to do with the makeup of the Metropolitan group, it is more likely representative of all three types worldwide.

The second section presents nineteen profiles, or shapes, with a verifiable Raqqa provenance. The first thirteen are found in the Metropolitan group, and the remaining six are seen on wasters from other collections. These, too, are introduced in the order of their frequency; once again, their number will surely be added to in years to come.

The final section presents these patterns and profiles in the context of the data supplied in Appendix 2, data that is clearly represented in figures A2.1 and A2.2 in the appendix. Although the resulting picture of glazed ceramic production in Raqqa is still a partial picture that will surely be expanded and refined in future studies, it is hoped that the methodology employed herein will serve to establish a foundation on which other scholars can build.

I. Patterns with a Verifiable Raqqa Provenance for Objects in The Metropolitan Museum of Art

The patterns included in this section can be securely attributed to Raqqa because they appear on wasters documented as coming from Raqqa, on objects in the Great Find, or on those from what Fahim Kouchakji referred to as "the palace of Harun al-Rashid," and/or because they have been scientifically verified.

Pattern 1. Calligraphy band[1]

This pattern is a popular filler for narrow horizontal bands on underglaze- and luster-painted objects of many different profiles. It consists of cursive pseudo-calligraphic decoration and is seen on eleven objects in the collection.[2] Three of these objects (MMA18–MMA20) are from the Great Find and were acquired in the 1925 Thomas B. Clarke sale.[3]

Two of the eleven objects bear the underglaze-painted design found on five wasters in the Karatay Museum, Konya; a waster in the Museum of Turkish and Islamic Art, Istanbul, can be similarly cited for a third object.[4] The same motif appears on four objects in the Freer Gallery of Art, Smithsonian Institution, Washington, D.C., acquired by Charles L. Freer from Vincenzo Marcopoli & Co. in Aleppo.[5] Two of the four (1908.140 and 1908.148) came from the Great Find. Another (1908.137) exhibits the same initial step as the above-cited waster in Istanbul.

1. Mason 1997, fig. 3, SM.18. Wherever possible, I have used Mason's terminology, citing my first use of each of his terms. Descriptions of patterns and profiles not cited as Mason's are my own.
2. Chapter 4, MMA7, MMA10, MMA12, MMA13, MMA17–MMA22, MMA27.
3. See chapter 1, note 27.

4. Chapter 3, w7–w9, w26, w27 (Karatay Museum); w64 (Museum of Turkish and Islamic Art).
5. 1908.137, 1908.140 (see Atil 1975: 81, no. 35), 1908.141 (Atil 1973: 148, no. 67), and 1908.148 (Atil 1975: 82–83, no. 36). For much of the information concerning the circumstances surrounding Freer's purchases, I have drawn on Bloom 1975.

Pattern 2. Cursive-script panels on spiraling ground

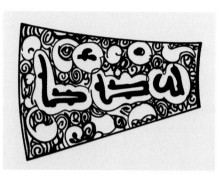

This pattern, an extremely popular decorative device for underglaze- and luster-painted vessels of many different profiles, consists of legible Arabic inscriptions executed in a cursive script and framed in contour panels reserved on a spiraling ground. The motif is seen on nine objects in the collection.[1] One of these objects (MMA18) came from the Great Find and was acquired in the 1925 Thomas B. Clarke sale (lot 645). Another object in the group (MMA14) is published as having been part of the Great Find.[2] It is tempting to ascribe the luster-painted decoration on all nine objects to the same painter, as the calligraphic hand is similar and the phrases are consistent.

The design incorporates the words, or word combinations, listed below:

sa'āda	happiness
sa'āda shāmila	total happiness
sa'āda kāmila	consummate happiness
baraka	blessing
baraka kāmila	consummate blessing
ni'ma	grace
ni'ma kāfiya	abundant grace
ni'ma shāfiya	healing grace
ni'ma bāqiya	continuing grace

jadd shāmil	total good fortune
sulāla dā'ima	lasting progeny
kāmila	consummate
. . . dā'im	lasting
lahu	to him (i.e., to its owner)

Three wasters in the Karatay Museum exhibit what would constitute the first step for the decoration on two objects in the collection.[3] Furthermore, strong circumstantial evidence for a Raqqa provenance for this pattern exists in five objects bearing this design in the Freer Gallery of Art, all of which were acquired by Freer in Aleppo from Vincenzo Marcopoli & Co. About one of these pieces (1910.28) Freer wrote that it was "purchased by me in Aleppo during trip 1909–1910 . . . brought to Aleppo by . . . caravan and unpacked and repaired during my visit."[4]

1. Chapter 4, MMA5, MMA10–MMA12, MMA14, MMA18, MMA24, MMA26, MMA27.
2. Kouchakji 1923: 523.
3. Chapter 3, w19, w26, w27.
4. 1908.141 (see Atil 1973: 148, no. 67), 1908.152, 1908.185, 1910.27, and 1910.28AB. For 1910.28 (unpublished), see Bloom 1975.

Pattern 3. Line back[1]

This device, consisting solely of a single narrow circular band, is the most frequently occurring exterior pattern on biconical and segmental bowls with broad flat rims that are painted in black under a clear turquoise glaze, or in cobalt and black or simply black under a clear colorless glaze. Eight objects in the collection bear this motif on their exterior.[2]

The pattern is seen on seven wasters in the Karatay Museum, four in the Museum of Turkish and Islamic Art, and two in the Raqqa Museum.[3]

The pattern does not appear on objects of the underglaze- and luster-painted type.

1. Mason 1997, fig. 3, SM.14.
2. Chapter 4, MMA29, MMA30, MMA32–MMA34, MMA44–MMA46. Mason views a single wavy line as a variant of this pattern.
3. Chapter 3, W77–W80, W83, W88, W93 (Karatay Museum); W82, W84, W126, W129 (Museum of Turkish and Islamic Art); W111, W124 (Raqqa Museum).

Pattern 4. *al-ʿizz* on spiraling ground

a

b

c

Eight instances of this design in two different calligraphic styles appear on seven objects in the collection.[1] On three examples, the Arabic word and its article are executed in a clear, angular script and framed in a contour panel reserved on a spiraling ground (MMA13, MMA15, and MMA25; pattern 4a). On a fourth example, the Arabic word and its article are executed in the same script but are unframed and reserved directly on the spiraling ground (MMA23; pattern 4b). On two of these objects (MMA23 and MMA25), the Arabic word and its

article are part of a longer inscription, while in the other two cases, the pattern is repeated four times. One of these objects (MMA15) was acquired in the 1917 Thomas B. Clarke sale and was among the "number of Rakka pieces which are in their original coloring, wholly or mainly free from iridescence, [that were] found within one large vase or receptacle in the cellar of a house in Rakka."[2]

The words inscribed in this design are as follows:

al-ʿizz	glory
al-ʿizz glory . . .

The pattern as exhibited on the first three objects cited above can also be seen on two objects in the Freer Gallery of Art. Both were acquired by Freer from Vincenzo Marcopoli & Co. in Aleppo in 1908. One was from the Great Find.[3]

The second version of this design is seen on four of the seven objects in the collection.[4] Here, the Arabic word and its article are executed in a more stylized manner (pattern 4c). With the exception of one tall-neck jug on a high foot, on which the band is interrupted by concentric circles and the pattern inverted (MMA23), the design is continuous and correctly oriented for viewing when the object is not in use. This same jug can be closely compared to the above-mentioned jug in the Freer Gallery that came from the Great Find. Indeed, it was probably executed by the same artisan.

The second version can also be seen on another object in the Freer Gallery acquired by Freer from Vincenzo Marcopoli & Co. in 1911.[5]

The two versions of this pattern appear on objects verifiable to Raqqa only of the underglaze- and luster-painted type.

1. Chapter 4, MMA2, MMA11, MMA13, MMA15, MMA22, MMA23, MMA25.
2. Dana H. Carroll, foreword to Clarke sale 1917.
3. 1908.138 (Atil 1973, no. 64) and 1908.140 (from the Great Find; Atil 1975, no. 35).
4. MMA 2, MMA11, MMA22, MMA23.
5. 1911.3 (Freer Gallery of Art).

Pattern 5. Hillock with three leaves

a

b

This vertically oriented motif is composed of a semicircular hillock from which grow three leaves (pattern 5a). The leaves may vary in size, and in certain cases, a stem may bear more than one leaf. In one variation, the hillock is a split palmette (pattern 5b). On the five objects in the collection that bear this pattern, it is to be found either set within a roundel or as an element in a linear design.[1]

The motif can be seen on three wasters in the Karatay Museum;[2] on a jar in the Walters Art Museum, Baltimore, acquired in the 1917 Thomas B. Clarke sale and among the "number of Rakka pieces which are in their original coloring, wholly or mainly free from iridescence, [that were] found within one large vase or receptacle in the cellar of a house in Rakka"; and on a bowl fragment picked up in Raqqa by Friedrich Sarre.[3]

It appears on objects verifiable to Raqqa of all three types, namely those painted in black under a clear turquoise glaze, those painted in cobalt and black or simply black under a clear colorless glaze, and those painted in cobalt and/or turquoise under a colorless glaze and luster-painted.

1. Chapter 4, MMA26, MMA29, MMA40 (from the Great Find), MMA44, MMA45.
2. Chapter 3, W80 (the design on this object is a variant with six, instead of three, leaves), W88, W123.
3. 48.1059, unpublished, and so similar to the

Metropolitan Museum jar MMA40 as to be its mate; Dana H. Carroll, foreword to Clarke sale 1917; and Sarre 1921, pl. XII4.

Pattern 6. Spiral back[1]

a

b

This horizontal pattern is the most frequently occurring decoration on the exterior of underglaze- and luster-painted biconical and segmental bowls with flat rims. Four objects in the collection bear this motif executed in two slightly different styles (patterns 6a,b); a fifth object is decorated with a modified version of the pattern.[2] One of these objects (MMA10) exhibits three patterns found on objects from the Great Find, namely patterns 1, 2, and 18.

Wasters in the Karatay Museum and in the Museum of Turkish and Islamic Art exhibit what would constitute the first step for the decoration on each of the four bowls in the collection with the spiral-back exterior decoration.[3] Strong circumstantial evidence for a Raqqa provenance for this popular pattern also exists in at least two objects in the Freer Gallery of Art.[4] Both were acquired by Freer from Vincenzo Marcopoli & Co. in Aleppo. About one of these (1910.34) Freer commented that it was "purchased by me in Aleppo during trip 1909–1910 . . . brought to Aleppo by . . . caravan and unpacked and repaired during my visit."[5]

1. Mason 1997, fig. 3, SM.19.
2. Chapter 4, MMA2, MMA10, MMA11, MMA13; the object with the modified pattern is MMA16.
3. Chapter 3, W1, W2, W7–W9, W19, W26, W27 (Karatay Museum); W4 (Museum of Turkish and Islamic Art).

4. 1910.34 (unpublished) and 1911.18. For 1910.34, see Bloom 1975.
5. Bloom 1975: 517 (Freer Gallery of Art folder sheet for 1910.34).

Pattern 7. Trefoils

This pattern, which is commonly used to decorate narrow bands, consists of a series of evenly spaced trefoils. It is seen on four of the objects in the collection.[1] One object incorporates in its decoration three patterns appearing on objects from the Great Find: the calligraphy band, the cursive-script panels on spiraling ground, and the symmetrical reserved arabesque (patterns 1, 2, and 18).[2] Another object was acquired in the 1917 Thomas B. Clarke sale.[3]

The identical pattern can be seen on four objects in the Freer Gallery of Art. All four were acquired by Freer from Vincenzo Marcopoli & Co. in Aleppo, one in 1908 (from the Great Find), another in 1910 (a waster), and two in 1911.[4]

The motif appears on objects verifiable to Raqqa of the underglaze- and luster-painted type as well as on those painted in black under a clear turquoise glaze.

1. Chapter 4, MMA2, MMA10, MMA12, MMA15.
2. MMA10.
3. MMA15.
4. 1908.148 (Atıl 1975: 82–83, no. 36), 1910.30, 1911.3, and 1911.21. For 1908.148, see Bloom 1975.

Pattern 8. Filler with leaf in concentric circles

This contoured filler pattern shows two concentric circles with a trilobed leaf in the center

on a ground of dots, slashes, and curved lines. It occurs on three objects in the collection.[1]

The design can be seen on a waster in the Karatay Museum.[2] It does not appear on objects verifiable to Raqqa of the underglaze- and luster-painted type.

1. Chapter 4, MMA29, MMA32, MMA46.
2. Chapter 3, W88.

Pattern 9. Lozenge rim[1]

This pattern is found only on the broad flat rims of segmental bowls. With one exception, the rims are divided into three sections, the innermost section bearing evenly spaced lozenge motifs, the middle section left plain, and the outer section consisting of a broad plain band. Three objects in the collection bear this pattern.[2]

The motif is seen on two wasters in the Karatay Museum,[3] as well as on a bowl in the Walters Art Museum (fig. 5.1) acquired in the 1917 Thomas B. Clarke sale and among the "number of Rakka pieces which are in their original coloring, wholly or mainly free from iridescence, [that were] found within one large vase or receptacle in the cellar of a

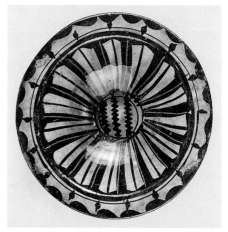

FIGURE 5.1 Underglaze-painted segmental bowl with flat rim. Raqqa, Syria, 1200–1230. The Walters Art Museum, Baltimore (48.1056)

house in Rakka."[4] The exception noted above is the bowl in Baltimore, which displays a lozenge rim of only two sections, the inner with evenly spaced lozenge motifs and the outer with a boldly scalloped band.

The pattern does not occur on objects verifiable to Raqqa of the underglaze- and luster-painted type.

1. Mason 1997, fig. 3, SM.15.
2. Chapter 4, MMA30, MMA33, MMA44.
3. Chapter 3, W88, W93.
4. Dana H. Carroll, foreword to Clarke sale 1917.

Pattern 10. Spiral-filled quadrilaterals

a

b

This pattern is seen on three objects in the collection, two of which formed part of the Great Find.[1] It consists of a series of quadrilaterals arranged in a single horizontal row (pattern 10a) or in staggered rows (pattern 10b) and filled with a tight spiral.

The identical pattern can be seen on two objects in the Freer Gallery of Art, both of which were acquired by Freer from Vincenzo Marcopoli & Co. in Aleppo, one in 1910 and the other in 1911, as well as on a biconical bowl in the Museum für Islamische Kunst, Staatliche Museen zu Berlin, purchased by Friedrich Sarre in Raqqa in 1907.[2]

The motif appears on objects verifiable to Raqqa only of the underglaze- and luster-painted type.

1. Chapter 4, MMA 12, MMA19, MMA20, the last two from the Great Find.
2. 1910.34; 1911.18 (Freer Gallery of Art). The Berlin biconical bowl (I.3992) is unpublished.

Pattern 11. Dotted double circle

This pattern is composed of a tight spiral that gives the illusion of being two concentric circles, with one ring highlighted by evenly spaced dots. It was popular on objects verifiable to Raqqa of the bichrome underglaze-painted type and on objects with the decoration painted in black under a clear turquoise glaze. The pattern occurs on three objects in the collection.[1]

It is exhibited also on five wasters in the Karatay Museum, three in the Museum of Turkish and Islamic Art, and one in the Raqqa Museum.[2]

1. Chapter 4, MMA33, MMA44, MMA45.
2. Chapter 3, W77–W79, W83, W88 (Karatay Museum); W108, W127, W129 (Museum of Turkish and Islamic Art); W124 (Raqqa Museum).

Pattern 12. Contoured fillers in roundel

Almost as popular as the preceding dotted double circle pattern and often combined with it, this motif is composed of fillers with dots placed on the perimeter of a central roundel in such a way as to be contoured around the principal design. It is found on three objects in the collection.[1]

The motif occurs on six wasters in the Karatay Museum, one waster in the Museum of Turkish and Islamic Art, and one in the Raqqa Museum.[2]

It does not appear on objects verifiable to Raqqa of the underglaze- and luster-painted type.

1. Chapter 4, MMA33, MMA44, MMA45.
2. Chapter 3, W77–W80, W83, W123 (Karatay Museum); W129 (Museum of Turkish and Islamic Art); W124 (Raqqa Museum).

Pattern 13. Floriated *alif-lām*

a

b

This vertically oriented pattern consists of a bold, and often quite large, *alif-lām* combination with each shaft terminating in a sinuous half palmette. Pattern 13a shows the motif in its simplest form, while 13b exhibits a more complex variation in which the shafts are elaborately interlaced and terminate in half palmettes at both top and bottom. Two different techniques are employed to execute this motif on three objects in the collection[1]— two large luster-painted jars and a segmental bowl with a wide flat rim acquired in the 1925 Thomas B. Clarke sale.[2] On the two jars the decoration is carved, and on the bowl it is painted in black under a clear turquoise glaze.

Five carved monchrome glazed jars in the Freer Gallery of Art that are very similar in decoration, shape, and size to those in the Metropolitan were acquired by Freer in Aleppo in 1908. Four of them were bought from Vincenzo Marcopoli & Co.; the fifth was purchased from a "street dealer in Aleppo."[3]

Another, very similar, monochrome jar was found "in the palace of Harun al-Rashid" in Raqqa.[4] A jar of the same type, but painted in black under a clear turquoise glaze, was

sold in the 1917 Thomas B. Clarke sale. And a fragment of a luster-painted jar of this type was picked up by Friedrich Sarre at Raqqa.[5]

1. Chapter 4, MMA6, MMA8, MMA30.
2. Clarke sale 1925, lot 633.
3. 1908.113 (from the street dealer), 1908.134, 1908.135, 1908.155, and 1908.184.
4. Kouchakji 1923: 521.
5. Clarke sale 1917, lot 731; Sarre 1921, pl. XII5. The presence of an elaborate version of this pattern on a cobalt-glazed and luster-painted jar in the al-Sabah Collection, Kuwait, which incorporates two inscriptions stating that the jar was made in Damascus, suggests that the motif traveled with migrating artisans to that center when Raqqa's importance waned. See Jenkins 1983a: 84, and Ettinghausen, Grabar, and Jenkins-Madina 2001: 250–51.

Pattern 14. Pseudo-cursive inscription on sketchy vegetal ground

a

b

This motif is composed of a pseudo-inscription in cursive script on a sketchy vegetal ground consisting of dots, commas, and long intersecting strokes. Three objects in the collection bear this pattern.[1]

The design can be seen on two wasters in the Karatay Museum and on three in the Museum of Turkish and Islamic Art.[2] Set into a band, a cartouche, or roundels, it occurs on objects verifiable to Raqqa in two of the decorative techniques under discussion. It is not found on objects of the underglaze- and luster-painted type.

1. Chapter 4, MMA31, MMA41 (from the Great Find), MMA44.
2. Chapter 3, W77, W123 (Karatay Museum); W108, W126, W127 (Museum of Turkish and Islamic Art).

Pattern 15. Dagger shape

This pattern occurs on two objects in the collection.[1]

It is also seen on three wasters in the Karatay Museum[2] and on a bowl in the Walters Art Museum (see page 103, fig. 3.5) acquired in the 1917 Thomas B. Clarke sale that was among the "number of Rakka pieces which are in their original coloring, wholly or mainly free from iridescence, [that were] found within one large vase or receptacle in the cellar of a house in Rakka."[3]

The motif does not occur on objects verifiable to Raqqa of the underglaze- and luster-painted type. It is most often seen radiating from a central design or point. On the Walters bowl, it is circumscribed in a circle.

1. Chapter 4, MMA33 (see pattern 17, below), MMA46.
2. Chapter 3, W77, W79, W80.
3. Dana H. Carroll, foreword to Clarke sale 1917.

Pattern 16. Arabesque medallion

Two objects in the collection bear as part of their decoration a series of patterns composed of split palmette leaves arranged to form a vertically oriented symmetrical arabesque medallion.[1]

The device can be found on a waster in the Museum of Turkish and Islamic Art, and, in an elaborate variation, on a segmental

bowl with flat rim in the Karatay Museum and on a waster of the same shape in the Los Angeles County Museum of Art.[2]

It is not seen on objects verifiable to Raqqa of the underglaze- and luster-painted type.

1. Chapter 4, MMA41 (from the Great Find), MMA46.
2. 26/4 (Karatay Museum); chapter 3, W117 (Museum of Turkish and Islamic Art); W89 (Los Angeles County Museum of Art).

Pattern 17. Reciprocal vegetal scroll

This pattern, which consists of a continuous, reciprocal, silhouetted vegetal scroll, is seen on two objects in the collection, one of which comes from the Great Find.[1] A jar in the Freer Gallery of Art acquired by Freer from Vincenzo Marcopoli & Co. in Aleppo in 1908 bears an identical pattern on its cylindrical neck.[2] Like the New York jar, it was part of the Great Find.

The motif appears only on objects verifiable to Raqqa of the underglaze-painted type.

1. Chapter 4, MMA33, MMA35 (from the Great Find).
2. 1908.136 (Atil 1975: 78, no. 33). For this object, see Bloom 1975.

Pattern 18. Symmetrical reserved arabesque

a

b

Numerous variations of this pattern are found on underglaze- and luster-painted objects. There is strong evidence that a Raqqa provenance can be attributed to one of these configurations. The pattern exists in both a complex and an abbreviated form. The former (pattern 18a) is composed of a pair of split palmettes that enclose an inverted full palmette. The latter gives rise to another pair of split palmettes that frames an inverted pair. These, in turn, enclose a full palmette. In the Metropolitan, it is seen on a segmental bowl with a broad flat rim (MMA 10), an object that also twice incorporates within its cavetto the abbreviated form of the motif (pattern 18b). Two wasters in the Karatay Museum bear the first step in the decoration on this bowl.[1] Another example in the Metropolitan of the abbreviated version occurs on a biconical bowl (MMA 11), for which, similarly, a waster exists in the Karatay.[2]

A nearly identical pattern in its complex version (except that it is reserved not on a plain luster-painted ground as on the Metropolitan bowl but on a tightly spiraled ground) is seen on a basin-shaped vessel in the Freer Gallery of Art. It was acquired by Freer from Vincenzo Marcopoli & Co. in Aleppo in 1908 and was part of the Great Find.[3] A pattern closely related to the abbreviated version on the New York bowl occurs on a jar also acquired by Freer from Vincenzo Marcopoli & Co. in Aleppo.[4] Decoration on a waster in the Museum of Turkish and Islamic Art can be cited as

constituting the first step in the decoration on such a jar.[5]

1. Chapter 3, w26, w27.
2. w19.
3. 1908.148 (Atil 1975: 82–83, no. 36). For this object, see Bloom 1975.
4. 1908.137.
5. w64.

Pattern 19. Xs in staggered rows

This pattern, which consists of staggered rows of small Xs filling entire sections of a design, is seen on two objects in the collection, one of which was found "in the palace of Harun al-Rashid and Wathiq" in Raqqa.[1]

It occurs also on a partial waster in the Museum für Islamische Kunst, Staatliche Museen zu Berlin, that was acquired by Friedrich Sarre in Aleppo (fig. 5.2).

The motif appears on objects verifiable to Raqqa only of the underglaze- and luster-painted type.

1. Chapter 4, MMA9 (Kouchakji 1923: 522), MMA11.

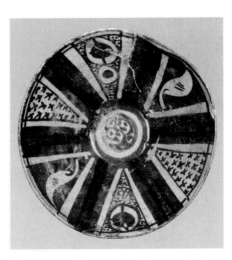

FIGURE 5.2 Underglaze- and luster-painted conical bowl. Raqqa, Syria, 1200–1230. Museum für Islamische Kunst, Staatliche Museen zu Berlin (I.3991)

Pattern 20. Reserved interlace on spiraling ground

This pattern is seen on two objects in the collection.[1] Oriented horizontally, it comprises an angular interlace design reserved on a spiraling ground.

The identical pattern can be seen on two objects in the Freer Gallery of Art, both acquired by Freer in 1908 from Vincenzo Marcopoli & Co. in Aleppo.[2]

The pattern appears on objects verifiable to Raqqa only of the underglaze- and luster-painted type.

1. Chapter 4, MMA5, MMA24.
2. 1908.137 (unpublished) and 1908.138 (Atil 1973: 142–43, no. 64).

Pattern 21. Bisected roundel

This vertically oriented motif, which appears on one object in the collection,[1] is composed of a stylized symmetrical palmette flanked by a single contoured filler and circumscribed by a double circle decorated with evenly spaced dots. As here, it is invariably combined with two other patterns, namely, 11 and 12.

The pattern can be seen on three wasters in the Karatay Museum, one waster in the Museum of Turkish and Islamic Art, and one in the Raqqa Museum.[2] In each case, it is placed at the center of the bowl's interior.

The pattern does not occur on objects verifiable to Raqqa of the underglaze- and luster-painted type.

1. Chapter 4, MMA33.
2. Chapter 3, w77–w79 (Karatay Museum); w129

(Museum of Turkish and Islamic Art); w124 (Raqqa Museum).

Pattern 22. Two intertwined leaves

This vertically oriented motif is composed of two intertwined leaves partially enclosed in a spiraling tendril. On the one object in the collection bearing this pattern, the two leaves are highlighted with incised details.[1]

This pattern can be seen on a double waster in the Museum of Turkish and Islamic Art as well as on a jar in the Walters Art Museum acquired in the 1917 Thomas B. Clarke sale that was among the "number of Rakka pieces which are in their original coloring, wholly or mainly free from iridescence, [that were] found within one large vase or receptacle in the cellar of a house in Rakka."[2] On the New York and Baltimore jars, which are so similar they could be a pair, the pattern is an element in a linear design. On the double waster in Istanbul, it is set in a roundel in the center of one of the bowls.

The pattern does not occur on objects verifiable to Raqqa of the underglaze- and luster-painted type.

1. Chapter 4, MMA40 (from the Great Find).
2. Chapter 3, w129 (Museum of Turkish and Islamic Art); 48.1059 (Walters Art Museum, unpublished). Dana H. Carroll, foreword to Clarke sale 1917.

Pattern 23. Contiguous bisected arches

This motif consists of a series of contiguous tapering arched panels, each of which is bisected by a single line. It is found on one object in the collection.[1]

The same pattern occurs on one waster in the Karatay Museum, one waster in the Museum of Turkish and Islamic Art,[2] and a bowl in the Walters Art Museum, Baltimore (see page 168, fig. 5.1). The bowl was acquired in the same 1917 Thomas B. Clarke sale as the similarly decorated jar in the Metropolitan Museum, both described as among the "number of Rakka pieces which are in their original coloring, wholly or mainly free from iridescence, [that were] found within one large vase or receptacle in the cellar of a house in Rakka."[3]

On objects verifiable to Raqqa, the pattern appears with either a vertical or radial orientation. It does not occur on objects of the underglaze- and luster-painted type.

1. Chapter 4, MMA36.
2. Chapter 3, w123 (Karatay Museum); w82 (Museum of Turkish and Islamic Art).
3. Dana H. Carroll, foreword to Clarke sale 1917. It would not be surprising to discover that this bowl and the New York jar, having been found inside the same container, were made in the same workshop as part of a set.

Pattern 24. Triple guilloche

This pattern, seen on one object in the collection, consists of a triple guilloche produced by incising through the paint.[1] It appears on one waster in the Karatay Museum and another in the Museum of Turkish and Islamic Art.[2]

The motif is found only on objects verifiable to Raqqa painted in black under a clear turquoise glaze.

1. Chapter 4, MMA29.
2. Chapter 3, w83 (Karatay Museum); w108 (Museum of Turkish and Islamic Art).

Pattern 25. *surr* with vegetation in roundel

This pattern is seen on only one object in the collection but appears to have been quite popular, especially on underglaze- and luster-painted biconical bowls.[1] It is invariably circumscribed in a roundel at the base of the bowl and reserved on a luster ground. The highly stylized vegetation, also always reserved on a luster ground, is standard for the pattern, with very few variations.

In addition to the identical hemispherical bowl brought from "Alep, kaza de Raqqa et de Maareh" in 1903 (Museum of Turkish and Islamic Art 1645/1969), there are also two fragmentary biconical bowls in the Museum of Turkish and Islamic Art that bear this pattern and the same provenance (except that one entered the museum in 1900 rather than 1903).[2] The motif occurs on a biconical bowl in the Freer Gallery of Art that was acquired by Freer from Vincenzo Marcopoli & Co. in Aleppo in 1908 and on a bowl of the same shape in the Museum für Islamische Kunst, Berlin, that was also acquired in Aleppo, by Friedrich Sarre, as well as on a fragmentary bowl picked up by Sarre in Raqqa.[3]

The pattern occurs on objects verifiable to Raqqa only of the glazed and luster-painted or underglaze- and luster-painted types.

1. Chapter 4, MMA3.
2. 1657/1975 and 1646/1499.
3. 1908.149 (Freer Gallery of Art); I.3990 (Museum für Islamische Kunst); Sarre 1921, pl. XIII5.

II. Profiles
A. Profiles with a Verifiable Raqqa Provenance: Objects in The Metropolitan Museum of Art

These profiles can be securely attributed to Raqqa on the basis of one or more of the following criteria: wasters documented as coming from Raqqa; vessels from the Great Find or "from the palace of Harun al-Rashid"; patterns verifiable to Raqqa; or scientific verification.

Profile 1. Inverted pear-shaped jar with cylindrical neck and everted rim

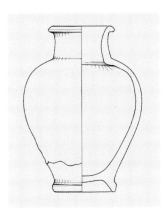

MMA5: patterns 2, 20
MMA18: Great Find; patterns 1, 2
MMA19: Great Find; patterns 1, 10
MMA20: w64 Great Find; patterns 1, 10
MMA27: patterns 1, 2
MMA35: Great Find; pattern 17
MMA36: pattern 23
MMA37: Great Find
MMA38: Great Find
MMA40: Great Find; patterns 5, 22
MMA41: Great Find; patterns 14, 16; scientific verification
MMA42: Great Find

Profile 2. Segmental bowl with flat rim[1]

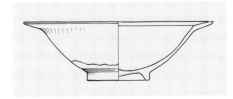

MMA10: w26, w27; patterns 1, 2, 6, 7, 18; scientific verification
MMA28: w24, w25; scientific verification
MMA30: patterns 3, 9, 13; scientific verification
MMA32: patterns 3, 8; scientific verification
MMA33: patterns 3, 9, 11, 12, 15, 17, 21; scientific verification
MMA44: patterns 3, 5, 9, 11, 12, 14; scientific verification

Profile 3. Biconical bowl[2]

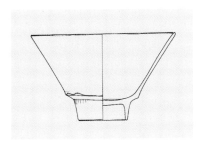

MMA2: w1, w2, w3, w4; patterns 4, 6, 7
MMA11: w19; patterns 2, 4, 6, 18, 19; scientific verification
MMA34: pattern 6; scientific verification
MMA45: w122, w123, w130; patterns 3, 5, 11, 12; scientific verification
MMA46: patterns 3, 8, 15, 16; scientific verification

Profile 4. Tall-neck jug on high foot

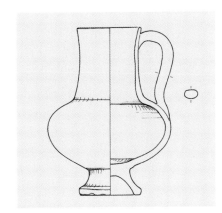

MMA21: pattern 1
MMA22: patterns 1, 4
MMA23: Great Find[3]; pattern 4
MMA25: pattern 4

Profile 5. Jar with molding at base of neck

a

b

c

MMA6: "from the palace of Harun al-Rashid";[4] pattern 13
MMA8: "from the palace of Harun al-Rashid"; pattern 13

173

MMA9: "from palace of Harun al-Rashid and Wathiq"; pattern 19

Profile 6. Segmental bowl with upper section sloping to small rimless opening

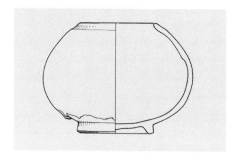

MMA15: patterns 4, 7
MMA26: patterns 2, 5
MMA31: pattern 14

Profile 7. Medium-neck jug

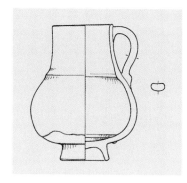

MMA7: W54, W57; pattern 1; scientific verification
MMA24: patterns 2, 20; scientific verification

Profile 8. Albarello

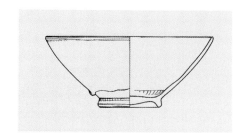

MMA17: pattern 1

Profile 9. Lobed cup with handle

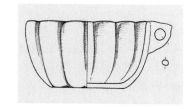

MMA14: Great Find; pattern 2

Profile 10. Lantern

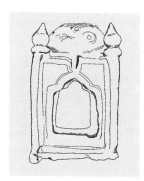

MMA1:[5] scientific verification

Profile 11. Conical bowl[6]

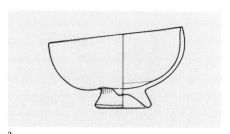

MMA4: scientific verification

Profile 12. Hemispherical bowl[7]

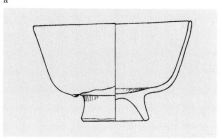

a

b

MMA3:[8] pattern 25
MMA12 (modified): patterns 1, 2, 7, 10

Profile 13. Cono-segmental bowl[9]

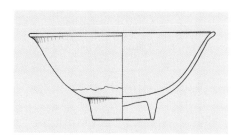

MMA29: patterns 3, 5, 8; scientific verification

B. Additional Profiles with a Verifiable Raqqa Provenance: Wasters in Various Collections

The profiles included in this section do not occur on objects in The Metropolitan Museum of Art but appear on wasters with a verifiable Raqqa provenance discussed in chapter 3.

Profile 14. Hemispherical bowl with slightly everted rim: w50, w96, w97, w98, w99, w101, w102, w103, w132

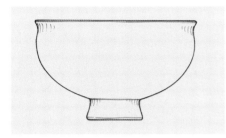

Profile 15. Handled pouring vessel: w70, w71, w117

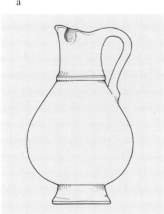

a

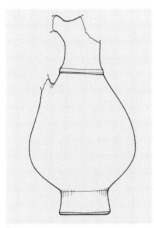

b

Profile 16. Hemispherical bowl with overhanging rim: w48, w105, w106, w107

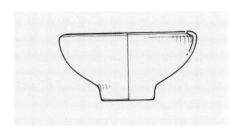

Profile 17. Hemispherical bowl with lobed rim: w49

Profile 18. Short-neck jug: w61

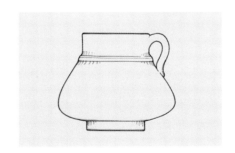

Profile 19. Oil lamp: w121

III. Scientific Verification to Raqqa

A. Black-Painted Decoration under a Clear Turquoise Glaze

Among the twenty-two objects in this tightly knit group, as defined scientifically in Appendix 2, there are two that have an unequivocal Raqqa provenance. The first of these is the fragment of a waster (chapter 4, RA1) that I collected in 2002 at the site of Raqqa.[10] The second is a jar in the Metropolitan Museum (chapter 4, MMA41) that formed part of the Great Find and was sold in the 1925 Thomas B. Clarke sale.[11] A third object, the waster of a handled pouring vessel in the Museum of Turkish and Islamic Art (chapter 3, W117), can be added to the first two on the basis of scientific analysis.[12] The remaining nineteen objects in this group are thus believed to be from Raqqa as well and can be used as building blocks to further define the production of this ceramic center.[13]

These objects show the following patterns:

Line back (pattern 3)
Hillock with three leaves (pattern 5)
Filler with leaf in concentric circles (pattern 8)
Lozenge rim (pattern 9)
Dotted double circle (pattern 11)
Contoured fillers in roundel (pattern 12)
Floriated *alif-lām* (pattern 13)
Pseudo-cursive inscription on sketchy vegetal ground (pattern 14)
Dagger shape (pattern 15)
Arabesque medallion (pattern 16)
Reciprocal vegetal scroll (pattern 17)
Bisected roundel (pattern 21)
Triple guilloche (pattern 24)

And exhibit the following profiles:

Inverted pear-shaped jar with cylindrical neck and everted rim (profile 1)
Segmental bowl with flat rim (profile 2)
Biconical bowl (profile 3)
Cono-segmental bowl (profile 13)
Handled pouring vessel (profile 15)

B. Luster-Painted and Underglaze- and Luster-Painted Decoration

Two of the thirty-four objects in this group, as defined scientifically in Appendix 2, share an unequivocal Raqqa provenance. The first object is a waster of a hemispherical bowl with overhanging rim in the Museum of Turkish and Islamic Art (chapter 3, W48). The Topkapı Çinili Köşk register books state that it was excavated by Theodore Makridy in Raqqa in 1906. The second is the waster of a tile acquired in Aleppo and now in the Los Angeles County Museum of Art (W75). The latter waster is identical to a fragmentary tile collected by Jean Sauvaget in Raqqa before 1948 and now in the Musée National de Céramique de Sèvres (fig. 5.3).[14] It is related technically and decoratively to the fragmentary waster of a polygonal tile excavated in Raqqa by Haydar Bey in 1908 (W76). A third object, the waster of a handled pouring vessel in the Museum of Turkish and Islamic Art (W71), can be added to the first two on the basis of scientific analysis.[15]

The circumstantial evidence that an additional five objects in this group are verifiable to Raqqa kilns is very strong. The segmental bowl with flat rim decorated with a large spotted duck in the Metropolitan Museum (chapter 4, MMA28) is central to the argument regarding three of the five. Not only is there a waster of this type in the Museum of Turkish and Islamic Art (W25) that is regis-

FIGURE 5.3 Tile fragment. Raqqa, Syria, 1200–1230. Musée National de Céramique de Sèvres

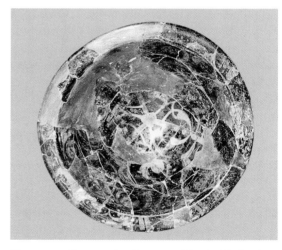

FIGURE 5.4. Luster-painted segmental bowl with flat rim. Raqqa, Syria, 1200–1230. Raqqa Museum (480). Photo: Marilyn Jenkins-Madina

tered as entering the Museum in December 1900 from Aleppo Province,[16] but a fragment from another bowl of the same type in the Çinili Köşk (41/1486) that exhibits within a lobed medallion a seated figure holding a beaker bears the notation "Raqqa" on the inventory card. The same information is repeated on the label for the fragment.[17] Furthermore, another such bowl, now in the Aleppo National Museum (561),[18] exhibits a central decoration identical to that on a large jar with molding at the base of the neck in the Freer Gallery of Art (see page 18, figs. 1.2, 1.3). The latter can be closely related to a jar in the Metropolitan Museum (MMA9) of the same shape and size and incorporating a similar vine scroll in its decoration that was excavated in Raqqa in the "palace of Harun al-Rashid and Wathiq." Another bowl which is part of the scientific group of the same type but exhibiting a different color scheme —luster painting on an aubergine ground— that was excavated in Raqqa and is now in the site museum there (fig. 5.4) bears a cen-

tral decoration comparable to that on the interior wall of a bowl in the Metropolitan Museum (MMA4), and shares its color scheme as well. And two other objects in this group, both large jars with molding at the base of the neck and with carved decoration (MMA6 and Madina Collection, New York, C0182), incorporate the floriated *alif-lām* pattern that, as we have seen, is indicative of a Raqqa provenance.

On this basis, the remaining twenty-six objects in this group must be considered to have been made in Raqqa.[19]

These objects show the following patterns:

Calligraphy band (pattern 1)
Cursive-script panels on spiraling ground (pattern 2)
al-ʿizz on spiraling ground (pattern 4)
Spiral back (pattern 6)
Trefoils (pattern 7)
Floriated *alif-lām* (pattern 13)
Symmetrical reserved arabesque (pattern 18)
Xs in staggered rows (pattern 19)
Reserved interlace on spiraling ground (pattern 20)
surr with vegetation in roundel (pattern 25)

In addition to profiles 2, 3, and 15, which were seen in the scientifically defined group with black-painted decoration under a clear turquoise glaze, this group also includes:

Jar with molding at base of neck (profile 5)
Medium-neck jug (profile 7)
Lantern (profile 10)
Conical bowl (profile 11)
Hemispherical bowl with overhanging rim (profile 16)
Short-neck jug (profile 18)

C. Black-and-Cobalt-Painted or Black-Painted Decoration under a Clear Colorless Glaze

This group, as defined scientifically in Appendix 2, is composed of eight objects decorated in two different ways: painted in black and cobalt blue under a clear colorless glaze or painted simply in black under a clear colorless glaze.[20] One or more objects with a secure Raqqa provenance are represented in each subgroup. The first type is verifiable to Raqqa by means of a fragment from the rim of a bowl that I collected in 2002 at the site of Raqqa (fig. 5.5), the body of which is identical in composition to that of the underglaze-painted waster collected at the same site (chapter 4, RA1). The type is further verifiable to Raqqa by means of the medium-neck jug in the Museum of Turkish and Islamic Art (chapter 3, W135), described in the Topkapı Çinili Köşk register books as coming from "Alep [Aleppo Province], kaza de Rakka et de Maareh, December 1900." The second type is firmly placed in Raqqa by a double waster with the same provenance in the same museum (W129).[21] The remaining five objects in this group are thus also scientifically verifiable to Raqqa.

In addition to patterns 3, 5, 8, 9, 11, 12, 14, 15, 16, and 21, which appear on the

scientifically defined group with black-painted decoration under a clear turquoise glaze, the objects in this group also exhibit an additional pattern, namely, pattern 22, two intertwined leaves.

Besides profiles 2, 3, and 7, which have been seen on objects in the other scientifically verifiable groups, this group also includes the hemispherical bowl, profile 12.

1. Mason 1997, fig. 2, middle right.
2. Ibid., fig. 2, upper left.
3. Freer Gallery of Art 1908.140 (Atil 1975: 81, no. 35).
4. See Kouchakji 1923: 521, 522.
5. The profile of the upper part of the dome cannot be ascertained because of breakage.
6. Mason 1997, fig. 2, lower left.
7. Ibid., upper right.
8. An identical bowl now in the Museum of Turkish and Islamic Art (1645/1969) was brought from "Alep, kaza de Rakka et de Maareh" in 1903.
9. Mason 1997, fig. 2, lower right.
10. I would like to thank Dr. Abdal Razzaq Moaz, the former director general of antiquities and museums of Syria, for his help during many phases of this research. Another object collected at the same time (chapter 4, RA4) should also be added to this group.
11. The close scientific matching of the waster fragment and this particular jar offers firm proof that the objects in the Great Find were made in Raqqa.
12. That this waster, inventoried in the Topkapı Çinili Köşk register books as coming from the province of Aleppo in December 1900, is included in the group defined in Appendix 2 allows us to conclude that the objects so noted in these register books can be more fully described as having come specifically from Raqqa.
13. Because five of these nineteen objects are among

those in the Karatay Museum registered as entering the museum in 1914 from Aleppo Province, we can confidently state that the objects so noted were made in Raqqa as well.
14. Sauvaget 1948, fig. 10, no. 85.
15. The fact that this waster, registered in the Topkapı Çinili Köşk as coming from Tell Halaf in 1912 as part of the Oppenheim mission, belongs to the group defined in Appendix 2 allows us to conclude that the objects so noted were acquired by Baron Max von Oppenheim in Raqqa, whence they were sent to Istanbul and Konya.
16. See note 12, above
17. Unfortunately, since the original accession number for 41/1486 appears to be unknown, the Topkapı Çinili Köşk register books cannot be used to shed further light on the provenance of this fragment.
18. *Land des Baal* 1982, no. 255.
19. See note 13, above. Four objects from the Karatay Museum are included in this group.
20. Dylan Smith has suggested that the group painted in black under a clear colorless glaze may be a cheaper version of the bichrome group, as cobalt was an expensive pigment (personal communication, 2004).
21. The fact that this waster with its precisely stated provenance is part of the scientifically defined group allows us to confidently state that the designation "Alep [Aleppo Province], December 1900" must be an abbreviated form of the more detailed "Alep, kaza de Rakka et de Maareh, December 1900." As noted in Appendix 2, the sample taken from this double waster was problematic. Those taken from two identical bowls in Berlin (W130, W131), however, were good samples. The clear provenance of the double waster and the firm test results of the two Berlin bowls allow us to firmly conclude that all three objects were manufactured in Raqqa.

FIGURE 5.5
Fragment from the rim of an underglaze-painted vessel (RA3), collected in Raqqa, Syria, 2002. Collection of Marilyn Jenkins-Madina

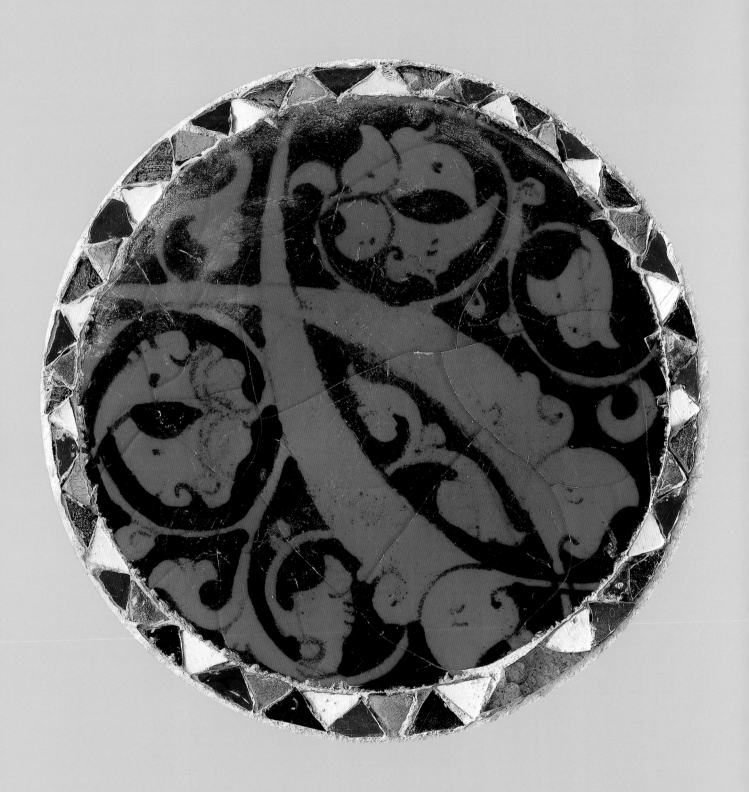

6. The Period of Production

WE HAVE REACHED the final chapter in our chronicle of Raqqa and the study of its medieval ceramic industry. What remains to be addressed is the question of when, specifically, these objects were made. Surprising as it may seem, given the numerous and often convoluted problems we have confronted in other aspects of this study, the task of dating appears to be relatively straightforward.

From 1901, when objects of the types here under discussion were first assigned a date, until the most recent publication on the subject (2004), the period of production has been variously attributed. In 1901, Gaston Migeon suggested a dating from before the thirteenth century;[1] Dikran Khan Kelekian, writing in 1903, believed those objects exhibiting a "decoration in black" should be assigned to the tenth century.[2] Migeon, again tackling the subject in 1907, stated that the latter group must have originated in the late twelfth century, but he placed the luster-painted ware three hundred years earlier, in the ninth century.[3] And starting in 1908, several authors—Garrett Chatfield Pier, Thomas B. Clarke, and the Kouchakjis, among others—ascribed the production of these types to the ninth-century date.[4] Friedrich Sarre placed them considerably later, in the eleventh or twelfth century.[5] In 1910, Azeez Khayat dated them to the eighth century.[6] The same year, A. Nöldeke-Hannover speculated that the objects painted in black under a turquoise glaze should be dated to the eleventh and twelfth centuries and the underglaze- and luster-painted objects to the twelfth and thirteenth centuries.[7] In 1922, Rudolf Riefstahl hedged his bets by suggesting the eleventh, twelfth, and thirteenth centuries. Approximately five years later, he extended this range to include the fourteenth century.[8]

In short, and as we have seen earlier, scholars and antiquarians writing before 1930 bequeathed a legacy of confusion concerning the dating of these ceramic objects. A century after Migeon first wrote about vessels that had come from Raqqa, Oliver Watson and Venetia Porter—both of whom worked on the more than 450 fragments of glazed pottery, including twenty-two wasters, excavated at that site in 1985—perpetuated this legacy by assigning similarly vague dates to ceramics they associated with the site or its kilns. Watson states that the Qasr al-Banat "is . . . filled with debris from the Raqqa kilns of the 12th and 13th century which surrounded it." And Porter writes that the "c. 12th-13th century . . . fritwares . . . are broadly of the 'Raqqa-ware' type."[9]

1. Migeon 1901: 197.
2. Introduction, Kelekian sale 1903.
3. Migeon 1907: 258, 286.
4. Pier 1908: 125; Clarke sale 1917; Kouchakji 1923.
5. Sarre 1909b: 388.
6. Khayat sale 1910.
7. Nöldeke-Hannover 1910–11: 16.
8. Riefstahl 1922: xiii; Riefstahl n.d.
9. Watson 1999: 424; Porter 2004: 41.

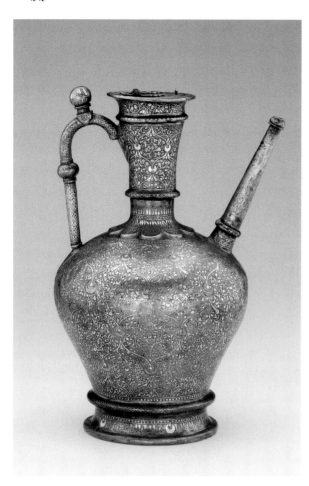

FIGURE 6.1. Brass ewer inlaid with silver and copper. Syria, dated A.H. 629/A.D. 1232. Freer Gallery of Art, Smithsonian Institution, Washington, D.C., Purchase (1955.22)

Because none of the extant vessels of or fragments from the three ceramic types under discussion are dated or bear any datable inscription, the confusion is not surprising.[10] Other means of ascribing a date had to be found. Fortuitously, four independent sources that suggest a closely circumscribed period of production presented themselves to me, and each one yielded the same answer, namely that this production took place sometime during the first three decades of the thirteenth century.[11]

One source was a group of seven inlaid metal ewers, all of which are signed by artisans with the *nisba "al-Mawṣilī"* (of the Jaziran city of Mosul) and dated between A.H. 620/A.D. 1223 and A.H. 657/A.D. 1259.[12] These vessels are pertinent to our discussion in that at least two ceramic objects attributable to Raqqa—one with under-glaze- and luster-painted ornamentation and the other with only luster-painted ornamentation—mimic the metal ewers in size, shape, and decoration (figs. 6.1–6.3).[13]

Although in a fragmentary state, the ewer in figure 6.2 exhibits a profile that mimics in almost every way that of its metal proto-type: the inverted pear-shaped body terminates at the top in a pro-nounced molded collar and incorporates a tapering spout projecting from the shoulder at a 45-degree angle; the tall cylin-drical neck is interrupted by a torus molding; and the wide, sharply flaring mouth is highlighted by a narrower torus molding.

Modifications to the profile of the prototype are dictated only by the difference in the two mediums. The broader of the two bands of Arabic inscription executed in cursive script and framed in contour panels reserved on a spiraling ground (pattern 2) is closest to that on the shoulder of the metal ewer dated A.H. 627/A.D. 1229 now in the Museum of Turkish and Islamic Art, Istanbul.[14] In shape, except for a plain as opposed to a scalloped collar at the base of the neck, it is closest to the metal ewers in Istanbul, in Cleveland (dated A.H. 620/A.D. 1223),[15] in Washington (dated A.H. 629/A.D. 1232 [fig. 6.1]), and in Baltimore (dated A.H. 644/A.D. 1246–47).[16]

The ceramist who executed the second, luster-painted ewer in the Freer Gallery (fig. 6.3) took a few more liberties with the shape vis-à-vis the metal prototype. The body is somewhat squatter; the neck is not as attenuated and lacks the medial torus molding; and the mouth is less everted. One can assume that the changes were dictated by the medium. The decoration, however, is very close to that on the metal ewer in the Freer Gallery. This vessel was made for Shihab al-Din Tughrul, the Turkish commander who served as regent in Aleppo on behalf of the Ayyubid ruler al-Malik al-Aziz (r. 1216–37). Both the proto-type and its ceramic imitation are decorated with spiral-filled quadrilaterals (pat-tern 10), those on the body tapering in size from bottom to top and on the neck from top to bottom. This pattern, as we have seen in the previous chapter, occurs on several vases from the Great Find in the Metropolitan Museum.

10. Sauvaget (1948: 41–42) mentions a luster-painted vase that the author says bears the name of the Ayyubid ruler of Homs, al-Malik al-Mujahid Shirkuh II (r. 1186–1239). It is likewise simply mentioned in the two references cited for this vase in *Répertoire chronologique d'épigraphie arabe* 1941: 118, no. 4178. Since it seems that no illustration has been published of this vase and it is otherwise unknown, this information cannot be verified.

11. Unlike Porter (1981: 23–25) and others before her, I believe that all three types of glazed pottery were contemporaneous.

12. Rice 1953: 229–32; Rice 1957: 283–326; and Atil, Chase, and Jett 1985: 117–23.

13. Freer Gallery of Art 1908.185 and 1911.15. Both vessels were acquired from Vincenzo Marcopoli & Co. in Aleppo and are unpublished.

14. Rice 1953, pl. 1.

15. Ettinghausen, Grabar, and Jenkins-Madina 2001, figs. 406, 407.

16. Walters Art Gallery 1997: 106.

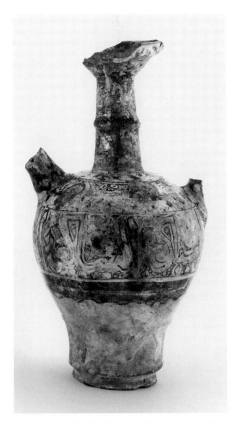

FIGURE 6.2. Underglaze- and luster-painted ewer. Raqqa, Syria, 1200–1230. Freer Gallery of Art, Smithsonian Institution, Washington, D.C., Gift of Charles Lang Freer (1908.185; see also fig. 2.4, no. 4)

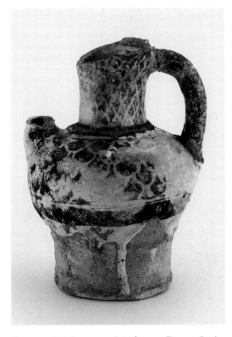

FIGURE 6.3. Luster-painted ewer. Raqqa, Syria, 1200–1230. Freer Gallery of Art, Smithsonian Institution, Washington, D.C., Gift of Charles Lang Freer (1911.15; see also fig. 2.10, no. 17)

Another inlaid metal object that helps us to home in on a more precise date is a biconical bowl in the Museo Civico Medievale, Bologna (fig. 6.4), made for a certain Najm al-Din Umar, an officer in the service of Badr al-Din Luʾluʾ, who ruled from Mosul from 1210 to 1259.[17] The bowl (a seemingly unique example in this medium) is believed to have been made in northwestern Iran. For our purposes, its importance lies in the fact that it indicates that this shape—so popular among the ceramic vessels discussed here—was current during the first half of the thirteenth century and that it was the shape of choice for a luxury object made for an officer of an important atabeg ruling in the Jazira. The size of the metal bowl is only slightly smaller than those of the ceramic versions.

We have seen that the two ceramic ewers in the Freer Gallery were made as cheaper versions of contemporary inlaid metal pouring vessels. The inlaid metal bowl in Bologna appears to present the reverse situation. Thus, I would agree with D. S. Rice that it should be viewed as an experiment that did not become current because of the difficulty of translating the pottery shape into metal.[18] The dependence of underglaze- and luster-painted ceramic objects manufactured in Raqqa on contemporary metalwork certainly warrants additional study. Metal prototypes exist not only for the profiles of ceramic objects and their decorative schemes but also for many individual designs and motifs. For example, one of the most common background designs on this pottery type, composed of tight overall spirals and the pattern of inscriptions in contour panels, seems to echo similar designs on metal objects inlaid with copper and silver.[19]

A well-known group of underglaze-painted biconical bowls similarly reinforces a date in the first half of the thirteenth century. The group has long been associated with the production of the Iranian ceramic center of Kashan starting about 1200. A number of bowls are dated; the best were produced between 1204 and 1216.[20] Although Robert Mason implies that the biconical shape was introduced before 1200,[21] thus disagreeing with both Porter and Helen Philon,[22] it is clear that this form was current—specifically in Kashan—in the first half of the thirteenth century (figs. 6.5, 6.6). Underglaze-painted biconical bowls were excavated in large numbers in Jerusalem in a context that suggested that such vessels were also apparently in use in Palestine after 1219 at the earliest or after 1227 at the latest.[23] This would indicate that the vogue for bowls of this shape moved from east to west.

The last two groups of objects that help shed light on the dating of the glazed ceramic vessels are to be found in the West—in Ravello, on the Amalfi coast, and in Pisa. The objects in Ravello comprise twenty-one fragmentary ceramic bowls that decorate the so-called Bove Pulpit in the Church of San Giovanni del Toro (figs. 6.7), sixteen of which are illustrated here (figs. 6.8–6.23). Each bowl has had its rim removed, most likely to better conform to the architectural context. The diameters range from 2¾ to 5⅜ inches (7–13.5 cm). Thirteen of the twenty-one vessels are painted in black under a turquoise glaze, four exhibit luster-painted decoration, two have polychrome underglaze-painted designs, one appears to have a sgraffito decoration, and the last is monochrome-glazed.[24]

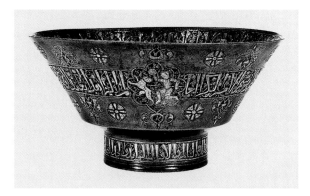

FIGURE 6.4. Brass biconical bowl inlaid with silver. Iran (?), first half of 13th century. Museo Civico Medievale, Bologna (2128)

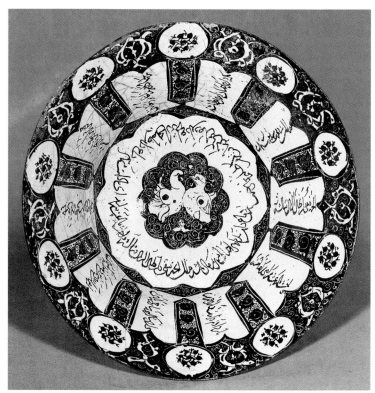

FIGURE 6.6. Interior of bowl in figure 6.5

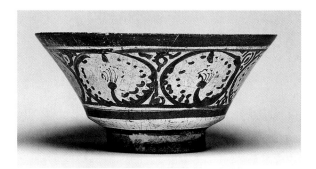

FIGURE 6.5. Luster-painted biconical bowl. Kashan, Iran, dated A.H. 609 / A.D. 1212. The Walters Art Museum, Baltimore, (48.1042)

17. Rice 1953: 232–38; Baer 1983: 118–19.

18. Rice 1953: 233.

19. Ettinghausen, Grabar, and Jenkins-Madina 2001: 250.

20. Ibid.: 176–77.

21. Mason 1997: 190. In the same context, however, he agrees that there was a "predominance of this form in Iranian groups dated after 1200."

22. Porter 1981: 18; Philon 1985: 117.

23. Tushingham 1985: 449.

24. Ballardini 1933: 391–400; Gabrieli and Scerrato 1979: 439, figs. 425–32; *Apollo* 1991; Schroerer et al. 1992: 74–96.

25. Berti, Gabbrielli, and Parenti 1996: 243–64.

26. To date, both Syria and/or Egypt have been variously suggested as possible sources of the *bacini* in the Bove Pulpit. Unfortunately, other than the seven *bacini* I have cited to compare with objects known to have come from Raqqa, this confused picture will likely remain so long as the *bacini* are in situ. Until their body fabrics can be analyzed and their exact profiles seen, the provenance of the remaining fourteen *bacini* cannot be definitively determined. Nevertheless, because of the strong comparisons with known Raqqa production and the similarities between five of the *bacini* in

Called *bacini*, these bowls—like the many others from Syria, Egypt, and elsewhere in the Islamic world that once graced or still adorn the facades of Romanesque churches and/or campaniles and pulpits in Italy—were installed at the time of the construction.[25] It is for this reason that *bacini* can offer a precise dating of entire types of Islamic pottery that have defied dating by any other means.

Most relevant to our study are the patterns found on seven of the Ravello *bacini*, namely those in figures 6.8–6.13 (the seventh is nearly identical to figure 6.13). Among the patterns discussed in the preceding chapter, the dotted double circle (pattern 11) can be seen on the *bacino* in figure 6.8 and, with a slight variation, on the *bacino* in figure 6.9, which also incorporates the pseudo-cursive inscription on sketchy vegetal ground (pattern 14) and the highly stylized palmette leaves found on a waster in the Museum of Turkish and Islamic Art, Istanbul (chapter 3, W108). The symmetrical reserved arabesque (pattern 18) is beautifully represented on the *bacino* in figure 6.10. The contoured fillers in roundel (pattern 12) occurs on the *bacino* in figure 6.11, as does a bird very similar to that found on a bowl in the Metropolitan Museum, MMA43. The *bacino* in figure 6.12 is nearly identical to a bowl in the Karatay Museum (6.24). Finally, a variation of the bold spiraling designs on two of the *bacini*, one of which is illustrated in

Ravello and the fragmentary *bacino* from Pisa,
their use as confirming data for purposes of dating
is more than justified.

27. Glass 1991: 120; Mauro 1991: 89–102, esp. n. 34;
Caskey 2004: 121–28, 157. A number of articles
on the *bacini* in this pulpit use the glazed ceramic
objects to date the pulpit. Until now, these attempts
at dating could, at best, be only educated guesses.

28. Fortnum 1896: 15, 83.

29. Berti 1987: 5–13, fig. 3, and pl. 1a; Berti 1997: 44.
The fragment in Pisa is published in Berti and
Tongiorgi 1981: 254 and pl. CLXXXVII.

FIGURE 6.7. Bove Pulpit, San Giovanni del Toro,
Ravello. Italy, ca. 1200–1230

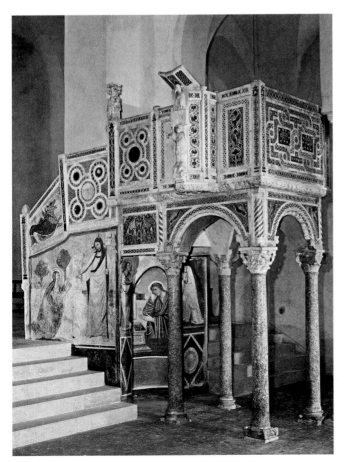

figure 6.13, can be seen on four wasters: w79, w81, w87, and RA4.[26]

Unfortunately, there is no dedicatory inscription on the pulpit. Jill Caskey, who has written about the merchant culture on the Amalfi coast during the medieval period, suggests that the absence of "familial marking" derives from the "shared nature of the foundation," the church having been established by a consortium of families in 1018. The church was reconstructed on a larger scale in the early twelfth century, but not consecrated until 1276. The pulpit was part of "a steady stream of furnishings, wall paintings, and vestments for the church . . . [that] indicate the wealth of its members and the commitment to the institution that they sustained over many generations." Based on the style of the sculpture on the pulpit, its manufacture has been placed in the first decades of the thirteenth century. Caskey dates the pulpit to about 1230; Daniela Mauro places it about 1220; and Dorothy Glass to between 1200 and 1220.[27]

Because this dating of the Ravello *bacini*, based on style alone, cannot by its nature be precise, it is fortunate that the second *bacini* source for dating the three types of Raqqa ceramics independently confirms this date. This source is a single fragmentary *bacino* painted in black under a clear turquoise glaze that once graced the Church of Santa Cecilia in Pisa. Three fragments of this bowl are extant. One is in the Ashmolean Museum of Art and Archaeology, Oxford (figs. 6.25–6.27), and one is in the British Museum, London. The last was removed from the church in 1972 and is today in the Museo Nazionale di San Matteo, Pisa. The two fragments now in England once formed one fragment that was acquired by C. Drury E. Fortnum in 1870.[28] Fortnum gave half the fragment to the Ashmolean Museum and the other half to a Mr. Henderson who, in turn, gave it to the British Museum. The Church of Santa Cecilia was founded in 1103 and consecrated in 1107, but according to Graziella Berti, the *bacini* were inserted during a reconstruction that took place between 1210 and 1236—the latter date being that of the campanile.[29]

Not only do the dates of the insertion of the two groups of *bacini* dovetail nicely, but two of the *bacini* in the Bove Pulpit (figs. 6.8 and 6.14) are very similar in style to the fragmentary example from Santa Cecilia, and three more (figs. 6.15–6.17) bear related designs, further confirming the contemporaneity of the underglaze-painted bowls. The profiles of the Santa Cecilia *bacino* fragment still in Pisa and of that in the British Museum have both been published; the profile of the Ashmolean fragment is being published here for the first time. The bowl from which these were taken is a segmental bowl with flat rim (profile 2). It is difficult to ascertain the shapes of many of the Bove Pulpit *bacini*. However, the close similarity of the decoration on the Santa Cecilia *bacino* and five of the *bacini* in Ravello makes it safe to assume that the

6.8

6.9

FIGURES 6.8–6.19
Fragmentary under-
glaze-painted *bacini*
set into the pulpit of
San Giovanni del Toro,
Ravello

6.10

6.11

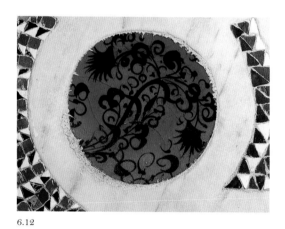

6.12

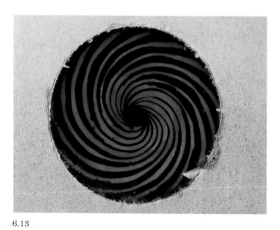

6.13

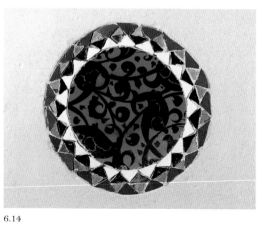

6.14

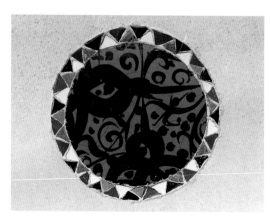

6.15

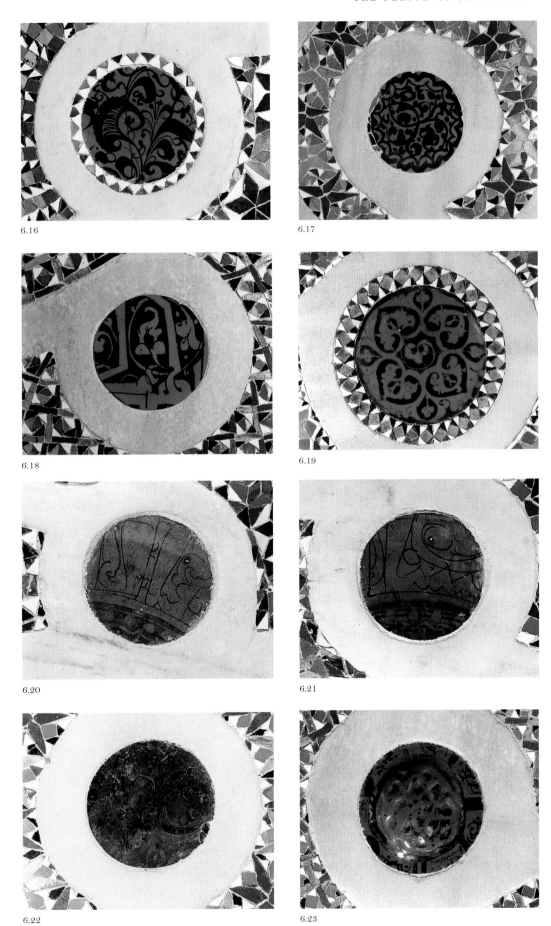

6.16

6.17

6.18

6.19

FIGURES 6.20–6.23
Fragmentary glazed and
luster-painted *bacini* set
into the pulpit of San
Giovanni del Toro, Ravello

6.20

6.21

6.22

6.23

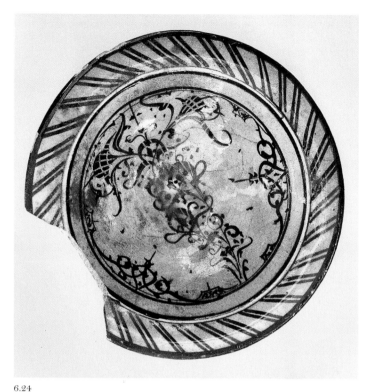

6.24

6.25

6.26

6.27

FIGURE 6.24. Underglaze-painted segmental bowl with flat rim. Raqqa, Syria, 1200–1230. Karatay Museum, Konya (26/2)

FIGURE 6.25. Interior of fragment of underglaze-painted *bacino* formerly part of interior decoration of Santa Cecilia, Pisa. Raqqa, Syria, 1200–1230. Ashmolean Museum of Art and Archaeology, Oxford (P.996)

FIGURE 6.26. Exterior of fragment in figure 6.25

FIGURE 6.27. Profile drawing of fragment in figures 6.25 and 6.26

shapes of these five vessels were comparable as well.

In sum, the five groups of objects discussed in this chapter that can be brought to bear on the dating of the three types of Raqqa pottery point unequivocally to a period of manufacture in the first half of the thirteenth century. How do these findings relate to the history of Raqqa during that fifty-year period? As noted in the Introduction, between 1201 and 1229, the Ayyubid prince al-Malik al-Ashraf Musa took up residence in the city and embarked on an ambitious program to construct buildings and gardens. This period of prosperity was soon followed by the occupation of the city by the Saljuqs of Rum in 1235–36 and, shortly thereafter, by the Khwarazm-Shahs in 1240–41. During the last thirty years of its history, before it was destroyed by the Mongols in 1265, the city acquired a more military function and went into decline.[30] This description, by the contemporary author Ibn Shaddad (d. 1285), helps to narrow the period of manufacture of the glazed ceramic objects even further. The conditions that would have fostered such a luxury production were those that thrived during the period of al-Malik

30. Heidemann 1999: 49–51.

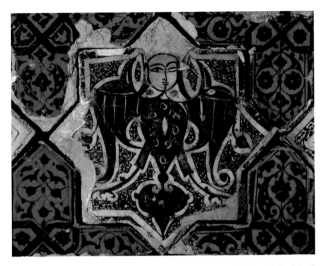

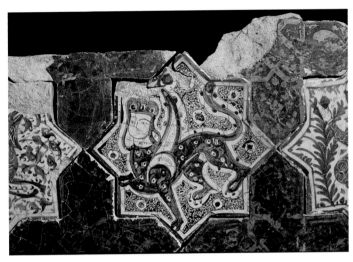

FIGURE 6.28. Detail of underglaze-painted tile panel from Kubadabad, founded 1227. Photo: Ruchan Arik

FIGURE 6.29. Detail of glazed and luster-painted tile panel from Kubadabad, founded 1227. Photo: Ruchan Arik

31. Ettinghausen, Grabar, and Jenkins-Madina 2001: 252. Compare Arik 2000, pl. 53, the tile at upper right, with the *bacino* in figure 6.10. The date of this palace in Kubadabad further confirms our dating of the Raqqa production here under discussion to the first three decades of the thirteenth century. For evidence of the relocation of Raqqa ceramists to Damascus, see chapter 5, pattern 13, note 5.

al-Ashraf, namely the first three decades of the thirteenth century.

The influence of these wares was to be strongly felt on tilework abundantly employed in a palace founded in 1227 by the Saljuq ruler ʿAlaʾ al-Din Kayqubad I at Kubadabad in central Anatolia (figs. 6.28, 6.29). I have suggested elsewhere that building tiles in Anatolia were produced with the help of imported or migrant craftsmen.[31] Is it possible that these underglaze-painted and glazed and luster-painted tiles were made by Raqqa craftsmen who, when the prosperity of their city waned during the period leading up to its conquest by the Rum Saljuqs, were lured 450 miles to the northwest by ʿAlaʾ al-Din Kayqubad to help decorate his new palace? History and art history both support such an end to the story of Raqqa pottery production. But that is the subject for another book!

Epilogue

THIS BRINGS ME to the end of my journey. When it started, little did I know that my voyage would lead me from Konya to the banks of the Euphrates, the balconies of Aleppo, the emporiums of Paris and New York, the drawing rooms of Fifth Avenue, and many places in between. Nor could I have imagined that I would be studying Ottoman documents, reading the personal diaries and letters of travelers, diplomats, and collectors, and sifting through their old photographs. When I began this project, I thought it would be a relatively straightforward art-historical undertaking. Clearly, this was not the case.

As we have seen, three specific types of glazed pottery produced in Raqqa, Syria, during the Early Medieval period have emerged: underglaze- and luster-painted; black under a clear turquoise glaze; and black and cobalt under a clear colorless glaze. We have also established the patterns and profiles preferred by those who fashioned these three pottery types, the scientific makeup of the materials they used, and the thirty-year period of their production.

Although the examples chosen to represent these types are far from exhaustive, the patterns, profiles, and body compositions presented can be used to augment each of the groups. Furthermore, since I was fortunate enough to obtain samples from complete—rather than fragmentary—objects, the decorative motifs incorporated with those identified in this study can be used by scholars to greatly expand not only the number of patterns isolated here but also, by extension, the number of objects constituting these three groups.

Other related subjects for future investigation might include those categories of glazed pottery often associated with these types, namely, carved monochrome-glazed wares and polychrome underglaze-painted wares. Such wares were not included in this study because none of the wasters I encountered were of these types. Pottery production in the rest of the Ayyubid realm should be revisited as well, taking these findings into account. How, for example, does Egyptian production during this period relate to that in Raqqa during the first three decades of the thirteenth century? The influence of Raqqa production on that in Anatolia under the Saljuqs of Rum also deserves attention. Indeed, much research remains to be done on the ceramics of the Saljuq successor states.

Another subject for future investigation also presented itself to me. It would appear that the frenzied enthusiasm for Early Medieval Syrian ceramics at the beginning of the twentieth century extended beyond the collecting of this pottery. At least one manufacturer of art pottery, Fulper Pottery in Flemington, New Jersey, at its height from 1905 to 1915, was copying a popular Raqqa profile

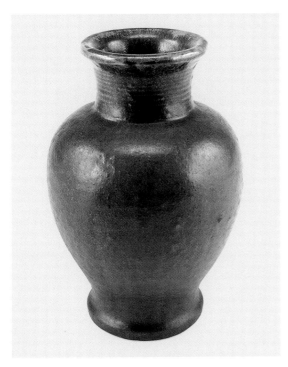

FIGURE E.1. Ceramic jar, Fulper Pottery, Flemington, New Jersey, early 20th century. Private collection

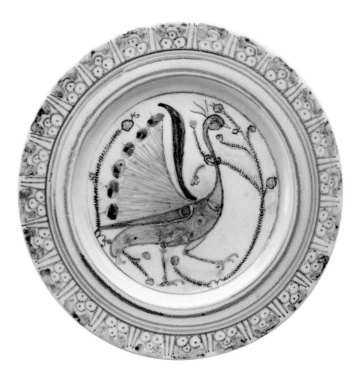

FIGURE E.2. Ceramic dish, William E. Hentschel, Rookwood Pottery, Cincinnati, Ohio, 1924. Private collection

(fig. E.1); and, in 1924, at Rookwood Pottery in Cincinnati, Ohio, William E. Hentschel produced a dish inspired by the patterns on underglaze-painted wares of Ayyubid Syria (fig. E.2)![1] Were other art-pottery manufacturers also attempting to satisfy an ever increasing taste for exotic wares?

The social and political history of this period not only provided information that helped to solve the art-historical conundrum presented by the group of objects in Konya but, more important, it opened the way to providing a secure provenance and date for all the objects now scattered worldwide that are connected to this group. We have seen that concurrent with the Ottoman government's eagerness to enter the modern age—using, among other means, the vehicle of museums to help it forge a new identity—there developed in the West a desire to construct "the Orient," what has been called a "timeless, static and exotic Other."[2] This involved collecting it as well. Paradoxically, the desire of the Ottoman state to foster a national spirit by assembling Islamic works of art produced within its empire was being stifled by the growing passion in Europe and America for collecting these works of art. It was this collision of Westernization in the East and Orientalism in the West in the final years of the Ottoman Empire that would supply answers on the specific subject of our inquiry—the ceramics of Ayyubid Syria and those of Raqqa in particular—that had eluded scholars for more than a century.

1. While it is well known that during the second half of the nineteenth and the early twentieth century European potters copied Ottoman pottery made in Iznik and Damascus, imitations of thirteenth-century pottery from Raqqa, in particular, or Ayyubid Syria, in general, in either Europe or the United States, have never been identified. Suzanne Valenstein, formerly of the Department of Asian Art at the Metropolitan Museum, has suggested that, in the absence of specific Ming Chinese parallels for the proportions and profile of the Fulper vessel, these features appear to follow a Syrian prototype. For the Rookwood dish, see Porter 1981, pl. XXII.

2. Shaw 2003: 21.

189

Appendix 1: *The Ottoman Response to Illicit Digging in Raqqa*

Ayşin Yoltar-Yıldırım

I would like to express deepest thanks to Havva Koç, librarian of the Istanbul Archaeological Museum Library archives, who considerably facilitated my research. The documents from the IAML used in this study were selected with her guidance. For all Ottoman documents in the IAML and the Istanbul Prime Ministry Archives (IPMA), I am indebted to my father, Fahri Yoltar, who patiently helped me with the handwritten Ottoman script. To Filiz Çağman, former director of the Topkapı Palace Museum, Istanbul, I am grateful for permission to study the inventory books. These notebooks were handwritten in French; I wish to extend my thanks to Marilyn Jenkins-Madina for helping me to decipher and translate them.

1. Cezar 1995: 331–32.
2. TIEM denotes the Museum of Turkish and Islamic Art in Turkish (Türk ve İslam Eserleri Müzesi).
3. I would like to thank Cihat Soyhan for showing this material to me.
4. The Çinili Köşk, or Tiled Pavilion, where Turkish tiles and ceramics are displayed, was built in the fifteenth century as part of the Topkapı Palace. It is today a division of the Archaeological Museums of Istanbul.
5. Some records of the ceramics from the Çinili Köşk also include "Alep, kaza de Rakka et de Maareh."

During the time that interest in Raqqa ceramics was being fueled in Europe and the United States, the Ottoman government was attempting to protect the site. The documentation in this appendix reflects the powerlessness of the government in this regard, despite the existence of what is generally referred to as the antiquities law (*Asar-ı Atika Nizamnamesi*), which was enacted on February 21, 1884. The law forbade individuals from keeping finds and from taking excavated material out of the country.[1] Nevertheless, the limited number of protective measures and the great demand for ceramics from the site led to what could be described as the plundering of the ruins for a number of years. The Ottoman Imperial Museum in Istanbul was able to conduct excavations only in two short campaigns, in 1905–6 and 1908.

Museum holdings of Raqqa material in Turkey today, especially ceramics, include objects from these two campaigns and objects confiscated by the government. The direct heirs of this material from the Imperial Museum are the Archaeological Museum and the Museum of Turkish and Islamic Art (TIEM), both in Istanbul.[2] In addition to the catalogued ceramics in these two institutions, there are also uncatalogued ceramics that were recently brought to TIEM from their old premises in the Süleymaniye complex.[3]

Some of the Raqqa ceramics in TIEM are inventoried only with a provenance of "Halep." These inventories are based on earlier records from the Çinili Köşk, a division of the Imperial Museum,[4] as many ceramics now in TIEM were transferred from that venue in 1941. However, the inventory records of TIEM do not include the full provenance "Alep, kaza de Rakka"[5] as it is cited in French in the original Çinili Köşk inventories. In these records, the French "Alep" is a designation for the province of Aleppo (Halep) and "kaza de Rakka" refers to the district within the province. During the Ottoman period, Halep was an Ottoman province (*vilayet*). It included a large region divided into *sancaks*, which were further subdivided into *kazas*. Raqqa was a *kaza* of the *vilayet* of Halep. During the period of the Turkish Republic, Halep became part of Syria; in Turkey, it was eventually associated with the Syrian city of Aleppo rather than with the larger province. It was perhaps these changes in administrative organization from the Ottoman period to the Turkish Republic that resulted in the more detailed initial provenance of "Alep, kaza de Rakka" being reduced simply to "Halep" in the TIEM inventories.

Two other museums in Turkey also have in their collections a considerable number of ceramics from Raqqa, the Karatay Museum in Konya and the Ethnographical Museum in Ankara. The Raqqa ceramics in the Karatay originally came from the Konya Asarı Atika Museum (see the discussion of Baron Max von Oppenheim below for these ceramics). The inventories of the Ethnographical Museum indicate that in

FIGURE A1.1. Copy of an official letter sent by the director of education of Halep to the Ministry of Education on Mart 6, 1318 (March 29, 1902). See document 6, below.

1928, when the museum in Ankara first opened, some Raqqa ceramics were received from the Istanbul Asarı Atika Museum (at that time the name of the Imperial Museum) and some came from the Konya Asarı Atika Museum in 1933. The Raqqa ceramics in the Karatay Museum and some pieces in the Ethnographical Museum are inventoried with a provenance of "Halep," without any reference to Raqqa, much like the records of TIEM. The lack of specificity in these records may be similarly explained as resulting from changes in the administrative system and by the designation of "Halep" as a city rather than as a province.

In this study three different sources have been consulted: archival records from the Istanbul Archaeological Museum Library (IAML), the Istanbul Prime Ministry Archives (IPMA), and the Topkapı Palace Museum. The records in IAML and IPMA complement each other and are similar in nature. These are composed primarily of the written correspondence between the Ottoman Imperial Museum, the administrative offices of the Ottoman Empire in Halep Province, and the Ottoman ministries in the capital. Included here is a selection of these documents. The records, originally in Ottoman Turkish (Turkish written with the Arabic alphabet), have been translated into English. The official language of the original records has been simplified and occasionally summarized.

The IAML documents are uncatalogued archives. Access is therefore limited and time-consuming. Unfortunately, it has not been possible to include images of all the documents consulted in this study; I have selected one (doc. 6; fig. A1.1) as a sample.[6] The records in the Prime Ministry Archives are well catalogued and easily accessible with permission. The third group of records, now in the Topkapı Palace Museum Ayniyat Office, consists of four inventory books (nos. 3033–3036) of the Çinili Köşk. According to a note in modern Turkish in notebook 3033, the records in these sources include those of objects inventoried in the Çinili Köşk from 1885 to 1939. Later stamps on the notebooks indicate that many of these objects were transferred to TIEM and the Ankara Ethnographical Museum. Thus, nearly all the Raqqa ceramics now in TIEM and discussed in this volume can be found in these notebooks, thanks to the old inventory numbers kept by TIEM. Unfortunately, the inventory numbers of the Çinili Köşk are not preserved in the present inventories of the Ethnographical Museum.

The four Çinili Köşk inventory books are the earliest preserved records of the Ottoman excavations in Raqqa and have remained unpublished until now. In these notebooks are preserved the inventories of the Ottoman excavations in Raqqa from

6. The author of this appendix can be consulted for photographs of the original documents.

1905 to 1906 by Theodore Makridy and in 1908 by the archaeologist Haydar Bey. Because they are published here for the first time, not only the ceramics but also other media from these excavations are listed. Included as well are ceramics whose Raqqa provenance, while not ironclad, is highly likely. The Prussian diplomat, archaeologist, and explorer Baron Max von Oppenheim and N. Marcopoli are two individuals related to this second group.[7] The group from Ischarah also includes a few ceramics from Raqqa, although the reason for their presence at this site remains unknown.

When the three groups of documents are studied chronologically, a relatively clear picture of events that occurred in Raqqa from the late nineteenth to the early twentieth century can be discerned. At least as early as 1900, local residents apparently had the permission of the Ottoman government to remove bricks in the ruins of Raqqa. This appears to have led to the unearthing of many ceramics. In December 1900, this permission was withdrawn and the government requested that the Imperial Museum conduct a scientific excavation. Although it took many years for the Imperial Museum to follow this injunction, objects confiscated from smugglers by the local authorities were sent to the museum (see doc. 6). The Çinili Köşk inventories also indicate deposits from Raqqa in 1900, 1903, and 1904. There was also a request in 1901 from German archaeologists wishing to conduct an excavation in Raqqa, perhaps as a result of the increasing number of ceramic finds on the art market. Permission was not granted, however, and the excavation did not materialize.

Ottoman excavations were begun in Raqqa by the Imperial Museum on December 31, 1905, under the directorship of Theodore Makridy. Most likely, they continued for two months, since the excavated antiquities—which filled fifteen caskets—were sent to the Imperial Museum on March 6, 1906. According to the Çinili Köşk inventory books, the objects arrived at the museum in March–April 1906. More objects are recorded as having arrived from Makridy's excavations in 1906, but no month is provided. A total of thirty-nine ceramic and glass objects are recorded. A letter dated April 12, 1906, confirms that the Imperial Museum Directorate had requested that the excavation work be continued.

The settlement of the Circassian refugees in Raqqa (see chapter 2, page 24) was seen as a threat to the safety of the antiquities. Already in 1907, the impact of this settlement was becoming apparent. Hundreds of refugees began to dig illegally, and the smuggling of antiquities was stepped up. In response to this activity, on August 3, 1908, Haydar Bey, who served as an officer of the Imperial Museum, embarked on a second campaign of excavations in Raqqa. In his communications to the Imperial Museum Directorate, he mentions the large number of illicit diggers who were disturbing the excavated areas. In November, after only a few months, he sent his finds in six caskets to the Imperial Museum. As in the first excavations by Makridy, Haydar Bey originally sent his finds to Iskenderun by land and from there by ship to Istanbul. Haydar Bey's material entered the Imperial Museum the same year, in which eighty-eight ceramic, glass, and metal objects were registered in the Çinili Köşk inventory.

As illegal digging and smuggling continued, demands for more excavations in Raqqa were repeatedly made, even after 1908. Halep (the city of Aleppo) became a center for trade in smuggled objects. Four dealers named in records dating from 1899 to

7. N. Marcopoli was a consul of Spain in the 1880s and 1890s. Georges Marcopoli was a dealer in Aleppo; he succeeded N. Marcopoli as consul.

1914 were Cemil bin Lupka Tabah, Corci Yusuf Tabah,[8] Karlos Hekim Efendi, and Demirciyan,[9] the last mentioned reported to have been operating in Paris. Certainly there were many more.

Merchants were not the only culprits. Baron Max von Oppenheim began excavating in Tell Halaf in 1911 and was several times accused of smuggling. Two attempts to smuggle caskets filled with antiquities from Aleppo into Europe are revealed in documents in the Istanbul Prime Ministry Archives and the Istanbul Archaeological Museum Library. Oppenheim first tried to send eleven caskets and five bales of antiquities from Raqqa in June 1913 (doc. 33). While this initial group was still being detained by the Ottoman government, he attempted to send another thirty to forty caskets from Aleppo by train first to Beirut and then to Europe in August 1913 (docs. 37, 39). This led to a diplomatic crisis between the Ottoman and German governments. In the end, over objections raised by local officers, the Ottoman government was forced to permit the second group of caskets to be sent via diplomatic pouch.

Following this success, Oppenheim tried, through the intercession of the German consulate, to repossess the antiquities that had been confiscated in June, claiming that the contents of the eleven caskets belonged to his personal physician (docs. 34, 35). When several of the caskets were opened, however, it was discovered that the contents were, instead, antiquities "of no value." The disposition of the remaining caskets involved the German consulate in Aleppo and the Ottoman Ministry of Internal Affairs (docs. 40–44, 46–48). Oppenheim's letter to the consulate reveals his methods of acquisition. Clearly, local officers sometimes looked the other way. Indeed, they were on occasion themselves responsible for making the sale (doc. 41). This is not surprising, as similar cases are noted in earlier records. Ultimately, Oppenheim did not succeed in repossessing the eleven caskets and five bales. Although they were first directed to the German consulate of Tripoli (doc. 42), they were eventually sent to the Imperial Museum in Istanbul (doc. 46).

According to the Çinili Köşk inventory books, several objects from Oppenheim's mission in Tell Halaf entered the Imperial Museum in 1912. Although initially this group seems irrelevant for this study of Raqqa ceramics, art-historical and scientific analyses show that at least some ceramics in this Tell Halaf group are in fact from Raqqa.[10] In 1913, Oppenheim picked up surface finds and bought ceramics from Raqqa on a tour from Tell Halaf. These ceramics, which he placed in eleven caskets and five bales, were later confiscated from him after long disputes (docs. 33–47). It is possible that Oppenheim acquired Raqqa ceramics in 1912, as he did in 1913, and that these had been confiscated and sent to the Imperial Museum as part of the ceramics from Oppenheim's mission in Tell Halaf. It is also possible that the inventory date is in error and the contents of the eleven caskets and five bales were included in what came from Tell Halaf in 1912. Unfortunately, the inventory books do not indicate which objects were picked up from Raqqa and which were excavated at Tell Halaf, the main area of Oppenheim's excavations.

Another, more likely, possibility is that the contents of the eleven caskets and five bales are now in Konya, in the Karatay Museum. In our interviews with the late Mehmet Önder, former director of the Karatay Museum, we were informed that the

8. The name Tabah recalls the firm Tabbagh Frères, which sold Raqqa ceramics to Charles L. Freer. See chapter 4, MMA5.

9. See chapter 2, note 63.

10. See chapter 3, W71, for such an object.

ceramics, which he had located in several caskets in the museum depots, had been sent in 1914 as Raqqa ceramics by the Fourth Army Commandant Cemal Pasha first to Istanbul and then to Konya following a museum fire in Damascus. Initially, this story seemed implausible, as there were no museums in Damascus at that time. Nevertheless, it was too specific to have been totally fabricated, and indeed our research indicates that these ceramics are in fact from Raqqa.

Document 42 may offer a partial explanation. The eleven caskets first deposited with the Halep Directorate of Education (doc. 40) were handed over to the German consulate in Tripoli. They were later registered in the Imperial Museum, Istanbul (doc. 46). Damascus is called Şam in Turkish, and Tripoli is called Trablusşam. It is possible that Trablus, in the name Trablusşam, was inadvertently dropped, leaving Şam—Damascus—as the provenance.[11] Although Cemal Pasha's full involvement is not known, there is likely some truth in this part of the story as well. We would like to suggest that the eleven caskets and five bales of antiquities confiscated from Oppenheim in Raqqa were taken first to Istanbul and in 1914 sent on to Konya.

Translation of Documents from the Istanbul Archaeological Museum Library (IAML) and the Istanbul Prime Ministry Archives (IPMA)

We have used modern Turkish orthography for unknown or little-known names of places and persons in English (i.e., Cemil instead of Jamil). Dates converted from the Ottoman Rumi and Hijra calendars are based on those from the website www.ttk.org.tr/takvim.asp, created by the Turkish History Institute in Ankara (Türk Tarih Kurumu). The documents are listed chronologically; those with no date are arranged according to the internal evidence in the document.

1. IAML box 9, dossier 1315/doc. 536
Copy of an official letter numbered 41, dated Nisan 28, 1315 [May 10, 1899], from the Directorate of Education of Halep Province [vilayet]
We understand that a bowl, a large jar, and another decorated bowl removed from the ruins in Raqqa were sold for 44 Ottoman liras by Hüseyin Efendi, the financial officer [*mal müdürü*] of Raqqa, to a merchant named Cemil bin Lupka Tabah, according to the written eyewitness account of Mehmet Seki from Aleppo and correspondence between the province and the local authorities. Mehmet Seki also informed us that officers were present during this transaction. We demanded from the local authority that the antiquities found in Raqqa be sent to the province. We then learned that Cemil Bey, who bought these objects, went to Damascus and upon our demand he was questioned. According to Cemil Bey's account he bought the three pieces for 40 Ottoman liras from the financial officer of the district and went to Damascus. He boarded a boat from Iskenderun and sold them for 42 Ottoman liras to a British traveler whose name he does not know. This amount will be taken from him and deposited with the Ministry of Finance. The antiquities coming from Raqqa will be detained.

11. Trablusşam derives from the Arabic name of the city Tarabulus al-Sham (Tripoli of Syria), as distinguished from Tarabulus al-Gharb (Tripoli of the West, i.e., in Libya).

2. IAML box 9, dossier 1315/doc. 536

Explanation by the museum of document 1 above, within the same dossier with no date

According to the 13th article of the antiquities law, antiquities that are found during illegal excavations are to be confiscated. If the individual has already disposed of the objects, their estimated value is to be collected from him. Accordingly, a bowl, a large jar, and a decorated bowl that were taken from the Raqqa ruins have been sold by Hüseyin Efendi, the district financial officer, for 44 liras. Thus, the same amount of money should be sent to the Ministry to be deposited in the museum coffers. Other confiscated antiquities should be treated in the same way.

3. IAML box 9, dossier 1316/no document number

Copy of an official report from the Directorate of Halep Province dated Kanunuevvel 7, 1316 [December 20, 1900], no. 795

Antiquities are being destroyed while people are searching for bricks in the ruins at the center of the district of Raqqa. Vases made of stone are being unearthed but no one can determine their value and merit. Thus they fall in the hands of others. In order to stop this, the permit to acquire bricks from the ruins should be temporarily halted and an officer from the Imperial Museum should be assigned there. A copy of the letter from the Directorate of Education of the province regarding this regulation has been included. The town of Raqqa was once the most developed city in the Jazira region, and there may well be valuable antiquities in the ruins of this site. Some attempts to find bricks may actually be coverups for looking for antiquities and stone vases. A letter requesting a halt to the removal of bricks has been sent to the governorate of the district [*kaymakamlık*] and the presence of an officer from the Imperial Museum has been requested.

4. IAML box 9, dossier 1316/doc. 539

Addendum to the official report dated Kanunuevvel 7, 1316 [December 20, 1900], from the administration [İdare Meclisi] of Halep Province, Subat 3, 1316 [February 16, 1901]

As we understand from the letter of the administration of Halep Province, under cover of looking for bricks in the ruins of Raqqa, antique vases are being removed. Since their value is not understood by the locals, they are falling into the hands of others. To stop this, an officer from the Imperial Museum is requested. Removal of antiquities by locals or foreigners is unlawful and removal of bricks should be stopped. It is necessary that an officer from the museum conduct the excavations. The excavated bricks should be sold to the people from the nearby villages. The site should be well inspected, and an officer either from the local or central government should be appointed. In order to understand what type of antiquities are buried, examples should be sent here.

5. IAML box 9, dossier 1317/doc. 540

Telegram sent from the province of Baghdad to the Ministry of Education

The area that the Germans want to excavate in the Raqqa ruins is located near the tribes living in the desert, and thus a squadron of horsemen is needed to protect the Germans from molestation. However, we do not have such authority. A telegram we sent on Subat 13, 1316 [February 26, 1901], addressed this matter. The German

consul in Baghdad received orders from the German ambassador and wants his request accelerated as a favor. But there is nothing we can do about this here in the province. The executive authority lies with Your Excellency.

Mart 11, 1317 [March 24, 1901]

Governor

Namık

6. IAML box 9, dossier 1318, within notebook 1

Copy of an official letter to the Ministry of Education

To His Excellency,

We received the antiquities consisting of pottery that the financial officer had attempted to smuggle to foreign countries after they had been illegally excavated in the ancient ruins of the district of Raqqa. Unfortunately these pieces, which are prone to breaking and crumbling even within hay or cotton cushioning, were considerably broken by the time they arrived at the central province. We have sent these pieces in three small caskets to Iskenderun. Through the Iskenderun Directorate of Customs they will be placed on government ships to be received by the Imperial Museum. Only twenty pieces have survived intact. However, these bowls were originally crooked and bent. The other sixteen large broken pieces have been packed with the intact ones in casket 1. Other smaller pieces have been placed in casket 2. We put the bowls from the ancient ruins whose function we were not able to determine in casket 3. We included the broken pieces, together with the confiscated material, because we thought they might be able to provide information about shape, color, and type and also about the production site and the method of their manufacture. We are pursuing legal action against the smugglers.

Zilhicce 19, 1319, Mart 16, 1318 [March 29, 1902]

Director of Education of Halep

7. IAML box 9, dossier 542/no document number

To the Directorate of the Imperial Museum

According to a notification we received, the financial officer of the district attempted to smuggle objects excavated from the old ruins in the vicinity of the district of Raqqa, which is subordinate to the central province. These antiquities consist of pottery. Unfortunately, some of them were broken while they were being handled. The unbroken objects were placed in a casket, and the broken pieces were placed in two smaller caskets and sent to Iskenderun to be shipped. Only twenty have survived intact. The other sixteen large pieces of crooked and twisted bowls were placed in casket 1. Smaller pieces were put in casket 2. There were also head [or cannonball]-shaped pottery pieces found in the ruins. We were unable to identify them and they were placed in casket 3. Perhaps you might have an idea. These antiquities were confiscated from smugglers and presented to the museum. Legal action is being taken against the smugglers.

Zilhicce 22, 1319/Mart 19, 1318 [April 1, 1902]

Director of Education of Halep

8. IAML box 9, dossier 1319/doc. 545

To the Directorate of the Imperial Museum

A broken vase that has been taken from the ruins of Raqqa has been confiscated and presented to the customs administration of Iskenderun. Executive authority for its arrival procedures lies with Your Excellency.

Ağustos 6, 1319 [August 19, 1903]

Deputy Director of Education of Halep

9. IAML box 9, dossier 1319/doc. 550

To the Directorate of the Imperial Museum

In response to your previous letter, numbered 1568 and dated Kanunusani 12, 1319 [January 25, 1904], we can confirm that a broken vase that had earlier been presented and an inscribed stone with Kufic letters are antiquities from the Raqqa ruins. Executive authority lies with Your Excellency.

Zilkade 22, 1321, and Kanunusani 26, 1319 [February 8, 1904]

Director of Education of Halep

10. IAML box 9, dossier 556/no document number

To the Directorate of the Imperial Museum

To His Excellency,

It has been reported that Corci [Georges] Yusuf Tabah, who has been involved in smuggling antiquities, has recently returned to Raqqa with the purpose of acquiring antiquities. To stop his activities, we applied to the provincial government to give notice to the governorate of Raqqa. We would also like to inform you that when we sell the bricks from the excavations, we will be able to cover about half the expenses of the excavation. Your orders are requested.

Rabiulahir 27, 1322, Haziran 27, 1320 [July 10, 1904]

Director of Education of Halep

Nadir

11. IAML box 9, dossier 1321/doc. 152

Telegram from Raqqa

Excavations have begun and today 182 silver coins were found.

Kanunuevvel 18, 1321 [December 31, 1905]

Officer of the Imperial Museum

Makridy

12. IAML box 9, dossier 358/doc. 151

Telegram from Raqqa

To the Directorate of the Imperial Museum

To strengthen the pieces that have been excavated, we request that two or three rolls of *sefotin* [?] be sent by the first mail.

Kanunuevvel 18, 1321 [December 31, 1905]

Officer of the Imperial Museum

Makridy

13. IAML box 9, dossier 1321/doc. 180

Telegram from Iskenderun

To the Directorate of the Imperial Museum

Fifteen caskets of antiquities have been sealed with lead and placed on the *Nemçe Oranu* with the necessary papers to be shipped to the Imperial Museum. It is requested that a servant be sent to the boat after they are released from customs.

Şubat 21, 1321 [March 6, 1906]

Officer of the Imperial Museum

Makridy

14. IAML box 9, dossier 490/doc. 9

To the Directorate of the Imperial Museum

Recently the excavation officer of the Imperial Museum, Makridy Bey, started excavations in the Raqqa ruins. In fifteen to twenty days of work (according to Makridy Bey), fifteen caskets of antiquities worth 1,500 liras have been excavated and sent to Istanbul. The cost of this excavation was 150–200 liras. Based on the information submitted by the officer [Makridy Bey], there are still 1,000–2,000 liras-worth of antiquities buried in the ruins. Thus, if only 5,000–10,000 *kuruş* [piastres] are spent, many valuable antiquities buried underground will remain there. Protection of the site is impossible and these antiquities may fall into the hands of anyone. Especially when the Circassian refugees are transferred to this area by the provincial government, it will not be possible to stop the smuggling. We hereby request that a suitable officer of the Imperial Museum be appointed to conduct excavations in order to maintain a law-abiding environment. The executive authority lies with Your Excellency.

Mart 30, 1322 [April 12, 1906]

Director of Education of Halep

15. IAML box 9, dossier 660, antecedent no. 490, 636

Draft answer to the Directorate of Education of Halep

Karlos Hekim Efendi and Corci [Georges] Tabah were caught smuggling antiquities from the ruins of Raqqa. I have received the papers of appeal regarding their prosecution on Mart 24, 1322 [April 6, 1906], with letter 401. We will follow the legal procedures.

Ağustos 2, 1322 [August 15, 1906]

16. IAML box 9, dossier 938/doc. 18

Telegram from Halep

To the Ministry of Education

According to information received from the school for teachers in Raqqa, the Circassian refugees who were settled in Raqqa have been working with locals and are active beyond their proscribed boundaries. More than five hundred robbers are at work in the ruins of Raqqa. The only solution is to ask for military troops from the central province. Necessary action is requested from the provincial government.

Nisan 9, 1323 [April 22, 1907]

Director of Education

Nadir

17. IAML box 9, dossier 1567/doc. 24

Telegram from Halep

To the Honorable Grand Vizierate

There are very valuable antiquities in the ancient ruins, which are half an hour away from the district of Raqqa. It has been repeatedly reported that it is impossible to protect the site and that at night people dig at the site all the time. Some days ago a large valuable jar and other antiquities were confiscated while being smuggled and were sent to the museum. Also confiscated were another pair of large jars taken from the ruins. Such antiquities, intended to be sold in Halep, have great value and they continue to be taken from the site. The need for proper excavations has been reported to the Ministry of Education many times. The executive authority lies with Your Excellency.

Mayis 21, 1324 [June 3, 1908]

Mehmed Nazım

Governor of Halep Province

18. IAML box 9, dossier 1621/doc. 95

To the Directorate of Imperial Museums

A valuable vase was confiscated at the order of Hamdi Bey, the director of the Telegram and Postal Office of Raqqa, while being smuggled by the postal driver. Furthermore, bricks, pottery, and et cetera from the ruins of Raqqa have been placed under the protection of the imperial troops with the necessary customs papers in a chest on the Russian boat *Karnilof* by the governorate of the district of Iskenderun. If these antiquities kept under the protection of the troops are valuable and important, an immediate action is necessary to prevent smuggling from the site. Perhaps an appropriate amount of money could be given to the authorities in return for presented antiquities in order to stop the illegal smuggling. The executive authority lies with Your Excellency.

Cemazeyilahir 8, 1326/Haziran 23, 1324 [July 6, 1908]

Nadir

Director of Education of Halep

19. IAML box 9, dossier 1733/doc. 56

Telegram from Raqqa

To the Imperial Museum

I would like to report that I am beginning excavations in Raqqa.

Temmuz 21, 1324 [August 3, 1908]

Officer of the Imperial Museum

Haydar

20. IAML box 9, dossiers 1621 and 1685, between docs. 1320 and 1324

a. Copy of official letter written soon after August 13, 1908, to the Ministry of Education from the Directorate of Education of Halep numbered 71, 87, 37 and dated Haziran 23, 1324 [July 6, 1908]

A valuable vase was confiscated at the order of Hamdi Bey, the director of the Telegram

and Postal Office of Raqqa, while being smuggled by the postal driver. Furthermore, bricks, pottery, and et cetera from the ruins of Raqqa have been placed under the protection of the imperial troops in a chest on the Russian boat *Karnilof.* The necessary customs papers have been sent to the Directorate of the Imperial Museum. Your orders are requested.

b. Notes made on a telegram dated Temmuz 31, 1324 [August 13, 1908], and sent by the Accounting Department of the Ministry of Education

In order to be used for bookkeeping purposes, the above-mentioned antiquities are being sent to the Imperial Museum by the Directorate of Education of Halep. We hereby request that their date and value be determined.

21. IAML box 9, dossier 1724/doc. 63

Telegram from Raqqa

To the Directorate of the Imperial Museum

As reported before, I have begun excavating and gathering objects as of Temmuz 21 [August 3, 1908]. Details will be sent with the weekly post.

Ağustos 14, 1324 [August 27, 1908]

Officer of the Imperial Museum

Haydar

22. IAML box 9, detached dossier between 1733 and 1724/doc. 161

To the Directorate of the Imperial Museum

I mentioned before that I had begun excavations in Raqqa. For over a month excavations have continued successfully. However, following the excavations hundreds of local people dig at the site day and night and very few places are left without disturbance. Since the local government cannot stop the illegal digging, soon there will be nothing left. Thus it is necessary to continue the excavations. However, even with careful handling, the money will last for only about three more weeks. If an order is given to continue, an appropriate amount of money is requested.

Ağustos 22, 1324 [September 4, 1908]

Officer of the Imperial Museum at Raqqa

23. IAML box 9, dossier 1802/doc. 83

Telegram from Halep

To the Directorate of the Ottoman Museum

The bill of lading and customs papers regarding six caskets of antiquities arrived yesterday from Iskenderun. They are submitted today by post.

Teşrinisani 8, 1324 [November 21, 1908]

Deputy Director of Education of Halep

Salim

24. IAML box 9, dossier 1802/doc. 207

To the Directorate of the Ottoman Museum

The six caskets of antiquities sent by Haydar Bey from the Raqqa excavations are

loaded on the *Dakrile* with their bill of lading and customs papers. For their arrival, your orders are requested.

Teşrinisani 8, 1324 [November 21, 1908]

Deputy Director of Education of Halep

25. IAML box 9, dossier 2383/unnumbered document

Copy of permit letter from the presidency of the Parliament dated Subat 11, 1325 [February 24, 1910], and numbered 3

Several people are reported to be illegally and secretly excavating in the Ottoman lands, and valuable antiquities are being partially destroyed and smuggled. In fact, recently newspapers wrote that antiquities removed from the ruins in Raqqa were seized in a casket while being smuggled from Halep to Beirut. To better protect the site, excavations have been placed under the authority of the Science Department. It has been decided that the official report of the commandant of Halep will be given to the Ministry and that the Ministry will take the necessary actions.

26. IAML box 9, dossier 3021/doc. 89

Telegram from Halep

To the Directorate of the Imperial Museum

Since I arrived at Halep I have been seeing valuable antiquities in many houses. Telegrams I receive from Raqqa indicate that antiquity smuggling is pervasive. Apparently, anyone who wishes to dig there takes valuable antiquities and sells them for profit. Since the gendarmes are limited in number and can hardly patrol the roads and villages, it is not possible to have guards on the site. Thus, people dig, steal, and sell. Obviously you are informed about the antiquities and the ancient city ruins here. If provisions are granted to the provincial government, an officer could be dispatched to protect the antiquities or a guard could be appointed to keep an eye on the site. If this is not possible, we must determine a method of procedure with special instructions. I am looking forward to your response.

Teşrinievvel 11, 1326 [October 24, 1910]

Governor of Halep

Hüseyin Kazım

27. IAML box 9, dossier 3020/doc. 90

Telegram from Halep

To the Directorate of the Imperial Museum

I confirm the telegram I sent on Teşrinievvel 11, 1326 [October 24, 1910]. The district governor [*kaymakam*] of Raqqa has written in a telegram that a Christian from Halep has come to the port of Şaşi from the Meskene district, three hours away, and has pitched his tent. Several local men and villagers from Halep are excavating for him. The governor heard that a large number of antiquities had been found, and he was going there immediately. If we cannot stop such activities completely we will not be able to undo the damage.

Teşrinievvel 13, 1326 [October 26, 1910]

Governor of Halep

Hüseyin Kazım

28. IAML box 9, dossier 3124/doc. 137

Draft letter from the Imperial Museum

Permit letter to the Ministry of Education

Teşrinisani 20, 1326 [December 3, 1910]

I understand from one of the two telegrams sent to me on Teşrinievvel 11 [October 24, 1910] from Halep Province that valuable antiquities have been seen in several houses in Halep and that the smuggling of antiquities is pervasive, especially from the ruins of Raqqa. According to several telegrams received from Raqqa, it is understood that anyone can dig at the site, remove valuable antiquities, and sell them for profit. Because the gendarmes are limited in number and do not even patrol the roads and villages, it is not possible to keep guards at the ruins.

As mentioned in the other telegram from Halep dated Teşrinievvel 13 [October 26, 1910], a Christian from Halep came to the port of Şaşi, a distance of three hours from the Meskene district, and pitched a tent there. He made deals with the locals and villagers from Halep to undertake illegal excavations. He is known to have gathered a large number of antiquities in this way. It is noted that if protective measures are not taken, it will be impossible to do anything. In your answer dated Teşrinisani 13, 1326 [November 26, 1910] you responded that although the Raqqa ruins are within the limits of the central district, the protection of the site from illegal digging is under the aegis of the local government. Thus, necessary action must be taken by the local government. In the last telegram, received from the local government on Teşrinisani 16, 1326 [November 29, 1910], it is repeated that it is impossible to stop illegal digging locally, and thus the local government has fulfilled its duty by notifying the central authorities.

Although you request new officials from the museum to conduct excavations in Raqqa, as you know there are many more areas in the Ottoman lands in a similar state. As money and time are allocated, excavations are conducted in these areas and the recovered antiquities are sent to the museum and preserved. If given the opportunity, it would be possible to excavate the entire area of the Raqqa ruins or to send guards to protect the site in the future. Thus, it is extremely important that no tolerance is shown either to illicit digging in any part of the ruins or to the smuggling of antiquities. Those who attempt such activities should be prosecuted according to the antiquities law. Nevertheless, some tolerance has been shown by local authorities and antiquities have been unnecessarily lost in this way. The Ministry is asked to forcefully notify the local authorities to implement the law and to take legal action against the criminals and precautionary measures.

29. IAML box 9, dossier 3626–3627/doc. 239/(55)

Telegram from Halep

To the Directorate of Museums

As mentioned in our telegram of Mart 23, 1327 [April 5, 1911], antiquities have

surfaced from Raqqa. There are also others from the same site that have been kept locally. Two hundred fifty *kuruş* [piastres] are required to transfer these objects to Halep and from there to Beirut. We would like to request a few thousand *kuruş* to be sent to the Provincial Accounts Office to be used for similar purposes.

Nisan 9, 1327 [April 22, 1911]

Director of Education of Halep

Salim

30. IPMA, DH.ID 129–2/1 16

Cipher letter from the sancak of Zor

The reports of the museum director to the Directorate of Education and the written reports of Aleppo Province indicate that Baron Oppenheim is looking for antiquities in Tell Halaf, which is in Resulayn. The baron arrived a few days ago and went one day to Tell Halaf. Dürri Bey has been appointed the excavation controller by the Directorate of the Museum to accompany Oppenheim. According to Dürri Bey, after leaving they spent fifteen days in the vicinity of Meskene, which is only one and a half days away. We understand from the baron's oral report that they will go to Tell Halaf the same way. He wants to explore the region thoroughly. He will be accompanied by two engineers, one doctor, and one scribe from the Academy of War in Berlin. Two Lebanese will join them to serve as Arabic translators. We sent enough officers to accompany them, and we gave directions to them and to Dürri Bey. As we talked, it became clear that he would also be building in Tell Halaf. We gave permission to build temporary huts for the duration of the excavations. However, he sent three large caskets of vegetable seeds to Tell Halaf. He also petitioned a few hundred hectares of land. Is he going to make a farm or excavate? He is also making inquiries among the locals about their treatment by the government. His inquiries and wanderings are worth paying attention to.

Temmuz 5, 1327 [July 18, 1911]

Governor of the *sancak* [*Mutasarrıf*]

Celalettin

31. IAML box 9, dossier 4749/no document number

To His Excellency,

For many years illegal digging has continued persistently in Raqqa, which is famous for its antiquities. Despite the fact that those involved in such illegal activities are prosecuted when caught and the antiquities confiscated, it is impossible to stop these activities completely so long as there are people who have acquired a taste for them. Valuable antiquities numbering in the hundreds have reached dealers in Halep. According to a statement made by the governor of Raqqa, smugglers are sometimes encouraged to excavate, especially at nighttime, in the ancient ruins where antiquities are to be found near the surface. A rescue excavation could perhaps be conducted on behalf of the museum. Executive authority lies with Your Excellency.

Director of Education of Halep

Mart 7, 1328 [March 20, 1912]

32. IAML box 9, dossier 4816/no document number

Telegram from Halep

To the Directorate of the Imperial Museum

Quantities of antiquities exist almost on the surface in the districts of Raqqa, Maareh, and Menbiç, and various other places in the province. Some people dig these up and sell them to those few who have made a profession out of it in Halep. Although the government has banned the search for antiquities and confiscates them when found in the hands of those involved in such activities, 99 percent of the antiquities are smuggled. Billions' worth of antiquities could be easily excavated by a few officials from the museum at a small expense. This would enrich the collections of the museum and would also benefit the country. We hope you will give this matter serious consideration.

Nisan 18, 1328 [May 1, 1912]

Governor of Halep

Galip

33. IAML box 64, dossier 5677, July 7, 1913/no document number

a. Copy of official letter from the governorate of Zor dated Haziran 12, 1329 [June 25, 1913], and numbered 4

Eleven caskets and five stone antiquities are being held in the center of the district of Raqqa in the name of Baron Oppenheim, who excavates in Tell Halaf. A copy of a telegram dated Mayıs 23 [June 5, 1913] written in response to a telegram from the province of Aleppo dated Mayıs 22, 1329 [June 4, 1913], has been attached. However, no answer has been received.

b. Copy of telegram from Halep Province dated Mayıs 22, 1329 [June 4, 1913], and numbered 218

Eleven caskets and five stone antiquities have been held in the name of Baron Oppenheim, who claims that he bought them in the same place [Raqqa]. Since there is no legal authority to sell antiquities in Raqqa, it is assumed that these antiquities have been unearthed from the site. We would like to know if he bought them locally or in another place. If he has acquired them from outside, the names of those agents are requested.

c. Copy of telegram written to Halep Province on Mayıs 22, 1329 [June 4, 1913]

The arrival of Baron Oppenheim coincides with the presence in Raqqa of the Affairs Committee. Oppenheim stayed there a few days. It is possible that he could have purchased that number of caskets of antiquities locally in such a short time, but we have not heard of such a purchase. It is highly possible that they were excavated from the site over a period of time. In any case, he is not entitled to acquire antiquities in any way, and it is understood that the government will keep them. Since it has been clearly stated that both the antiquities and the five stones were acquired in Raqqa, the agents should themselves be in Raqqa. To prevent a recurrence of a similar incident, the names of the agents should be requested.

34. IPMA, DH.ID 129–2/1 147

Cipher telegram from Halep

Very urgent

Addendum to Ağustos 5, 1329

Dr. Gühel has claimed that there are no antiquities inside the two groups of caskets received from the German consulate. Instead, they are claimed to be the belongings of Dr. Gühel, the personal physician of Baron Oppenheim. The caskets were intended to be sent to Europe via Halep. However, when the government retained the caskets and the personnel who brought them to Halep, Dr. Gühel claimed to have spent 20,000 francs unnecessarily as a result of this delay. Because he had asked the government to return the caskets and to reimburse him for the money he had spent, the caskets were to be opened in the presence of Dr. Gühel himself, a translator from the consulate, a committee from the Assembly of Administration, and the police. However, during this process Dr. Gühel insisted that only four caskets belonged to him and that only those four should be opened. When the translator thought that Dr. Gühel's words might not be reflecting the facts, he protested against the government and, without seeing the opening of the caskets, he left with Dr. Gühel. The value of the antiquities inside these caskets is approximately 20,000–30,000 liras. Is there any need to have a translator present when they are opened, and, if so, what happens if he does not come? Please send your orders urgently.

Ağustos 7–8, 1329 [August 21, 1913]

Deputy Governor

Recep

35. IPMA, DH.ID 129–2/1 149

Cipher telegram from Halep

Very urgent

Response to August 7–8, 1329: As we explained in detail in our telegram of Ağustos 7, 1329, Dr. Gühel and the translator left during the opening of the caskets, which they claimed were filled with ceramic and tile pieces of no value. As is apparent from their sudden departure, valuable antiquities must be stored in these caskets. Are we supposed to return them without opening them? Please send your orders immediately.

Ağustos 8, 1329 [August 21, 1913]

Deputy Governor

Recep

Note on telegram: The caskets should be sent unopened. The relevant telegram will be forwarded to the second branch.

36. IPMA, DH.ID 129–2/1 177

Copy of cipher telegram from Halep

The caskets, which purportedly include the private possessions of Dr. Ludwig Gühel, are noted by the German Embassy to contain ceramic pieces of no value. The remaining caskets should be prevented from being opened. According to Baron Oppenheim's own account, these were not excavated at his excavation site [Tell Halaf] but purchased from dealers elsewhere. Although we do not completely trust his statements, the antiquities law makes this kind of activity illegal since antiquities inherently belong to the government. We cannot make an exception. Even in the past, when the government would present antiquities to foreign countries and rulers, imperial

permission was necessary. If the material belonging to Baron Oppenheim now creates a political problem and it is decided that the antiquities should be returned to Baron Oppenheim, a new law must be established. Otherwise they belong to the Ministry of Education and should be sent from here to the Ministry, which can then handle the rest. You noted in the last part of your telegram dated Ağustos 7, 1329, that in the future if similar shipments are made, the consulate should notify the authorities in the province. However, since the exportation of antiquities is not permitted, by so doing we will be allowing the excavators and discoverers to be exempt from any law. If once we open this door, it will be impossible to stop foreigners from acquiring antiquities. If these caskets are not confiscated, then doubtless a similar request will be made for the other 11 caskets kept in Raqqa. We suspect that the contents of the caskets are valued at about 80,000–100,000 liras. If we give these valuable antiquities away, we shall incur people's wrath. Since this will certainly have consequences for my future, I kindly ask that I be excluded from this obligation.

To the Ministry of Foreign Affairs

Directorate of Politics

Ağustos 15, 1329 [August 28, 1913]

37. IPMA, DH.ID 129–2/1 178

Copy of cipher letter from Halep

Baron Oppenheim arrived from his excavation site in two to three days after learning that the 19 caskets belonging to him had been detained. The baron brought with him 30 to 40 additional caskets. He stored some of them in his hotel and some in the depots of the consulate. Tonight he was caught secretly attempting to send 6 tin-covered European caskets as goods and also 26 wooden caskets as commercial goods to the railroad station, thence to be sent on to Beirut by the morning train. We also learned that he, too, would be leaving to go to Beirut tomorrow. We gave orders to the police to detain the caskets. As noted in today's cipher telegram, the previous caskets have not been returned either. We would like by tomorrow to have instructions as to how we should proceed.

To the Ministry of Foreign Affairs

Directorate of Politics

Ağustos 15, 1329 [August 28, 1913]

38. IAML box 64, dossier 5880/no document number

To the Directorate of the Imperial Museum

This is in response to your letter dated Ağustos 7, 1329 [August 20, 1913], and numbered 5733/259.

We asked that Halep Province make the necessary inquiries regarding the 11 caskets of antiquities and 5 stones that were confiscated in Raqqa from Baron Oppenheim, the excavator of Tell Halaf. We asked also that the results of these inquiries be sent to us.

Ramazan 23, Ağustos 15, 1329 [August 28, 1913]

On behalf of the Minister of Education

Director of Higher Education

39. IPMA, DH.ID 129–2/1 179–180

Cipher letter from Halep

Received from the governorate of Halep

Response to a telegram dated Ağustos 16, 1329 [August 29, 1913]. The local police took custody of 19 caskets that Baron Oppenheim had attempted to smuggle. Similarly, 34 caskets filled with antiquities were earlier taken from the German consulate to the railroad station with the intention of sending them to Beirut. Such smuggling will not be tolerated. A notice regarding this has been given to the German consulate. Although the German consulate is among those whose possessions we believe it unnecessary to check when they are transferred, the fact is that these objects were smuggled by Baron Oppenheim, who has been in touch with the highest authorities in Istanbul and Europe. Smuggled objects are confiscated wherever they are found. Like any government, we reserve the right to inspect objects if there is suspicion about their true ownership [i.e., about their contents]. Thus, the German consulate in Beirut will try everything to stop us from inspecting the contents of these 53 caskets and will perhaps try to divert them from customs. It will also try to send abroad other caskets that are hidden here. If the caskets are confiscated the embassy will doubtless call upon the intervention of the government in order to have them returned to the German government just as they did this time. Although it is our right and duty to take custody of these antiquities, we understand that we are required by your orders not to proceed with such actions. Nevertheless, antiquities are our national treasure and it is impossible always to overlook such obvious smuggling. We believe the German consulate will continue smuggling and will attempt to send the other caskets that are being detained in Aleppo. I would like to inform you that this will not be tolerated next time, even if an order is given to allow their free travel.

Ağustos 18, 1329 [August 31, 1913]

Governor Celal

40. IAML box 64, dossier 5812/no document number

Summary: 11 caskets and 5 bags of antiquities have been deposited with the Education Department.

To the Directorate of the Imperial Museum

To His Excellency,

The 11 caskets and 5 bags of antiquities confiscated from Baron Oppenheim, the excavator of Tell Halaf, mentioned in your letter dated Ağustos 7, 1329 [August 20, 1913], and numbered 5733/256 have been deposited with the Halep Directorate of Education according to a telegram received on Ağustos 12, 1329 [August 25, 1913].

Eylül 16, 1329 [September 29, 1913]

On behalf of the Minister of Education

Director of Higher Teaching

41. IAML box 64, dossier 5880/no document number

Copy of translation of letter written by Baron Max von Oppenheim to the German Embassy, undated

I have learned that the 10 caskets and 6 bales that I wanted to submit at the end of May through the Raqqa Nuriş Company have been detained by the Raqqa government. There was also a letter that was to have arrived with them but that was not sent to you either. The Ottoman government has not informed me or you about their custody. It is also unknown where the caskets and bales are being kept today. The contents of these caskets and bales were bought from Bedouin Arabs during my trip from Tell Halaf to Raqqa. In addition, there are pottery pieces collected from the surface and old ruins. These pieces not only have scientific importance but also tell us about their date of production in this area. In addition, there are pieces of pottery and other objects that belong to Arabs from the period of the Byzantine Middle Ages and later, which I bought in my name in Raqqa. All of this was purchased openly with the help of a guide provided to me by the local government. In Raqqa, Arabs and Circassians brought several objects to me while numerous soldiers, revenue officers, and guests were with me in my tent. Those who sell me these goods include government officials such as the first secretary [*baş katip*], revenue officers [*zabıta*], and soldiers. That these goods were sold by government officers in the presence of government officials gave me the impression that there was nothing wrong with purchasing objects in Raqqa, especially when I saw that similar goods were displayed and sold openly in the shops in Halep and Beirut. However, at this point I did not insist. Two *sancak* governors saw several people digging in the ruins with very good excavating tools two minutes away from the government offices of Raqqa during the daytime while two hundred soldiers were patrolling the area under the control of the gendarme commander. This is the situation, and thus the ten caskets and 6 bales should be requested from the Ottoman government and compensation should be asked if there is damage or loss to the contents. If this material is not here but still in Raqqa, you should request that it be sent here immediately in order to ascertain whether there are any broken or missing pieces.

42. IPMA, DH.ID 129–2/1 169

Cipher letter from Beirut

Urgent

Response to letter dated Eylül 16, 1329 [September 29, 1913]. Caskets that belonged to Baron Oppenheim were taken from Aleppo and handed over to the German consulate of Celep and Trablusşam [Tripoli]. The Ministry of Education required that any antiquities found after a detailed inspection of the caskets be kept in custody. The local consul requested their return after the inspection. He also requested that a jar in one of the caskets be kept in custody. Information regarding other caskets that belonged to Oppenheim and that were earlier brought to Beirut was mentioned in a cipher telegram dated Ağustos 24, 1329 [September 6, 1913]. The inspection of these caskets should not be rushed, and written correspondence should be kept.

Teşrinievvel 3, 1329 [October 16, 1913]

Governor

Bekir Sami

43. IAML box 64, dossier 5880, antecedent [evveliyat] no. 5677, dated November 4, 1913

Copy of letter from the Educational Directorate of Halep Province dated Teşrinievvel 22 [September 21, 1913], and numbered 153

This is in answer to your letter dated Ağustos 15, 1329 [August 28, 1913], and numbered 678.

The aforementioned 11 caskets of antiquities have been detained in Raqqa. After having received a request from Baron Oppenheim through the German consulate, we asked that the governorate of Raqqa send them to the central province. A telegram that arrived today from Raqqa informs us that they have been sent. We attached the translation of the French letter submitted by Baron Oppenheim. According to this, the baron claims that there are unimportant things inside these caskets. He says that while some of these are antiquities, he bought them from agents openly and in front of Raqqa government officials. It is very possible that the caskets include extremely valuable antiquities similar to those that have been smuggled and freely sent to Europe before. As instructed in your telegram dated Haziran 27, 1329 [July 10, 1913], the contents of these caskets will be given to the Directorate of Education. However, it is likely that their return will soon be required, as happened before. Here one can find antiquities in the homes of every foreigner and even the locals. There are also those who have made a profession out of antiquities smuggling. Not only are no measures taken against the biggest smuggler but no measures are taken against those merchants who have money. No doubt Baron Oppenheim took these antiquities from Tell Halaf. However, there is a commissar there who was appointed by the Ministry. If the antiquities were removed from a site within the province of Aleppo, we would have to ask the commissar how well he was executing his job. However, this site is within the borders of the *sancak* of Zor and we are unable to do anything. We hope that definitive protective measures will be taken against this audacious smuggling and the commissar who has abused his job will be prosecuted in a way that would discourage others who would do so.

44. IPMA, DH.ID 129–2/1 175

Summary: Concerning the illegal excavators and smugglers in the Raqqa ruins.

To the Ministry of Internal Affairs

The 11 caskets and 6 bales of antiquities belonging to Baron Oppenheim that were detained in Raqqa are claimed to have been bought in Raqqa in the presence of officers and with the guidance of the governor of Raqqa. There are even government officials included among those who sell antiquities. Furthermore, people are digging at the site with tools, despite the fact that two governors of *sancaks* and 200 armed individuals under the authority of the gendarme commanders of Halep and Raqqa guard the site, which is only two hours from the governorate of Raqqa. We learned this from the letter written by Baron Oppenheim in French and translated into Turkish. The letter came from Halep Province on Eylül 8, 1329 [September 21, 1913], with the number 153. It is very important that immediate action be taken against those responsible.

Minister of Education

Zilhicce 18, 1331/Teşrinisani 5, 1329 [November 18, 1913]

45. IAML box 9, dossier no. 5981, antecedent no. 3020, dated Kananuevvel 9, 1329 [December 22, 1913]

Copy of letter sent from the Ministry of Internal Affairs on Teşrinisani 12, 1329 [November 25, 1913], with the number 85855/150

This is in answer to your letter dated Teşrinisani 5, 1329 [November 18, 1913], and numbered 1298.

You require that legal action be taken against those who sold the antiquities that now belong to the German Baron Oppenheim and those who conducted excavations in the ruins half an hour away from the district of Raqqa. However, authorization to excavate has not been extended to all ruins in Halep Province or to all parts of the Jazira region, nor has attention been given to all these areas by the museum. Local people continue to dig up antiquities in these areas, which they then sell here and there for a goodly amount of money. In this way, several people have become rich. The antiquities sold in Raqqa must belong to this category, and since digging has continued for such a long time, it will not be of any use to have more communications in this regard. It is also physically impossible to guard the unattended ruins and the antiquities buried in them with the existing personnel. Thus, the museum should conduct its own excavations, or it should extend legal permission for excavations to be conducted in these areas so that antiquities worth billions will be saved. We hope the Ministry will be able to establish strong measures and that the antiquities will be saved from destruction.

46. IAML box 64, attached to a letter in French dated January 27, 1914/ no document number

Letter to the Directorate of the Imperial Museum

The German Baron Max Oppenheim, who excavates in Tell Halaf in Resulayn in the *sancak* of Zor, sent to the German consulate in Halep 10 caskets and 6 bags. These included items collected during a trip from Tell Halaf to Raqqa that he purchased from dealers in Raqqa and also picked up from the ruins in Raqqa. The caskets have been sent to Istanbul from the province of Halep. The German Embassy has requested that someone from the embassy be present when the caskets are opened. The baron claims that among the items in the caskets are personal belongings and things belonging to his wife. To ensure that nothing is missing, we hereby approve the baron's request that someone from the embassy be present when the caskets and bags are opened in the museum.

Kanunuevvel 14, 1329 [December 27, 1913]

On behalf of the Minister of Foreign Affairs

Undersecretary

To be considered by the Directorate of Museums

Second page with a note from the director of the museum: Since I stated to the Ministry of Foreign Affairs that under no condition would I open the caskets in the presence

of an official from the Embassy, a second petition has come from the embassy.
Mart 23, 1330 [April 5, 1914]

47. IPMA, DH.ID 129–2/1 181
Summary: Concerning the goods that belong to Max Oppenheim who excavates in Tell Halaf, 3 attachments
To the Ministry of Internal Affairs
To Your Excellency,
Baron Oppenheim, who, as you know, excavates in Tell Halaf in the district of Resulayn in the *sancak* of Zor, picked up antiquities on his way from Tell Halaf to Raqqa and made purchases in Raqqa. He also picked up some antiquities from the old ruins in Raqqa according to his own account. These were stored in 10 caskets and 6 bags. They were sent in May in the name of the German consulate in Halep. However, they were detained by the authorities of the province and sent to Istanbul. The German consulate demanded that they be seized, but no explanation was given and nothing has been returned nor has their value been assessed. Nevertheless, that the goods were sent in the name of the German consulate and redirected to the Turkish authorities in Istanbul instead of being returned to Oppenheim is considered inappropriate behavior toward a consul of a friendly country. The governor made clear that he does not want to please the consul in order to solve this conflict. We did, however, have success with the use of appropriate wording during our verbal communication. The telegrams from the province regarding this issue have been returned to you, and the province of Halep has been notified.
Minister of Foreign Affairs
Kanunuevvel 15, 1329/Muharrem 29, 1332 [December 28, 1913]

48. IAML box 64, attached to a letter in French dated January 27, 1914
Letter in German from the German Embassy in Pera dated March 28, 1914/no document number
Esteemed Halil Bey,
Your Excellency noted a concern about Oppenheim, especially the investigation of the caskets from Raqqa. I did inform the diplomats about Your Excellency. Baron von Wangenheim, as myself, is very much concerned that you may think the Imperial Embassy must be interested only in the just consideration and protection of its own rights. You could somehow perceive that as an insult to your person. To remove this impression, I have been commissioned to explain to Your Excellency that the Imperial Embassy has not hesitated in placing settlement of this matter fully in your hands. In accordance with your wishes, I include a copy of the list of objects in the shipment. Please inform me alone about the results of your search. I would very much like to talk to Your Excellency again.
Note in French: Twenty-seven bags of ceramics collected by Baron Oppenheim are classified according to their provenance and labels.

49. IAML dossier 6385/doc. 270
To the Directorate of the Imperial Museum

Summary

As there is no designated place to sell wheat, et cetera, in the town of Raqqa, profiteers sell cereal here and there. To put a stop to this, bricks from the old ruins of Raqqa could be used [to build a suitable place] if permission were granted from the district government. A letter written by the Directorate of Education in the province in response to this request states that public buildings in the central district have been built with bricks taken from the ancient city ruins. According to the ninth article of the antiquities law, such material is the property of the state and it is illegal to remove it without permission of the museum. We have asked that, with the proviso that a commissar representing the Ministry be present to collect the valuable tiles and etc. that surface during the diggings, the museum permit the local government to remove bricks to be used as building material. Because Raqqa has been annexed to the *sancak* of Urfa, communications should be directed to the governorate of that *sancak*.

Gurreireceb 1332/ Mayıs 16, 1330 [May 29, 1914]

Deputy Governor of Halep

50. IAML box 9, no dossier or document number

Draft letter from the Imperial Museum dated July 22, 1914

To the Ministry of Education

Raqqa has been made part of the *sancak* of Urfa after its separation from Halep Province. Because the palaces of the Abbasids are in Raqqa, Islamic antiquities are found within the city walls. The site has twice been excavated by officers from the Imperial Museum, and the antiquities from the excavations have been sent there. However, antiquities continue to be found in various other places around the country, and it requires a large amount of money to conduct excavations at each site. This is not possible. Excavations in Raqqa were suspended for similar reasons. In order to protect those areas that have antiquities, digging is not permitted without a license and the removal of antiquities from the site is prohibited. If an individual attempts to perform such activities, he will be prosecuted by the Ministry of Internal Affairs. This has already been conveyed to both the former and present provinces. Despite the fact that the Raqqa ruins are in plain sight of the central district, local people continue to dig at the site and to sell the antiquities they find to smugglers for a pittance. Valuable antiquities are destroyed in this way and often they fall into the hands of foreigners. An Armenian named Demirciyan has long been known to smuggle valuable antiquities from Raqqa and to sell them for profit in Paris. He is now back in Raqqa to pursue his trade. We have heard that he has accumulated a considerable amount of wealth in this fashion. Since it is no longer acceptable to tolerate illegal digging in the Raqqa ruins, it is advised that such activity be stopped immediately and that those who are involved be prosecuted according to the eighth article of the antiquities law. I also request that an inquiry as to the affairs of Demirciyan be initiated and that the governor [of Urfa] be notified to take action.

Translations of the Çinili Köşk Inventory Books

List of objects excavated in Raqqa by Makridy Bey. Entered museum 1322/ March 1906

2548. Silver. Ring in oval form, Kufic inscription on carnelian bezel, 1.2 x 6 cm

3921. Faience. Drinking cup, restored, white ground with blue decoration, H. 16 cm, D. 11 cm. Transferred to TIEM

3922. Faience. Flattened bowl, white ground, decorated in brown and green, restored, half is missing, H.13, D. 30 cm, at opening 9 cm. Transferred to TIEM

3923. Faience. Large vase with a slim neck and without a handle, cobalt blue, decorated with indentations, H. 51 cm, D. at opening 15 cm. Transferred to TIEM

3924. Faience. Flattened bowl, white ground decorated in blue, iridescent, H. 16 cm, D. in middle 21 cm, D. at opening 9 cm. Transferred to TIEM

3925. Faience. Bowl with restored foot, white ground, brown decoration on exterior and interior, Arabic inscription in center, H. 13 cm, D. 27.5 cm. Transferred to TIEM

3926. Faience. Flared bowl, restored, white ground and sectional floral decoration in brown and green, H. 11 cm, D. 24.5 cm. Transferred to TIEM

3927. Faience. Footed pot, many fragments restored, white ground, decoration and simulated writings in brown, large inscription in blue on interior bottom, H. 11.5 cm, D. 27 cm. Transferred to TIEM

3928. Faience. Carafe with thin neck and two missing handles. Also missing is part of the vase, now restored, white ground, decoration in brown, inscription separated by floral designs, H. 27 cm. Transferred to TIEM

3929. Faience. Footed plate, restored, white ground, geometric decoration in blue and black, H. 8 cm, D. 28 cm. Transferred to TIEM

3930. Faience. Footed bowl, restored, dirty-white ground, floral decoration in brown, iridescent, H. 9.5 cm, D. 16 cm. Transferred to TIEM

3931. Faience. Fragment of a rim, floral decoration in brown on exterior and interior, blue inscription, L. 22 cm, mounted on wooden base. Transferred to TIEM

3932. Faience. Fluted pot on foot, white ground, brown in the fluting, H. 10 cm, D. 9 cm. Transferred to TIEM

Objects excavated in Raqqa by Makridy Bey. Entered museum in 1906 [no month recorded]

3998. Green glazed faience. Large basin, incised decoration on the exterior on the rim, H. 13 cm, D. 51 cm. Transferred to TIEM

3999. Terracotta. Pot covered with dark maroon glaze, H. 17 cm, D. 28 cm. Transferred to TIEM

4000. Glazed terracotta. Jar with three handles, turquoise green, iridescent, part of mouth missing, H. 42 cm. Transferred to TIEM

4001. Glazed terracotta. Footed and lidded bowl, lid missing, white glaze, decoration in blue, H. 11.5 cm. Transferred to TIEM

4002. Glazed terracotta. Saucer, restored, green glaze, concentric circles in black, D. 14 cm. Transferred to TIEM

4003. Glazed terracotta. Footed bowl, glazed in clear green, whitish iridescence, H. 6.5 cm, D. 12 cm. Transferred to TIEM

4004. Glazed terracotta. Large container with foot for fruit, restored, green color, black inscription, H. 21 cm, D. 38 cm. Transferred to TIEM

4005. Green glazed terracotta. Large vase with decoration and inscription in relief, restored, H. 45 cm, D. of mouth 16 cm. Transferred to TIEM

4006. Green glazed terracotta. Same in technique and form as previous, H. 32 cm, D. of mouth 11 cm. Transferred to TIEM

4007. Terracotta. Large basin, decoration on rim, incised undulation, part of rim missing, restored, H. 19 cm, D. 56 cm. Transferred to TIEM

4008. Glazed terracotta. Small pot, relief decoration, bluish green, H. 5.5 cm. Transferred to TIEM

4009. Faience. Bowl with foot, part of rim restored, glazed white, decoration in concentric circles in dark blue, linear floral decoration on ground, H. 7 cm, D. 12 cm. Transferred to TIEM

4010. Glazed terracotta. Small pot, incised decoration covered by yellow and blue layer. Transferred to TIEM

4011. Faience. Fragment of European faience, 4.5 x 3.5 cm. Transferred to TIEM

4012. Glazed terracotta. Lamp with one opening, greenish blue, L. 10 cm. Transferred to TIEM

4013. Glazed terracotta. Pot, part of rim restored, black concentric circles and diverse decoration, birds, etc., H. 17 cm. Transferred to TIEM

4014. Faience. Fragment of faience, not from Raqqa, perhaps European, part of base of vase with seated woman, H. 5 cm, W. 6.5 cm. Transferred to TIEM

4015. Glass. Fragment of hanging lamp, decorated with a blazon with enamels in light and dark blue, H. 8 cm, L. 8.8 cm. Transferred to TIEM

4016. Glass. Drinking glass, upper part displays an Arabic inscription between two circles, on the belly are standing figures and another decoration in yellow, brick red, and blue enamels, restored, and part missing, H. 11.5 cm. Transferred to TIEM

4053. Glazed terracotta. Small bowl with two adhering fragments on the interior, D. 9 cm [chapter 3, w48]

4054. Glazed terracotta. Small jug (oenochoe) with one handle, white, iridescent, H. 13 cm

4137. Glazed terracotta. Ewer with handle. Transferred to TIEM

4143. Terracotta. Four roundels serving as platform for firing of vases in kiln, drops of vitrified material in brown, aubergine, and green, D. 14.5 cm, D. 15.5 cm. Transferred to TIEM [see page 23, figs. 2.1–2.3]

4144. Terracotta. Cylindrical rods probably for use in kiln, L. 59 cm. Transferred to TIEM

4278. Glazed terracotta. Small saucer, brown color, D. 14 cm. Transferred to TIEM

4279. Glazed terracotta. Small saucer with foot, brown, one part missing, D. 10 cm. Transferred to TIEM

List of objects excavated in Raqqa by Haydar Bey in 1324/1908. Entered museum same year

2938. Faience. Octagonal tabouret, restored, H. 37 cm. Transferred to TIEM

2941. Faience. Fragment of a tabouret (?). Transferred to TIEM

2942. Faience. Fragment of a tabouret (?). Transferred to TIEM

2943. Faience. Fragment of a tabouret (?). Transferred to TIEM

2944. Terracotta. Conical object. Transferred to TIEM

2953. Faience. Fragment of a tabouret, H. 15 cm. Transferred to TIEM

2954. Faience. Small fragment of a tabouret, H. 8.5 cm. Transferred to TIEM

2955. Faience. Small fragment of a tabouret, H. 11 cm. Transferred to TIEM

2956. Faience. Small fragment of a tabouret, H. 8 cm. Transferred to TIEM

2957. Faience. Fragment of a Kufic inscription, L. 8 cm. Transferred to TIEM

2958. Faience. Fragment of a tabouret, L. 15 cm. Transferred to TIEM

2959. Faience. Half of a hexagonal tile, D. 17 cm. Transferred to TIEM

2960. Terracotta. Animal, one foot missing, glazed, L. 12 cm. Transferred to TIEM

2961. Faience. Head of a statuette, H. 5 cm. Transferred to TIEM

2962. Faience. Animal, leg and [illegible] broken, L. 6 cm. Transferred to TIEM

2963. Faience. Head of a lizard, L. 5 cm. Transferred to TIEM

2964. Faience. Fragment of a vase with representation of a horse's head, L. 6 cm. Transferred to TIEM

2965. Faience. Fragment of a vase with representation of a bird with the head of a man, back also decorated, L. 8 cm. Transferred to TIEM

2966. Faience. String of 18 beads. Transferred to TIEM

2967. Blue faience. Lower part of a figurine, H. 3.5 cm. Transferred to TIEM

2968. Faience. Cock, section of feet broken. Transferred to TIEM

2969. Faience. Base of unidentifiable object, white ground, bluish spots, L. 2.5 cm. Transferred to TIEM

2970. Faience. Pierced base of a [illegible]. Transferred to TIEM

2971. Blue faience. Unidentifiable object in the form of a duck, L. 2 cm. Transferred to TIEM

2972. Faience. Cylinder, L. 2 cm. Transferred to TIEM

2973. Faience. Cylinder, L. 2 cm. Transferred to TIEM

2974. Terracotta. Bowl. Transferred to TIEM

2975. Bone. Decorated prismatic object, H. 6 cm, L. 2 cm. Transferred to TIEM

2976. Bone. Fragment of a probe with concentric circles, one part missing, L. 9.5 cm. Transferred to TIEM

2977. Bone. Convex part ornamented and engraved, D. 3 cm

2978. Carnelian. Two beads

2979. Lapis lazuli. Faceted button with a hole, D. 1.5 cm

2980. Black stone. Two beads

2981. Hematite. Unidentifiable object, L. 1.5 cm

2982. Green stone. Small dove. Transferred to TIEM

2983. Mother-of-pearl. Unidentifiable object. Transferred to TIEM

2984. Glass. Two beads, one multicolored. Transferred to TIEM

2985. Glass. Small box, H. 1.5 cm. Transferred to TIEM

2986. Glass. Flask with missing neck, H. 4.5 cm. Transferred to TIEM

2987. Glass. Fragment of an enameled vase with inscription, L. 4.5 cm. Transferred to TIEM

2988. Glass. Fragment of a flask, H. 6 cm. Transferred to TIEM

2989. Glass. Fragment of a flask, H. 5 cm. Transferred to TIEM

2990. Glass. Fragment of a vase, 4 cm. Transferred to TIEM

2991. Glass. Neck of an iridescent vase, H. 9 cm. Transferred to TIEM

2992. Glass. Fragment of a vase, H. 3 cm. Transferred to TIEM

2993. Glass. Fragment of a vase, H. 3 cm. Transferred to TIEM

2994. Glass. Unidentifiable object, L. 4 cm. Transferred to TIEM

2995. Glass. Handle of a blue vase, L. 6 cm. Transferred to TIEM

2996. Glass. Small flask with iridescence, H. 3 cm. Transferred to TIEM

2997. Glass. Fragment of a twisted bracelet, blue iridescence, L. 5 cm. Transferred to TIEM

2998. Glass. Bead. Transferred to TIEM

2999. Glass. Fragment of a colored twisted bracelet, L. 7 cm. Transferred to TIEM

3000. Glass. Blue probe, L. 10 cm. Transferred to TIEM

3001. Glass. Bracelet in two fragments, light blue. Transferred to TIEM

3002. Glass. Opaque bead. Transferred to TIEM

3003. Glass. Blue prism. Transferred to TIEM

3004. Glass. Opaque bead. Transferred to TIEM

3005. Faience. Blue quadrilateral support with four feet and two holes on upper face, the large side pierced with geometric shapes, the small sides ornamented, H. 20 cm, L. 20 cm. Transferred to TIEM

3006. Bronze. Five animals, D. 2.5–4 cm. Transferred to TIEM

3007. Bronze. Bracelet, one part missing, D. 6 cm, depth 1 cm. Transferred to TIEM

3008. Bronze. Small cup, D. 6 cm, H. 2 cm. Transferred to TIEM

3009. Bronze. Type of handle, D. 10 cm, depth 4.5 cm. Transferred to TIEM

3010. Bronze. Small plaque, L. 4.5 cm, H. 5 cm. Transferred to TIEM

3011. Bronze. Fragment of a fastener, L. 2.5 cm, W. 1.9 cm. Transferred to TIEM

3012. Bronze. Foot of an object, H. 4 cm and 1.5 cm. Transferred to TIEM

3013. Bronze. Fastener in two pieces, L. 3.5 cm, W. 2.5 cm. Transferred to TIEM

3014. Bronze. Fragment of an appliqué, L. 3.5 cm, W. 2 cm

3015. Bronze. Number [*chiffre*], L. 1.5 cm. Transferred to the Ethnographical Museum, Ankara

3016. Bronze. Probe, L. 1.1 cm. Transferred to the Ethnographical Museum, Ankara

3017. Bronze. Ring with broken shank, bezel with red stone, D. 2.5 cm. Transferred to TIEM

3018. Copper. Three rings, D. 2 cm. Transferred to TIEM

3019. Bronze. Two small urns, L. 2 cm, W. 1.8 cm. Transferred to TIEM

3020. Iron. Chisel, broken, L. 15 cm. Transferred to TIEM

3021. Bronze. Weight, truncated cube, 43½ dirhams in weight. Transferred to the Ethnographical Museum, Ankara

3022. Bronze. Weight, truncated cube, 18½ dirhams in weight. Transferred to the Ethnographical Museum, Ankara

3023. Bronze. Weight, truncated cube with decoration of concentric circles, 8¾ dirhams in weight. Transferred to the Ethnographical Museum, Ankara

3024. Faience. Oblong box with four feet, restored, L. 16.5 cm, L. 22 cm

4283. Enameled terracotta. Fragment of a tabouret, seven pieces, turquoise blue, L. 9–10 cm

4284. Enameled terracotta. Corner of a tile with cavity, turquoise blue ornamented in black, L. 13 cm, H. 105 cm. Transferred to TIEM

4298. Glass. Drinking vessel, gilded decoration in one area, in several fragments, H. 14 cm, D. 8.5 cm at opening

4299. Glass. Drinking vessel, in several fragments, one part missing, iridescent, H. 13 cm, D. 10 cm at opening. Transferred to TIEM

4300. Glass. Neck of a flask with a green serpentine band, H. 10.5 cm. Transferred to TIEM

4301. Glass. Neck of a bottle, relief decoration on lower part, H. 9.5 cm. Transferred to TIEM

4302. Glass. Bottom of a drinking vessel, one part missing, iridescent, H. 6.5 cm. Transferred to TIEM

4303. Neck of a large bottle, iridescent, H. 9.5 cm. Transferred to TIEM

4304. Glass. Neck with four openings, iridescent, H. 6 cm. Transferred to TIEM

4305. Glass. Foot of a vase, D. 7.5 cm

Aleppo, ruins of Raqqa, 1320/1904

2036. Glazed terracotta. Small vase, neck and handle missing, H. 12 cm. Transferred to the Ethnographical Museum, Ankara, in 1928

Raqqa (?), old confiscation

3396. Terracotta, blue glazed. Vase with two handles, H. 4.2 cm. Transferred to TIEM

3397. Terracotta, blue glazed. Small vase with one handle, H. 10.5 cm. Transferred to TIEM

3598. Faience. Ram, green with luster, H. 10 cm. Transferred to TIEM

Raqqa, 1906

4176. Bronze triangle. Geometric instrument, 12 x 8.2 cm. Transferred to TIEM

4243. Terracotta. Cover of a large vase in rounded form with one handle and a decorated rim, D. 19 cm. Transferred to TIEM

4244. Terracotta. Vase in form of flattened sphere, rim missing, sphinxes in medallions alternate with Kufic monograms, H. 9.5 cm. Transferred to TIEM

4245. Same as the previous, swans in medallions between Arabic inscription, vine scrolls on lower part of vase, H. 11.5 cm. Transferred to TIEM

4246. Same as previous, Arabic inscription in two bands, H. 10.5 cm. Transferred to TIEM

Objects confiscated from N. Marcopoli. Entered museum in 1320/September 1913

3500. Faience. Large turquoise blue vase, inscription, including decoration, in relief, restored, H. 40 cm

3501. Faience. Restored vase with white ground and black decoration, H. 23 cm. Transferred to TIEM

3502. Faience. Sweetmeats dish with seven cavities, on a cylindrical foot, white ground with luster-painted decorations in cavities, H. 16 cm. Transferred to TIEM

3503. Faience. Restored bowl with white ground and interior decoration in black, blue, and red, D. 24 cm. Transferred to TIEM

3504. Faience. Restored bowl with iridescence, bluish, D. 31 cm. Transferred to TIEM

3505. Faience. Restored bowl with blue ground, decorated in black, representation of a lion (?) in center, D. 26 cm. Transferred to TIEM

3506. Faience. Vase with blue ground and black decoration, H. 16 cm. Transferred to TIEM

3507. Faience. Neck of a large vase in white with iridescence, H. 10 cm. Transferred to TIEM

3508. Faience. Small vase with handle and mouth, handle broken, H. 7 cm. Transferred to TIEM

3509. Faience. Lamp with iridescence, L. 11 cm. Transferred to TIEM

3510. Faience. Lamp with iridescence, L. 11 cm. Transferred to TIEM

3511. Faience. Tabouret with six footed sides, inscriptions on sides and pierced geometric decoration, blue, H. 39 cm. Transferred to TIEM

3512. Faience. Basin, restored, turquoise ground and black decoration, D. 27 cm. Transferred to TIEM

3513. Faience. Basin, restored, turquoise blue ground and black decoration, D. 26.5 cm. Transferred to TIEM

3514. Faience. Basin, restored, green ground with luster, black decoration, D. 32 cm. Transferred to TIEM

3515. Faience. Basin, restored, white ground with bluish decoration, D. 24 cm. Transferred to TIEM

3516. Faience. Bowl, restored, green ground with luster, D. 22 cm. Transferred to TIEM

3517. Faience. Vase, restored, green ground and black ornament, iridescent, H. 20 cm. Transferred to TIEM

3518. Faience. Pitcher with handle and spout, restored, inscription in white on brown ground, H. 18 cm. Transferred to TIEM

3519. Faience. Fragment of a dish. Transferred to TIEM

3520. Faience. Fragment of a vase. Transferred to TIEM

The following objects are listed by inventory number, provenance, and date of entry to the museum:

1416–1541: Alep, kaza de Rakka et Maareh, December 1316/1900

1542–1568: Alep, kaza de Rakka, December 1316/1900

1932–1983: Alep, kaza de Rakka, June 1316/1903

2027–2029: Alep, kaza de Rakka et Maareh, April 1320/1904

2483–2485: kaza of Ischarah, *sancak* of Zor, August 1321/1905

3862–3879: Tell Halaf, Oppenheim mission, 1912

3880–3881: Tell Halaf (?), confiscation (?)

4018–4051: Tell Halaf, Oppenheim mission, 1912

4055–4082: Tell Halaf, Oppenheim mission, 1912

4138–4142: Tell Halaf, Oppenheim mission, 1912

4145–4175: Tell Halaf, Oppenheim mission, 1912

4231–4242: Tell Halaf, Oppenheim mission, 1912

4263–4277: Tell Halaf, Oppenheim mission, 1912

4280–4282: Tell Halaf, Oppenheim mission, 1912

4285–4297: Tell Halaf, Oppenheim mission, 1912

4306–4324: Tell Halaf, Oppenheim mission, 1912

Separate typewritten pages in modern Turkish

4951, 4952: Raqqa

Appendix 2: *Compositional Analysis of Early-Thirteenth-Century Ceramics from Raqqa and Related Sites*

Dylan T. Smith

I would like to thank Marilyn Jenkins-Madina for initiating this project and choosing to include a scientific perspective in her work; Mark Wypyski, Department of Scientific Research, The Metropolitan Museum of Art, and M. James Blackman, National Museum of Natural History, Smithsonian Institution, Washington, D.C., without whom none of the scientific analyses would have been possible; James H. Frantz, Department of Scientific Research, Metropolitan Museum, for recommending me for this project; Lawrence Becker and Dorothy H. Abramitis, Sherman Fairchild Center for Objects Conservation, Metropolitan Museum, for supporting my continuing participation; Daniel Walker, formerly of the Department of Islamic Art, Metropolitan Museum, Gisela Helmecke, Museum für Islamische Kunst, Naci Bakırcı, Mevlana Museum, and the staff of the Karatay Museum, Nazan Ölçer, formerly of the Museum of Turkish and Islamic Art, for allowing the sampling of objects in their collections; the Los Angeles County Museum of Art for providing additional samples for this study; and the Hess Foundation for its financial support of this project.

1. This term is borrowed from Mason 1994: 11. It is derived more directly from the Persian name for this fabric type and avoids the confusing terms "frit" and "faience," which refer to distinct materials.
2. One study of ceramics from Gritille, Turkey (Blackman and Redford 1994: 31–34), concluded that "of the 168 glazed ceramics sampled, 37 were found not to be fritwares at all, but had calcareous clay bodies as determined by chemical analysis." Three earthenware samples were considered in the present study; only one (MMA 1998.44.5) might represent an example of this phenomena.
3. The abbreviations MMA, MIK, KKM, TIEM, and LACMA, respectively, will be used for the first five institutions in the notes (those for the museums in Konya and Istanbul derive from their Turkish names). Numbers preceded by "w" refer to objects appearing in chapter 3 of this volume; those preceded by "MMA" and ranging from 1 to 46 refer to objects in chapter 4 (RA1 and RA4 are also in chapter 4). All other numbers are either museum

Well-established provenances are lacking for many Islamic ceramics in museum collections. Such objects have therefore generally been attributed to sites solely on the basis of traditional designations that were variously developed during the last century. For this reason, scientific analysis of ceramic fabrics has recently become an important companion to scholarly research. A collaborative approach provides a firmer basis for historical evidence and stylistic associations, which in turn offer a context for the scientific results.

The present study attempts to address through scientific analysis three major issues concerning a group of early-thirteenth-century ceramics known as Raqqa ware. The first was to determine whether objects grouped on a historical and stylistic basis had related ceramic fabric compositions. To allow the fullest consideration of patterns and profiles, the majority of samples were taken from more complete objects rather than sherds, for which only the glaze color and decorative technique can usually be identified. The second objective was to assign the group or groups of objects to particular points of origin by comparing them with a number of reference samples from relevant sites. The last aim was to definitively assign each object to a single site, ruling out all other possible places of origin. This is particularly important for the historical period in question, because the regions of interest are known to have traded extensively. Toward this end, data from a number of prior studies was considered, in order to form a more complete picture of ceramic compositions in Islamic lands at that time.

This study focuses on vessels and tiles composed of a body type referred to here as "stonepaste,"[1] an artificial ceramic fabric consisting primarily of silica combined with lesser amounts of clay and alkaline glass frit. Stonepaste was typically used for finer decorated ware during this period, although earthenware objects are sometimes decorated in a similar fashion.[2]

Analytical Methodology

Sampling

Objects for analysis were selected from The Metropolitan Museum of Art, New York; the Museum für Islamische Kunst, Staatliche Museen zu Berlin; the Karatay Museum, Konya; the Museum of Turkish and Islamic Art, Istanbul; the Los Angeles County Museum of Art; and the Madina collection.[3] Most important within the group are eleven stonepaste objects known to be from Raqqa, including four recently collected samples and one earthenware sample, also recently collected from Raqqa.[4] Sixteen tiles from Konya and Kubadabad in

Figure A2.1 Raqqa Stonepaste Group Arranged by decorative technique

■ Raqqa waster
□ Raqqa-attributed
⊞ High silica

Luster

Black-under-turquoise

Bichrome

Manganese and luster

Polychrome

Monochrome

*Although this object is almost certainly stonepaste, the sample taken from the surface proved to be earthenware kiln furniture.
**This object has recently been deaccessioned.

Figure A2.2 Comparative Material Included in Scientific Study

■ Raqqa waster

Syrian Other Stonepaste

MMA 28.89.2

MMA 1978.546.9

MMA x365

Turkish Stonepaste (Vessels)

MIK I.350

MIK Konya 1a

MIK Konya 1b

Outlier

MMA 48.113.8

Turkish Stonepaste (Tiles)

MIK I. 356

MIK I.926

MIK I.935

MIK I.1368

MIK I.1369

MIK I.1895,83

Photo of similar object, MIK Konya 4

MIK I.6579

MIK Kubadabad 1

MIK Kubadabad 2

MIK Kubadabad 3a

MIK Kubadabad 3b

MIK Kubadabad 4a

MIK Kubadabad 4b

MIK Kubadabad 5

MIK Konya 2

TIEM3555

Raqqa Earthenware

RA5

MMA 1998.44.5

■

inventory numbers or those assigned in the various studies cited.

The LACMA objects were formerly in the Madina collection; note that LACMA M.2002.1.106 has recently been deaccessioned. One of the Madina collection objects, C0182 (MC2265), considered in the study had been previously analyzed.

4. Three of these, W48, W129, and RA1, the last a recently collected sample, are all wasters and can be securely assigned to Raqqa. The sample taken from W129, a double waster, was apparently not the fabric of the vessel but kiln furniture that had bonded to the surface. However, that sample was similar in composition to RA5, a sample of earthenware kiln furniture from Raqqa clearly associated with local production. RA4 is a probable waster, recently collected at Raqqa. Although this sherd has pronounced bubbling of its glaze, as only a fragment it does not clarify the overall state of the original vessel or whether it would still have been functional and therefore salable and transportable. LACMA M.2002.1.39 is not a waster but a floor tile from a palace in Raqqa, where many such tiles are known (see Toueir 1985: 297–319, pl. 79b). W75 is a waster tile of a type excavated in Raqqa, although this particular example was acquired in

the Berlin collection were also considered.[5] (All objects included in this study are presented in figures A2.1 and A2.2.) Objects were chosen on the basis of the historical and stylistic criteria specified in previous chapters, including the full range of decorative techniques and vessel profiles.[6] The decorative techniques were divided into five categories: luster, black under turquoise, bichrome (blue and black underglaze), manganese and luster, and polychrome. One monochrome tile was also included. Dominant among the many profiles were the inverted pear-shaped jar with cylindrical neck and everted rim, the segmental bowl with flat rim, and the biconical bowl (profiles 1–3).[7]

Among the study objects were three waster bowls with pale green transparent glazes and black underglaze decoration. It was not immediately apparent whether this unusual type resulted from misfiring or represented a distinct decorative scheme.[8] The uniformity of the glaze and similarity of the three objects argued for deliberate creation. The green color, although visually suggestive of the black-under-turquoise technique, appears to have resulted from absorption of iron and chromium during excessive firing and perhaps from a lower level of refining of the glaze materials.[9] If the glaze was originally clear, stylistic similarities suggest an affiliation with the bichrome ware. The small, simple form and impure glaze color

Aleppo. RA2 and RA3 were recently acquired in Raqqa but are not wasters. While not wasters, MMA9 and MMA41 are documented as originating in Raqqa.

5. These are not wasters, but it is highly probable that, as tiles, they were locally manufactured. Not discussed in great detail here, they are presented only to establish that the study objects did not originate from those sites. A separate publication is planned for this material.

6. These are more fully discussed in chapter 5.

7. There are a great many objects of the inverted-pear-shaped-jar type, but this may not represent the actual frequency of their production, since nearly all of them come from the Great Find. The true frequency is more likely reflected by the two bowl types, acquired over time from a variety of collections.

8. The wasters, W130 and W131, and the double waster, W129.

9. Iron and chromium would be present in the black underglaze pigment and the ceramic body itself in the form of chromite and various iron oxides.

10. W38 is essentially a single object, as it consists of two sherds fused together, but samples were taken from each sherd and are labeled "a" and "b." MMA13.190.187, a member of the Fustat group from the Mamluk study (see note 26, below), was considered but is not presented here. Three additional objects that were analyzed proved to be outliers and shed little light on the discussion at hand: TIEM 2346, believed to originate in Samarra; MMA 07.238.30 and MMA 08.256.149, believed to be from Samsat. None are wasters.

The author of this appendix may be contacted for a full report of EDS results.

11. Using an Oxford Instruments INCA analyzer equipped with an energy dispersive X-ray spectrometer (EDS), attached to a LEO Electron Microscopy Model 1455 variable pressure-scanning electron microscope (VP-SEM). Tests were performed under high-vacuum conditions at an accelerating voltage of 20 KV with a beam current of approximately 1 nA.

12. Oxide content measured for Na_2O, MgO, Al_2O_3, SiO_2, P_2O_5, SO_3, Cl, K_2O, CaO, TiO_2, and FeO. Standard deviations in the measurements were typically 2 to 3 percent, with none higher than 6 percent. Problematic samples fell into two categories. Those with unusually high calcium and low silica appeared to be unrepresentative samples resulting from uneven distribution of these materials in the body fabrics. Those with high calcium and sulfur were apparently contaminated by plaster used for restoration. Replacement samples were taken when possible.

13. As mentioned in note 12, above, sulfur did prove useful as an indicator of contamination.

14. See Frierman, Asaro, and Michel 1979: 125. The data was reported in atomic percentages, which were converted to oxide percentages using the atomic and oxide percentages of the Metropolitan EDS data to generate a conversion factor.

of these bowls are consistent with a "low-end" version of objects produced by that technique, in which the expensive cobalt colorant was abandoned.

Energy dispersive spectrometry analysis (EDS)

Samples were taken from ninety objects for EDS analysis.[10] Since many of these were complete, the taking of large or drilled samples was generally undesirable or in some instances not permitted. Therefore, a technique of "opportunistic" sampling was used, in which a mixture of powder and small fragments of ceramic fabric was removed with a stainless steel scalpel blade from damaged areas and other discrete locations. The samples were crushed into a uniform powder and applied to a carbon sample mount. They were then analyzed by Mark Wypyski in the X-ray microanalysis laboratory at The Metropolitan Museum of Art.[11] The percentage of oxides was identified for eleven major elements.[12] Results for phosphorus, sulfur, and chlorine proved highly variable and were not included.[13] Two objects included in the study had prior EDS results.[14]

Neutron activation analysis (NAA)

Thirty-four objects were assessed by neutron activation analysis for this research.[15] For each sample, approximately 200 milligrams was extracted by a drill with a tungsten carbide bit.[16] For two smaller sherds, a smaller-diameter hardened-steel bit was used.[17] For the tiles from Berlin, a portion of the samples taken for EDS analysis was tested. Insufficient sample material was available to analyze the vessels from the Museum für Islamiche Kunst and the Karatay Museum by this technique.

NAA was carried out by Dr. M. James Blackman, formerly Senior Research Chemist, at the INAA facility of the Smithsonian Center for Materials Research and Education.[18] The percentages of twenty-nine elements were determined,[19] with a primary interest in the trace results. Of these, twelve were reliably identified.[20] Chromium was also excluded because a number of samples displayed unrepresentative high values, likely due to the presence of coarse chromite particles.[21]

Other analytical methods

Initial X-ray fluorescence analysis of a limited number of objects confirmed their glazes as alkaline. This technique was not used for grouping purposes, however, because of its inability to discriminate between highly similar glaze compositions. Such compositions were expected for the study objects, given the use of established formulations during this period.[22] Thin-section analysis was considered, but its efficacy would have been limited since samples of sufficient size could not have been taken from most of the objects under investigation.

Prior Studies

Few studies have reported on the bulk composition of Syrian ceramics from this period. Research by Roberto Franchi and his colleagues on objects excavated at Qaʾat Jabar found two related groups linked to that site by wasters and a third group that was apparently imported.[23] A study of northern Syrian ceramics by

The results show only minor deviations from expectations.

15. Nineteen additional samples analyzed by NAA were not considered in this study: fourteen tile samples from Konya and Kubadabad, four modern clay samples from the Konya and Kubadabad region, and a jar (TIEM 2346) believed to be from Samarra that proved to be not a waster but an outlier.

The author of this appendix may be contacted for a full report of NAA results.

16. One hundred milligrams was requested for the analysis; most samples exceeded this, while a few were slightly under but sufficient for testing.

17. W48 (chapter 3) and RA1 (chapter 4, p. 162). When it became apparent that the hardened-steel sampling bit noticeably elevated the iron level in these, two samples were taken from RA4 with the two different bits and the results used for correction. Qualitative XRF (X-ray fluorescence) analysis was done on both bits to consider their potential contribution; among those identified, only Fe and Cr were among the elements considered. The hardened-steel bit was reported as nearly 99 percent Fe and less than 1 percent Cu, Mn, Zn, and Cr. The tungsten carbide bit was reported as approximately 83 percent Fe, 11 percent W, 4 percent Cr, 1 percent V, and less than 1 percent Cu.

18. The 20-megawatt reactor at the National Institute of Standards and Technology was used. The procedure is described in Blackman 1984: 19–50; refinements for analysis of stonepaste fabrics are found in Redford and Blackman 1997: 237.

19. Content measured for Na, K, Ca, Fe, Sc, Cr, Co, Zn, As, Br, Rb, Sr, Sb, Cs, Ba, La, Ce, Nd, Sm, Eu, Tb, Yb, Lu, Hf, Ta, Th, U, and W.

20. "Reliably" meaning values were reported for each sample. This included Na, Ca, Sc, Cr, Fe, Cs, La, Ce, Sm, Eu, Hf, and Th. Cs was not reported for RA3, and Hf for MMA 41.165.4; in these instances, probable values were assigned on the basis of the close correlation with the iron content.

21. Dark particles were noted on occasion during sampling. Redford and Blackman (1997: 239) reported that the earthenware they analyzed had higher relative levels of chromium than the stonepaste ware, and they believed that the chromite was introduced with the temper. This observation accords with the fact that high chromium was not found in the kiln furniture sample RA5, which would be expected to use an unrefined clay. The hardness and refractory nature of chromite explain its survival in coarse form despite refining and firing. Iron content was also higher in the samples containing chromite; however, because the iron content was typically several percent, the increase of a few parts per million had little effect.

22. Surface analysis was done under a variety of testing conditions using a Jordan Valley X-ray fluorescence unit in the Sherman Fairchild Center for Objects Conservation at The Metropolitan Museum of Art. The limited precision of this technique for lighter elements and the susceptibility of glazed surfaces

Josefina Perez-Arantegui and others identified six distinct stonepaste groups, including two assigned to Raqqa.[24] A broad project by Robert Mason reported bulk compositions for a small number of relevant Syrian ceramics.[25]

A substantial body of NAA data on Islamic ceramics of comparable date is found in three prior studies. The first, carried out at the Metropolitan Museum, focused on ceramics of the Fatimid period inscribed with the word *sa'd* and included a number from the Mamluk period for reference purposes.[26] Several objects selected for the present investigation were analyzed, and all five decorative techniques were represented. The ceramic samples were divided by composition into three groups: Syrian Composite, Iranian (?) Composite, and Egyptian Composite. Only the last group was established by wasters; the others were assigned a provenance on the basis of style alone.[27]

The second study, also from the Metropolitan, considered Mamluk underglaze-decorated ware.[28] A small number of objects in the present study were included; among these were representatives of all the decorative techniques except manganese and luster. The Mamluk study results defined three compositional groups—two, Fustat and Damascus, attributed by wasters, and one, Syria (Site Unknown), unattributed.

For the purposes of the present inquiry, the NAA data for fourteen objects from the *Sa'd* and Mamluk studies was considered in detail; twelve of these were additionally sampled and analyzed by EDS, while two had prior EDS results.[29] The remaining NAA results from these two studies were also compared more generally.

The third study, by Scott Redford and M. James Blackman, focused on a large group of recently analyzed sherds from Gritille, Turkey, a site neighboring the Raqqa region. These are datable by archaeological stratification from the mid-twelfth to the mid-thirteenth century, including some earlier than those in the present study.[30] The Gritille results divided samples into two large compositional types, coarse and fine, with the coarser fabrics further subdivided into six groups (GRT1–GRT5, GRT9) and the finer fabrics into three groups (GRT6–GRT8).[31] The decorative techniques represented were somewhat different from those in the present study.[32] Of the 130 Gritille samples, 80 percent were manganese- and turquoise-glazed objects with luster decoration. Only eleven had any variety of underglaze decoration;[33] these fell into just three of the compositional groups, primarily GRT4 and GRT5, and to a lesser extent GRT3. Samsat was suggested as the production site for some of these objects,[34] but the production of frit and lusterware has not been firmly established at that site. In addition, because no reference material from possible sites of origin was analyzed in the Gritille study, none of the sherds can be firmly associated with a provenance.

For the present study, NAA data from ten of the Gritille objects was considered in detail, and samples were taken from these for EDS analysis.[35] At least one object was analyzed from five of the six "coarse" compositional groups, with additional samples taken from those with underglaze decoration.[36] The NAA results for all the Gritille study objects were also considered in some detail.

Results

The stonepaste bodies of the study objects were found generally to be hard, brittle, and somewhat porous. They ranged in color from white to very pale yellow or very

to alteration and contamination made interpretation difficult. In a few examples, most of them polychrome-decorated, the presence of lead was noted. Because these objects were from a group (Syrian Other Stonepaste) that was not the focus of the present study, this discovery has not yet been pursued further.

23. Franchi et al. 1995: 197–205.

24. Perez-Arantegui et al. 1995: 475–82.

25. Mason 1994. For Syrian data, see p. 231.

26. Jenkins 1988: 67–76. This data survived only as a printout in which the results were reported in a nonstandard manner. Edward Sayre, at that time senior research chemist, Smithsonian Center for Materials Research and Education [SCMRE], decided upon review that these results did not meet the standard for reliability (Ronald L. Bishop, senior research archaeologist, SCMRE, personal communication, December 2001). For the purposes of this study, it was highly desirable to incorporate this data, because of the large number of relevant museum objects included. The results for five objects from the 1988 *Sa'd* study were paired with those for the same five in the more reliable 1984 Mamluk study (see below) in order to define a function to translate other *Sa'd* results for comparison with the Mamluk data.

27. The relevant reference samples are FA06 to FA09, which were taken from a prior study by Helen V. Michel, Jay D. Frierman, and Frank Asaro. All were archaeologically excavated—FA06, FA07, FA08 at Fustat and FA09 at Samarra. FA06 contains a number of wasters that indicate its Fustat origin. The five samples constituting FA07 were established as compositionally distinct from the Fustat local ware, and thus of a nonlocal provenance. The origin of these sherds is suggested by the fact that they are "in the style of thirteenth to fourteenth century A.D. Iran" and bear some similarity in composition to Iranian ware from another study; however, it was recognized that no provenance could be assigned (Michel, Frierman, and Asaro 1976: 84–92). Reconsideration of the styles represented in FA07 in the course of this study makes Syria a more probable source. FA08 and FA09 were found to be "distinctly different in chemical composition from Egyptian faience [FA06] or the probable Iranian Underglaze Painted Faience [FA07]." However, speculation regarding their origin is based only on the fact that "[t]hey are typical of the North Syrian Rakka-Rusafa type wares of the late twelfth and early thirteenth centuries in both technique and design" (Frierman, Asaro, and Michel 1979: 126). The samples studied by Frierman, including some from this Fustat research, are now in the possession of LACMA. See Jenkins 1988 for the dendrogram based on NAA results (fig. 25) and additional object numbers (p. 72).

28. Jenkins 1984: 95–114. This data, originally stored at Brookhaven National Laboratory, Upton, New York, was retrieved in reliable computerized form from the research archives at SCMRE, where it was located with the assistance of Ronald L. Bishop at

pale pink. Fabric color and texture were not used as grouping criteria, except for the separation of stonepaste from earthenware, because variations in firing conditions and burial deterioration can result in unrepresentative differences.

The bulk compositions reported by EDS primarily indicated the relative proportions of the various components that were combined to form the stonepaste rather than the individual character of each component.[37] Distinctive stonepaste formulations were expected to provide some insight into production site, as the preparation of this fabric type was still evolving during the early thirteenth century in the regions of interest.[38] Oxide ratios as reported by EDS, particularly the iron oxide–aluminum oxide ratio, should also shed some light on provenance by revealing the nature of the clay component.[39]

Elevated levels of calcium were found in most of the study objects, but the manner of its introduction remains uncertain. Results indicated that the primary source of the calcium was not the clay, but that it was added, along with silicon, in a single component such as a siliceous limestone or calcareous sandstone.[40]

NAA quantified trace elements found principally in the clay component, which was expected to better indicate provenance by association with a source of a particular prepared clay.[41] One potential problem with trace results for any type of ceramic fabric is that "slightly variable amounts of aplastic materials, such as tempers, result in a dilution effect."[42] This effect would be amplified in stonepaste fabrics, in which clay is actually present in relatively small amounts.[43] Thus, differing formulations of stonepaste might obscure the fact that two ceramics used the same clay from the same site.[44] This dilution effect was corrected for by considering a combination of bulk and trace results adjusted for aluminum content.[45]

The combined adjusted compositions provided by the EDS and NAA results were then examined by cluster analysis (CA) (chart 1) and principal component analysis (PCA).[46] Based on comparison to the reference samples, three groups attributed to two sites were identifiable: Raqqa Stonepaste, Raqqa Earthenware, and Turkish Stonepaste. A fourth group, Syrian Other Stonepaste, was identified but not attributed. The same groups were also identified within the EDS data, independent of the NAA results, on the basis of stonepaste formulation and the iron oxide–aluminum oxide ratio (charts 2, 4).[47] Using these criteria, thirty additional objects, tested only by EDS, could be assigned to a production site.[48] In addition, the relationships between the study objects and those tested in the *Sa'd*, Mamluk, and Gritille studies were identified by considering shared members, the EDS-NAA combined results for the twenty objects from the prior studies, and the NAA data more generally.[49]

The three prior studies reporting only bulk compositions were found to have limited usefulness for the present inquiry. In the study by Franchi and his colleagues, the composition of the import group, for which Raqqa is a likely source, resembled that of the Raqqa Stonepaste objects; however, the use of different analytical and sampling methods made a firm conclusion impossible.[50] The two groups that Perez-Arantegui identified as associated with Raqqa had overall compositions and iron oxide–aluminum oxide ratios similar to those for the Raqqa Stonepaste group, but, again, differences in reporting could not be fully resolved.[51] The results from Mason's research were

CONCORDANCE

The inventory numbers given in the charts below correspond as indicated to objects in chapters 3 and 4:

KKM 17/11	W21
KKM 17/12	W18
KKM 18/3	W9
KKM 20/1	W28
KKM 25/2	W80
KKM 25/5	W77
KKM 25/7	W83
KKM 26/5	W93
LACMA M.2002.1.41	W75
LACMA M.2002.1.75	W89
LACMA M.2002.1.180	W62
LACMA M.2002.1.211	W56
LACMA M.2002.1.262	W22
MIK I.411	W38
MIK I.1239	W131
MIK I.1240	W130
MMA 08.102.4	MMA44
MMA 10.44.2	MMA4
MMA 17.120.36	MMA6
MMA 20.120.225	MMA7
MMA 22.196.1	MMA29
MMA 34.71	MMA30
MMA 42.113.3	MMA45
MMA 48.113.5	MMA10
MMA 48.113.6	MMA11
MMA 48.113.8	MMA13
MMA 48.113.19	MMA24
MMA 56.185.6	MMA32
MMA 56.185.9	MMA33
MMA 56.185.14	MMA34
MMA 56.185.21	MMA41
MMA 91.1.138	MMA1
MMA 1970.24	MMA28
MMA 1974.161.11	MMA46
RA1	p. 162
RA4	p. 163
TIEM 1549/4053	W48
TIEM 1558/4058	W71
TIEM 2188/1447	W135
TIEM 2193/1539	W129
TIEM 2224/1448	W117

In charts 1–3, each vertical line denotes a statistical distance between the objects or groups of objects it connects, based on the combined differences in their elemental compositions. Smaller distances indicate greater similarity, and larger distances indicate less similarity. The largest divisions, on the left, were removed and are indicated by shading. The symbols in charts 1, 2, and 4 represent the following:

Raqqa
- ◉ Stonepaste
- ◆ Earthenware
- ● Knowns

▲ Syrian Other Stonepaste
▣ Turkish Stonepaste
○ Outlier

Chart 1

Cluster Analysis of Combined Adjusted NAA and EDS Results

Based on K, Mg, Ti, Fe, Sc, Cs, La, Ce, Sm, Eu, Hf, Th; results standardized to Al and trace results scaled to Fe; clustering determined by the average linkage.

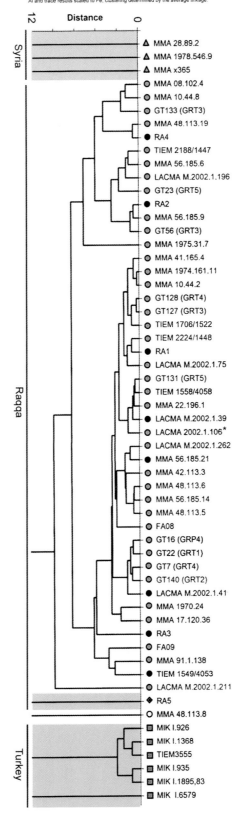

Chart 2

Cluster Analysis of EDS Results

Based on NaO, MgO, Al2O3, SiO2, K2O, CaO, TiO2, and FeO;
clustering determined by the average linkage.

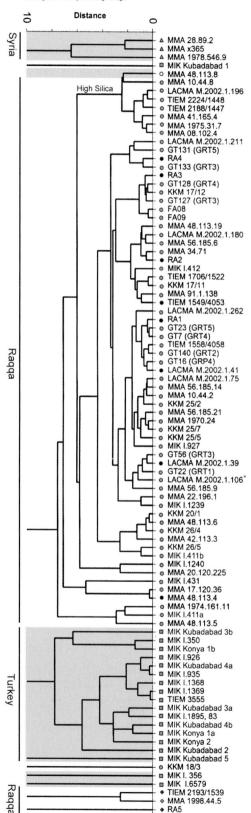

Chart 3

Cluster Analysis Based on NAA Results
for Raqqa Stonepaste, GRT3, GRT4 and GRT5

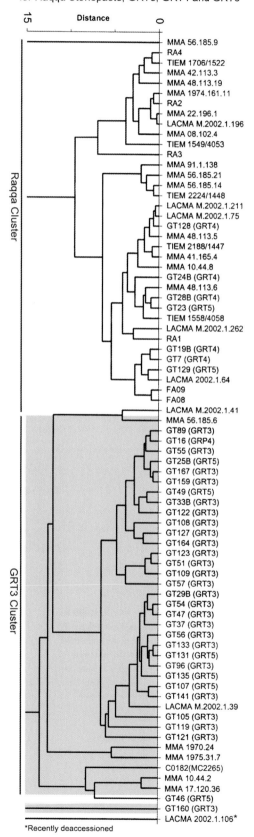

*Recently deaccessioned

Chart 4

EDS Results for Iron Oxide vs. Aluminum Oxide

Based on Na$_2$O, MgO, Al$_2$O$_3$, SiO$_2$, K$_2$O, CaO, TiO$_2$, and FeO; principal component analysis used
Varimax, Kaiser normal rotation, estimated communalities set to highest correlation, and calculated
communalities repeated until residuals smaller than 0.05, minimum eigenvalue was 1.

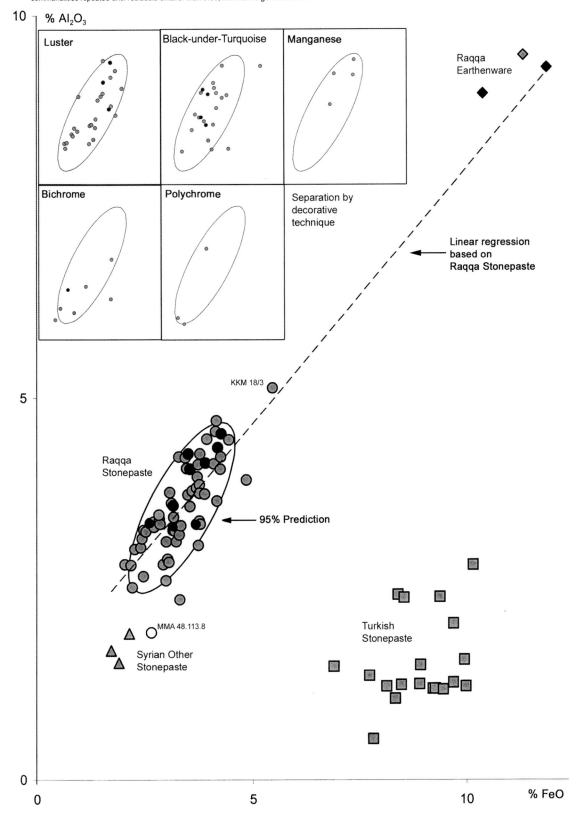

SCMRE and Pieter Meyers, senior research chemist, Los Angeles County Museum of Art. A dendrogram of results appears on page 95; see notes 6, 7, and 9 for object numbers.

29. *From the Sa'd and Mamluk studies:* MMA 28.29.2 (*Sa'd* 47, Mamluk 93), 41.165.4 (*Sa'd* 10, Mamluk 81). *From the Sa'd study:* MMA4 (*Sa'd* 32), 10.44.8 (*Sa'd* 5), MMA6 (*Sa'd* 9), MMA13 (*Sa'd* 12), MMA28 (*Sa'd* 15), 1975.31.7 (*Sa'd* 20), 1978.546.9 (*Sa'd* 26), LACMA M.2002.1.64 (*Sa'd* 53), LACMA M.2002.1.106 (formerly) (*Sa'd* 54), C0182/MC2265 (*Sa'd* 55). *From the Mamluk study:* MMA44 (Mamluk 47), X365 (Mamluk 82). LACMA M.2002.1.64 and C0182 (MC2265) were not analyzed by EDS; FA06–FA09 had prior EDS results (see note 27, above).

30. Redford and Blackman 1997: 233–47. The samples from this study have the advantage of being analyzed by NAA by the same researcher at the same facility.

31. Redford and Blackman 1997: 246.

32. Because only sherds were considered in the Gritille study, full understanding of the decoration and profile was not possible. This issue was recognized by the researchers (see Redford and Blackman 1997: 246).

33. One with underglaze and luster, two with cobalt blue (which were likely to have been lustered), six with black-under-turquoise, and two bichrome. Some objects reported as undecorated turquoise-glazed could be sherds that happened to lack any of the original object's underglaze black decoration, but it seems more likely that they were undecorated or lustered.

34. "During this period some local production center turned out glazed calcareous clay and fritware vessels, making them available and affordable to the rural populace of this remote region [Gritille]. For Gritille, that center must have been Samsat, the nearby commercial and administrative center. Excavations in medieval levels at Samsat have uncovered kiln furniture, wasters, and unfinished pottery . . . , but only further publication of these discoveries will reveal whether or not these included frit and lusterwares." Redford and Blackman 1997: 245.

35. Redford and Blackman 1997: GT7 (in group GRT4), GT16 (GRT4), GT22 (GRT1), GT23 (GRT5), GT56 (GRT3), GT127 (GRT3), GT128 (GRT4), GT131 (GRT5), GT133 (GRT3), and GT140 (GRT2).

36. Objects from GRT6–GRT8 were not considered by EDS because their NAA results clearly distinguished them from the objects presently under investigation. GRT9 was not considered as it was an outlier group in the original study and did not include objects that were similar in style or decoration to those in our investigation.

37. For example, silicon would have been introduced mainly by the siliceous component, sodium by the glass frit, and aluminum by the clay. The high silica concentrations suggest the use of powdered quartz or very pure sand. Perez-Arantegui et al. 1995: 478.

also found not to be readily comparable to those of the present study.[52] In addition, the results from each of these studies were found not to be comparable with those from the others.

Raqqa Stonepaste

A total of sixty-eight objects were identified as belonging to the Raqqa Stonepaste group, forty-six based on the combined EDS-NAA results, twenty on EDS results only, and two on NAA only (charts 1, 2, 4; fig. A2.1).[53] This includes the bulk of the study objects and all the Raqqa knowns, thus identifying Raqqa as the source of production. All five decorative techniques were included in this group, as well as a representative variety of profiles. For the typical object, the silicon oxide content was about 75 percent, and sodium oxide just over 3 percent. Aluminum oxide ranged from 2 to 5 percent, owing in part to deliberate changes in the formulation and in part to accidents of manufacture and sampling. Some samples with increased clay content were from larger vessels, and additional clay may have been necessary to successfully throw such forms.[54] There were also changes in clay content related to decorative technique, as discussed in detail below.

Of the forty-six samples with EDS and NAA results, thirty-six were found to be within a 95 percent prediction range as established by PCA.[55] Seven additional objects just outside this range were clearly associated with the Raqqa Stonepaste group.[56] A sample from a luster waster tile fell slightly farther from the group but is itself attributed to Raqqa and was therefore considered a member; a luster-decorated vessel fragment from the Gritille study was very similar in composition to this tile and was therefore also considered part of the group.[57] Falling yet farther outside the Raqqa group but still most closely related to it was the only sample with luster on cobalt blue decoration, which may account for this slight difference in composition.[58]

Of the twenty-one samples assigned to the Raqqa Stonepaste group based on EDS results alone, eighteen fall into the range of compositions established by Raqqa reference samples, and a nineteenth can be added with a little further consideration (chart 2).[59] While the composition of a luster waster bowl from the Karatay Museum placed it far outside the Raqqa group, it was found to have a similar iron oxide–aluminum oxide ratio, which associated it with Raqqa (chart 4).[60] An additional object, a double waster from the Museum of Turkish and Islamic Art attributed to Raqqa, could be associated with the Raqqa Stonepaste group using the EDS results, although the sample itself was earthenware kiln furniture from its surface.[61]

Within the Raqqa Stonepaste group, a subgroup of seven objects with high-silica compositions was noted in the EDS results (chart 2).[62] This apparently deliberate shift in formulation resulted in an average silicon oxide content of approximately 80 percent, with a corresponding reduction of other elements.[63] Polychrome and bichrome decorative techniques are dominant in this group, but all techniques are represented, except manganese and luster. One sample associated with this high-silica group in the cluster analysis proved to be an outlier of the Raqqa Stonepaste group (see discussion below).[64]

38. For more on the history of stonepaste fabrics, see Mason and Tite 1994: 77–91.

39. As both iron and aluminum are primarily contributed by the clay, their ratio should remain relatively constant if objects contain the same clay, regardless of the amount. Although pronounced differences in other elements may have suggested differences in the clay component, these were not as clearly dependent on the clay alone (K, Mg) or were too variable to be reliable indicators of grouping (Ti).

40. While calcareous clays have been reported for the region in question, a relationship between calcium and aluminum contents was not noted. A consistent inverse relationship between silicon and calcium was identified, with the total silica-calcium remaining relatively constant. It is unlikely that calcium was added as an independent component, because the sodium and aluminum levels were not significantly reduced even in objects with exceptionally high calcium contents. The presence of silica in significant quantities in the frit and clay components makes it difficult to be certain. Calcareous sources for silica have been suggested by a number of authors who relied mainly on observations for Persian ware, including Hans Wulff (1966), Owen Rye and Clifford Evans (1976), and Mason (1994).

41. These compositions must be considered indicative of the prepared ceramic paste rather than directly representative of a clay deposit. Mommsen 2004: 267–71.

42. Ibid.: 269.

43. The values were as high as 10 percent, but as low as 2 percent in some silica-rich samples.

44. Although discussing a different type of ceramic, Mommsen (2004: 268) points out that "[t]here are known cases in which different pastes have been used contemporaneously in the same workshop for different types of wares."

45. Observations based on K_2O, MgO, TiO_2, FeO, Sc, Cs, La, Ce, Sm, Eu, Hf, and Th, with results standardized to aluminum content and the trace results scaled to iron, which was reported by both analytical methods. That these elements are typically contributed by the clay was supported by their observed dependency on aluminum content in the study objects.

46. Winstat software was used in EXCEL for both techniques. CA was determined using average linkage. PCA was done using Varimax, Kaiser normal rotation, and estimated communalities set to highest correlation. Calculated communalities were repeated until residuals were smaller than 0.05; minimum eigenvalue of 1. Two principal components were identified.

47. CA for the EDS results used the same settings as described in note 46, above.

48. The majority of these objects had strict limitations on sample size, and although sufficient material was taken for EDS, they were well below the 100 mg standard for NAA.

49. In addition to the sampled objects shared with the present study, there are twenty objects shared

The combined EDS-NAA results indicated that the Raqqa Stonepaste group was the same as the Syrian Composite group in the *Sa'd* study.[65] This finding provided a more definitive origin for the *Sa'd* group and allowed two additional luster-decorated objects to be assigned to the Raqqa Stonepaste group based on NAA data alone.[66] The association with the Syrian Composite group also established the distinction of the Raqqa Stonepaste group from the attributed Egyptian and Iranian (?) Composite groups in the *Sa'd* study.[67] The Raqqa Stonepaste group was additionally linked to two outliers in the Mamluk results,[68] distinguishing this group from the three others in that study—the attributed Fustat, attributed Damascus, and the Syria (Site Unknown).

Statistical analysis of the NAA results from the present and prior studies, as well as consideration of the EDS-NAA results for the selected Gritille samples, indicated that the Gritille study objects were more similar to the Raqqa Stonepaste group than compositions from other sites.[69] Closer consideration revealed that the three Gritille groups containing underglaze-decorated objects (GRT3–GRT5) were particularly closely associated with the Raqqa Stonepaste group (chart 3).[70] Consideration of the NAA data suggested that GRT5 might be an artificial group resulting from unrepresentative high chromium values; when chromium is not considered, its members fall into either GRT3 or GRT4.[71] A limited statistical consideration of these two groups and the Raqqa Stonepaste group divided the samples into two clusters, one including the Raqqa objects and GRT4, the other essentially GRT3.[72] All but one object from the GRT4 group is included in the Raqqa cluster. A few members of the Raqqa Stonepaste group, most of them luster-decorated, were found to fall in and around the GRT3 cluster; a tile attributed to Raqqa fell securely within that cluster.[73] The distinction between the Raqqa and GRT3 clusters may be accounted for by a higher clay content in the latter rather than by a different provenance, as suggested by a consistent shift in the trace element contents.[74] These results assign a Raqqa provenance to the GRT4 and GRT5 samples in that cluster and strongly suggest that the GRT3 cluster is of the same origin.[75]

Raqqa Earthenware

The Raqqa Earthenware group has only three members, as earthenware was not the focus of this study (charts 1, 2, 4; figure A2.2).[76] The first, a kiln furniture sample from Raqqa, was assigned to this group using the combined bulk and trace assessment and established Raqqa as the production site for this group.[77] The second member is an undecorated bowl that may have been intended for luster decoration; earthenware objects are known to employ the same form and decoration as those fabricated from stonepaste.[78] The last earthenware sample appeared to be kiln furniture fused to the surface of a double waster attributed to Raqqa. Since the vessel fabric would have been stonepaste, this object was assigned to the Raqqa Stonepaste group.[79]

A relationship between the Raqqa Stonepaste and Raqqa Earthenware groups was indicated by regression analysis of the iron oxide–aluminum oxide ratio (chart 4). Both groups were provenanced to Raqqa by their own members, but this analysis reinforced that conclusion and suggested that the same clays were used in a variety of ceramic types.[80]

between the *Sa'd* and Mamluk studies. For these, see notes 27 and 29, above. Considering only the NAA results with those from the Gritille study, and Syria (Site Unknown) and Damascus samples from the Mamluk study, thirty-five of the Raqqa objects remain in a cluster. MMA33 and LACMA M.2002.1.106 (formerly) are outliers in the NAA data, but are pulled back into the Raqqa group by the combined EDS-NAA.

50. The objects from this study (Franchi et al. 1995) should show some relationship to the ones in the present investigation. Although it also used SEM/EDS, the analysis was done on thin sections rather than powdered samples, which appears to have made a significant difference in the results. However, these results are still of interest for the chronological shift in stonepaste formulations that they suggest.

51. In that study (Perez-Arantegui et al. 1995), results were reported only as an overall average, which made it difficult to integrate them into the present investigation. The distinct analytical technique is also a likely source of variation in results.

52. The problems that were encountered seemed to be primarily differences in the analytical technique. Mason 1994; for Syrian data, see p. 231.

53. *Based on combined EDS-NAA results:* MMA: MMA1, MMA4, MMA6, MMA10, MMA11, MMA13, MMA24, MMA28, MMA29, MMA32–MMA34, MMA41, MMA44–MMA46, 10.44.8, 41.165.4, 1975.31.7, 1998.44.5. TIEM: W48, W71, W117, W135, 1706/1522. LACMA: W22, W56, W75, W89, M.2002.1.39, M.2002.1.106 (formerly), M.2002.1.196. Collected from Raqqa: RA1–RA4. Gritille study: GT7, GT16, GT22, GT23, GT56, GT127, GT128, GT131, GT133, GT140. Frierman, Asaro, and Michel 1979: FA08, FA09. *Based on EDS results:* MMA: MMA7, MMA9, 34.71. MIK: W38, W110, W130, W131, I.412, I.927. TIEM: W129. LACMA: W62. KKM: W9, W18, W21, W28, W77, W80, W83, W93, 26/4. *Based on NAA results:* LACMA M.2002.1.64, C0182 (MC2265).

54. MMA6, MMA9, MMA32, LACMA M.2002.1.106 (formerly).

55. Based on the first two principal components. See note 46, above.

56. MMA24, MMA44, MMA 10.44.8, W56, W135, RA3, and FA09.

57. W75 and GT140. See discussion of the Gritille groups above for further thoughts on the latter.

58. MMA 1975.31.7. Although this object is left in the Raqqa Stonepaste group, examination of additional objects and sites in the future may well displace it.

59. CA based on Na_2O, MgO, Al_2O_3, SiO_2, K_2O, CaO, TiO_2, and FeO, using average linkage. PCA of the EDS results was also considered but did not provide additional insight. The range is established by RA4 and MMA9. The sherd W38a can be pulled closer into the group by its literal attachment to W38b; both have unusually high calcium levels but are otherwise similar to the Raqqa Stonepaste group. Overfiring may play a role in these distinctions. MMA10 and MMA46 are placed in the Raqqa Stonepaste group by the

Turkish Stonepaste

Seventeen objects are assigned to the Turkish Stonepaste group, five based on combined EDS-NAA data and twelve on EDS alone (charts 1, 2, 4).[81] Statistical analysis found these samples to be markedly different from those identified as Raqqa Stonepaste.[82] This group included objects attributed to both Konya and Kubadabad and was rather heterogeneous, almost certainly using a variety of stonepaste formulations and possibly distinct clays. However, certain compositional characteristics are shared, in particular, a high aluminum oxide content and a very low iron oxide–aluminum oxide ratio. This level of refinement is sufficient for the purposes of the present study.[83]

Although distinct in overall composition, three additional objects can be associated with the Turkish Stonepaste group based on their similar iron oxide–aluminum oxide ratios (chart 4). This suggests that their differences are primarily in formulation and that they could originate from neighboring sites.[84] These included a double eagle tile, a luster-on-manganese tile, and the only *lajvardina* vessel included in the study.[85]

This investigation considered whether the distinction between the Raqqa Stonepaste and Turkish Stonepaste groups resulted from different requirements for the manufacture of vessels and tiles (the Raqqa group consists primarily of the former, the Turkish group of the latter).[86] However, several facts argued against this conclusion. First, a few tiles are included in the Raqqa group, and a few vessels in the Turkish group.[87] Second, the combined EDS-NAA analyses clearly divide these groups, indicating a distinction in the clays used, not just in their stonepaste formulations. Finally, the vessels associated with the Turkish group are decorated in a different style from the Raqqa objects, which suggests that they come from a distinct production site. The discovery that, within the Raqqa and Turkish Stonepaste groups, vessels and tiles shared compositions also supported the use of either as reference samples for the other.[88]

The Turkish Stonepaste samples were found to be distinct from any groups identified in the prior studies, including those associated with the Raqqa Stonepaste and Syrian Other Stonepaste groups as well as those attributed to Egypt, Fustat, and Damascus.

Syrian Other Stonepaste

Using a combined EDS-NAA assessment, three objects were assigned to the Syrian Other Stonepaste group (charts 1, 2, 4).[89] While displaying significant variations, these were clearly more similar to each other than to either the Raqqa Stonepaste or the Turkish Stonepaste group. The iron oxide and aluminum oxide contents of these samples were similar to those of the objects in the Raqqa group containing the least aluminum, but the ratio of the two oxides was distinct.[90] The EDS results indicated that these objects used a distinct stonepaste formulation as well as a distinct clay.[91]

The Syrian Other Stonepaste group was determined to be the same as the Iranian (?) Composite group from the *Sa'd* study and the Syria (Site Unknown) group from the Mamluk study.[92] This discovery reinforced the distinction between this large combined group and the Raqqa Stonepaste objects and separated the

combined adjusted EDS-NAA results, although they are outliers in the EDS cluster analysis.

60. w9. This sample falls along the regression line for iron and aluminum established by the Raqqa Stonepaste group. Unfortunately, a sufficient sample could not be taken for NAA analysis, which might have resolved any doubts. This bowl may have used a distinct high-clay formulation, or the variation may be the result of an unrepresentative sample.

61. w129. See the Raqqa Earthenware section below and also note 4, above.

62. MMA44, 10.44.8, 41.165.4, 1975.31.7, w117, w135, LACMA M.2002.1.196. Using CA. See notes 46 and 47, above.

63. A rough estimate would be that the core group used a 7:2:1 mixture (siliceous component:glass frit:clay), while the high-silica group used an 8:2:1 mixture. These calculations assume that the clay contained approximately one-third Al_2O_3 and two-thirds SiO_2, the frit two-thirds SiO_2, and the remainder one-half Na_2O. Calcium is considered part of the siliceous component (see note 40, above). While this could be the effect of accidental inclusion of the whiter slip on many study objects, samples were typically taken in locations unlikely to be affected, such as the interior of the foot.

64. MMA13.

65. *Saʾd* Syrian Composite members: MMA4 (*Saʾd 32*), MMA6 (*Saʾd 39*), MMA13 (*Saʾd 12*), 10.44.8 (*Saʾd 5*), 41.165.4 (*Saʾd 10*), 1975.31.7 (*Saʾd 20*), LACMA M.2002.1.64 (*Saʾd 53*), M.2002.1.106 (formerly) (*Saʾd 54*), FA08, FA09, C0182 (MC2265) (*Saʾd 55*). See also the dendrogram accompanying that article (note 26, above).

66. LACMA M.2002.1.64, C0182 (MC2265).

67. See note 29, above, for information on these prior groupings.

68. MMA44 (Mamluk 47), 41.165.4 (Mamluk 81). See also the dendrogram accompanying that article (note 28, above).

69. PCA and CA based on Sc, Fe, Cs, La, Ce, Sm, Eu, Hf, and Th. The results from the Gritille study and the present study should be the most comparable because the NAA analyses were performed by the researcher at the same facility. Three outliers were noted from either the Raqqa or GRT3 clusters. MMA33 and LACMA M.2002.1.106 (formerly) were assigned to the Raqqa Stonepaste group by the combined EDS-NAA analysis; the sample from GT160 is similar to LACMA M.2002.1.106 (formerly) and likely to be accidentally clay-rich.

70. Based on NAA assessment of Sc, Fe, Cs, La, Ce, Sm, Eu, Hf, and Th, and limited to the Raqqa Stonepaste group and GRT3–GRT5.

71. See the section on Neutron Activation Analysis, above.

72. CA aided by PCA and a comparison of z-scores for certain boundary objects.

73. LACMA M.2002.1.39 clearly falls in the GRT3 cluster. Consideration of z-scores in relation to the cluster averages placed w75 and GT46 in the Raqqa cluster, and MMA4, MMA6, MMA28, MMA32, MMA 1975.31.7, and C0182 (MC2265) in the GRT3

Syrian Other Stonepaste group from the *Saʾd* Egyptian group and the Mamluk Fustat group. Reconsideration of NAA data from the Mamluk study did not demonstrate a clear division between the Damascus and Syria (Site Unknown) groups, which tentatively suggested Damascus as the origin of all Syrian Other Stonepaste objects.[93]

Other Groups

Statistical analysis of the NAA data found two Gritille groups, GRT1 and GRT2, to be close to, but distinguishable from, the Raqqa Stonepaste group.[94] One object from each group was tested by EDS and determined to be generally similar to the Raqqa Stonepaste samples. Additional testing would be necessary to verify whether they are related to the Raqqa objects or are a distinct, unattributed group.[95]

The three finer fabric groups from the Gritille study (GRT6–GRT8) were readily separated from the Raqqa Stonepaste group.[96] Intriguingly, statistical analysis placed a luster- and underglaze-decorated bowl, from the Metropolitan Museum, closest to GRT6.[97] Although this bowl has strong stylistic similarities to the Raqqa Stonepaste group and certain trace elemental ratios in common with the Syrian Other Stonepaste group, it was found to be an outlier of both (charts 1, 2, 4).[98] Its distinct composition appeared to be primarily a result of the clay used, and its formulation was generally similar to that of the high-silica Raqqa Stonepaste subgroup.[99] The relationship to GRT6 suggested that the object and the group together represent a distinct, unattributed production site,[100] although additional EDS analysis of the Gritille groups would be needed to confirm this.

Clay Content and Composition

Considering the Raqqa Stonepaste group in greater detail revealed certain associations between aluminum content and decorative technique (chart 4; figure A2.1). For the two dominant styles, luster and black-under-turquoise, no clear distinction in the aluminum oxide contents was found. Although there was a slight tendency toward lower contents in luster and higher in black-under-turquoise, each technique was distributed across the full range of the group.[101] This discovery was somewhat surprising in light of the distinct nature of the decorative techniques and the absence of shared patterns.[102] However, vessel profiles are fully shared between the two techniques, suggesting that the potter's practice was to create standard forms that could be ornamented in several ways.[103] The lack of shared patterns may be an indication that the decoration was executed by different artisans or workshops, although the impact of the application techniques on style must also be considered.

Of the three less represented styles in the Raqqa Stonepaste group, the manganese-and-luster objects were found to have a higher aluminum oxide content than the average, the bichrome-decorated objects lower than the average, and the polychrome objects much lower.[104] Again, these are distinctions in the amount of clay used in the stonepaste formula for these decorative types, not in the clay itself.[105] These changes appeared to be a distinct phenomenon from the high-silica subgroup, which included four of the five decorative techniques.[106]

cluster. MMA32 is an unusually large black-under-turquoise-decorated bowl. LACMA M.2002.1.39 is a monochrome tile.

74. The ratio for all the trace elements showed an increase of approximately 20 percent, with the exception of Cs, which was found to be less linked to the clay component in general. It is noteworthy that all but one of the Raqqa Stonepaste objects in the GRT3 cluster had unusually high contents of aluminum oxide. The exception is MMA1975.31.7, the cobalt- and luster-decorated object, which suggests that this may be an outlier of both groups.

75. "A certain specialization of production of underglaze painted ceramics is implied by their association with smaller groups and their limited presence at the site [Gritille]." Redford and Blackman 1997: 244. Note that the Gritille groups not associated with Raqqa contain no underglaze-decorated objects and are instead primarily luster-decorated.

76. These objects have aluminum contents from 10 to 12 percent and an iron oxide–aluminum oxide ratio slightly greater than 1.

77. This sample (RA5) was found to fall surprisingly close to the Raqqa Stonepaste group, despite its radically different formulation, which suggests that the influence of the clay component of the stonepaste is emphasized by the combined adjusted EDS-NAA method.

78. MMA 1998.44.5. However, there was no clear evidence that this bowl was a waster.

79. W129; see note 4, above, for further details. This small bowl is nearly identical in form and decoration to two waster bowls from Berlin (W130, W131), which both fall in the Raqqa Stonepaste group.

80. Many more earthenware samples would need to be analyzed to be certain of this conclusion, which is lent weight by Redford and Blackman's observation (1997: 244) that "raw materials were used for both the lower quality fritwares and for calcareous clay ceramics." Probable relationships between earthenware and stonepaste ware have been noted in other studies.

81. *Based on EDS-NAA combined results:* MIK: I.926, I.1368, I.935, I.1895,83. TIEM: 3555. *Based on EDS results:* MIK: I.1369, I.350, I.431, Konya 1a,b, Konya 2, Kubadabad 2, Kubadabad 3a,b, Kubadabad 4a,b, Kubadabad 5.

82. PCA and CA of the combined adjusted EDS-NAA results and the EDS results.

83. EDS identified aluminum contents between 7 and 10 percent and an iron oxide–aluminum oxide ratio of about 0.2.

84. MIK I.6579, which proved to be an outlier in the EDS-NAA combined and EDS results, is likely to represent a distinct formulation and production site. Although an outlier in the EDS cluster analysis, MIK Kubadabad 1 could simply have a distinct formulation. MIK I.356 may also be distinct only in formulation, which is almost certainly associated with its *lajvardina* decoration, which makes use of a limited palette of enamel colors applied over a blue base glaze.

These compositional differences may be explained by the relative importance of a white ceramic for the aesthetic of a particular decorative scheme. Lighter-colored fabrics would be particularly important to the bichrome- and polychrome-decorated objects, which have clear glazes that reveal the ceramic surface as a background to the design.[107] White fabrics would be less critical for the black-under-turquoise-decorated objects, in which the glaze is colored, and for the luster-decorated objects, which have little open space left in the design. In manganese-colored glazes, which can be nearly opaque, the underlying body color would be least important, although reflectance off the ceramic surface played a role. The importance of whiteness for all these wares is indicated by the choice of a stonepaste fabric rather than earthenware, as well as by the presence of a fine white slip on most study objects.[108]

These differences in clay content may also reflect changes in stonepaste formulation, and in the decorative styles themselves, over the course of the period in question. Manganese decoration has been associated with the earlier Tell Minis ware, and bichrome decoration was to become dominant in the Mamluk period.[109]

An attempt has been made to present the preceding results in as straightforward a manner as possible, starting from a group of ceramics of unknown provenance and leading to the determination of Raqqa as their site of production. However, the actual course of research was more convoluted. The study began with the very reasonable expectations that the large collection of wasters from the Karatay Museum in Konya were produced locally and that many stylistically similar objects of the "Raqqa ware" type would prove to originate from that site. EDS analysis did indeed find that the study objects, including those from the Karatay Museum, were of very similar composition and likely to derive from a single site.

To confirm the Konya theory of origin, reference samples (primarily tiles) were collected from Konya and Kubadabad. However, EDS analysis of these Turkish tiles revealed that they were dissimilar to the study objects in both formulation and clay type. Comparison to prior bulk composition analyses of similar ceramics from Raqqa did not clearly confirm or deny that site as the source of the study objects. For this reason, additional reference material was collected from Raqqa.[110] The EDS results for those samples were very similar to those for the study group and raised serious doubts that Konya was the source of these objects. It became clear that an additional level of refinement was needed to make a conclusive statement; therefore, trace-element analysis using NAA was included in the study.

The combination of EDS and NAA results proved necessary to fully answer questions of provenance. EDS had insufficient specificity because of the overpowering effect of formulation, but this formulation had to be understood for NAA to correctly distinguish differences in the clay composition from those in the clay content. NAA results were found to be more comparable to data from prior studies and provided greater insight into provenance through the inclusion of additional sites. EDS was found to be problematic for such comparisons.

Consideration of the combined EDS-NAA results ultimately overturned the Konya theory and confirmed that Raqqa was indeed the place of origin of the so-called

85. MIK I.356, MIK I.6579, MIK Kubadabad 1, respectively.

86. That the tiles contained more clay than the vessels was surprising since the latter, formed on a wheel, require a higher level of plasticity than the former, which are normally cast in a mold. However, clay content may have been reduced in the vessels in order to produce whiter fabrics. In addition, increasing clay in the tiles may also have lowered cost, if sources of appropriate pure silica were rarer than those of appropriate clays.

87. *Vessels in Turkish Stonepaste group:* MIK I.350, Konya 1a,b. *Tiles in Raqqa Stonepaste group:* W75, LACMA M.2002.139.

88. This finding is discussed further below.

89. MMA 28.89.2, 1978.546.9, X365. PCA and CA were used. Within the NAA data alone, the Sc/La ratio clearly separates these objects.

90. These objects have aluminum contents of about 2 percent and an iron oxide–aluminum oxide ratio of slightly less than 1.

91. CA and iron oxide–aluminum oxide ratio comparison based on the EDS results.

92. Reconsideration by Marilyn Jenkins-Madina of the style and decoration of the *Saʾd* Iranian (?) Composite group indicated that Syria would be a more probable place of origin.

93. PCA and CA of the NAA data. Additional consideration is needed to make a firm assignment of provenance.

94. PCA best demonstrated these distinctions; CA was also used.

95. GT22 was tested from GRT1, GT140 from GRT2. These objects are considered part of the Raqqa Stonepaste group for the purposes of this study, given that there are no contradictory attributions at present.

96. By either PCA or CA.

97. MMA13.

98. PCA and CA of the combined EDS-NAA results, as well as CA and iron oxide–aluminum oxide ratio consideration based on the EDS data. The Sc/La ratio was found to be particularly useful in differentiating between groups. See note 89, above. Changes in the La content would be especially problematic because of the importance of the Sc/La ratio for grouping.

99. Based on cluster analysis of the EDS results.

100. Samsat is the most probable place of origin given the present data for this object and associated group.

101. In the Raqqa and GRT3 clusters defined by NAA within the group, it was observed that the Raqqa cluster, primarily composed of underglaze-decorated objects, had a lower aluminum content than the GRT3 cluster, which is primarily luster; however, the two groups contain both styles.

102. Luster is fluidly applied onto a smooth, fired glaze surface, while underglaze decoration uses coarser particles applied over a rougher, unfired ceramic surface. For descriptions of the patterns, see chapter 5.

103. Another consideration is the relationship between the underglaze decoration of the luster decoration and the luster itself, since these are applied at distinct stages of the firing process. It is likely that "luster blanks" were prepared with a limited set of underglaze pattern schemes, such as stripes and concentric circles.

104. Whether the manganese and luster objects should simply be considered luster-decorated or a distinct type is yet to be determined; this difference in composition suggests the latter may be true. One sample (GT131) was a clear exception to the aluminum scale if considered polychrome-decorated, but as it is a sherd, the nature of the decoration is not entirely certain.

105. This seems to be primarily a substitution of silica for clay in the formulation, as the sodium value remains relatively stable.

106. The manganese-and-luster technique is not found.

107. In the Gritille study, it was also noted that the finer fabric groups had larger numbers of clear glazed sherds. Redford and Blackman 1997: 244.

108. The slip was observed but not analyzed during the course of the study.

109. Some objects once thought to be "Tell Minis" have recently come to be considered as from Raqqa. See Watson 1999: 425.

110. Samples RA1–RA5. For full description and documentation, see chapter 5.

Raqqa ware. This conclusion was supported not only by the great similarity of the study objects to the Raqqa reference material but also by their distinctness from reference samples from Konya and Kubadabad, Damascus, and Fustat. Although underglaze decoration and Raqqa were strongly associated, a variety of decorative techniques appear to have been used at that site. It should be kept in mind that the study objects likely represent only a portion of Raqqa production during the period in question.

The causes of variations in composition are an important consideration for provenance studies in general, as is the range of compositions that might be associated with a single site. Among the study objects, compositions were found to be similar for tiles and vessels, as well as for vessels of different profiles. Changes in the stonepaste formula were noted in some unusually large vessels that had an elevated clay content and in a high-silica subgroup within the Raqqa Stonepaste objects that may represent finer production. Clay content was found to be associated with decorative technique to a certain extent, with those types that logically required whiter bodies using less clay. The result of these influences is that the Raqqa Stonepaste group displays considerable variations in composition—variations that could disguise the fact that the objects originate from the same site. The evidence in this study suggests that although this broad group will probably be subdivided as additional data becomes available, such divisions will be more indicative of time, technique, and workshop than of geography.

It is hoped that this study will help to attribute other objects in museum collections to Raqqa and to shed some light on other Syrian and Turkish ceramics produced in the early thirteenth century. But if Islamic ceramics of this period and others are to be fully understood, additional centers of production must be established for the times and regions in question. Collection of samples from Aleppo, Hama, and Samsat would clarify the relationship of these sites with the ware produced in Raqqa and aid in identifying the origin of the large Syrian Other Stonepaste group discussed here. As the inclusion of samples from prior studies was important in interpreting the present results, so too would the inclusion of standard reference samples in future studies allow for more accurate sharing of data and for the eventual construction of a larger picture of ceramic production in Islamic lands during the Early Medieval period.

Concordance

The museum inventory numbers
listed at left correspond as indicated
to the catalogue numbers at right in
chapter 3 and 4.

**The Metropolitan Museum of Art,
New York**

07.212.3	MMA2
08.102.4	MMA44
09.51	MMA3
10.44.2	MMA4
17.74.2	MMA5
17.120.36	MMA6
20.120.225	MMA7
22.196.1	MMA29
34.71	MMA30
38.84.2	MMA8
42.113.3	MMA45
45.153.3	MMA31
48.113.4	MMA9
48.113.5	MMA10
48.113.6	MMA11
48.113.7	MMA12
48.113.8	MMA13
48.113.9	MMA14
48.113.10	MMA15
48.113.11	MMA16
48.113.12	MMA17
48.113.13	MMA18
48.113.14	MMA19
48.113.15	MMA20
48.113.16	MMA21
48.113.17	MMA22
48.113.18	MMA23
48.113.19	MMA24
56.185.6	MMA32
56.185.9	MMA33
56.185.14	MMA34
56.185.15	MMA35
56.185.16	MMA36
56.185.17	MMA37
56.185.18	MMA38
56.185.19	MMA39
56.185.20	MMA40
56.185.21	MMA41
56.185.22	MMA42
57.61.1	MMA25
57.61.2	MMA26
57.61.3	MMA27
68.223.7	MMA43
91.1.138	MMA1
1970.24	MMA28
1974.161.11	MMA46

Aleppo National Museum

10	w137
105	w59
173	w39
262	w139
379	w91
385	w92
390	w32
394	w13

**Ashmolean Museum of Art
and Archaeology, Oxford**

1978.2196	w125
1978.2215	w73
1978.2216	w68
1978.2354	w122
1980.67	w47
x3027	w109
415	w29

British Museum, London

1902 5-19 1	w138
1902 5-19 2	w136
1902 5-19 3	w60
1902 5-19 4	w115
1902 5-19 5	w120
1902 5-19 6	w58
1902 5-19 7	w132
1902 5-19 8	w46
1902 5-19 9	w40

Ethnographical Museum, Ankara

1844	w97
1846	w86
1852	w49
5171	w95
7379	w11

**Freer Gallery of Art, Smithsonian
Institution, Washington, D.C.**

1904.143	w63
1904.293	w128
1905.240	w35
1905.258	w102
1908.69	w116
1908.112	w118
1909.376	w119
1910.30	w101
1910.31	w51
1910.36	w74

Hetjens-Museum, Düsseldorf

1957/50	w16

Hitchcock collection (formerly)

	w67

Karatay Museum, Konya

19	w3
22	w37
23	w123
17/1	w7
17/2	w8
17/3	w14
17/4	w5
17/5	w15
17/6	w6
17/7	w1
17/8	w2
17/9	w17
17/10	w20
17/11	w21
17/12	w18
18/1	w12
18/2	w19
18/3	w9
20/1	w28
20/2	w26
20/3	w34
20/4	w27
20/5	w24
25/1	w79
25/2	w80
25/5	w77
25/6	w78
25/7	w83
26/3	w88
26/5	w93
34/2	w66

Los Angeles County Museum of Art

M.2002.1.41	w75
M.2002.1.75	w89
M.2002.1.180	w62
M.2002.1.211	w56
M.2002.1.262	w22

Musée du Louvre, Paris

MAO250	w23

**Musée Nationale de Céramique
de Sèvres** w31

Museum für Islamische Kunst,
Staatliche Museen zu Berlin

I.411	w38
I.431	w110
I.1239	w131
I.1240	w130

Museum of Turkish and Islamic Art,
Istanbul

1549/4053	w48
1554/4044	w64
1555/2483	w57
1558/4058	w71
1569/1431	w70
1570/1435	w52
1573/1433	w53
1577/1434	w55
1578/1424	w54
1604/1529	w45
1605/1545	w72
1606/1544	w36
1607/1538	w126
1610/1502	w25
1614/1946	w44
1626/1470	w4
1694/1953	w105
1698/1959	w94
1699/1471	w98
1702/1948	w106
1704/1521	w84
1708/1553	w85
1710/1957	w107
1713/1494	w108
1715/1520	w134
1721/1464	w133
1723/1460	w127
1971/4957	w82
2139/2942	w76
2165/1542	w140
2175/1493	w81
2178/1428	w99
2188/1447	w135
2193/1539	w129
2215/1473	w100
2216/1518	w104
2224/1448	w117
2229/1486	w50

National Museum, Damascus

156	w65

Raqqa Museum

153/788	w124
770	w111
775	w112
777	w113
778	w114
8955	w33

Victoria and Albert Museum,
London

103-1909	w96
104-1909	w103
105-1909	w121
106-1909	w41
107-1909	w42
108-1909	w43
109-1909	w63
110-1909	w61
113-1909	w30
119-1909	w87
c851-1922	w10

The Walters Art Museum,
Baltimore

48.1117	w90

Bibliography of Works Cited

Books, Exhibition Catalogues, and Articles

Aanavi 1968
Don Aanavi. "Devotional Writing: 'Pseudo-inscriptions' in Islamic Art." *Metropolitan Museum of Art Bulletin*, n.s., 26 (May 1968): 353–58.

Ackerman 1997
Gerald M. Ackerman. *Jean-Léon Gérôme: His Life, His Work, 1824–1904*. Courbevoie: ACR Édition, 1997.

Allan 1981
[James W. Allan.] *Eastern Ceramics and Other Works of Art from the Collection of Gerald Reitlinger: Catalogue of the Memorial Exhibition*. Exh. cat., Ashmolean Museum, Oxford, July 18–September 13, 1981. Oxford: Ashmolean Museum; London: Sotheby, Parke Bernet, 1981.

Allan 1991
James W. Allan. *Islamic Ceramics*. Oxford: Ashmolean Museum, 1991.

***Almanach de Gotha* 1903**
Almanach de Gotha: Annuaire, généalogique, diplomatique et statistique. Gotha: J. Perthes, 1903.

***Apollo* 1991**
Apollo, Bollettino dei Musei Provinciali del Salernitano 7 (1991). Salerno, 1991.

Arık 2000
Rüçhan Arık. *Kubad Abad, Selçuklu Saray ve Çinileri*. Istanbul, 2000.

Artin Pacha 1907
Y. Artin Pacha. "Description de quatre lampes en verre émaillé et armoriées, appartenant à M. J. Pierpont-Morgan, des États-Unis d'Amérique, et déposées au South-Kensington Museum, à Londres." *Bulletin de l'Institut Égyptien*, ser. 5, 1 (1907): 69–92.

***Arts of Islam* 1976**
The Arts of Islam. Exh. cat., The Hayward Gallery, London, April 8–July 4, 1976. London: Arts Council of Great Britain, 1976.

Atil 1973
Esin Atil. *Freer Gallery of Art: 50th Anniversary Exhibition*. Vol. 3, *Ceramics from the World of Islam*. Exh. cat., Freer Gallery of Art, Washington, D.C., January–May 1974. Washington, D.C.: Smithsonian Institution, 1973.

Atil 1975
Esin Atil. *Art of the Arab World*. [Exh. cat., Freer Gallery of Art, Washington, D.C.] Washington, D.C.: Smithsonian Institution, 1975.

Atil, Chase, and Jett 1985
Esin Atil, W. T. Chase, and Paul Jett. *Islamic Metalwork in the Freer Gallery of Art*. Exh. cat., Freer Gallery of Art, Washington, D.C., September 27, 1985–January 5, 1986. Washington, D.C.: Freer Gallery of Art, Smithsonian Institution, 1985.

Baer 1983
Eva Baer. *Metalwork in Medieval Islamic Art*. Albany: State University of New York Press, 1983.

Ballardini 1933
Gaetano Ballardini. "'Bacini' orientali a Ravello." *Bollettino d'arte*, ser. 3, 27 (1933): 391–400.

Bell 1911
Gertrude L. Bell. *Amurath to Amurath*. London: W. Heinemann, 1911.

Berti 1987
Graziella Berti. "Notizie su bacini ceramici di chiese di Pisa." *Faenza* 73 (1987): 5–13.

Berti 1997
Graziella Berti. *Pisa. Le "Maioliche Arcaiche," secc. XIII–XV (Museo Nazionale di San Matteo)*. Ricerche di archeologia altomedievale e medievale, nos. 23–24. Florence, 1997.

Berti, Gabbrielli, and Parenti 1996
Graziella Berti, Fabio Gabbrielli, and Roberto Parenti. "'Bacini' e architettura: Tecniche di inserimento e complesso decorativo." In *Atti: I bacini murati medievali; problemi e stato della ricerca*: 243–64. Convegno Internazionale della Ceramica, 26th, Albisola, 1993. Albisola, 1996.

Berti and Tongiorgi 1981
Graziella Berti and Liana Tongiorgi. *I bacini ceramici medievali delle chiese di Pisa*. Rome: "L'Erma" di Bretschneider, 1981.

Blackman 1984
M. James Blackman. "Provenance Studies of Middle Eastern Obsidian from Sites in Highland Iran." In *Archaeological Chemistry III*, edited by Joseph B. Lambert: 19–50. Washington, D.C.: The American Chemical Society, 1984.

Blackman and Redford 1994
M. James Blackman and Scott Redford. "Glazed Calcareous Clay Ceramics from Gritille, Turkey." *Muqarnas* 11 (1994): 31–34. Also available online at http://archnet.org/library/documents/one-document.tcl?document_id=4231.

Bloom 1975
Jonathan M. Bloom. "'Raqqa' Ceramics in the Freer Gallery of Art, Washington, D.C." Master's Thesis, University of Michigan, Ann Arbor, 1975.

Burlington Fine Arts Club 1908
Exhibition of the Faience of Persia and the Nearer East. Exh. cat., Burlington Fine Arts Club, London. London: Printed for the Burlington Fine Arts Club, 1908.

Butler 1926
Alfred J. Butler. *Islamic Pottery, a Study, Mainly Historical*. London: E. Benn, 1926.

Caskey 2004
Jill Caskey. *Art and Patronage in the Medieval Mediterranean: Merchant Culture in the Region of Amalfi*. Cambridge: Cambridge University Press, 2004.

Cezar 1995
Mustafa Cezar. *Sanatta Batıya Açılış ve Osman Hamdi*. Istanbul, 1995.

Day 1941
Florence E. Day. "A Review of 'The Ceramic

Arts. A. History,' in *A Survey of Persian Art*."
Ars Islamica 8 (1941): 13–48.

Dimand 1930
Maurice S. Dimand. *A Handbook of Mohammedan Decorative Arts*. New York: The Metropolitan Museum of Art, 1930.

Dimand 1931
Maurice S. Dimand, with Joseph M. Upton. *Loan Exhibition of Ceramic Art of the Near East*. Exh. cat., The Metropolitan Museum of Art, New York, May 12–June 28, 1931. New York, 1931.

Dimand 1936a
Maurice S. Dimand. "Accessions of Islamic Art." *Bulletin of The Metropolitan Museum of Art* 31 (July 1936): 146–48.

Dimand 1936b
Maurice S. Dimand. *Islamic Pottery of the Near East, a Picture Book*. New York: The Metropolitan Museum of Art, 1936.

Dimand 1944
Maurice S. Dimand. *A Handbook of Muhammadan Art*. 2nd ed. New York: The Metropolitan Museum of Art, 1944.

Dimand 1949
Maurice S. Dimand. "Recent Additions to the Near Eastern Collections." *Metropolitan Museum of Art Bulletin*, n.s., 7, no. 5 (January 1949): 136–45.

Dimand 1957
Maurice S. Dimand. "The Horace Havemeyer Bequest of Islamic Art." *Metropolitan Museum of Art Bulletin*, n.s., 15, no. 9 (May 1957): 208–12.

Dimand 1958
Maurice S. Dimand. *A Handbook of Muhammadan Art*. 3rd ed. New York: The Metropolitan Museum of Art, 1958.

Ebla to Damascus 1985
Ebla to Damascus: Art and Archaeology of Ancient Syria. Exh. cat., Walters Art Gallery, Baltimore, and other venues, September 1985–September 1987. Washington, D.C.: Smithsonian Institution Traveling Exhibition Service, 1985.

Edhem 1947
Halil Edhem. *Halil Edhem hâtıra kitabı / In Memoriam Halil Edhem*. Vol. 1. Ankara: Türk Tarih Kurumu Basımevi, 1947.

Ettinghausen, Grabar, and Jenkins-Madina 2001
Richard Ettinghausen, Oleg Grabar, and Marilyn Jenkins-Madina. *Islamic Art and Architecture*,

650–1250. New Haven: Yale University Press, 2001.

Fortnum 1896
C. Drury E. Fortnum. *Maiolica: A Historical Treatise on the Glazed and Enamelled Earthenwares of Italy, with Marks and Monograms, also Some Notice of the Persian, Damascus, Rhodian, and Hispano-Moresque Wares*. Oxford: Clarendon Press, 1896.

Franchi et al. 1995
R. Franchi, C. Tonghini, F. Paloschi, and M. Soldi. "Mediaeval Syrian Fritware: Materials and Manufacturing Techniques." In *The Ceramics Cultural Heritage: Proceedings of the International Symposium, The Ceramics Heritage, of the 8th CIMTEC—World Ceramics Congress and Forum on New Materials, Florence, Italy, June 28–July 2, 1994*, edited by P. Vincenzini: 197–205. Faenza: Techna, 1995.

Frelinghuysen et al. 1993
Alice Cooney Frelinghuysen et al. *Splendid Legacy: The Havemeyer Collection*. Exh. cat., The Metropolitan Museum of Art, New York, March 27–June 20, 1993. New York: The Metropolitan Museum of Art, 1993.

Frierman, Asaro, and Michel 1979
Jay D. Frierman, Frank Asaro, and Helen V. Michel. "The Provenance of Early Islamic Lustre Wares." *Ars Orientalis* 11 (1979): 111–26.

Gabrieli and Scerrato 1979
Francesco Gabrieli and Umberto Scerrato. *Gli Arabi in Italia: Cultura, contatti e tradizioni*. Milan: Libri Scheiwiller, 1979.

Garner 1927
Julian Garner. "Ancient Potteries from the Site of Rakka." *International Studio* 87 (1927): 52–59.

Glass 1991
Dorothy F. Glass. *Romanesque Sculpture in Campania: Patrons, Programs, and Style*. University Park: Pennsylvania State University Press, 1991.

Grube 1963
Ernst J. Grube. "Raqqa-Keramik in der Sammlung des Metropolitan Museum in New York." *Kunst des Orients* 4 (1963): 42–78.

Heidemann 1999
Stefan Heidemann. "Die Geschichte von ar-Raqqa/ar-Rāfiqa: Ein Überblick." *Raqqa* (Mainz am Rhein) 2 (1999): 9–56.

Hess 2004
Catherine Hess, ed. *Arts of Fire: Islamic Influences*

on Glass and Ceramics of the Italian Renaissance*. Contributions by Linda Komaroff and George Saliba. Exh. cat., J. Paul Getty Museum, Los Angeles, May 4–September 5, 2004. Los Angeles: J. Paul Getty Museum, 2004.

Hobson 1932
R. L. Hobson. *A Guide to the Islamic Pottery of the Near East*. London: British Museum, 1932.

Islamische Kunst 1981
Islamische Kunst: Meisterwerke aus dem Metropolitan Museum of Art New York / The Arts of Islam: Masterpieces from the Metropolitan Museum of Art, New York. Exh. cat., Museum für Islamische Kunst, Staatliche Museen zu Berlin, Stiftung Preussischer Kulturbesitz, June 20–August 23, 1981. Berlin: Edition "Kunstbuch Berlin," 1981.

Jenkins 1983a
Marilyn Jenkins, ed. *Islamic Art in the Kuwait National Museum: The al-Sabah Collection (Dār al-Āthār al-Islāmīyah)*. London: Sotheby, 1983.

Jenkins 1983b
Marilyn Jenkins. "Islamic Pottery: A Brief History." *Metropolitan Museum of Art Bulletin*, n.s., 40, no. 4 (Spring 1983).

Jenkins 1984
Marilyn Jenkins. "Mamluk Underglaze-Painted Pottery: Foundations for Future Study." *Muqarnas* 2 (1984): 95–114. Also available online at http://archnet.org/library/documents/one-document.tcl?document_id=3890.

Jenkins 1988
Marilyn Jenkins. "Saʻd: Content and Context." In *Content and Context of Visual Arts in the Islamic World: Papers from a Colloquium in Memory of Richard Ettinghausen, Institute of Fine Arts, New York University, 2–4 April 1980*, edited by Priscilla P. Soucek: 67–89. College Park: Pennsylvania State University Press, 1988.

Jenkins, Meech-Pekarik, and Valenstein 1977
Marilyn Jenkins, Julia Meech-Pekarik, and Suzanne G. Valenstein. *Oriental Ceramics: The World's Great Collections*. Vol. 12, *The Metropolitan Museum of Art*. Tokyo: Kodansha, 1977.

Jenkins-Madina 2000
Marilyn Jenkins-Madina. "Collecting the 'Orient' at the Met: Early Tastemakers in America." *Ars Orientalis* 30 (2000): 69–89.

Kamerling 1977
Bruce Kamerling. "Edward C. Moore, the Genius behind Tiffany Silver," parts 1–2.

Silver 10, no. 5 (September–October 1977): 16–20; no. 6 (November–December 1977): 8–13.

Keene 1977
Manuel Keene. "Raqqa Bowl." *Studio Potter* 5, no. 2 (1977): 60–61.

Kelekian 1910
Dikran Kelekian. *The Kelekian Collection of Persian and Analogous Potteries, 1885–1910.* Paris: H. Clarke, 1910.

Koechlin 1903
Raymond Koechlin. "L'art musulman: À propos de l'exposition du Pavillon d Marsan." *La revue de l'art ancien et moderne* 13 (January–June 1903): 409–20.

Konyalı 1964
Ibrahim H. Konyalı. *Âbideleri ve Kitâbeleri ile Konya Tarihi.* Konya: Yeni kitap Basımevi, 1964.

Kouchakji 1923
Fahim [Joseph] Kouchakji. "Glories of Er Rakka Pottery." *International Studio* 76 (March 1923): 515–24.

Kouchakji obituary 1976
"Obituary of Fahim Joseph Kouchakji." *New York Times*, August 21, 1976: 24, col. 5.

Kuhnel 1938
Ernst Kuhnel. *Die Sammlung türkischer und islamischer Kunst im Tschinili Köschk.* Meisterwerke der Archäologischer Museen in Istanbul, vol. 3. Berlin: W. de Gruyter, 1938.

***Land des Baal* 1982**
Land des Baal: Syrien, Forum der Völker und Kulturen. Exh. cat. edited by Kay Kohlmeyer and Eva Strommenger, contributions by Ali Abou Assaf et al.; organized by the Museum für Vor- und Frühgeschichte, Berlin; traveled to various venues from March 4, 1982–April 10, 1983. Mainz am Rhein: P. von Zabern, 1982.

Lane 1947
Arthur Lane. *Early Islamic Pottery: Mesopotamia, Egypt, and Persia.* London: Faber and Faber, 1947.

Lane 1956
Arthur Lane. *Islamic Pottery from the Ninth to the Fourteenth Centuries A.D. (Third to Eighth Centuries A.H.) in the Collection of Sir Eldred Hitchcock.* London: Faber and Faber, 1956.

Lewis 1987
Norman N. Lewis. *Nomads and Settlers in Syria and Jordan, 1800–1980.* Cambridge: Cambridge University Press, 1987.

Littmann 1960
E. Littmann. "Alf Layla wa-Layla." In *The Encyclopaedia of Islam*, vol. 1: 358–64. New ed. Leiden: E. J. Brill, 1960.

Lukens 1965
Marie G. Lukens. *Guide to the Collections: Islamic Art.* New York: The Metropolitan Museum of Art, 1965.

Mason 1994
Robert B. Mason. *Islamic Glazed Pottery, 700-1250.* Ph.D. diss., Oxford University, 1994.

Mason 1995
Robert B. Mason. "Defining Syrian Stonepaste Ceramics: Petrographic Analysis of Pottery from Ma'arrat Al-Nu'man." In *Islamic Art in the Ashmolean Museum*, edited by James W. Allan, vol. 2: 1–18. Oxford: Oxford University Press, 1995.

Mason 1997
Robert B. Mason. "Medieval Syrian Lustre-Painted and Associated Wares: Typology in a Multidisciplinary Study." *Levant* 29 (1997): 169–200.

Mason and Tite 1994
Robert B. Mason and M. S. Tite. "The Beginnings of Islamic Stonepaste Technology." *Archaeometry* 36 (1994): 77–91.

Mauro 1991
Daniela Mauro. "La decorazione scultorea [dell'ambone di San Giovanni del Toro a Ravello]." *Apollo: Bollettino dei Musei Provinciali del Salernitano* 7 (1991): 89–102.

Mayor 1957
A. Hyatt Mayor. "The Gifts That Made the Museum." *Metropolitan Museum of Art Bulletin*, n.s., 16, no. 3 (November 1957): 85–107.

McAllister 1938
Hannah E. McAllister. "Recent Gifts: Near Eastern Ceramics and Textiles." *Bulletin of The Metropolitan Museum of Art* 33 (November 1938): 242–44.

Meinecke 1995
M. Meinecke. "al-Raḳḳa." In *Encyclopaedia of Islam*, vol. 8: 410–14. New ed. Leiden: E. J. Brill, 1995.

Mendel 1909
Gustave Mendel. "Les nouvelles salles du Musée de Constantinople," part 2. *La revue de l'art ancien et moderne* 26 (July–December 1909): 337–52.

Metropolitan Museum 1983
The Metropolitan Museum of Art Guide. Edited by Kathleen Howard. New York, 1983.

Michel, Frierman, and Asaro 1976
H. V. Michel, J. D. Frierman, and F. Asaro. "Chemical Composition Patterns of Ceramic Wares from Fustāt, Egypt." *Archaeometry* 18, 1 (1976): 85–92.

Migeon 1901
Gaston Migeon. "Céramique orientale à reflets métalliques: À propos d'une acquisition récente du Musée du Louvre." *Gazette des Beaux-Arts*, ser. 3, 26 (1901): 192–208.

Migeon 1903
Gaston Migeon. *Exposition des arts musulmans au Musée des Arts Décoratifs.* Exh. cat. Paris: E. Lévy, 1903.

Migeon 1907
Gaston Migeon. *Manuel d'art musulman.* Vol. 2, *Les arts plastiques et industriels.* Paris: A. Picard, 1907.

Mommsen 2004
Heide Mommsen. "Short Note: Provenancing of Pottery—The Need for an Integrated Approach?" *Archaeometry* 46, no. 2 (2004): 267–71.

Nöldeke-Hannover 1910–11
A. Nöldeke-Hannover. "Zur Kenntnis der Keramik von Raqqa, Rhages und Sultanabad." *Orientalisches Archiv* 1 (1910–11): 16–17.

Ölçer 2002
Nazan Ölçer. "History of the Museum." In *Museum of Turkish and Islamic Art*, by Nazan Ölçer et al.: 8–26. Istanbul: Akbank Dept. of Culture and Art, 2002.

***Orient de Saladin* 2001**
Orient de Saladin: L'art des Ayyoubides. Exh. cat., Institute du Monde Arabe, Paris, October 23, 2001–March 10, 2002. Paris: Gallimard, 2001.

Perez-Arantegui et al. 1995
Josefina Perez-Arantegui, Guirec Querre, Alexander Kaczmarczyk, and Marthe Bernus-Taylor. "Chemical Characterization of Islamic Glazed Ceramics from Northern Syria by Particle Induced X-ray Emission." In *The Ceramics Cultural Heritage: Proceedings of the International Symposium, The Ceramics Heritage, of the 8th CIMTEC—World Ceramics Congress and Forum on New Materials, Florence, Italy, June 28–July 2, 1994*, edited by P. Vincenzini: 475–82. Faenza: Techna, 1995.

Pézard 1920
Maurice Pézard. *La céramique archaïque de l'Islam et ses origines*. Paris: E. Leroux, 1920.

Philon 1985
Helen Philon. "Stems, Leaves, and Water-Weeds: Underglaze-Painted Pottery in Syria and Egypt." In *The Art of Syria and the Jazira, 1100–1250*, edited by Julian Raby: 113–26. Oxford and New York: Oxford University Press, 1985.

Pier 1908
Garrett Chatfield Pier. "Pottery of the Hither Orient in the Metropolitan Museum—I." *Burlington Magazine* 14 (November 1908): 120–25.

Porter 1981
Venetia Porter. *Medieval Syrian Pottery: Raqqa Ware*. Oxford: Ashmolean Museum, 1981.

Porter 2004
Venetia Porter. "Glazed Pottery from the Great Mosque at ar-Rāfiqa." In *Ar-Raqqa / Deutsches Archäologisches Institut*, vol. 3, *Baudenkmäler und Paläste I*, edited by Verena Daiber and Andrea Becker: 41–43. Mainz am Rhein: P. von Zabern, 2004.

Porter and Watson 1987
Venetia Porter and Oliver Watson. "'Tell Minis' Wares." In *Syria and Iran: Three Studies in Medieval Ceramics*, edited by James W. Allan and Caroline Roberts: 175–248. Oxford, 1987.

Raby 1989
Julian Raby. "İznik: The European Perspective." In Nurhan Atasoy and Julian Raby, *İznik, the Pottery of Ottoman Turkey*: 71–74, 372. London: Alexandria Press, in association with Thames and Hudson, 1989.

Redford and Blackman 1997
Scott Redford and M. James Blackman. "Luster and Fritware Production and Distribution in Medieval Syria." *Journal of Field Archaeology* 24 (1997): 233–47.

Répertoire chronologique d'épigraphie arabe 1941
Répertoire chronologique d'épigraphie arabe. Vol. 11. Cairo: Institut Français d'Archéologie Orientale du Caire, 1941.

Rice 1953
D. S. Rice. "Studies in Islamic Metalwork, III." *Bulletin of the School of Oriental and African Studies* 15, no. 2 (1953): 229–38.

Rice 1957
D. S. Rice. "Inlaid Brasses from the Workshop of Ahmad al-Dhaki al-Mawsili." *Ars Orientalis* 2 (1957): 283–326.

Riefstahl n.d.
R[udolf] Meyer Riefstahl. *A Collection of Ancient Raqqa Pottery*. N.p., n.d.

Riefstahl 1922
R[udolf] Meyer Riefstahl. *The Parish-Watson Collection of Mohammadan Potteries*. New York: E. Weyhe, 1922.

Riis and Poulsen 1957
Poul J. Riis and Vagn H. Poulsen. *Hama: Fouilles et recherches de la Fondation Carlsberg, 1931–38*. Vol. 4, part 2, *Les verreries et poteries médiévales*. National-museets skrifter; Større beretninger, vol. 3. Copenhagen: I Kommission hos Gyldendal, 1957.

Rivière 1913
Henri Rivière, ed. *La céramique dans l'art musulman*. Vol. 1. Edited by Émile Lévy; preface by Gaston Migeon. Paris: Librairie Centrale des Beaux-Arts, 1913.

Rogers 1969
J. M[ichael] Rogers. "Recent Work on Seljuk Anatolia." *Kunst des Orients* 6 (1969): 134–69.

Rogers 1995
[J.] M[ichael] Rogers. "Saldjūkids: Ceramics and Glass." In *Encyclopaedia of Islam*, vol. 8: 968. New ed. Leiden: E. J. Brill, 1995.

Roxburgh 2000
David J. Roxburgh. "Au Bonheur des Amateurs: Collecting and Exhibiting Islamic Art, ca. 1880–1910." *Ars Orientalis* 30 (2000): 9–38.

Rye and Evans 1976
Owen S. Rye and Clifford Evans. *Traditional Pottery Techniques of Pakistan: Field and Laboratory Studies*. Smithsonian Contributions to Anthropology, no. 21. Washington, D.C.: Smithsonian Institution Press, 1976.

Sarre 1909a
Friedrich Sarre. *Erzeugnisse islamischer Kunst, Teil II, Seldschukische Kleinkunst*. Berlin: Kommissions-verlag von K. W. Hiersemann in Leipzig, 1909.

Sarre 1909b
Friedrich Sarre. "Rakka Ware" (letter to the editor). *Burlington Magazine* 14, no. 72 (March 1909): 388.

Sarre 1921
Friedrich Sarre. *Die Keramik archäologische Reise im Euphrat- und Tigris-Gebiet*. Offprint of *Archäologische Reise im Euphrat- und Tigris-Gebiet*, vol. 4 (1920): 1–25. Berlin: Dietrich Reimer, 1921.

Sarre 1927
Friedrich Sarre. "Drei Meisterwerke syrischer Keramik: Neuerwerbungen der islamischen Kunstabteilung." *Berliner Museen: Berichte aus den Preussischen Kunstsammlungen* 48 (1927): 7–10.

Sarre and Herzfeld 1911
Friedrich Sarre and Ernst Herzfeld. *Archäologische Reise im Euphrat- und Tigris-Gebiet*. Vol. 3. Berlin: Dietrich Reimer, 1911.

Sarre and Martin 1912
Friedrich Sarre and F. R. Martin, eds. *Die Ausstellung von Meisterwerken muhammedanischer Kunst in München, 1910*. 3 vols. Munich, 1912.

Sauvaget 1948
J[ean] Sauvaget. "Tessons de Rakka." *Ars Islamica* 13–14 (1948): 31–45.

Schroerer et al. 1992
M. Schroerer, C. Ney, C. Raffaillac-Desfosse, and P. Peduto. "Bacini et tesselles en céramique glaçurée de l'église San Giovanni del Toro, Ravello." *Apollo: Bollettino dei Musei Provinciali del Salernitano* 8 (1992): 74–96.

Schwedt, Mommsen, and Zacharias 2004
A. Schwedt, Heide Mommsen, and N. Zacharias. "Post-Depositional Elemental Alterations in Pottery: Neutron Activation Analyses of Surface and Core Samples." *Archaeometry* 46, no. 1 (2004): 85–101.

Shaw 2003
Wendy M. K. Shaw. *Possessors and Possessed: Museums, Archaeology, and the Visualization of History in the Late Ottoman Empire*. Berkeley: University of California Press, 2003.

Soustiel 1985
Jean Soustiel. *La céramique islamique*. With the collaboration of Charles Kiefer. Fribourg: Office du Livre; Paris: Vilo, 1985.

Tonghini 1994
Cristina Tonghini. "The Fine Wares of Ayyubid Syria." In Ernst J. Grube, *Cobalt and Lustre: The First Centuries of Islamic Pottery*: 249–94. The Nasser D. Khalili Collection of Islamic Art, vol. 9. London: Nour Foundation, 1994.

Tonghini and Grube 1988–89
Cristina Tonghini and Ernst J. Grube.

"Towards a History of Syrian Islamic Pottery before 1500." *Islamic Art* 3 (1988–89): 59–93.

Toueir 1985
Kassem Toueir. "Der Qasr al-Banat in ar-Raqqa: Ausgrabung, Rekonstruktion und Wiederaufbau (1977–1982)." *Damaszener Mitteilungen*, 1985: 297–319.

Tushingham 1985
A. D. Tushingham. *Excavations in Jerusalem, 1961–1967.* Vol. 1. Toronto: Royal Ontario Museum, 1985.

Vahit 1909
Mehmet Vahit. *Müze-yi Hümayun-i Osmaniʿye Mahsus Muhtasar Rehnüma.* Istanbul: Matbaa-yi Ahmet İhsan, A.H. 1325/A.D. 1909.

Vernoit 1998
Stephen Vernoit. "Islamic Gilded and Enamelled Glass in Nineteenth-Century Collections." In *Gilded and Enamelled Glass from the Middle East,* edited by Rachel Ward: 110–15. London: British Museum Press, 1998.

Walters Art Gallery 1997
Walters Art Gallery: Guide to the Collections. [Edited by Moira Johnston.] Baltimore: Walters Art Gallery, 1997.

Watson 1999
Oliver Watson. "Museums, Collecting, Art-History, and Archaeology." *Damaszener Mitteilungen* 11 (1999): 421–32.

Watson 2004
Oliver Watson. *Ceramics from Islamic Lands.* New York: Thames and Hudson in association with the al-Sabah Collection, Dar al-Athar al-Islamiyyah, Kuwait National Museum, 2004.

Weinberg 1976
H. Barbara Weinberg. "Thomas B. Clarke: Foremost Patron of American Art from 1872 to 1899." *American Art Journal* 8 (May 1976): 52–83.

Wood 2000
Barry D. Wood. "'A Great Symphony of Pure Form': The 1931 International Exhibition of Persian Art and Its Influence." *Ars Orientalis* 30 (2000): 113–30.

Wulff 1966
Hans E. Wulff. *The Traditional Crafts of Persia: Their Development, Technology, and Influence on Eastern and Western Civilizations.* Cambridge, Mass.: MIT Press, 1966.

Yusuf 1930
Mehmet Yusuf. *Resimli ve muhtasar Konya Asarı Atika Müzesi Rehberi.* Istanbul: Alâeddin Klişe Matbaası, 1930.

Sale Catalogues

Clarke sale 1917
American Art Galleries. *Illustrated Catalogue of the Important and Interesting Collection of Beautiful Pottery Vases of Eastern Origin Dating from the Sixth Century B.C. to the Eighteenth Century A.D.; Being the Collection of the Widely Known Connoisseur Mr. Thomas B. Clarke of New York City.* Sale cat. New York, January 3–6, 1917.

Clarke sale 1925
American Art Galleries. *The Private Collection of Mr. Thomas B. Clarke from His Own Residence on Murray Hill: Rare English, American and French Furniture, XVI Century Ispahan Rugs, Chinese Rugs, XVI and XVII Century Velvets, Brocades and Damasks, Ecclesiastical Vestments and Decorative Banners and Needlework Panels, Italian Faience, Hispano-Moresque Plaques, Persian XIII Century Glass, Rhodian Ceramics, Greek Vases and Sculptures, Rakka Pottery from "The Great Find."* Sale cat. New York, January 7–10, 1925.

Goupil sale 1888
Hôtel Drouot. *Catalogue des objets d'art de l'Orient et de l'Occident: Tableaux, dessins, composant la collection de feu M. Albert Goupil.* Sale cat. Paris, April 23–27, 1888.

Kelekian sale 1903
American Art Galleries. *Catalogue of Rare and Beautiful Greek, Egyptian, Byzantine and Other Glass, Persian and Other Pottery . . . and Many Other Ancient Objects of Extraordinary Interest. The Collection of Dikran Khan Kelekian.* Sale cat. New York, April 15–18, 1903.

Khayat sale 1907
American Art Galleries. *Catalogue of Greek and Roman Iridescent Glass, Babylonian Glazed Pottery, Bronzes, Ivories, Tanagra Figurines, Scarabs, Gold and Silver Coins, Enamels, Jades, Textiles and Other Rarities; the Collection to Be Sold by Order of the Well-Known Expert Mr. Azeez Khayat.* Sale cat. New York, February 14–16, 1907.

Khayat sale 1908
Fifth Avenue Art Galleries. *Catalogue of Greek and Roman Iridescent Glass, Babylonian Glazed Pottery, Bronzes, Ivories, Tanagra Figurines, Scarabs, Ushebties, Cylinders, Tablets, Coins, Beads,*

Rare Chinese Porcelains, Jades, Snuff Boxes, Enamels and Fine Oriental Jewels, etc. Sale cat. New York, February 12–13, 1908.

Khayat sale 1910
Fifth Avenue Art Galleries. *Catalogue of a Rare Collection of Rekka Iridescent Potteries, Beautiful Pieces of Phoenician Glass from Recent Excavations in Syria; Rare Egyptian Scarabs, Beautiful Necklaces of Egyptian Beads and Amulets, Artistic Tanagra Figures, Greek Bronzes, Greek Coins, Persian Plates, and Other Rare Egyptian and Greek Antiquities; the Collection to Be Sold by Order of Mr. Azeez Khayat.* Sale cat. New York, February 9–10, 1910.

Khayat sale 1928
Anderson Galleries. *Egyptian, Greek, Roman, and Persian Antiques Collected by Azeez Khayat Expert in Egypt, Palestine, Syria, and Greece.* Sale cat. New York, April 11–12, 1928.

Kouchakji Frères sale 1916
Kouchakji Frères. *Interesting Examples of Saracenic Art Chiefly Consisting of Rakka, Syro-Egyptian, Rey or Rhages, Sultanabad, Rhodian, Hispano-Mauresque, Koubatcha Faiences and Arabic Enameled Glasses.* Sale cat. New York, January 28–February 19, 1916.

Kouchakji Frères sale 1918
American Art Association. *The Kouchakji Frères Collection of Graeco-Roman, Rakka, Persian, Hispano-Moresque Faiences, Italian Majolicas, Persian and Indian Miniatures and Rugs, Egyptian, Ptolemaic, Sidonian, Roman and Arabic Glass, Greek and Roman Bronzes.* Sale cat. New York, March 8–9, 1918.

Kouchakji Frères sale 1927
Anderson Galleries. *Rakka, Persian, Rhodian, Damascus, Hispano-Moresque Faiences; Egyptian, Ptolemaic, Alexandrian, Roman, Arabic, and Syrian Glass; Persian and Indian Miniatures and Manuscripts; Greek and Roman Statuary; Gold and Silver Objects; Persian Rugs and Other Objects of Rarity: The Collection of Kouchakji Frères, Paris and New York.* Sale cat. New York, January 25–26, 1927.

Monif sale 1929
Anderson Galleries. *Near Eastern Antiques Collected by H. Khan Monif, New York City and Teheran, Persia.* Sale cat. New York, January 16–17, 1929.

Sotheby's sale 1986
Sotheby's. *Islamic Works of Art: Carpets and Textiles.* Sale cat. London, October 15, 1986.

Index

Page numbers in *italic type* refer to illustrations.

Photograph Credits

Photographs are reproduced courtesy of the institutions cited in the captions and the sources listed below:

Ashmolean Museum of Art and Archaeology, Oxford: figure 1.1 (neg. c.6678)
Gabrieli and Scerrato 1979, pl. 424: fig. 6.7
The Gertrude Bell Archive, Newcastle University, Newcastle upon Tyne: figs. 2.4–2.9
Charles Lang Freer Papers, Freer Gallery of Art and Arthur M. Sackler Gallery Archives, Smithsonian Institution, Washington, D.C.: fig. 2.10
Museum für Islamische Kunst, Staatliche Museen zu Berlin, Bildarchiv Preussischer Kulturbesitz/Art Resource, New York: fig. 5.2
Rago Arts and Auction Center, Lambertville, New Jersey: fig. E1
Sauvaget 1948, fig. 10, nos. 84, 85: W31, fig. 5.3
Peter Zeray, The Photograph Studio, The Metropolitan Museum of Art: figs. E2, A1.1

PLATE I